HOUSE OF THURN UND TAXIS

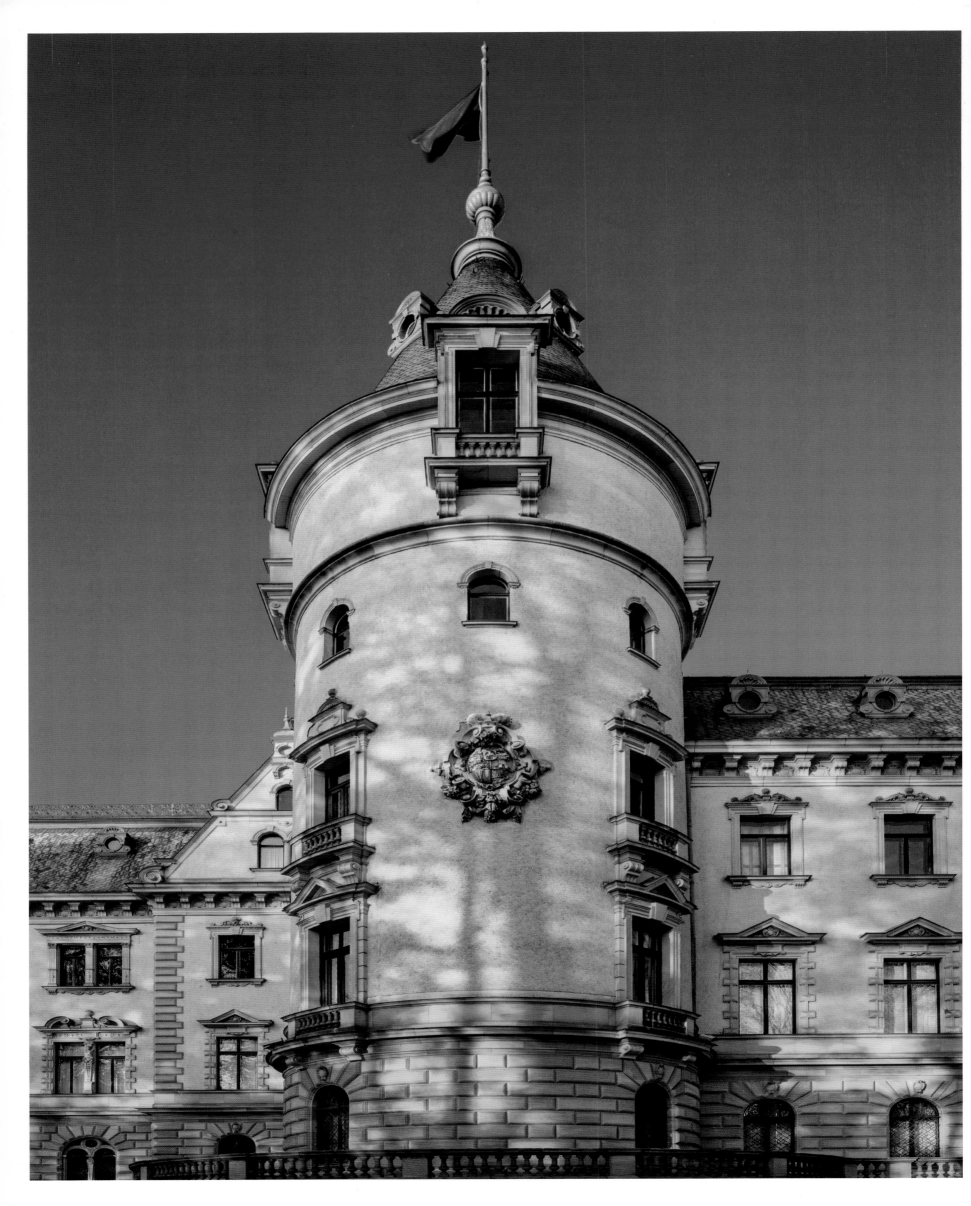

House of Thurn und Taxis

PRINCESS MARIAE GLORIA THURN UND TAXIS

AND

TODD EBERLE

Skira *RIZZOLI*
NEW YORK

INTRODUCTION BY

PRINCESS MARIAE GLORIA THURN UND TAXIS

FOREWORD BY

TODD EBERLE

A CONVERSATION BETWEEN

PRINCESS MARIAE GLORIA THURN UND TAXIS

AND

SIR JOHN RICHARDSON

WITH CONTRIBUTIONS BY

JEFF KOONS

PRINCESS ELISABETH THURN UND TAXIS

MARTIN MOSEBACH

AND ANDRÉ LEON TALLEY

DESIGN BY

PANDISCIO CO.

POP AND CIRCUMSTANCE

The first time I drove into the courtyard of St. Emmeram, I was totally overwhelmed by the size and grandeur of the palace. I could hardly imagine that this was the home of my date, Johannes—Prince Johannes Thurn und Taxis, to be precise—the eleventh Prince of the House of Thurn und Taxis.

Johannes, my late husband, and I had met just a couple weeks before in Munich in 1979. He had given a luncheon at Bratwurst Glöckl, a typical Bavarian restaurant, and his nephew Johannes Schoenborn brought me there, along with other friends. A few days later, Johannes walked into Café Reitschule, an afternoon hangout. My friends and I had concert tickets for Supertramp that night, but Johannes asked me to dinner, and so instead I decided to go with him. We had a wonderful time together and from that evening on, we were inseparable. One day he asked me to drive to Regensburg with him. I was picked up at my small apartment by his chauffeur, Willi, in the Prince's beautiful Mercedes 600.

Of course, I had no idea then how serious Johannes was about our freshly blooming relationship. He was fifty-three; I was twenty.

The palace guardian showed me around the house, a tour that took about three hours. I came back to the drawing room totally exhausted. Johannes seemed pleased with the fact that I had visited almost the whole schloss.

Then I met his father—a skinny, short gentleman with a huge nose—who was about eighty-five years old. He welcomed me in his drawing room, which was filled with birds, including parrots and a crow who screamed and croaked while we conversed. We hit it off immediately. I found out that he spoke about eight languages fluently, and so we talked in Hungarian, my mother tongue.

* * *

Opposite: Princess Mariae Gloria Ferdinanda Joachima Josephine Wilhelmine Huberta Thurn und Taxis

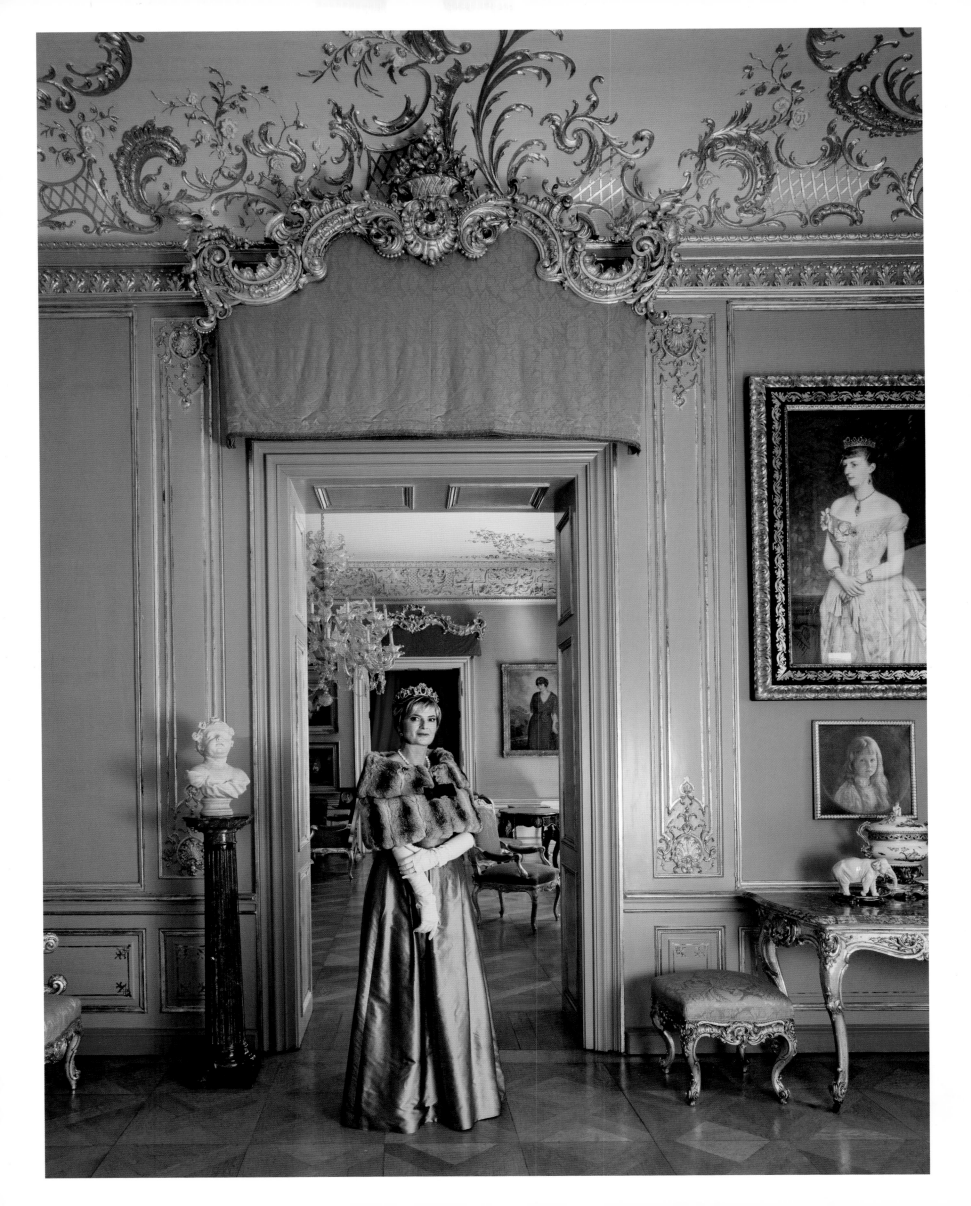

Both my parents come from illustrious families. My father, Count von Schoenburg-Glauchau, descended from a very old Saxonian family who had ruled their lands for almost a thousand years. My siblings and I grew up with no money at all because both of my parents had fled their families' estates to escape the Russian Bolsheviks. My father left in a horse and carriage with his mother and very young brothers and sisters, as his father was killed at the end of the war. They found refuge with their relative Prince von Fuerstenberg, who gave them the beautiful Castle Heiligenberg to live in. Later, my father worked in a morgue to finance his political studies and then he became a journalist.

My mother descends from the famous Count István Széchenyi, one of the great philanthropists and reformers of Hungary—he built the Széchenyi Bridge, and his father, Ferenc, founded the national library in 1802. My mother fled Hungary in 1953. My parents met because my father was one of the volunteers of the Order of Malta, who gave first aid to the expelled Hungarians.

* * *

After my first visit to the palace, I returned to Munich to prepare for acting school and my exams. Then Johannes asked me to spend New Year's with him in Mexico and Brazil. I did not hesitate, thinking I could return to acting school the next semester.

While traveling, we fell in love, and soon after, he proposed. I knew instantly that Johannes was the love of my life and that I wanted to have children with him. He called home and asked his majordomo to prepare for a wedding in May. (Yes, Johannes still employed a majordomo— and forty footmen.) I simply called my parents to let them know I was going to get married.

Our fairy-tale wedding passed by like in a dream. We traveled to Rome to get my wedding dress from Johannes's friend Valentino and then, after the wedding, we embarked on his sailing yacht, *Aiglon*, for a three-month cruise in the Mediterranean.

Our oldest daughter, Maria Theresia, was born in November 1980. Johannes was more than happy about his first daughter—he was absolutely in love. Nevertheless, he was longing to have an heir. One year later I had Elisabeth, our second girl. Johannes was very pleased to see how our family was growing. And then our son, Albert, was born in 1983. It was then that I realized how important the birth of a son had been to my husband. He was so happy and fulfilled.

The years went by in our wonderfully pampered life. No worries, no problems—just fun and adventure. Life was good to us and we enjoyed ourselves, taking the kids with us everywhere: January and February on his farm in Brazil and then to Rio de Janeiro, March in St. Moritz, April in Paris, May in London, June at home in Regensburg, July to August or September on the *Aiglon* cruising the Mediterranean, October in New York City, November back in Germany until after Christmas, and then off again to the Caribbean on his boat.

* * *

Johannes, my husband, always wanted me to be elegantly dressed. He loved to give me jewelry and took me to Paris for couture dresses, where I was allowed to buy whatever I fancied. I went to Chanel at first, and I affectionately remember being met by Karl Lagerfeld and Gilles Dufour for my fittings. I also chose Jean Patou, as there was a young designer named Christian Lacroix whose talent I adored.

I always ordered the entire outfit with matching hat and shoes, and I looked like I was off the catwalk every time we hit a party. Johannes dressed in the most perfect English tailored suits, with a white or red carnation, depending on his mood. One can imagine how stylish we looked when we left the Hôtel Ritz in Paris. French *Vogue* asked us to be photographed by Helmut Newton for a Christmas/ New Year's issue, and so we invited him to take the pictures on Johannes's sailing yacht, which was anchored in Ibiza, and I dressed up from head to toe in Kansai Yamamoto.

My husband was very generous. He was amused by my enthusiasm when we first met Keith Haring at Andy Warhol's Factory in the early eighties. Keith Haring's works were my first art acquisitions.

Johannes pushed me to visit the museums in every country we visited so that I could learn about Old Master paintings. There was no way for me to understand Andy Warhol's genius at the time. But Keith drew and painted himself—this I understood, and so I started to hang around his studio. I also met Jean-Michel Basquiat and visited his studio. I bought my first Basquiat at Tony Shafrazi's gallery. This is how I started to collect, slowly but surely—and with limited funds because my "Goldie" (as I called my husband) did not like contemporary art. But he wanted me to have fun, and so he sponsored my new passion.

My life became richer through meeting lots of artists, and my husband was amused by these people, too. He was very fond of Andy and Keith and invited them to visit Regensburg Palace. They both came and Keith got a real kick out of my kids—he loved to play with them and, of course, to paint with them. He took his Edding marker and drew all over the door of the playroom. Everything is still there!

I also met Jeff Koons very early in the eighties because he was represented by Max Hetzler, a German art dealer I knew. I loved Jeff's work right from the start and always said to him, "I want to sell all I have and only collect your work!" Jeff came to visit our estate with his family and we became very good friends.

I have always loved pop music and was a regular at the huge rock concerts for seventies bands like Pink Floyd and Genesis, but I was also addicted to the new Philly sound and Motown's funk music. Bob Colacello had written a huge article on us in *Vanity Fair*, which put me in the limelight in the US; the article gave me entrée to Steven Fargnoli, Prince's manager. Steven invited me to join the band on the Sign o' the Times tour. Prince kept very much to himself and seemed concentrated on his performances, which included a nightly show in a large stadium and then an aftershow in a nightclub. No one, not even the band, knew until the very last minute where they where going to perform their aftershow. I met Prince's father, John Nelson, and we got along like a house on fire, and then I was invited to sit next to Prince and him in the nightclubs we visited while on tour. I even organized an impromptu aftershow in a Munich nightclub called Nachtcafé, and invited all my friends. John Nelson

came to visit us in Regensburg wearing a purple suit, and Johannes was very impressed—although he had no clue who Prince was. John invited him to a show and Johannes wore earplugs and sat at the soundboard, which is when he started to understand why I got such a kick out of Prince.

Johannes had his own rock'n'roll experience since his best friend was Prince Rupert Loewenstein, who managed the financial business of the Rolling Stones. Johannes had been to their concerts, and become friends with Mick Jagger. (This is why Mick came to the costume ball that I threw at Regensburg Palace in 1986 for Johannes's sixtieth birthday.)

* * *

One day, Johannes started to feel ill and had to be treated for heart problems. We went back to Regensburg and stayed put for a while. It was at this time that I realized that his administration was taking advantage of him. The T&T family had become so grand that they never had to deal with financial issues directly. Instead, they operated like a royal court with a majordomo and administrative officers who bowed when they saw the prince. My husband wanted to change this old-fashioned formality by introducing modern management. So he hired Harvard graduates (at the time, everything was thought to be better when it came from the US), who acquired all sorts of financial boutique firms and set the stage for a multinational financial-services outfit.

Then one day, I overheard a conversation between his managers and figured that something was wrong. Huge sums of money were at stake and I had to move quickly. Unfortunately, Johannes was already too ill to be fully involved. Divine providence sent me Nicolas Hayek, the man who invented the Swatch and single-handedly saved the Swiss watch industry, and his management consulting company, Hayek Engineering. Hayek and I convinced Johannes to investigate the management's doings. Soon afterward, everyone was fired and a tight restructuring plan was established; I followed very closely as they did their audits.

In the meantime, I found a business professor to work with me and to explain, step-by-step, what our business options were. Soon enough, I understood the whole shebang and which route to take: cut costs and sell unprofitable businesses.

Besides the businesses the "Harvard Boys" had bought, we had a conglomerate of companies that had once been very innovative but then had lost market shares, including a company that manufactured parts for the electronic and car industries, a brewery, and even a bank that carried huge risk. By the time Johannes got sick and could no longer follow what was going on, we were losing millions. Thank God Johannes saw that I was out to help, and that I had good ideas about who to hire to restructure the company. My motto was, "Don't mention a problem to the old man unless you have a solution to offer." Johannes saw that I was about helping rather than taking advantage, and that he could trust my judgment.

In the midst of this rough patch, my darling Johannes passed away. My children, who were still very young, and I were left in the huge St. Emmeram all by ourselves.

I could not consult with friends, as I was too involved in top-secret business issues, but I was lucky because I found fabulous advisers to help me, including Alfred Taubman, the American shopping mall tycoon, who helped me to resolve our North American real estate issues. I owe him a lot and will never forget his generosity. I found lawyers who went the extra mile just to help me. I found very good advisers who liked my deep involvement and the way I was pursuing my goals. And, last but not least, our own staff in Regensburg saw that I was for real: I stripped our own lifestyle down to less than half of what it had been before.

Here is where my faith in God and my strict Catholic upbringing came in handy. I went to church daily and consulted with God. This gave me the strength to deal with the tough decisions I was confronted with every day. And cutting costs was not exactly making me very popular around Regensburg. I found my sole refuge with my kids and at church.

Of course, it was no fun to fire people or to not replace old employees. But it was the only way forward. I did it, although I was criticized for doing so in the press almost every day. One day, we even had people with banners demonstrating in the palace courtyard. But thank God people forget, and now only the old ones with good memories remember.

Finally, after about ten years of hard work, there was a light at the end of the tunnel and I started to take my childern on trips throughout the world again. This was the nicest time for me, after so many hard years. Soon, I had regained my joy of life. And when my children went abroad to study, I remained in my east wing apartment thinking about the future, including how to make the palace more attractive for the public. We also needed to generate income to pay for the upkeep of this enormous cultural inheritance, which costs millions to maintain and receives no government assistance.

Today, the palace has fully renovated facades and a new twenty-thousand-square-meter roof. We founded an open-air summer festival, the Thurn und Taxis Schlossfestival, which runs for two weeks every year in July, where we have musical performances of all types to please a large audience. We also established a Christmas market, which is held in the palace's courtyard and gardens for four weeks before Christmas.

Most of the rooms in the palace are open to the public and visitors can see and witness what life looks like in such a vast home.

When I was growing up, there was very little money, but my parents were fun, loving, and amusing. My father loved to play on his electric organ and we sang folk songs and church songs all the time. My mother was sweet, lovely, and beautiful. We lived in a very wonderful, small, prefabricated house, and we four children all had our own rooms. Of course, I had my fantasies and dreams as a little girl and I always saw myself married to a prince—no details, no castle, only a loving prince. But to be honest, I was so busy trying to work, by picking apples and cherries at a farm or making pottery for a little bit of money, that I had little time to dream. By the time my real prince came, I had forgotten my childhood dream. After it had come true, I remembered.

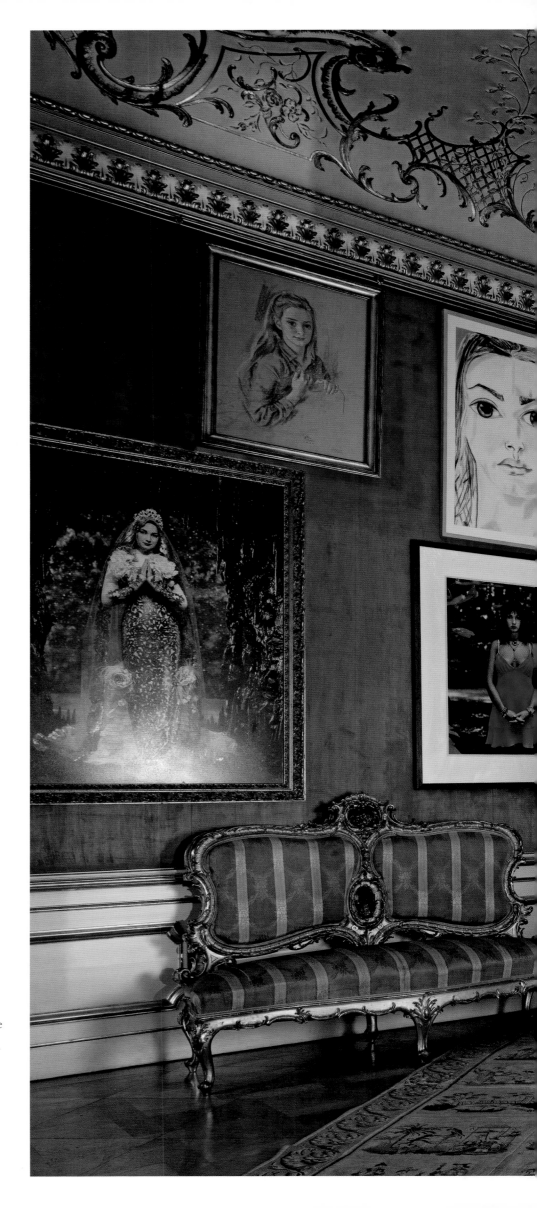

Princess Maria Theresia Ludovika Klothilde Helene
Alexandra Thurn und Taxis

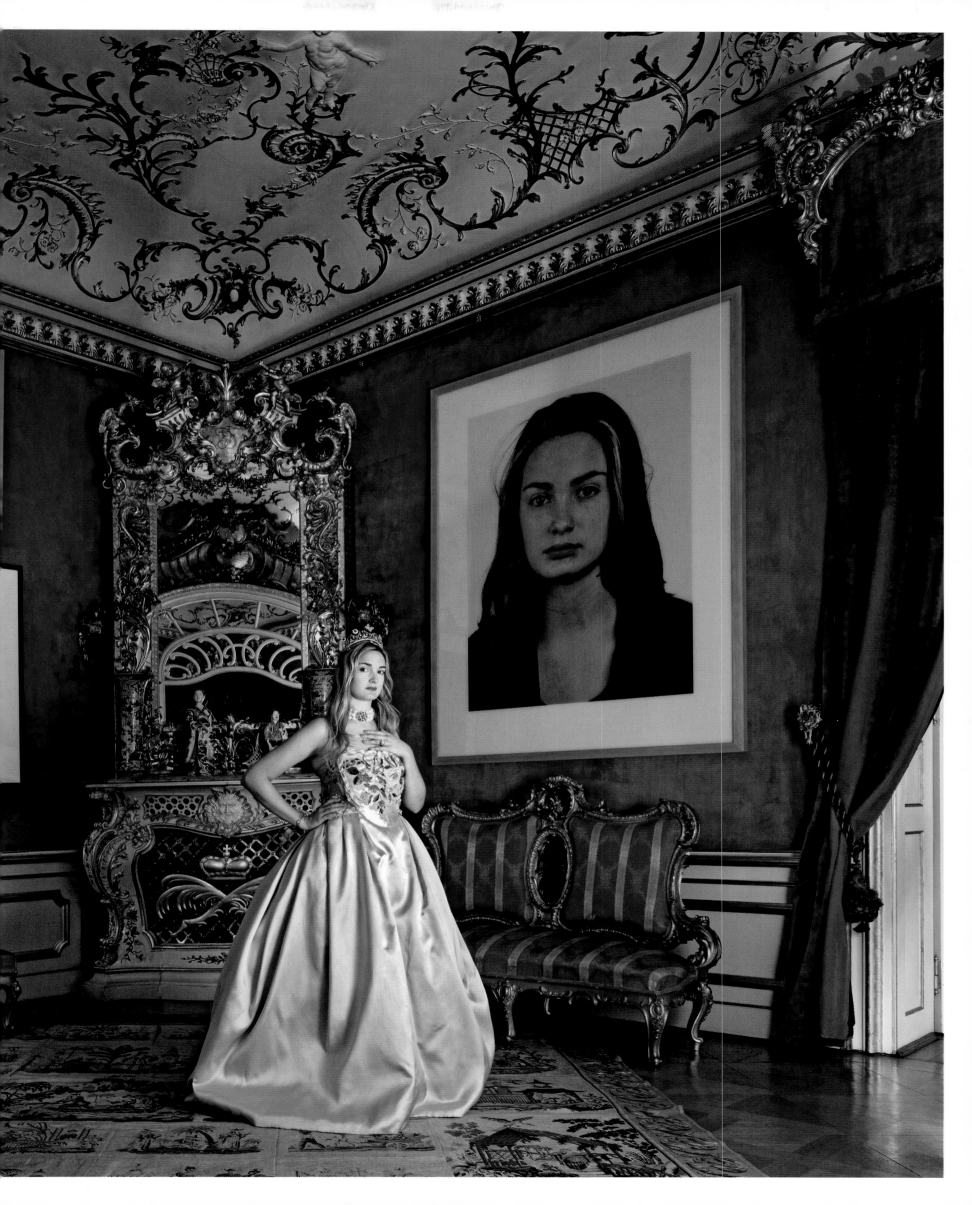

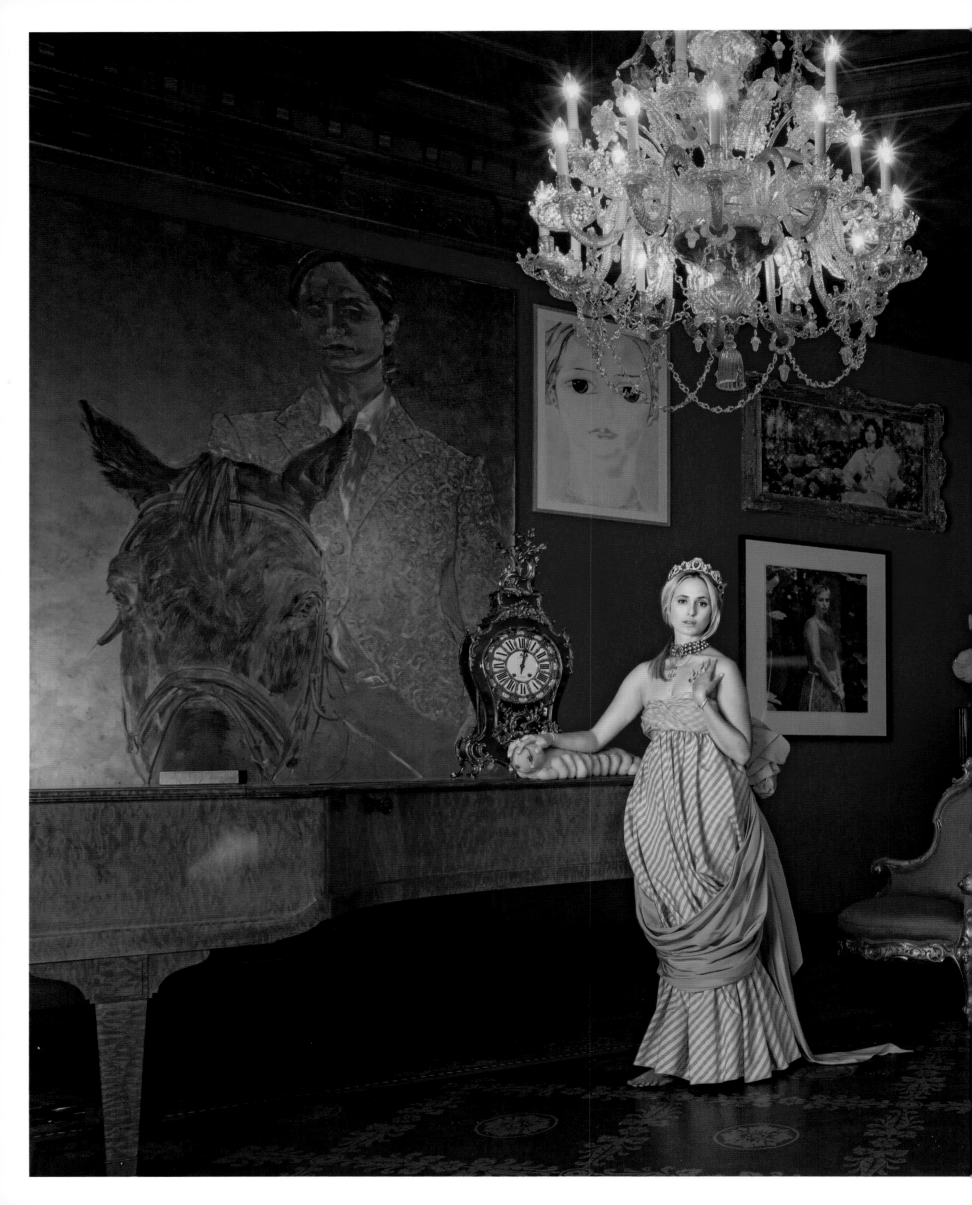

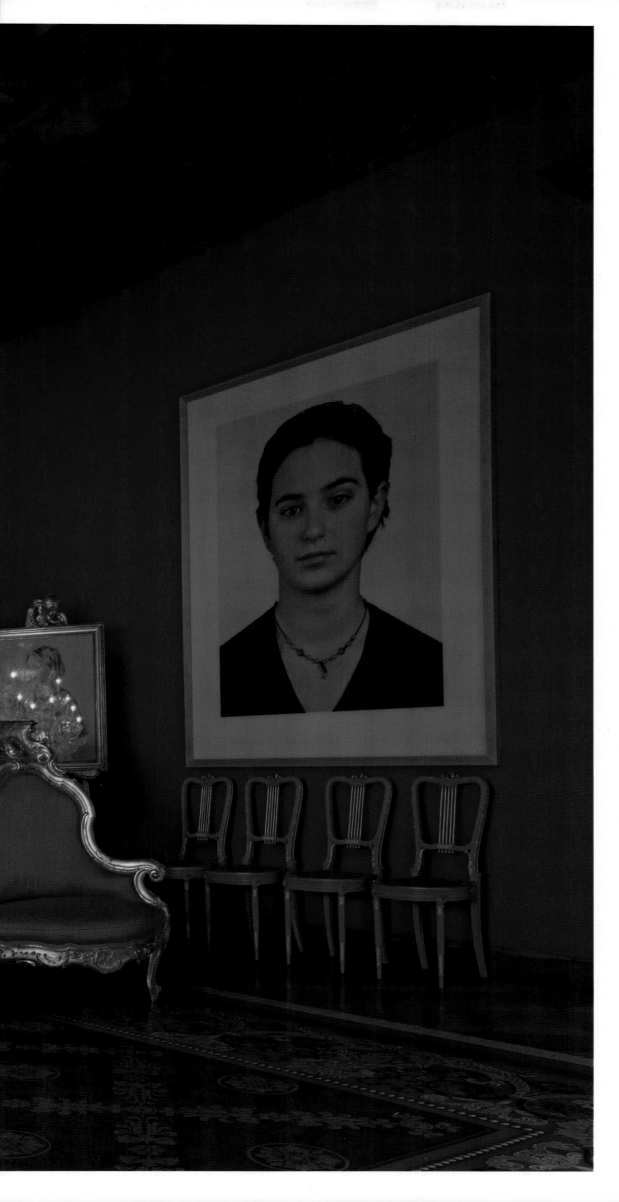

Princess Elisabeth Margarete Maria
Anna Beatrix Thurn und Taxis

15

Opposite: Prince Albert II Maria Lamoral Miguel Johannes Gabriel Thurn und Taxis

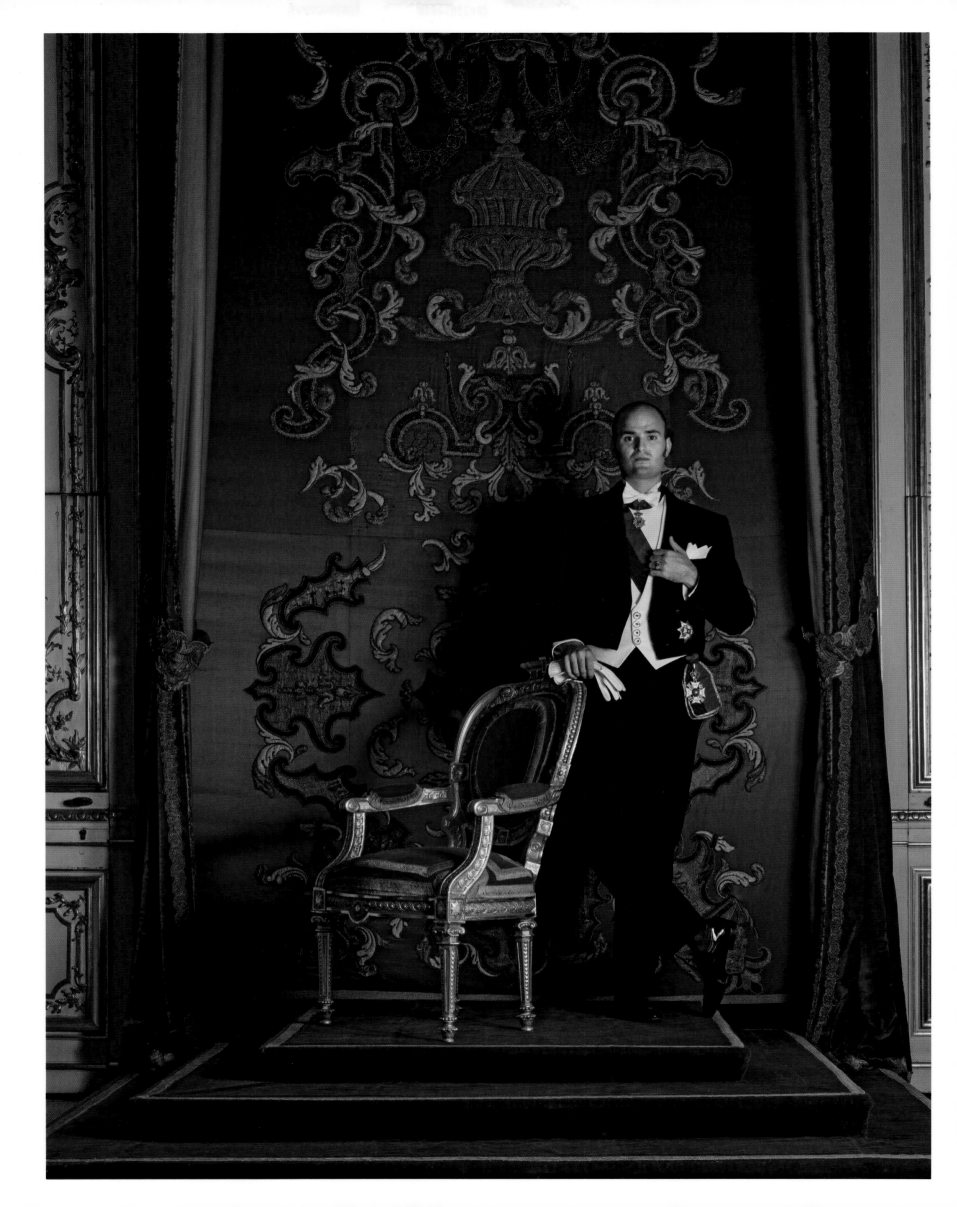

I.

Raths-Sessions-Protokoll

der

General-Post-Direction

Januar ———————— Juny

1804.

Von N. 1. — 1858

FOREWORD

The pop myth of Princess Gloria Thurn und Taxis has fascinated me ever since Bob Colacello coined the nickname "Princess TNT" in a *Vanity Fair* article that chronicled her husband, Prince Johannes Thurn und Taxis' sixtieth birthday party. Pop and royal entities dressed in Baroque wigs and livery attended the decadent forty-eight-hour bacchanal in the schloss.

I had no idea at the time I would get to observe her fairy-tale life up close while making the photographs for this book.

For over three years, I found myself with the keys to the castle, and made my way through the 500-plus rooms with a tripod and a couple of cameras. The schloss cannot be logically or fully described in words, or even in photographs. You may find yourself in colorful rooms that were disassembled from a castle whose country fell into debt to the family; or playing in the single-lane bowling alley festooned with deer horns, experiencing Mass in High Latin in the private chapel, imagining what decadence went on in the mirrored ballroom, or picturing the minds that were enlightened in the grand library. You might wonder what it's like to have most of your ancestors in the family crypt, or to park your custom Harley-Davidson under a Jeff Koons painting.

This assemblage was brought together by the family who, in the fifteenth century, founded the postal system as we know it today. Some five centuries later, their name remains synonymous with the power of connectivity. To celebrate this magnificent family and the immensity of their achievements, we've made this book in a way that mirrors the castle—there are pieces from different regions, different eras, and different styles. They are now bound between the covers of this book, much as they live together under the castle roof.

Welcome to the *House of Thurn und Taxis*, the Schloss at St. Emmeram, where one can observe, as I did, the fairy-tale life that is lived within its many walls.

TODD EBERLE

THE ABBEY

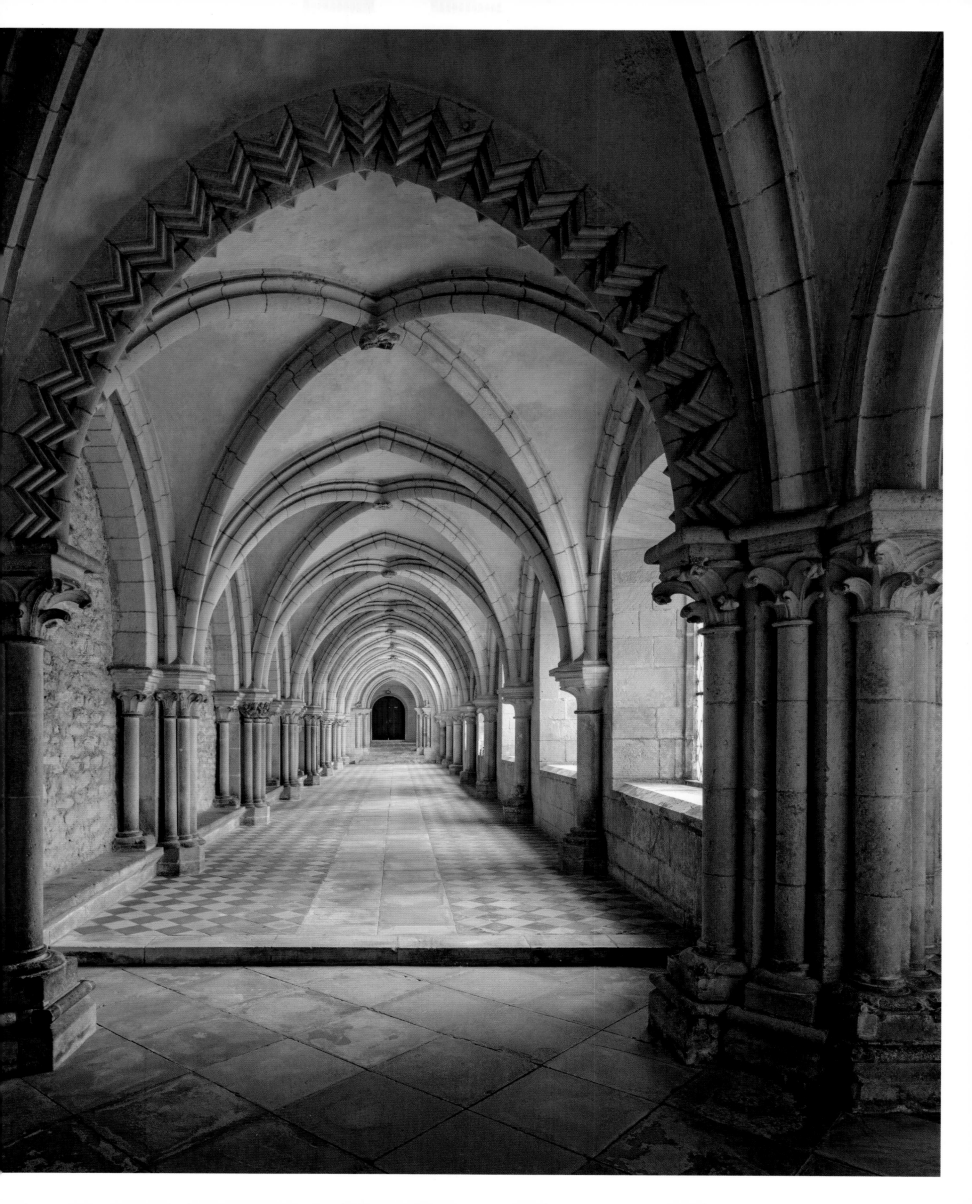

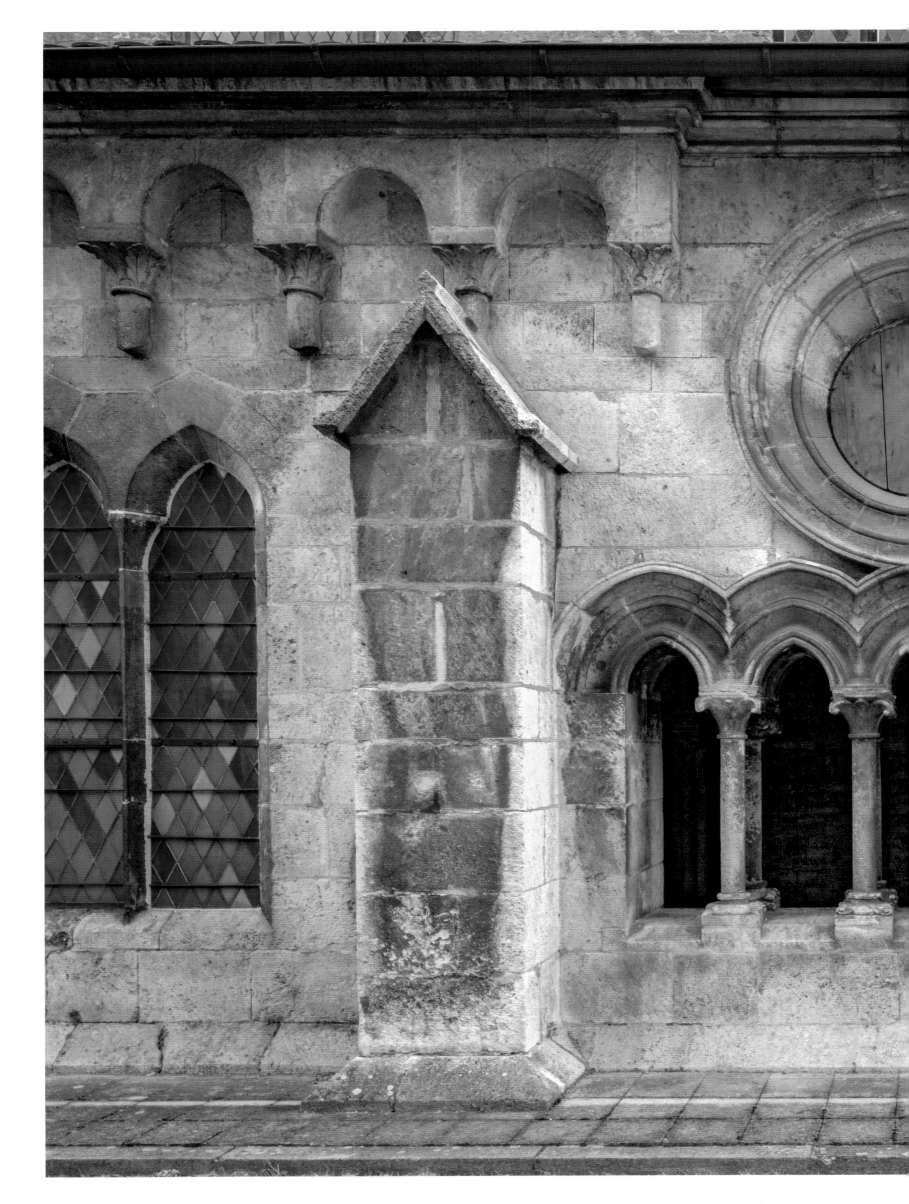

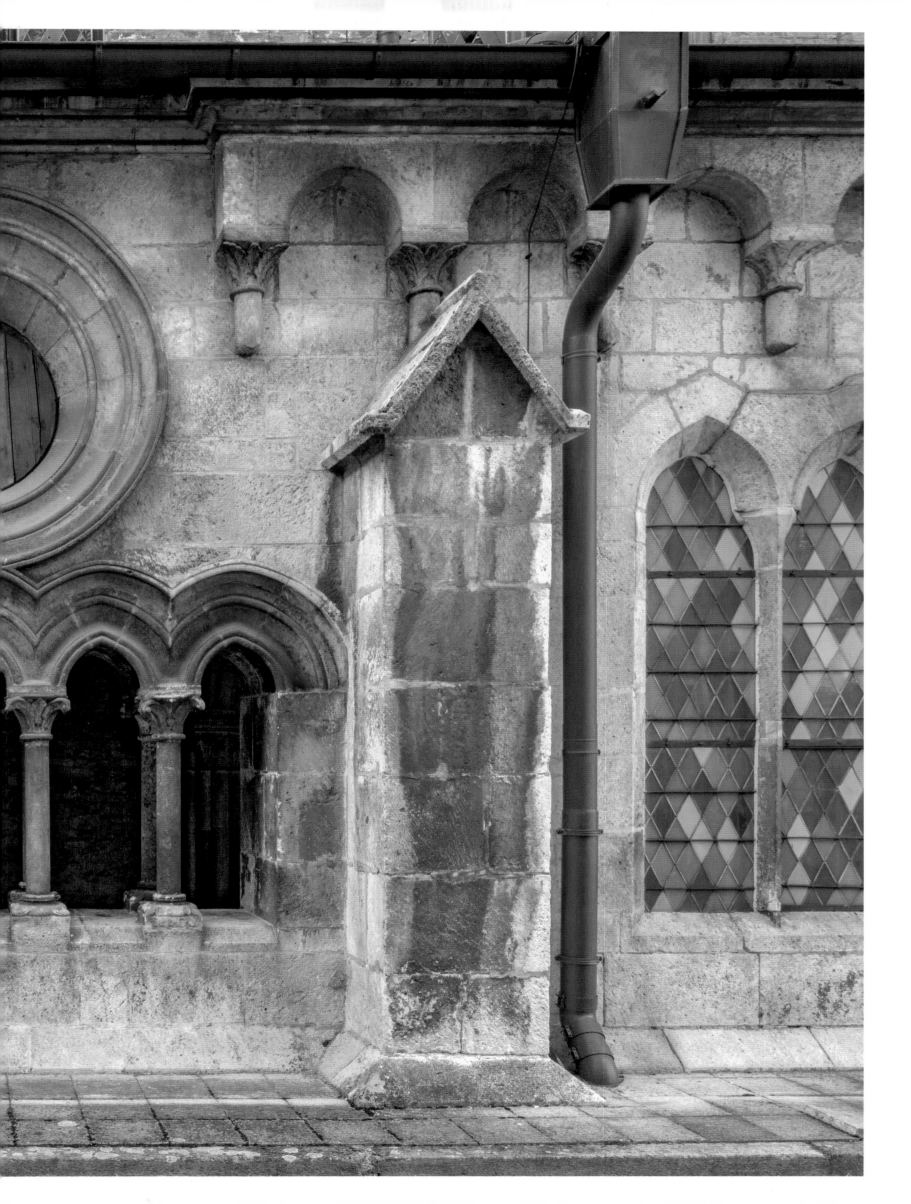

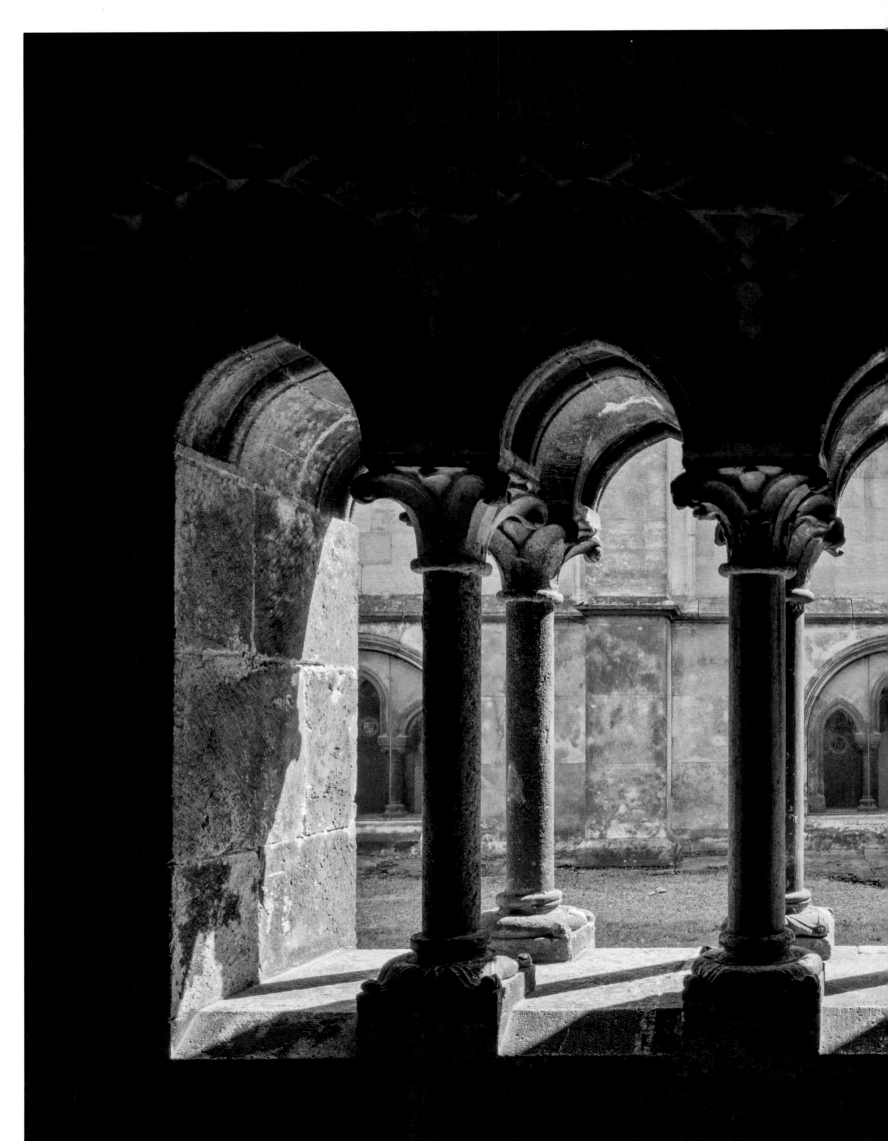

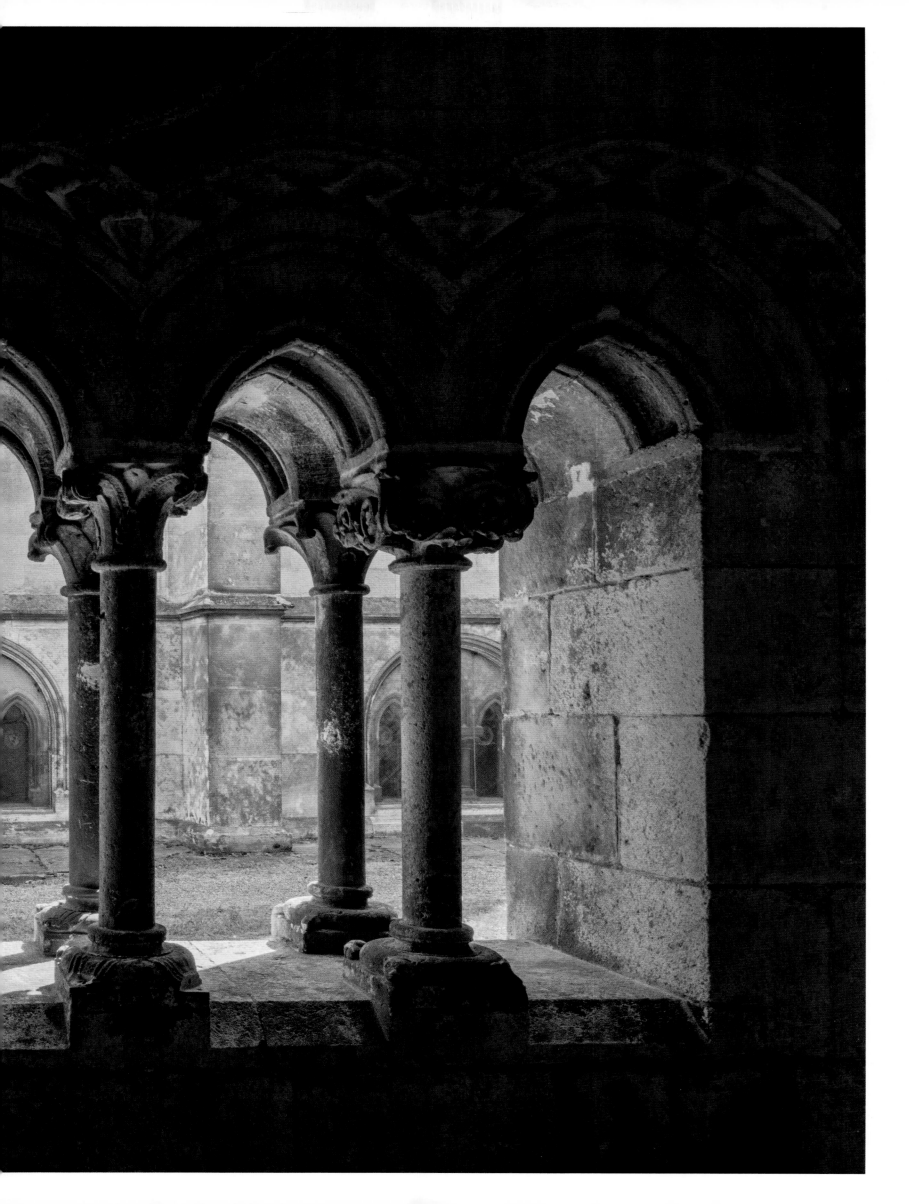

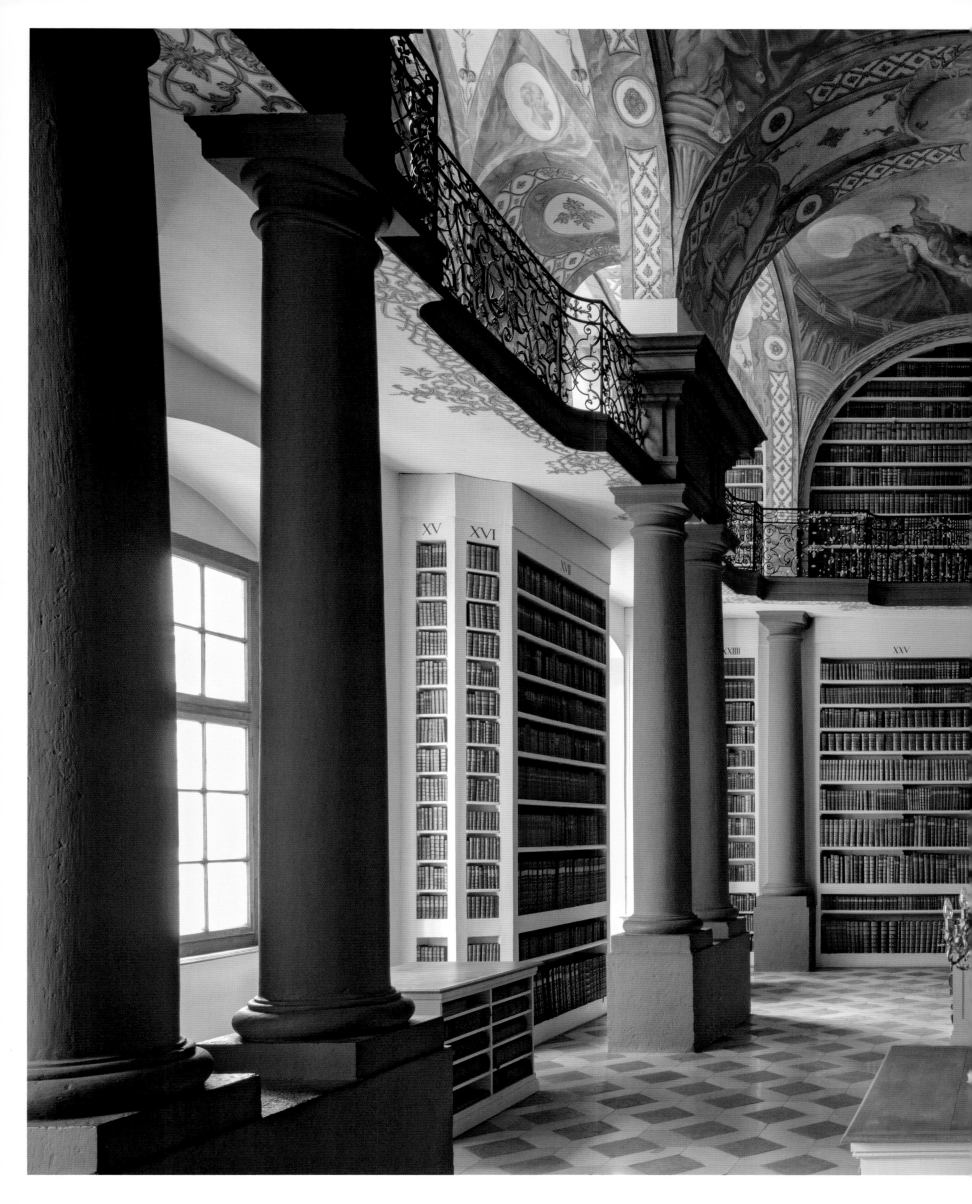

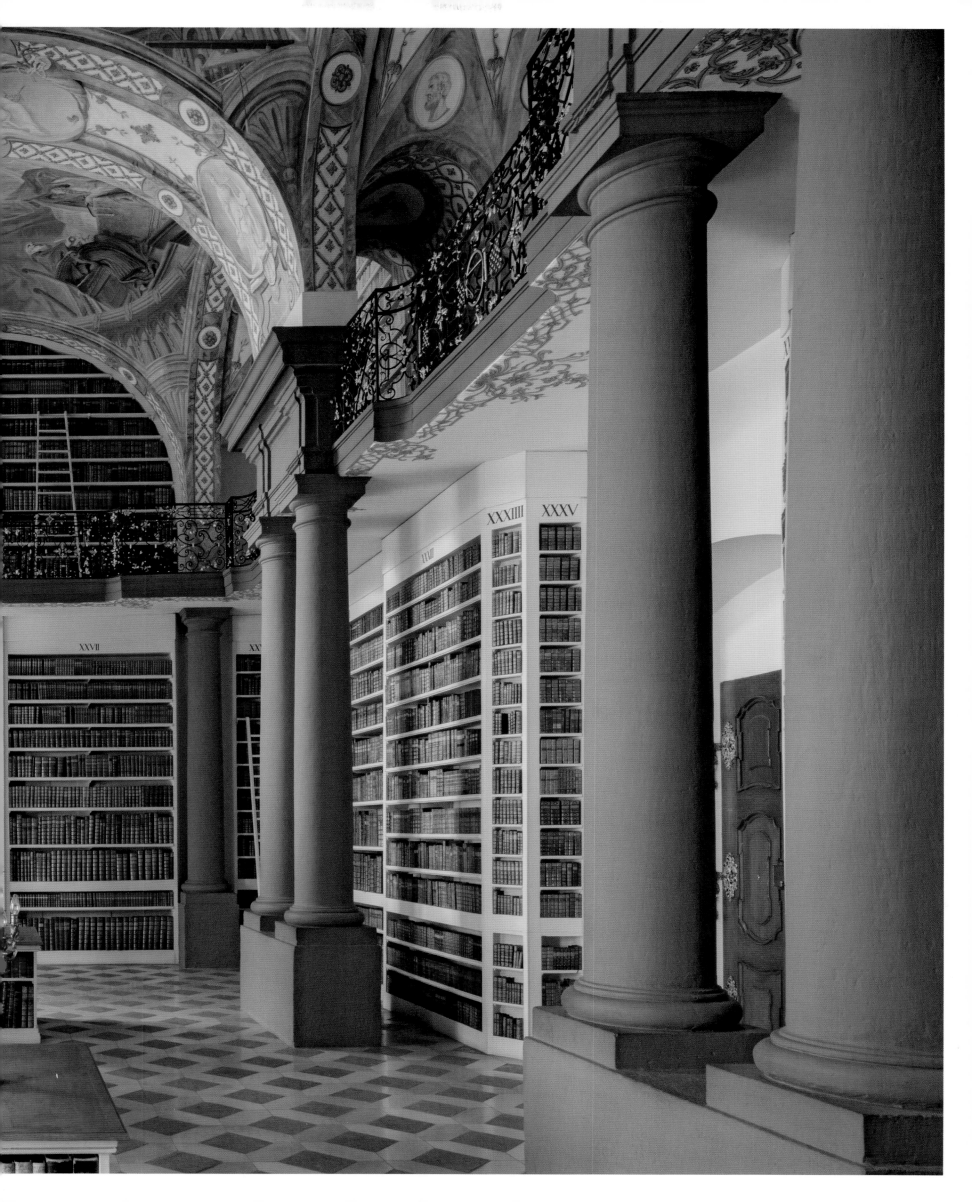

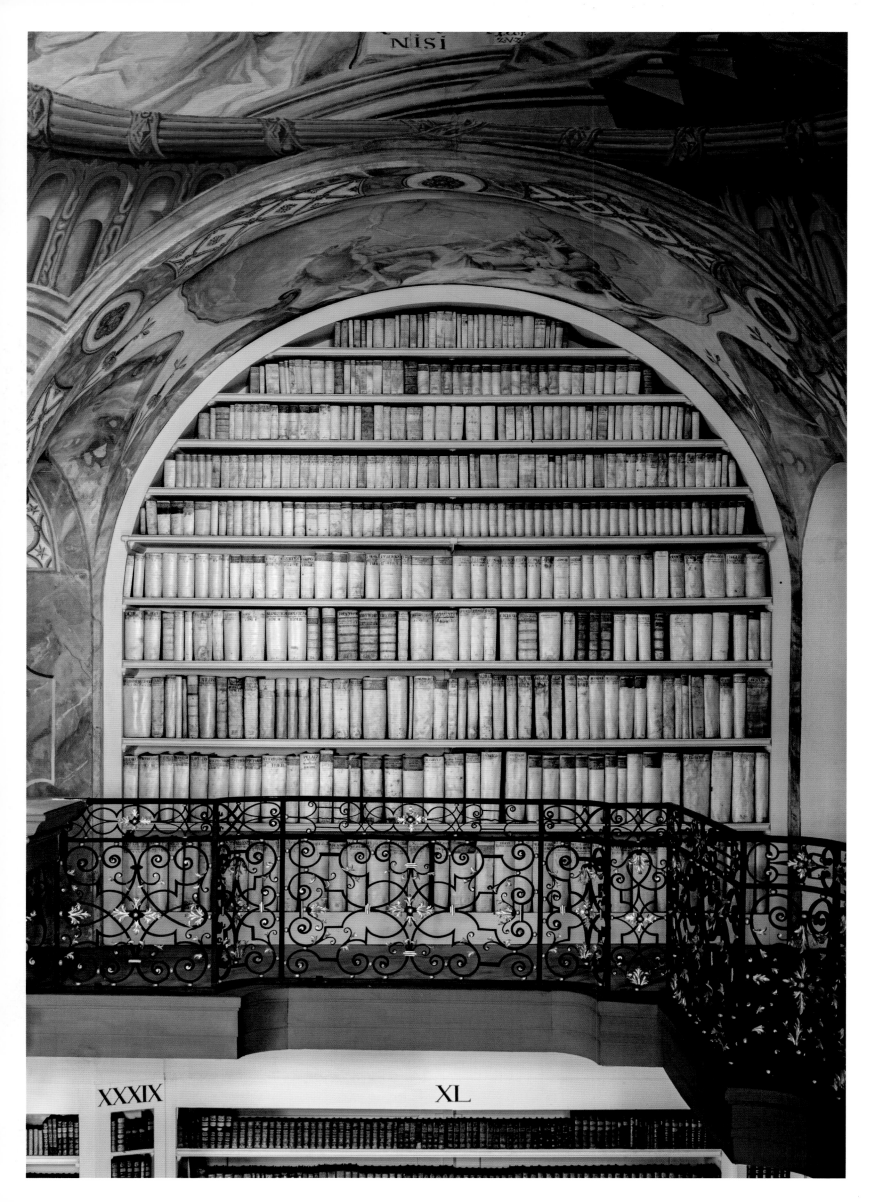

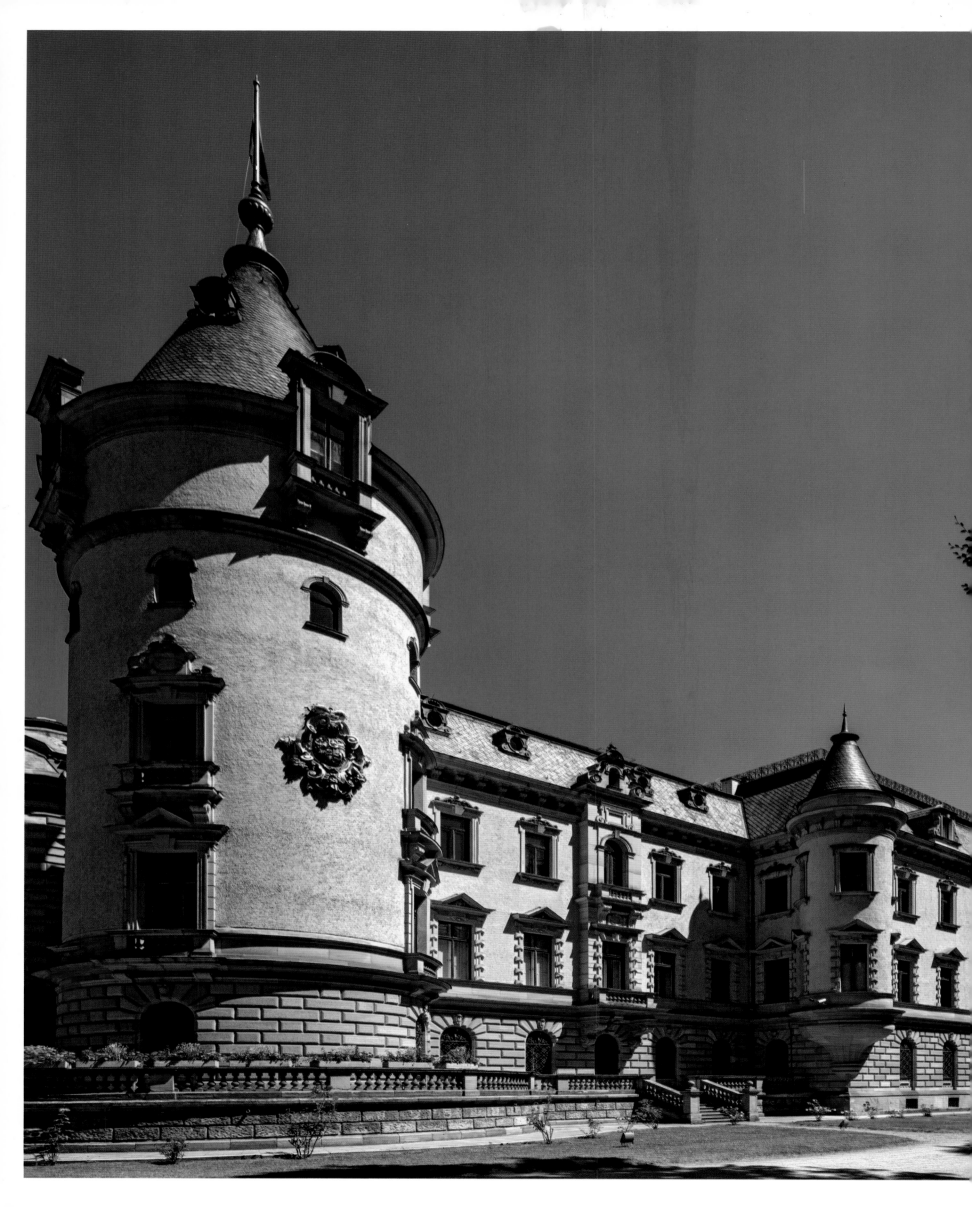

THE PALACE
AT ST. EMMERAM

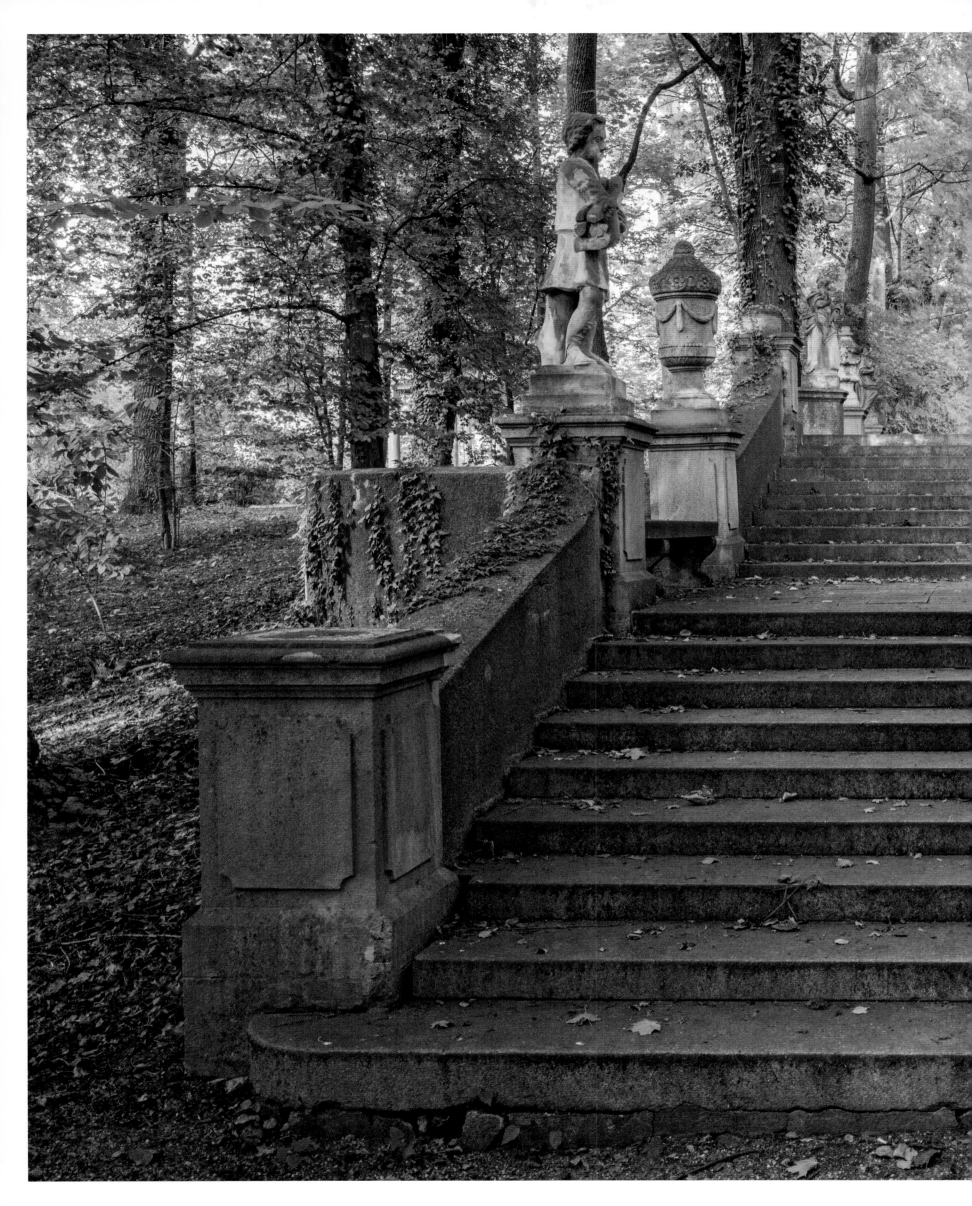

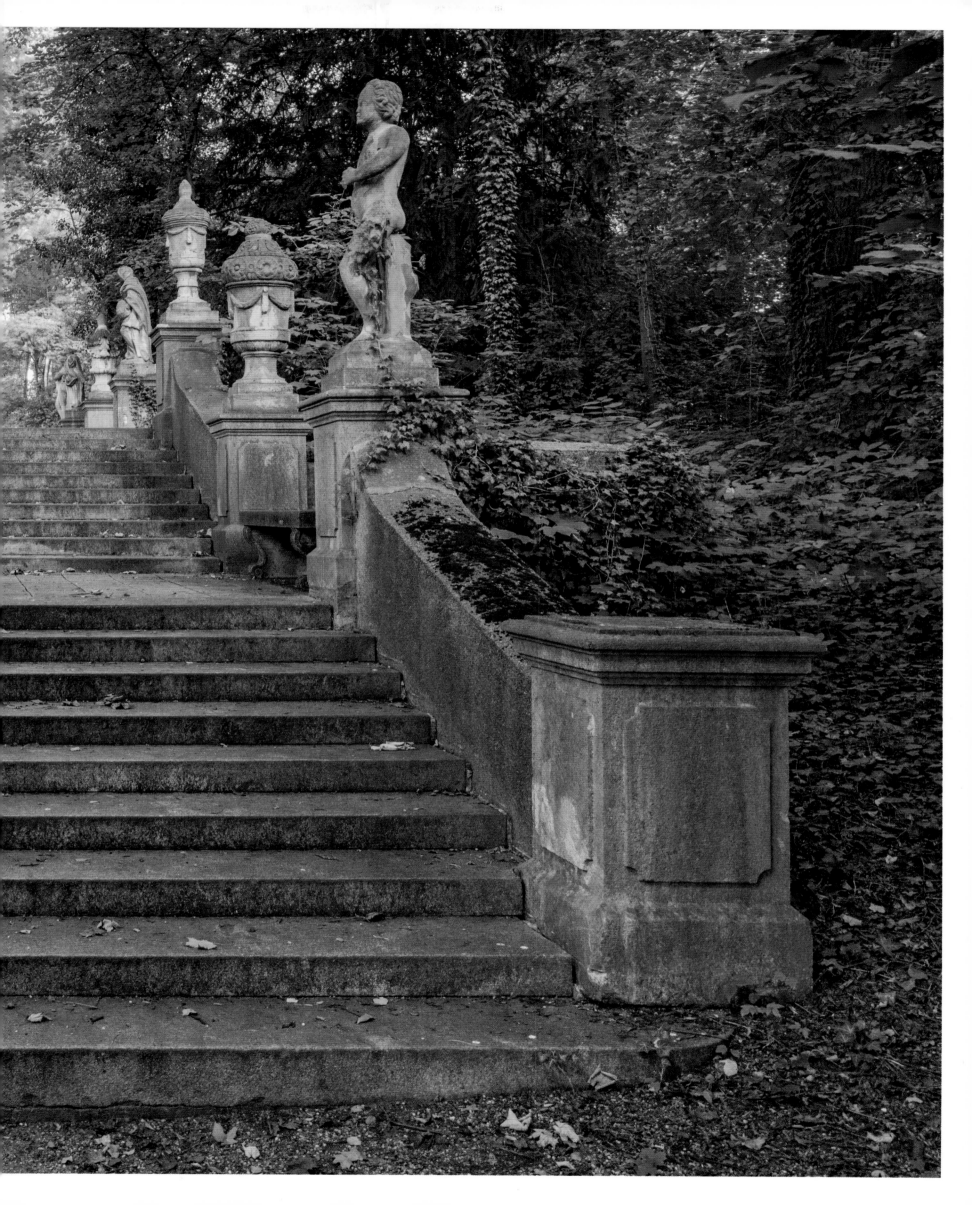

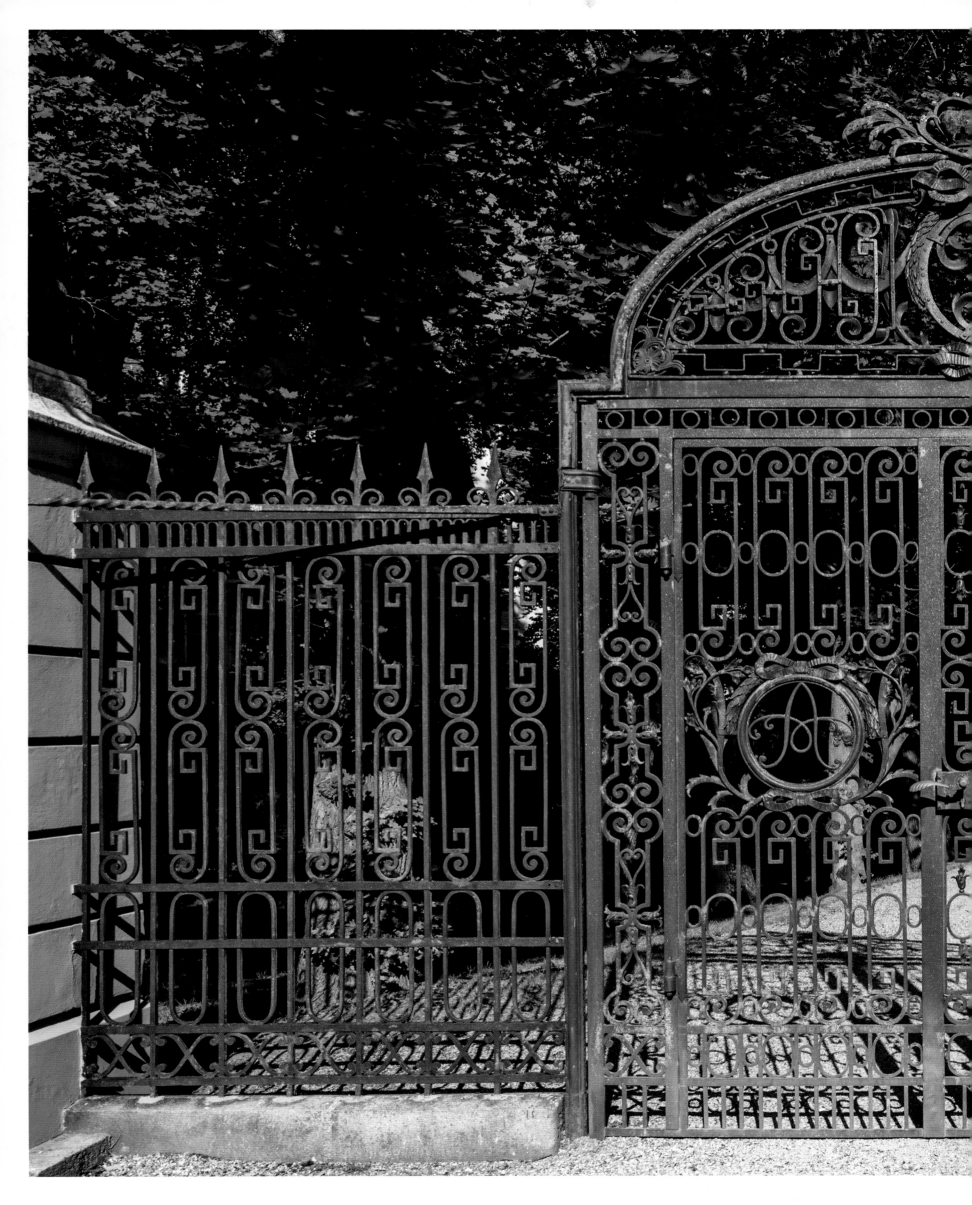

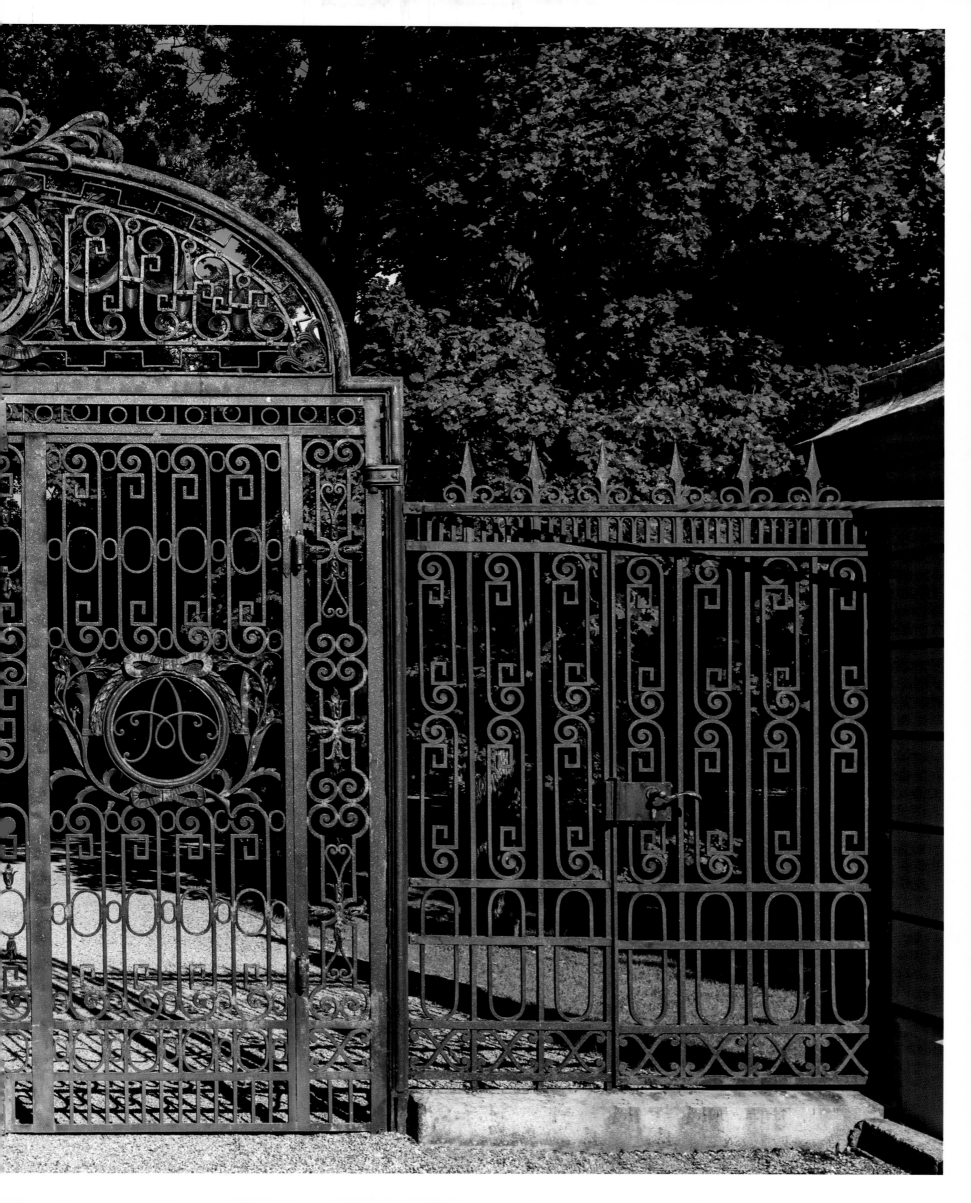

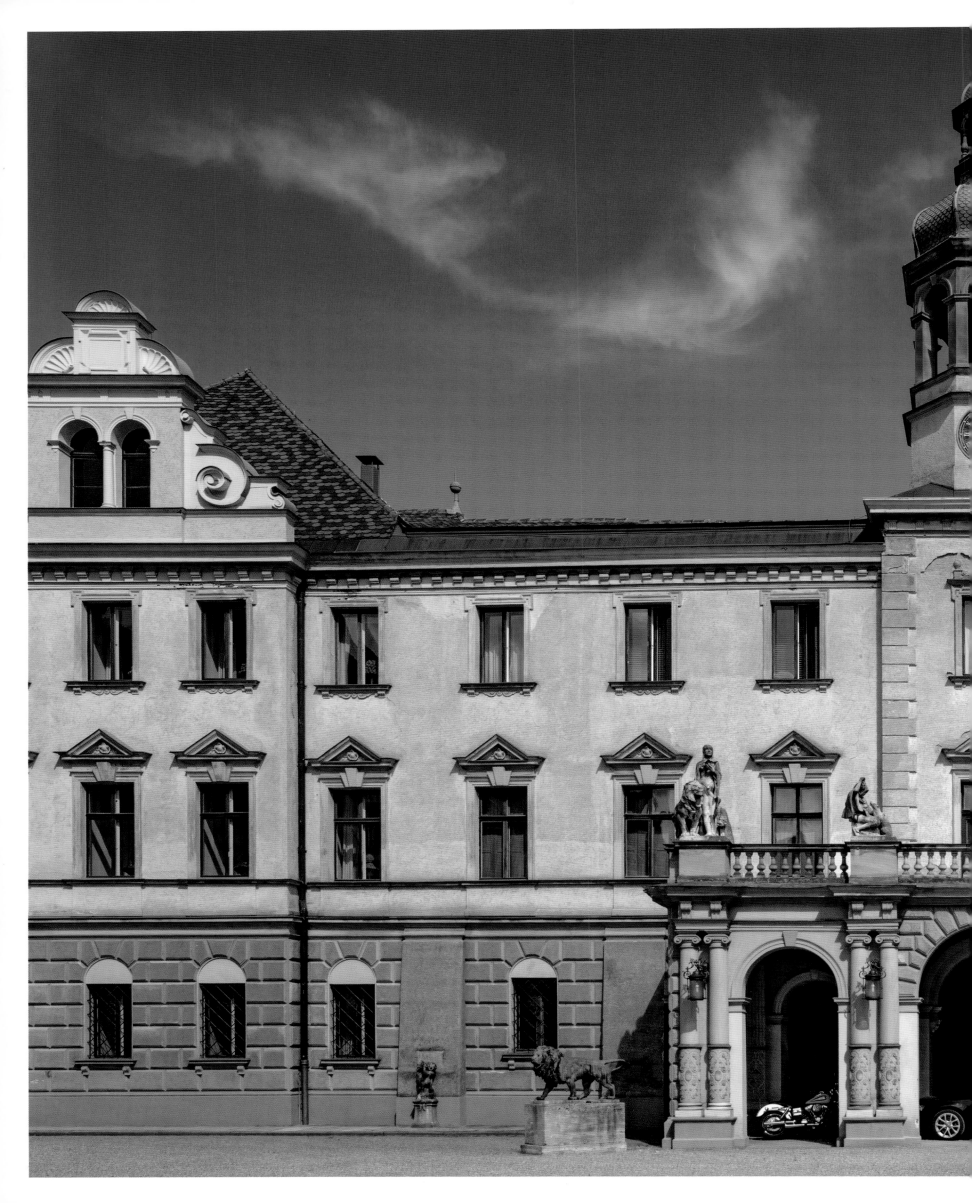

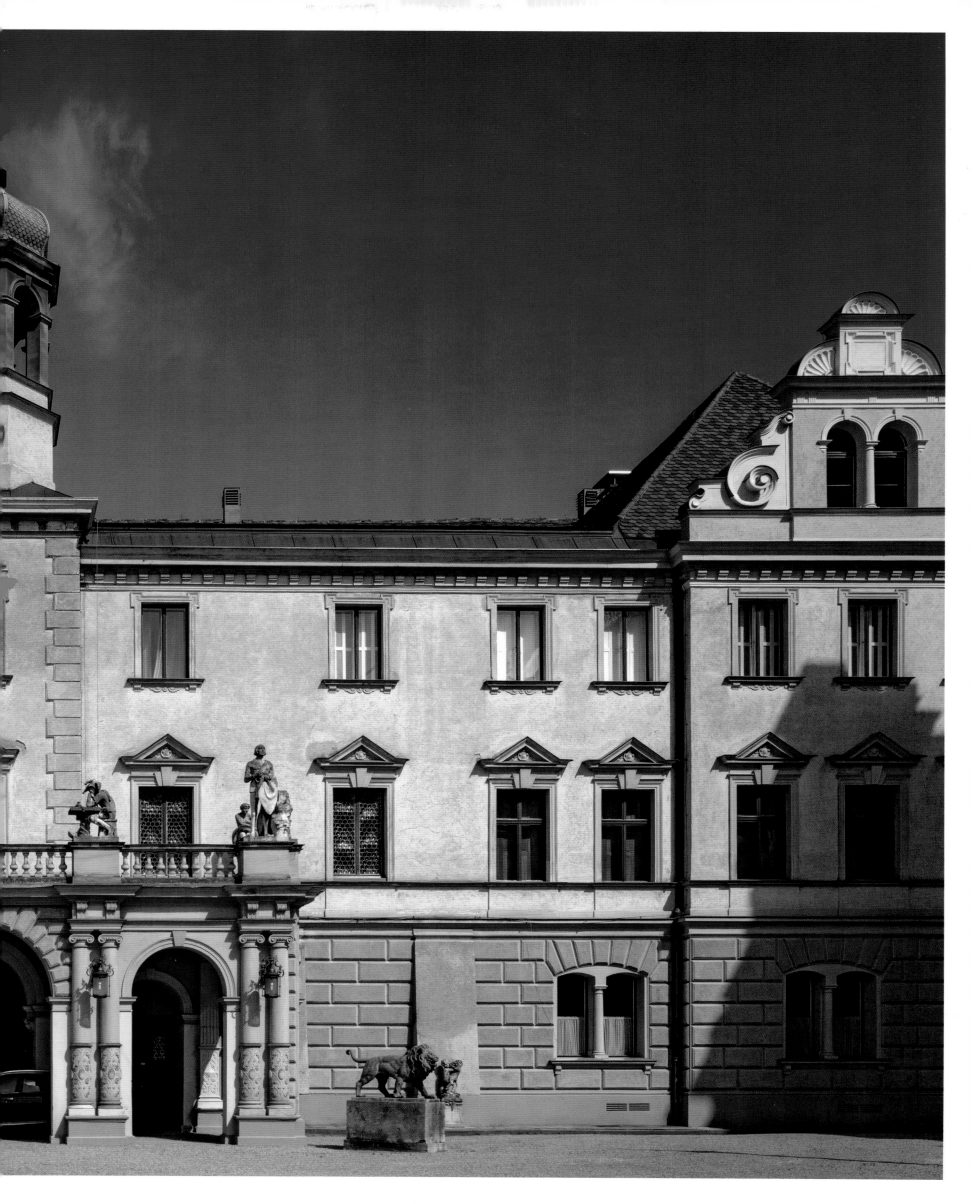

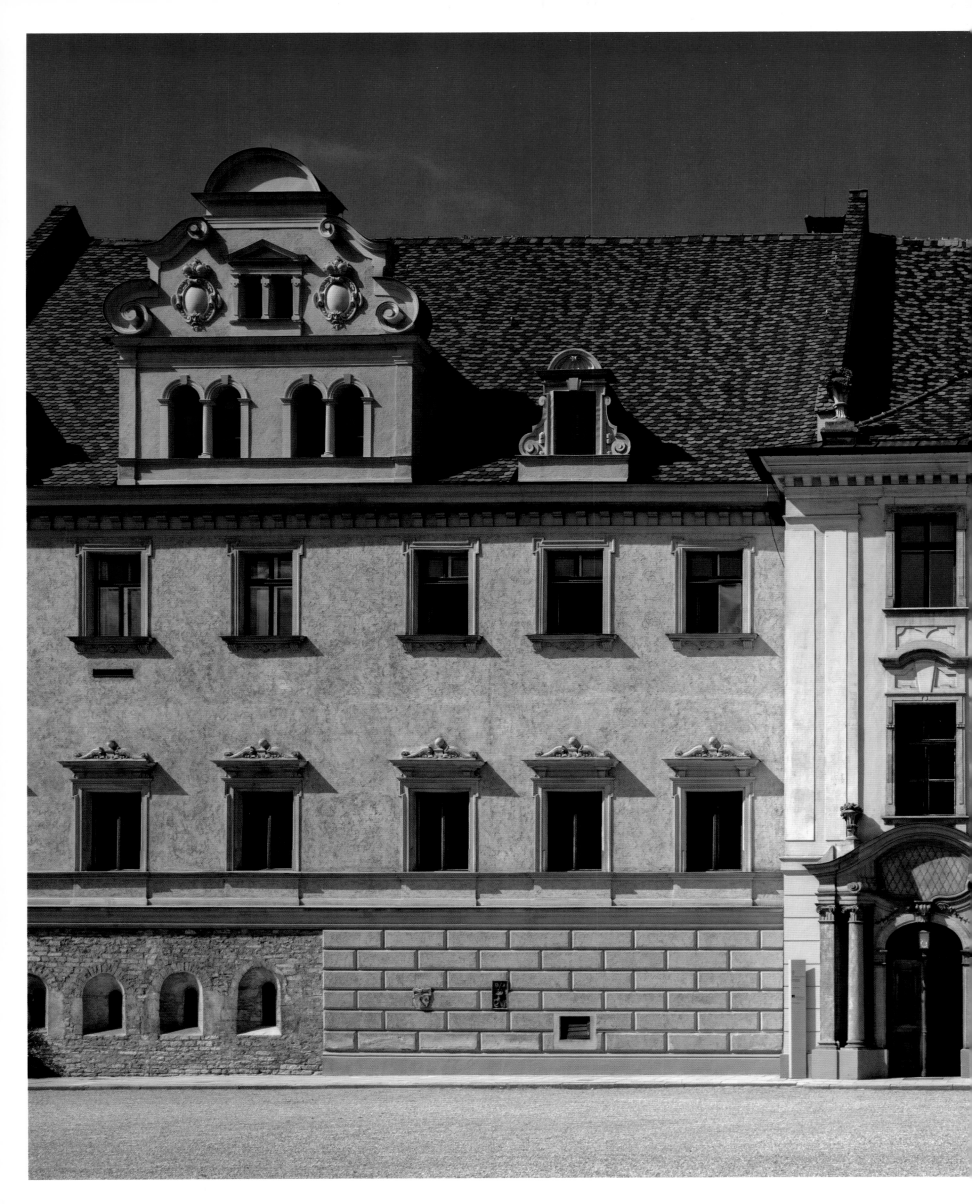

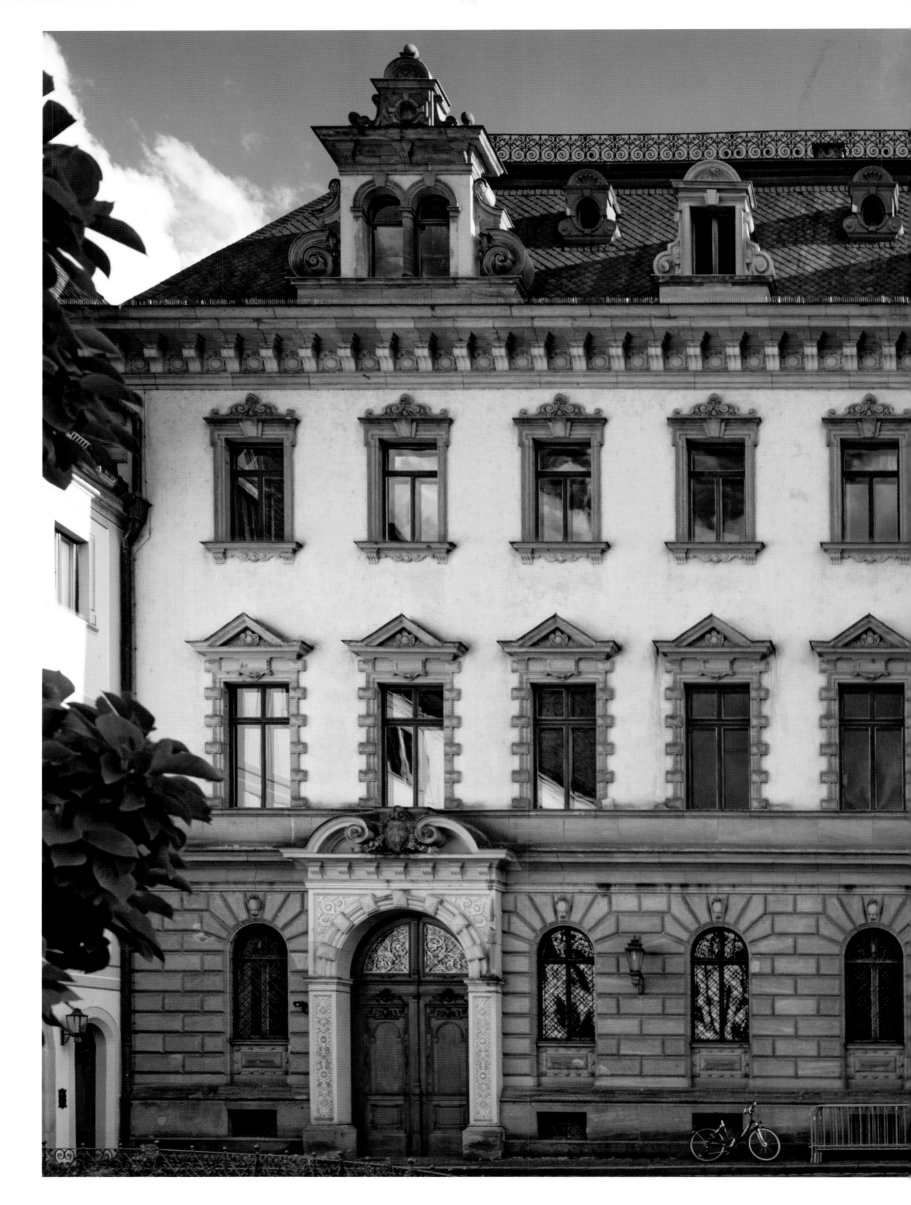

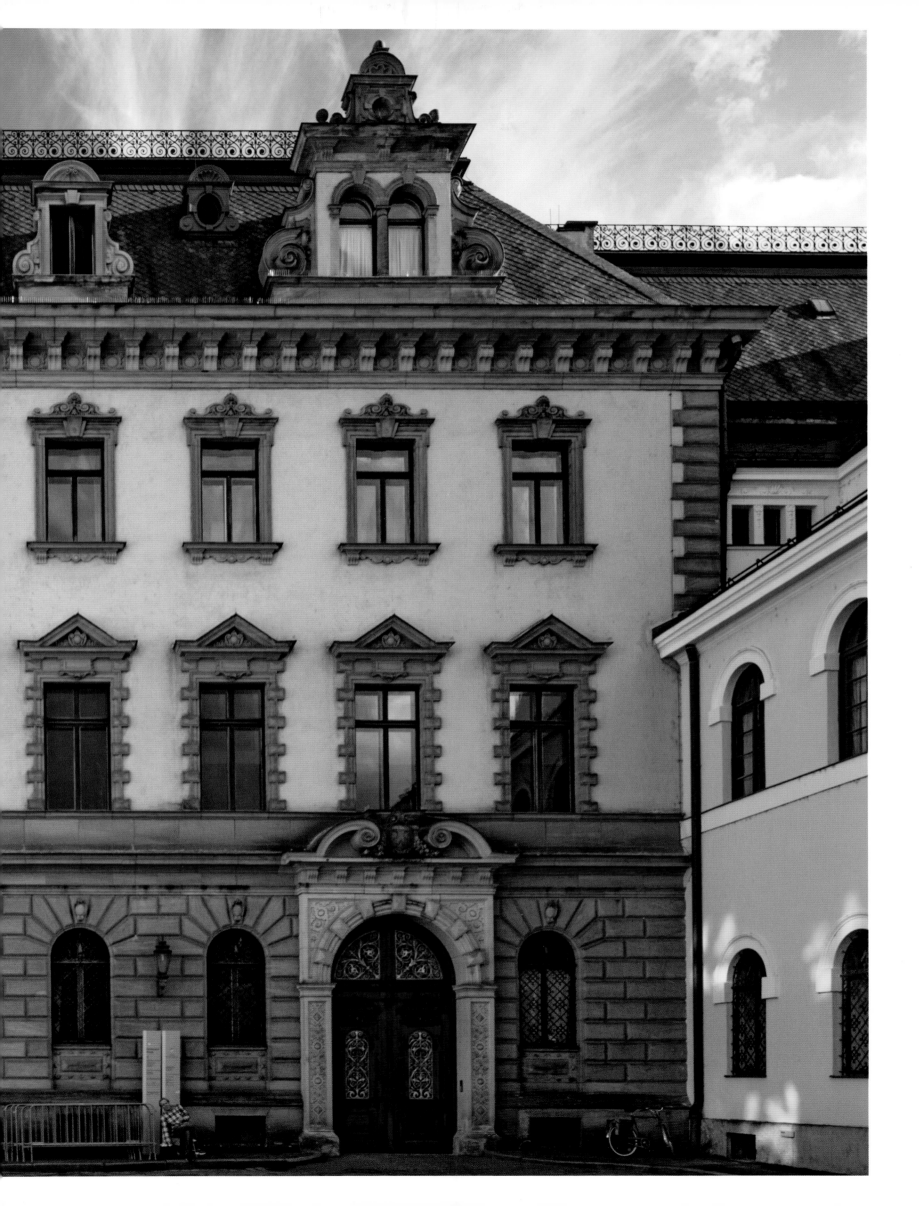

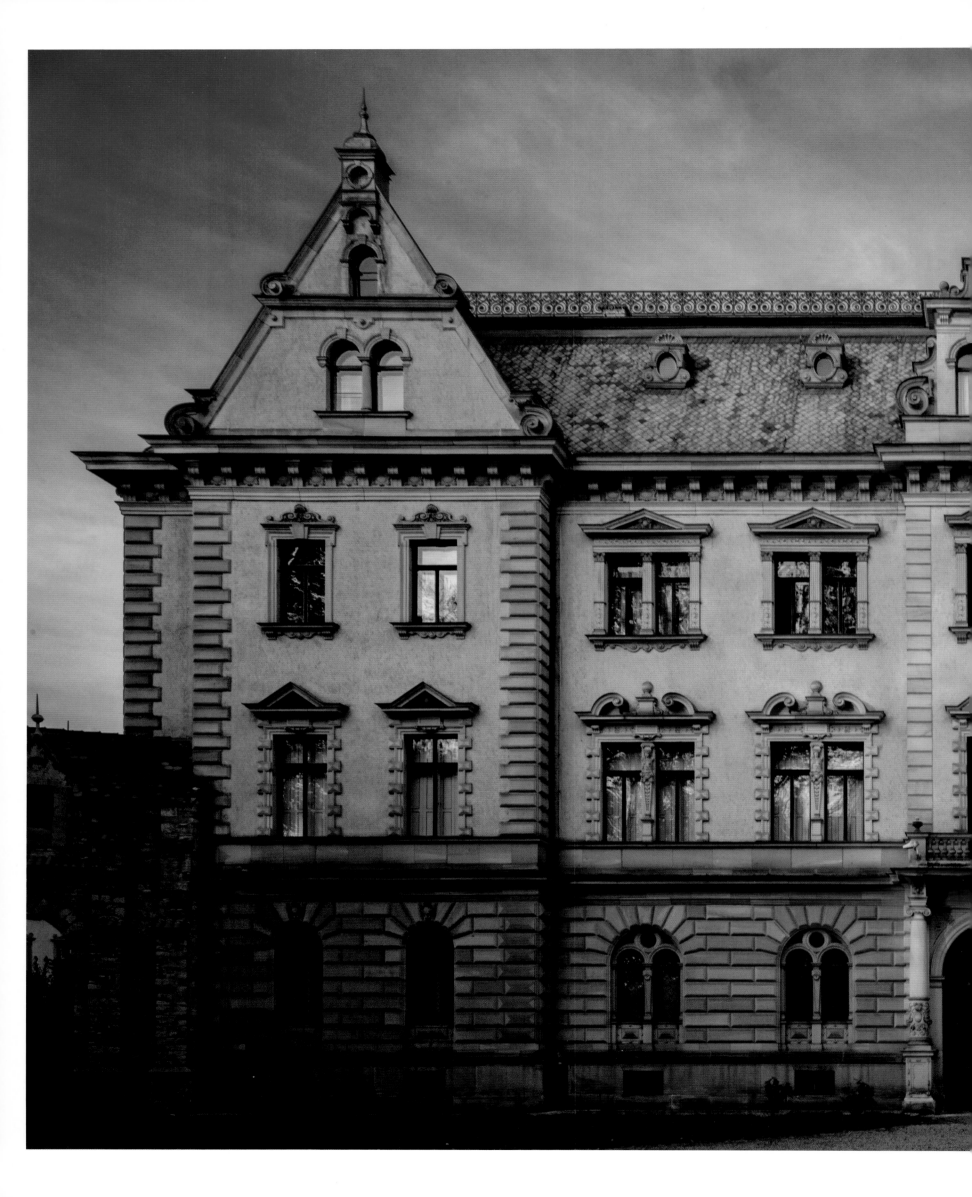

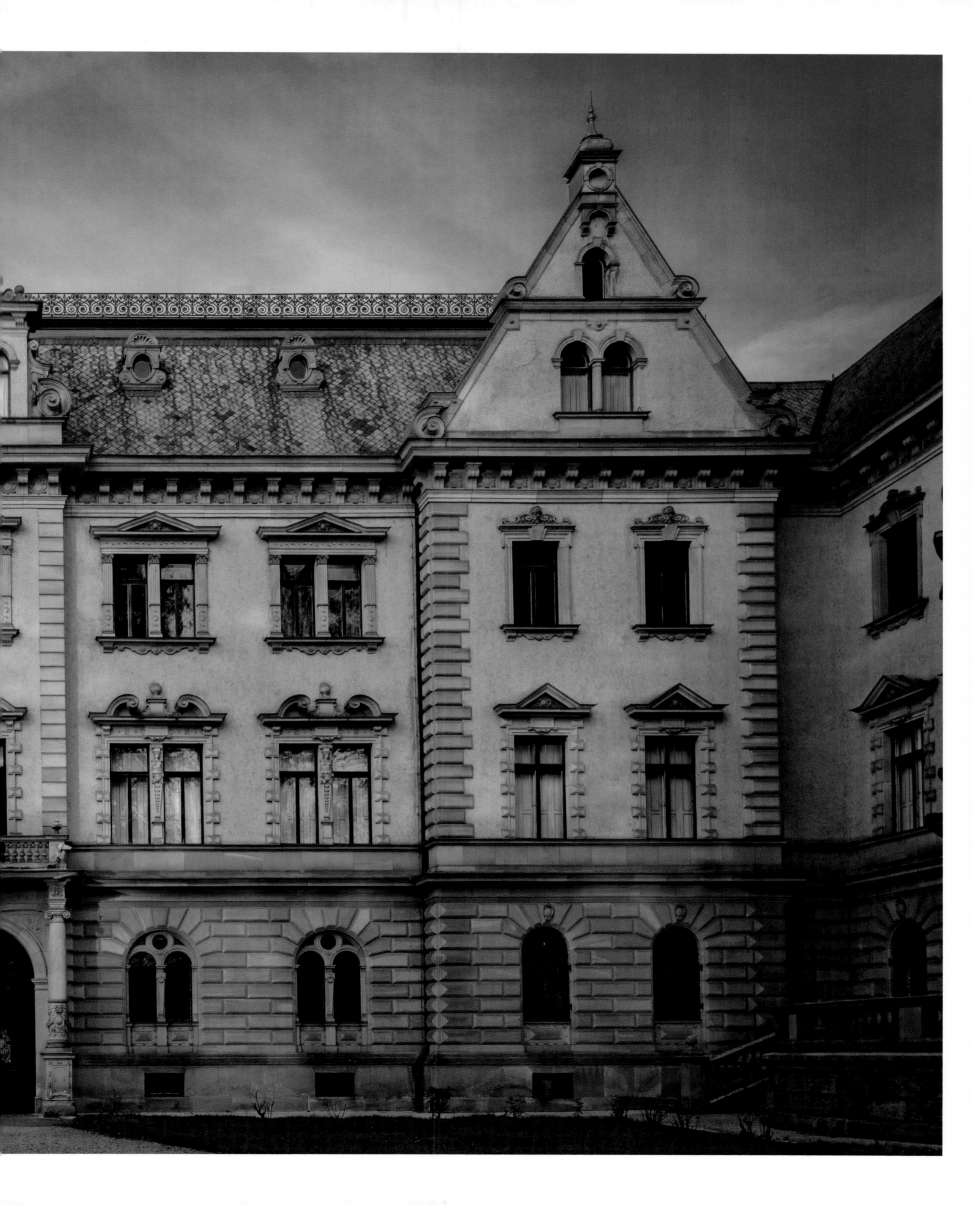

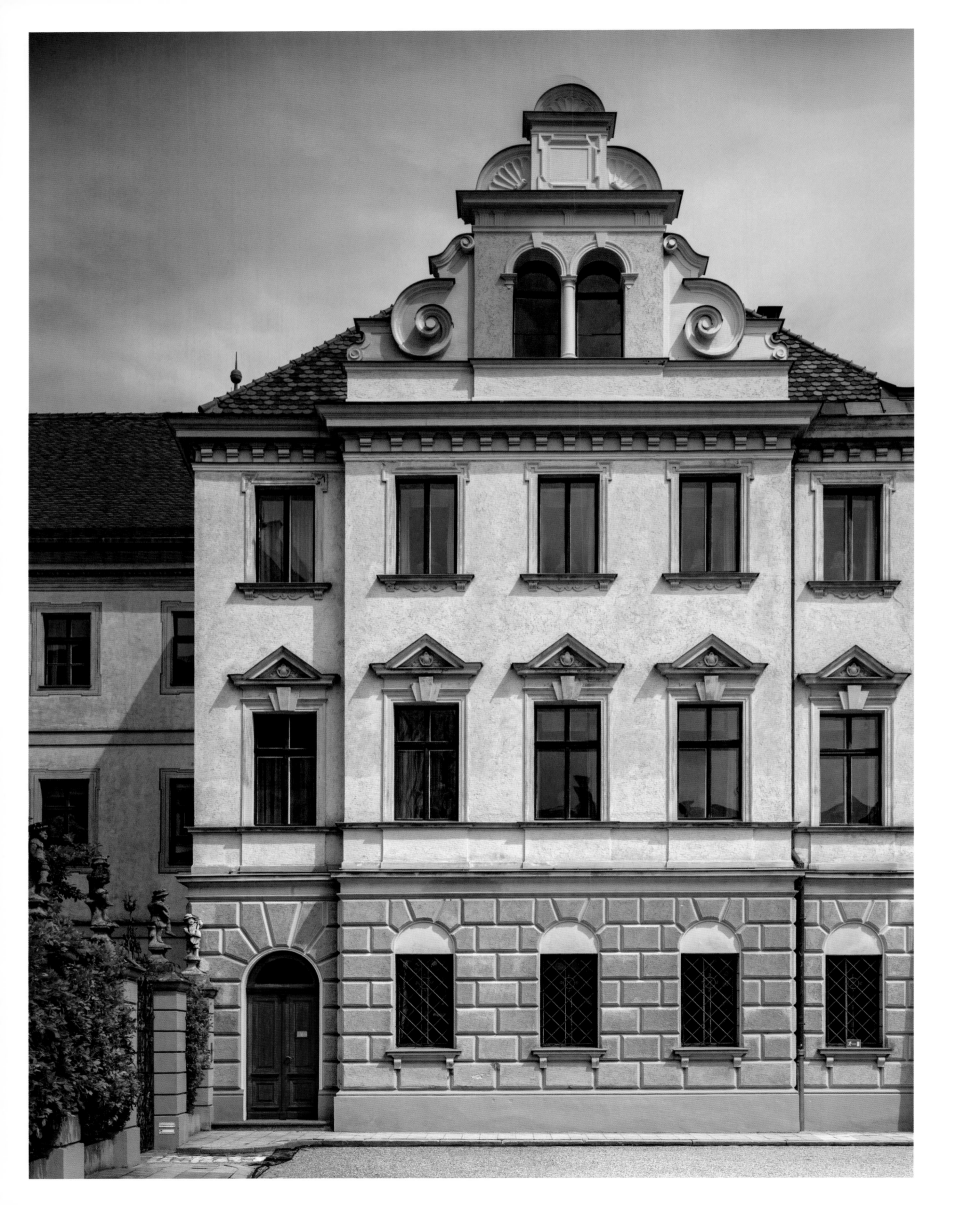

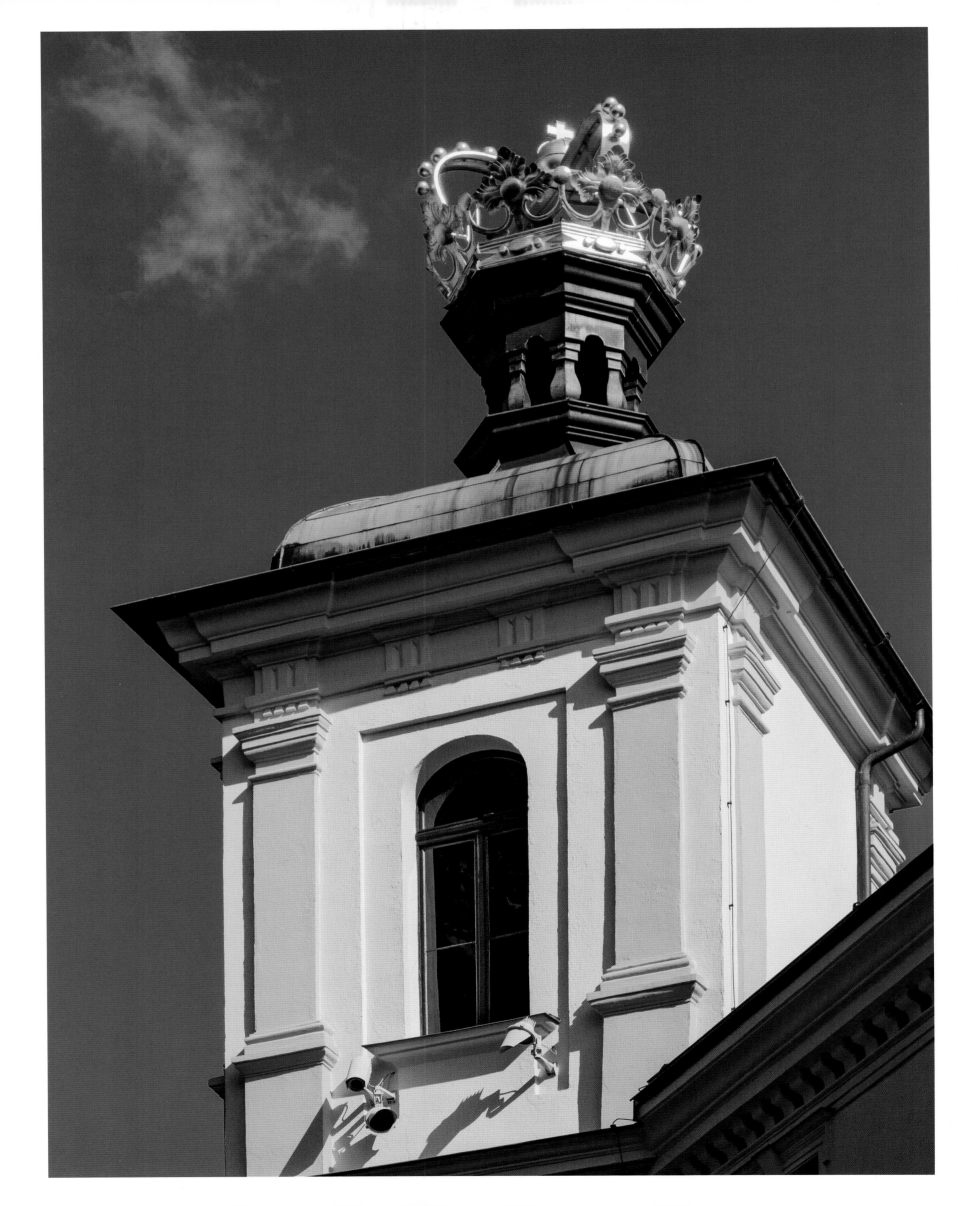

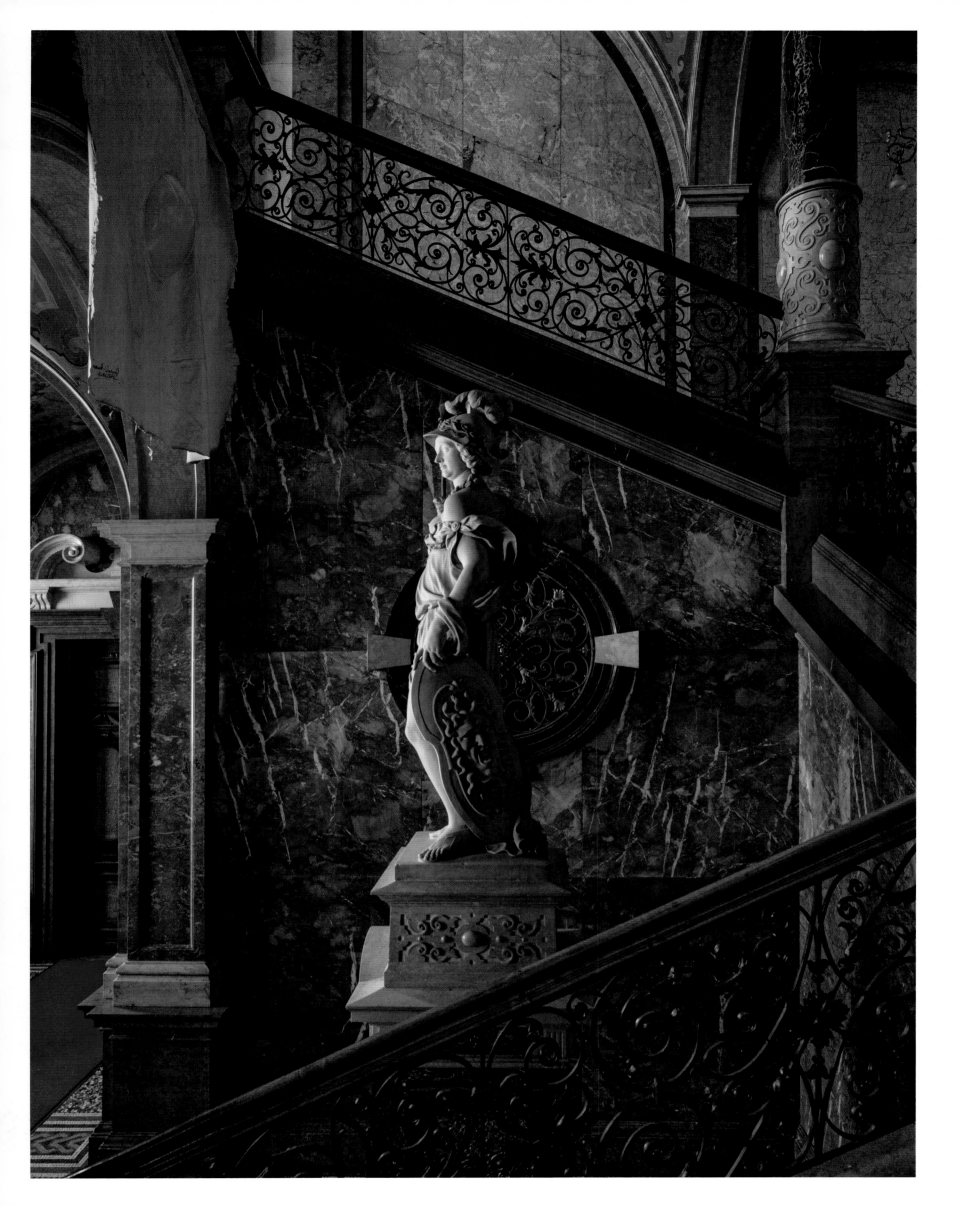

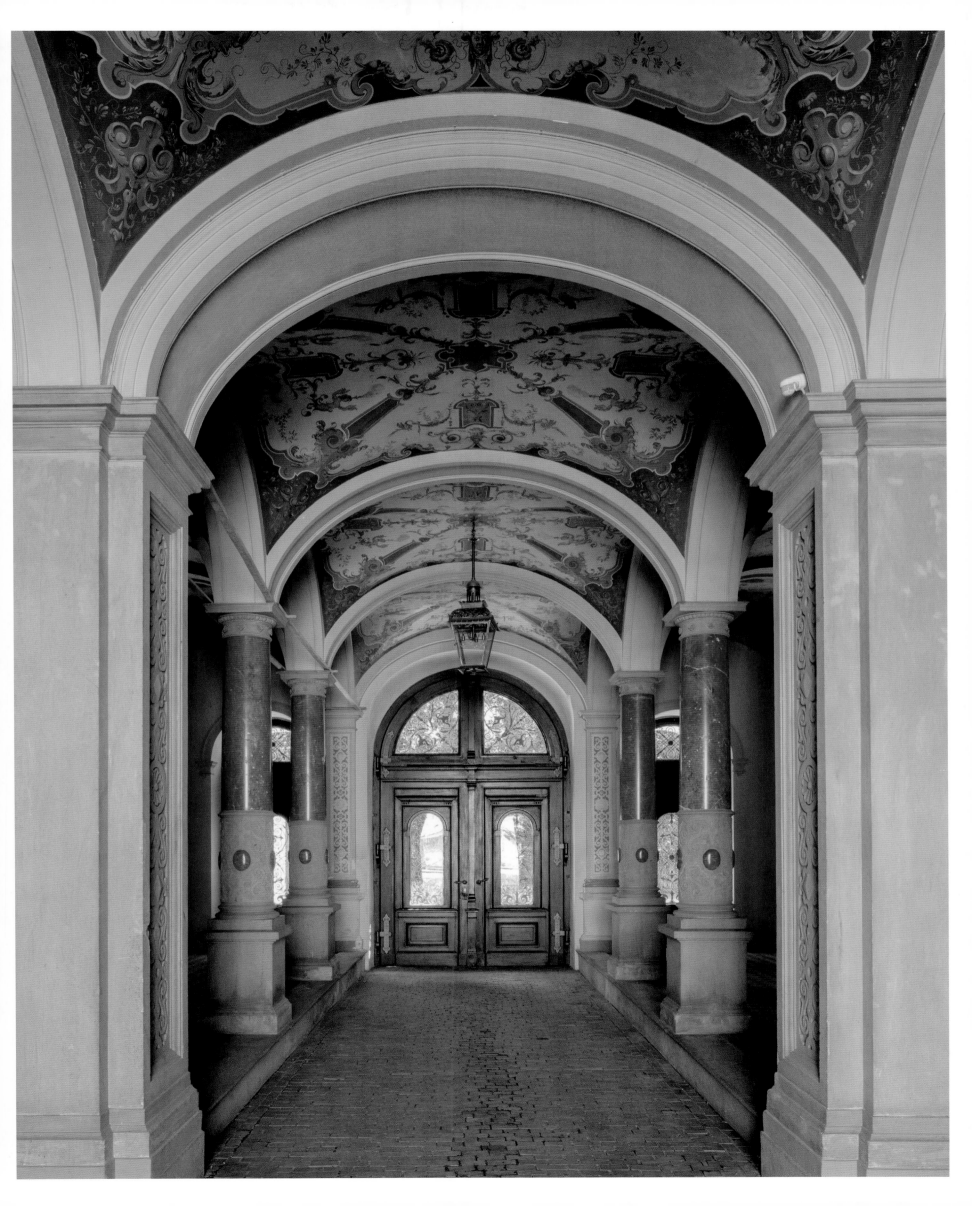

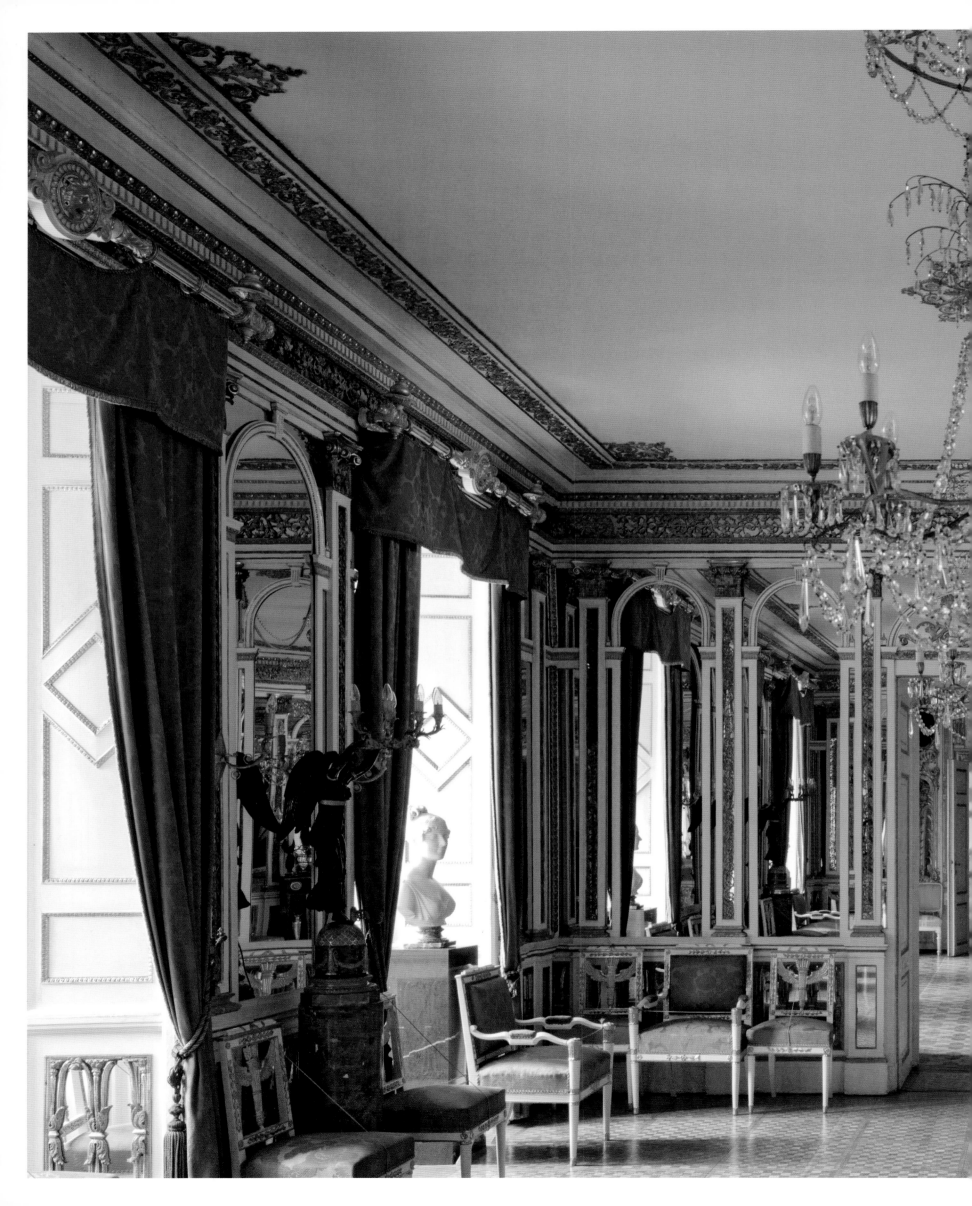

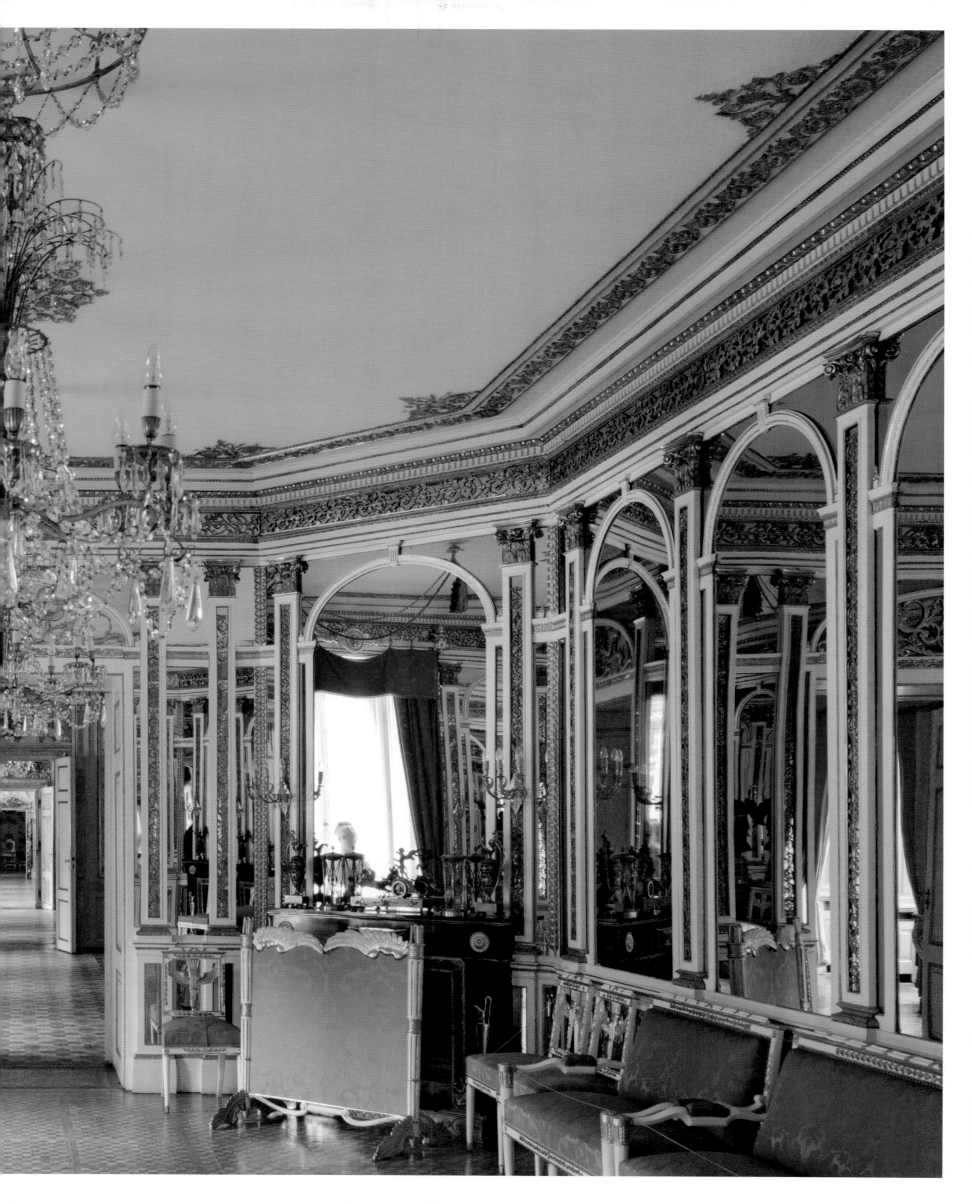

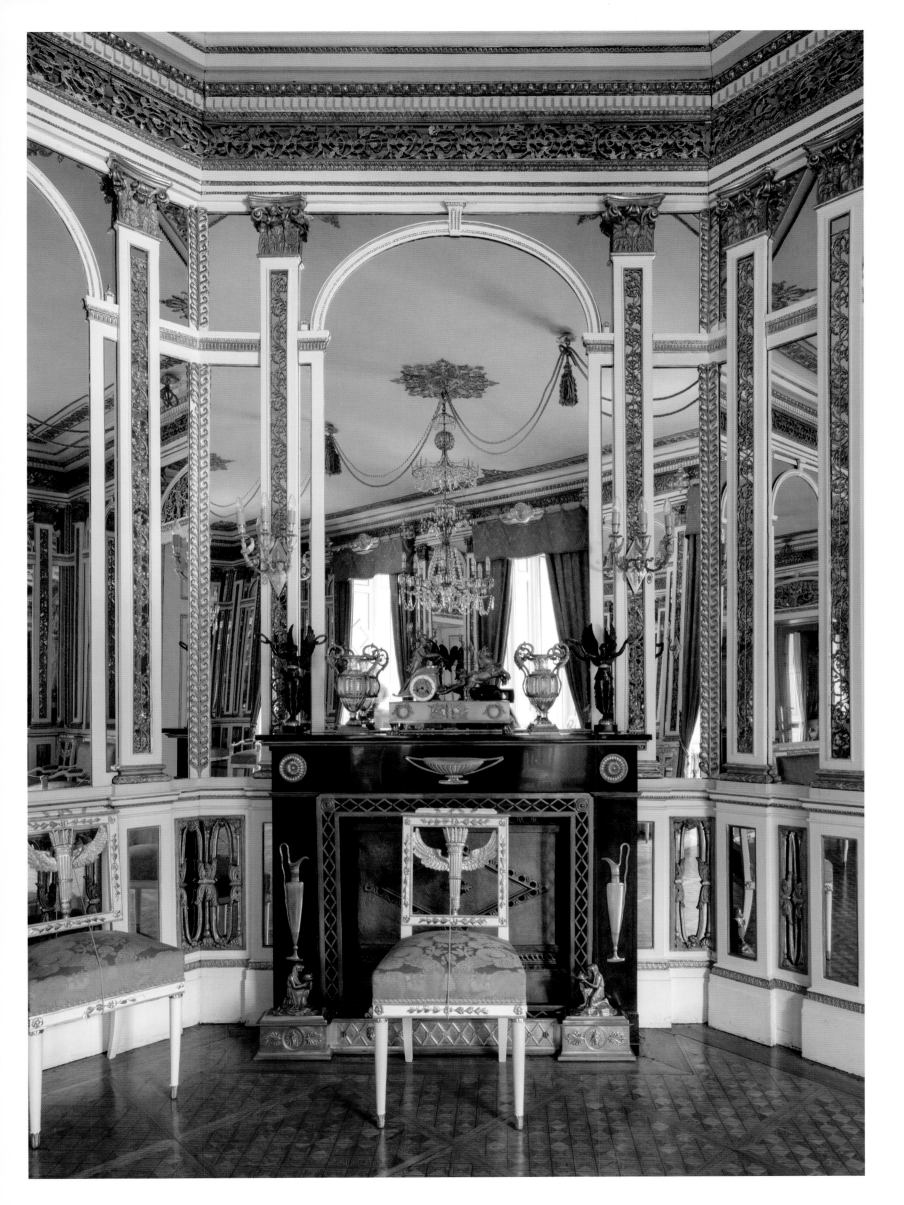

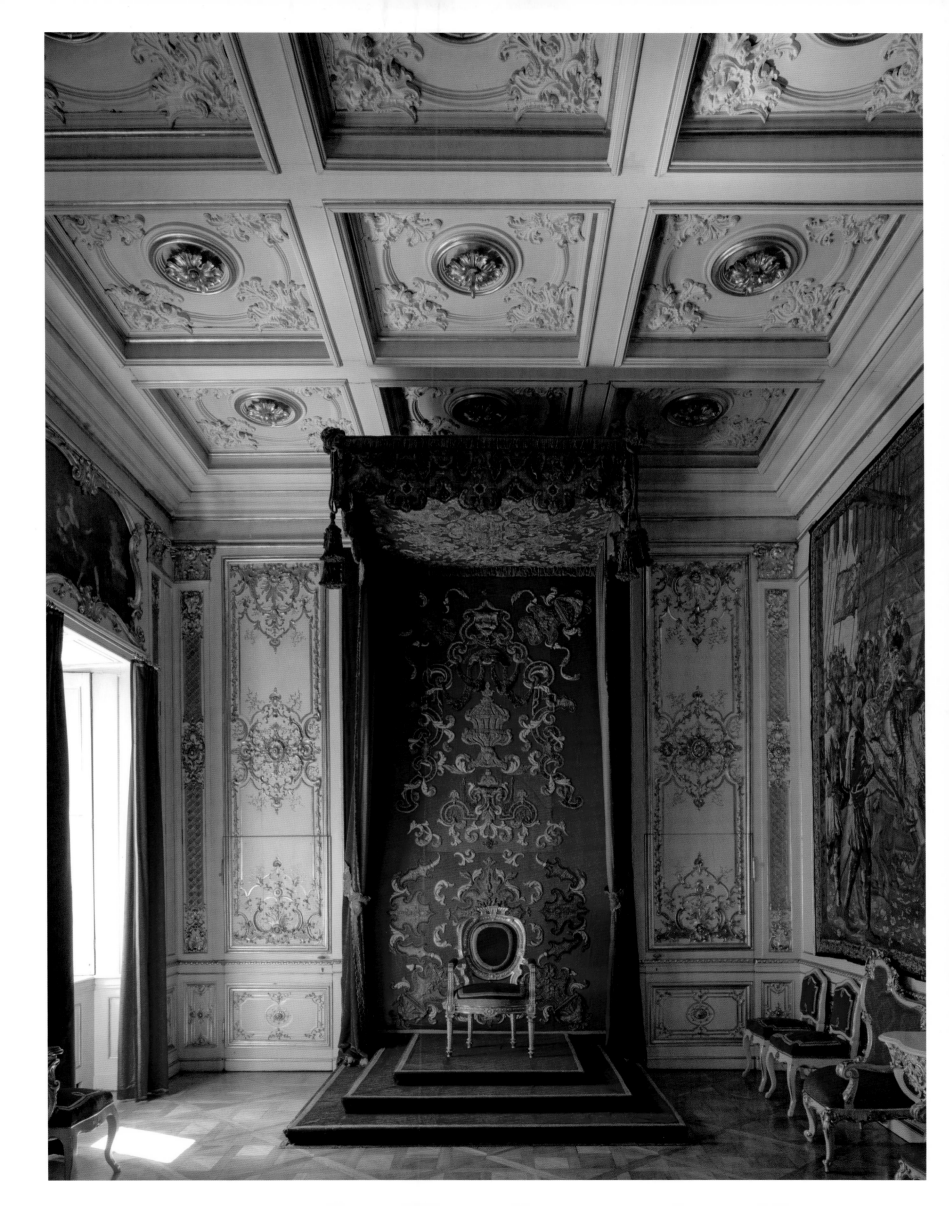

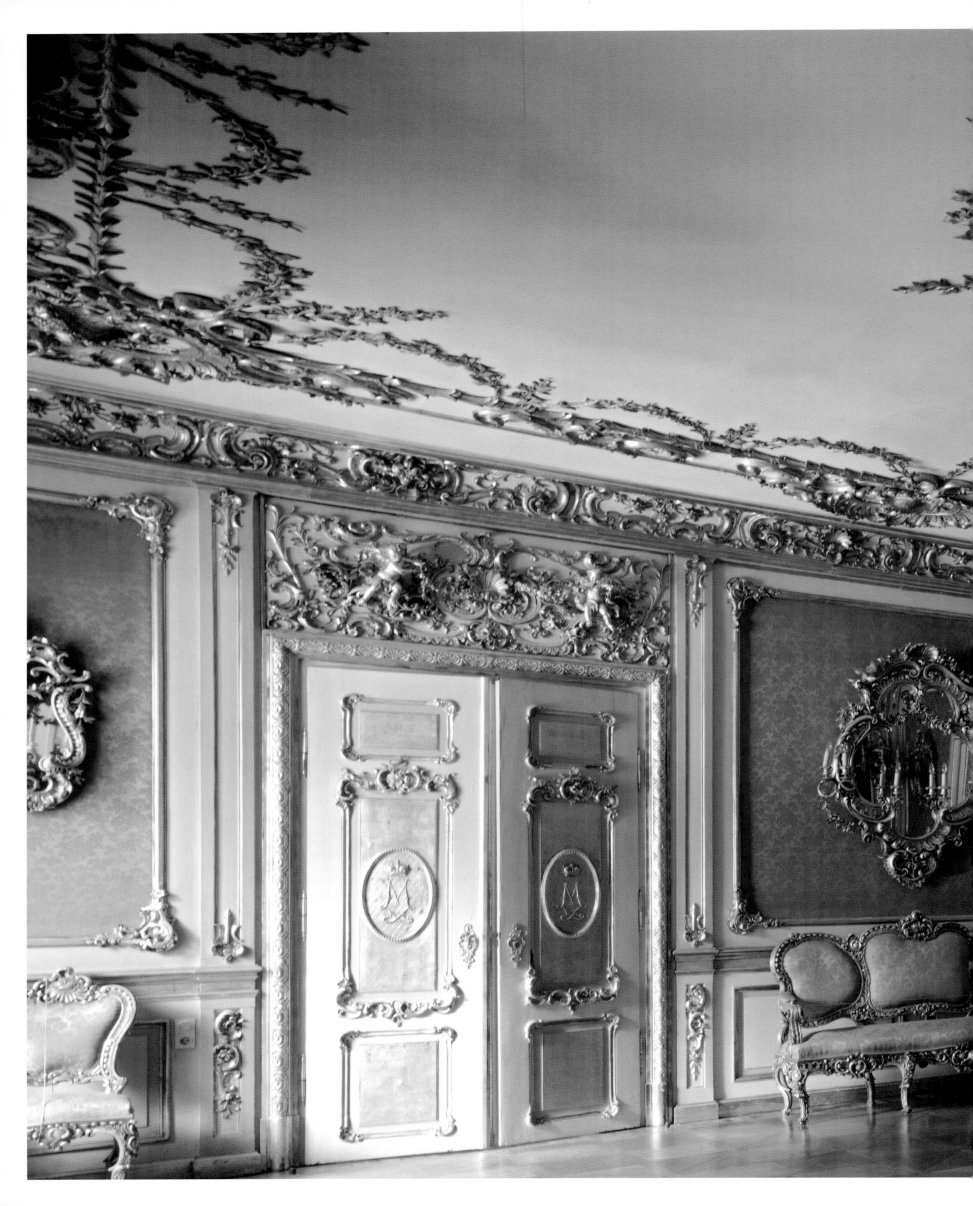

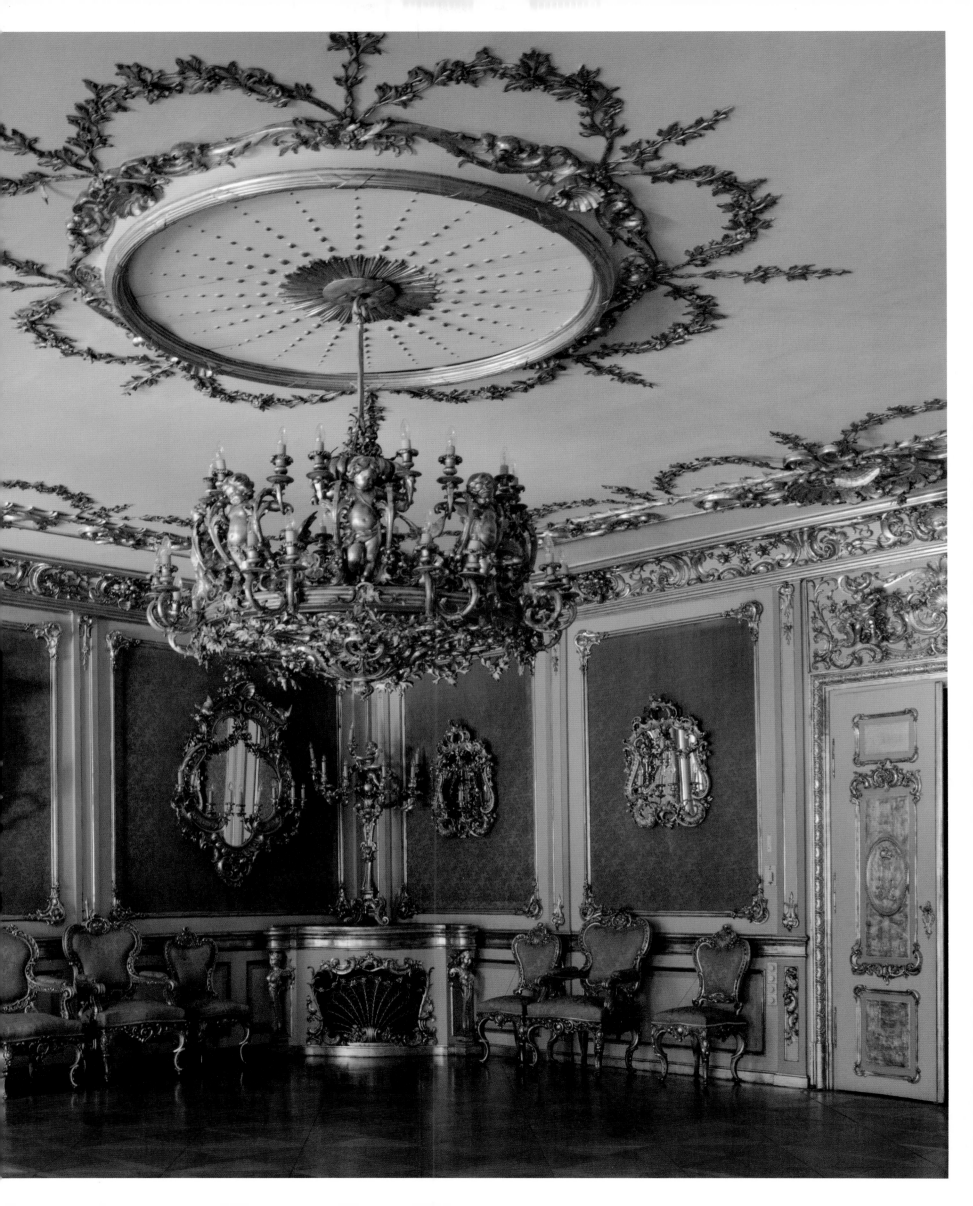

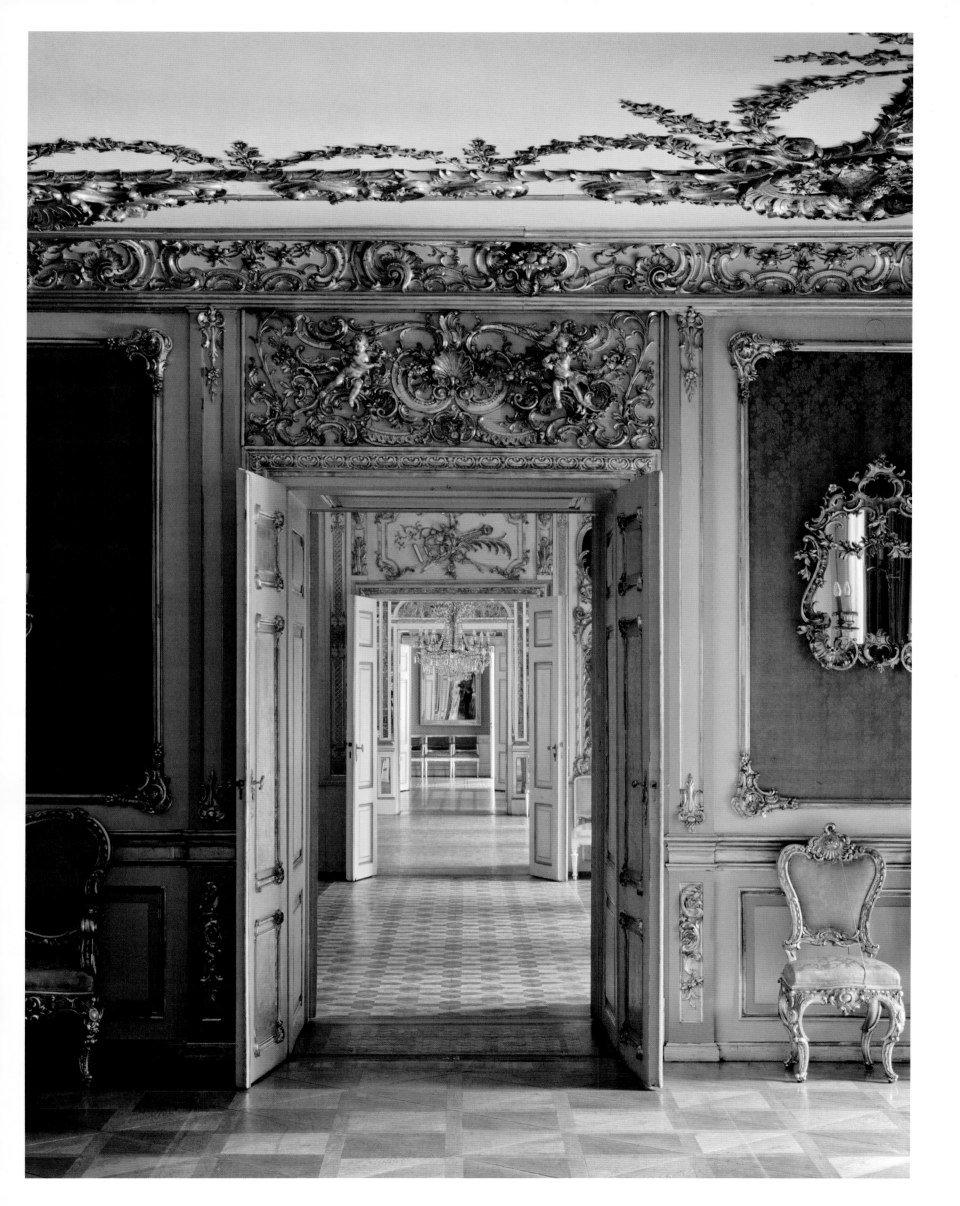

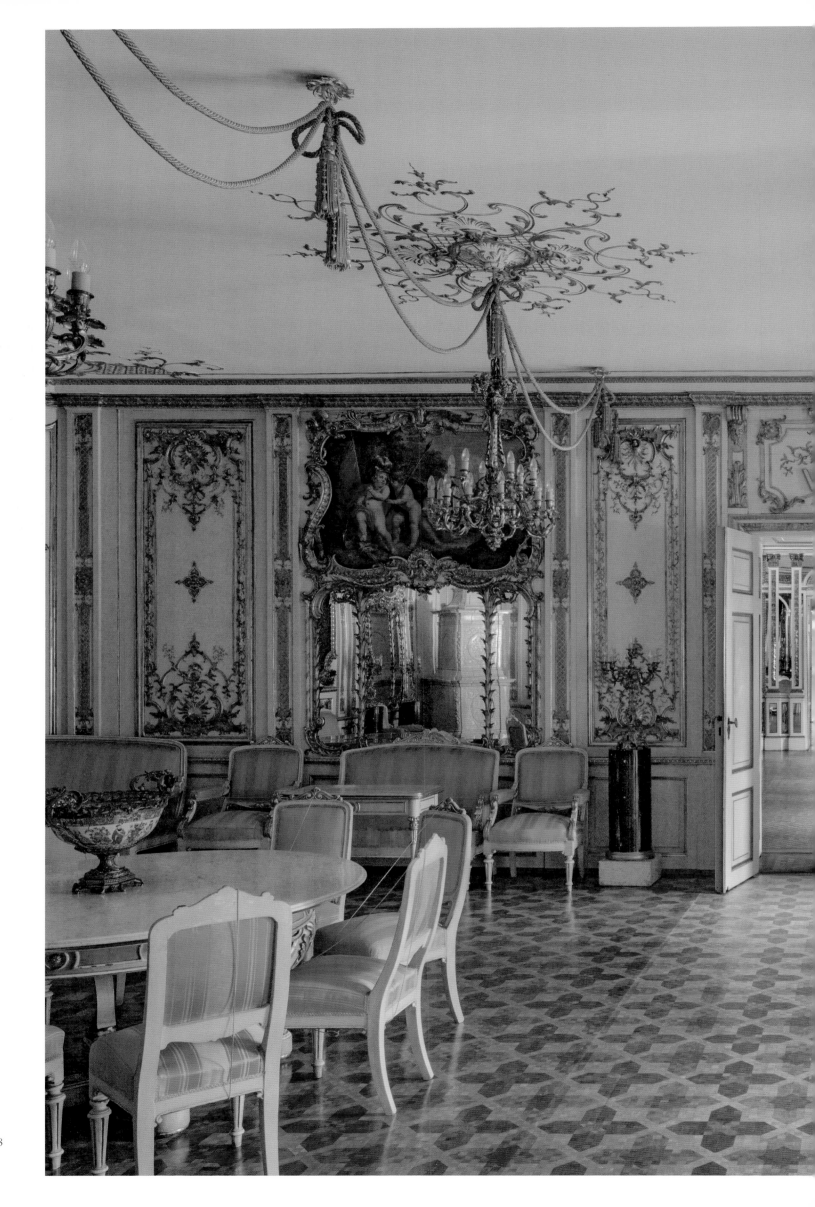

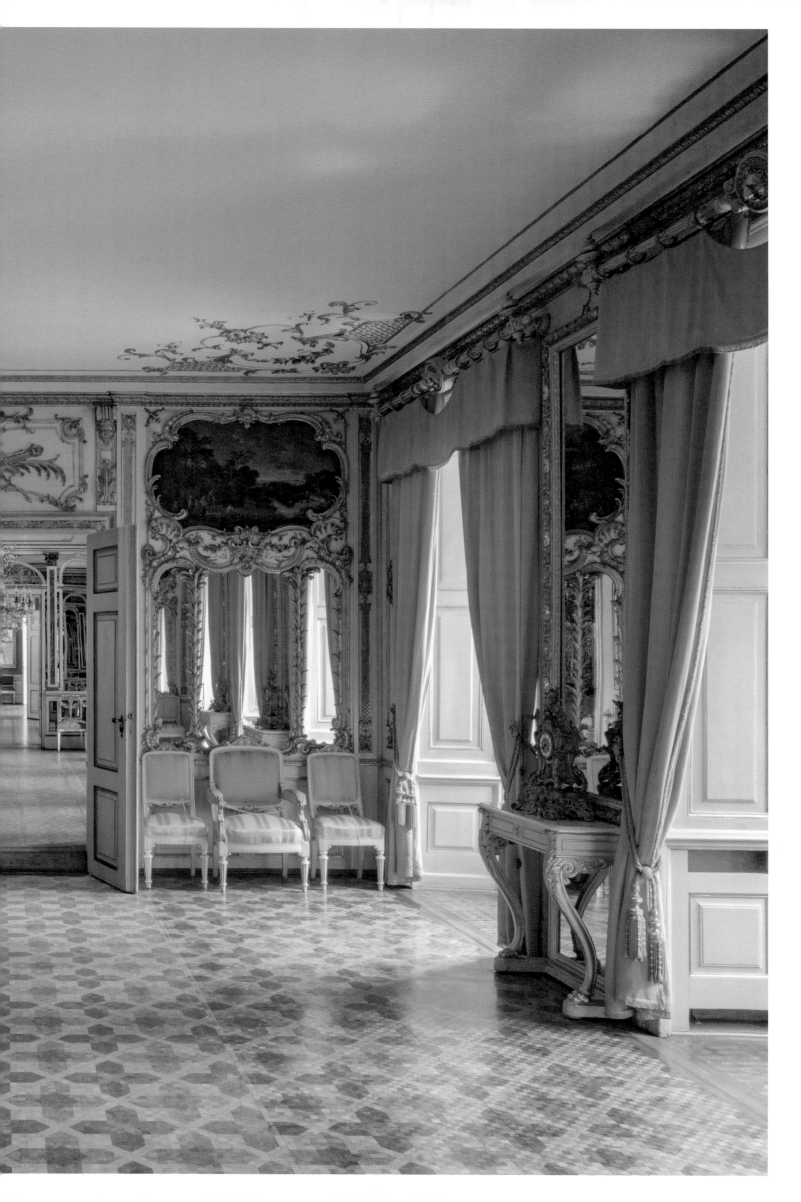

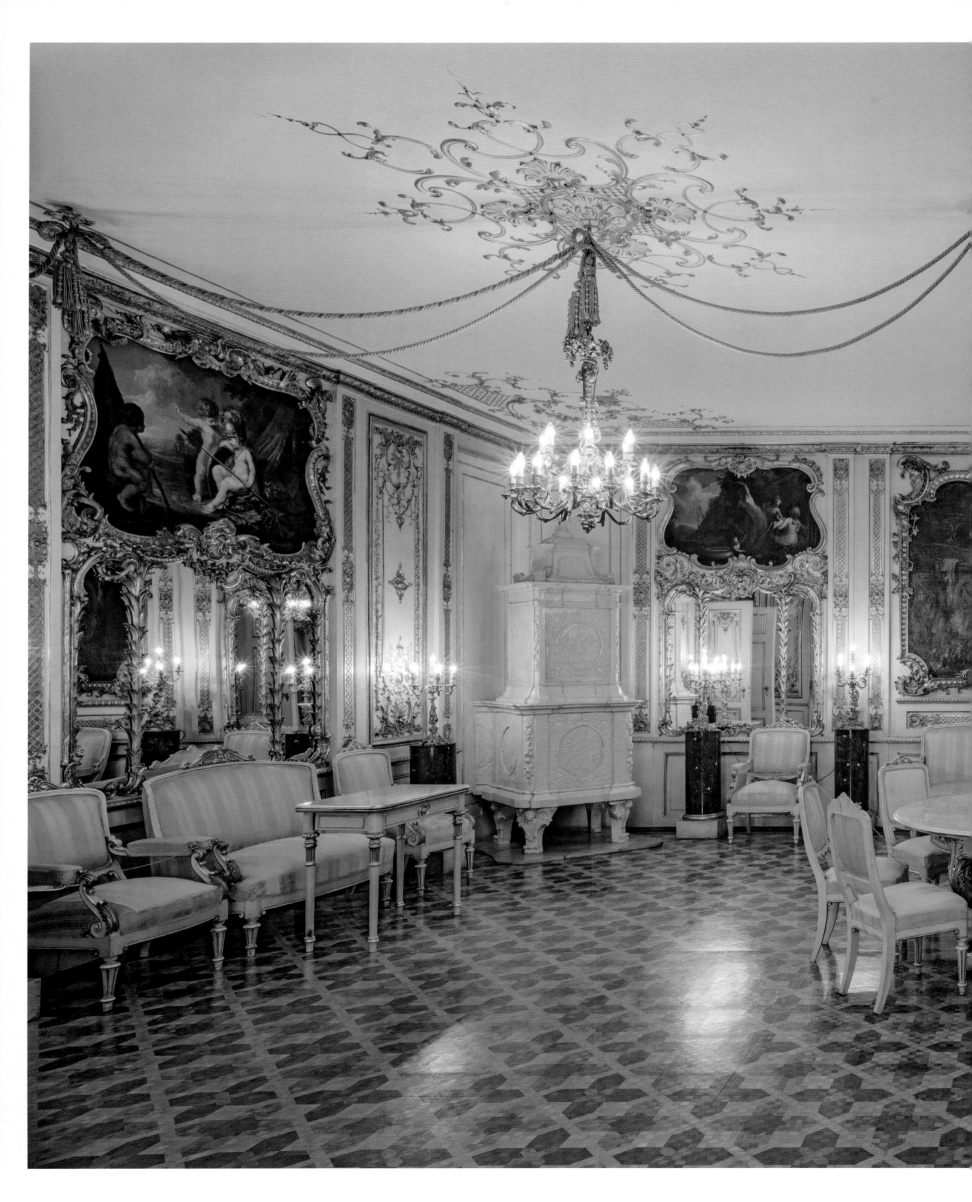

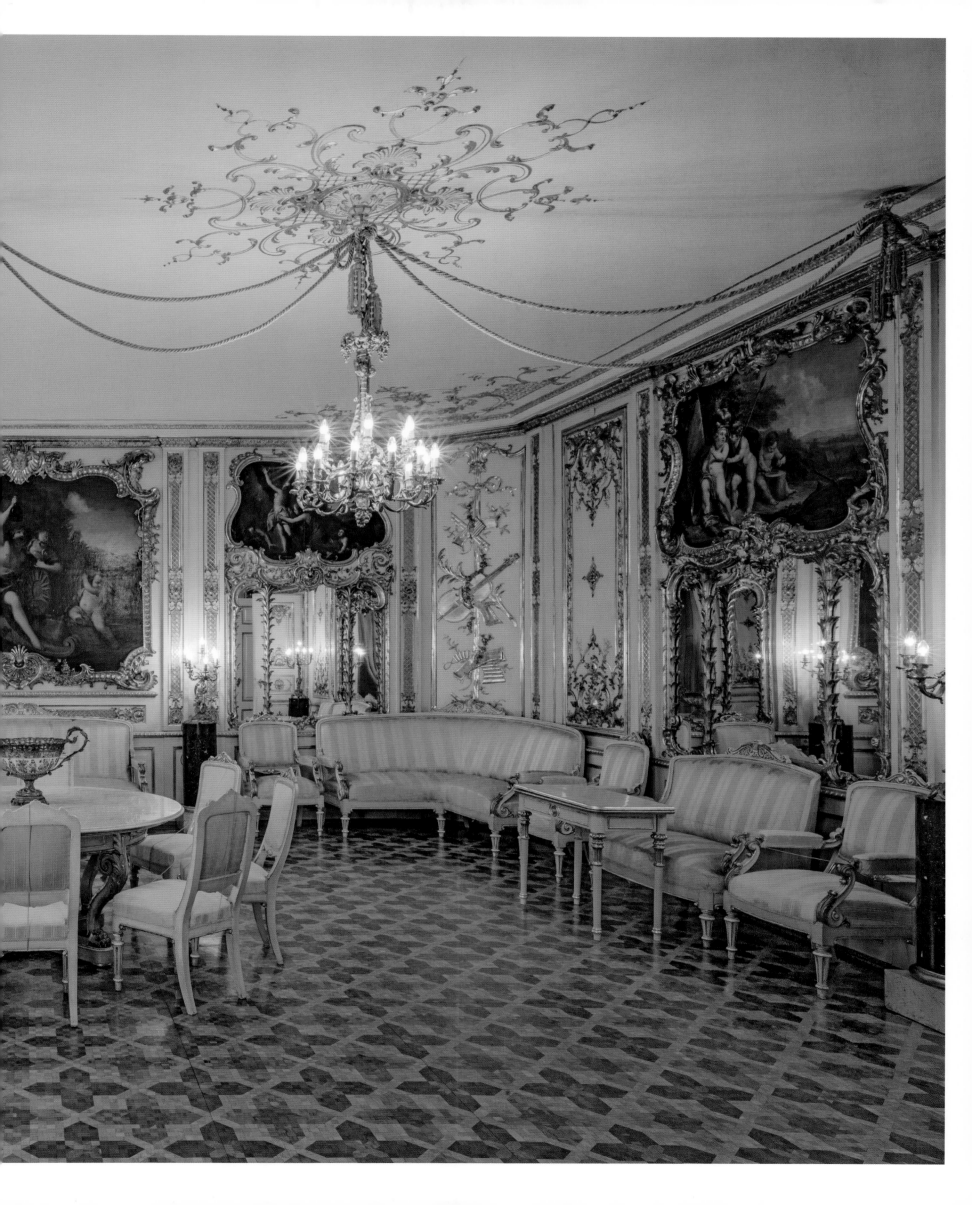

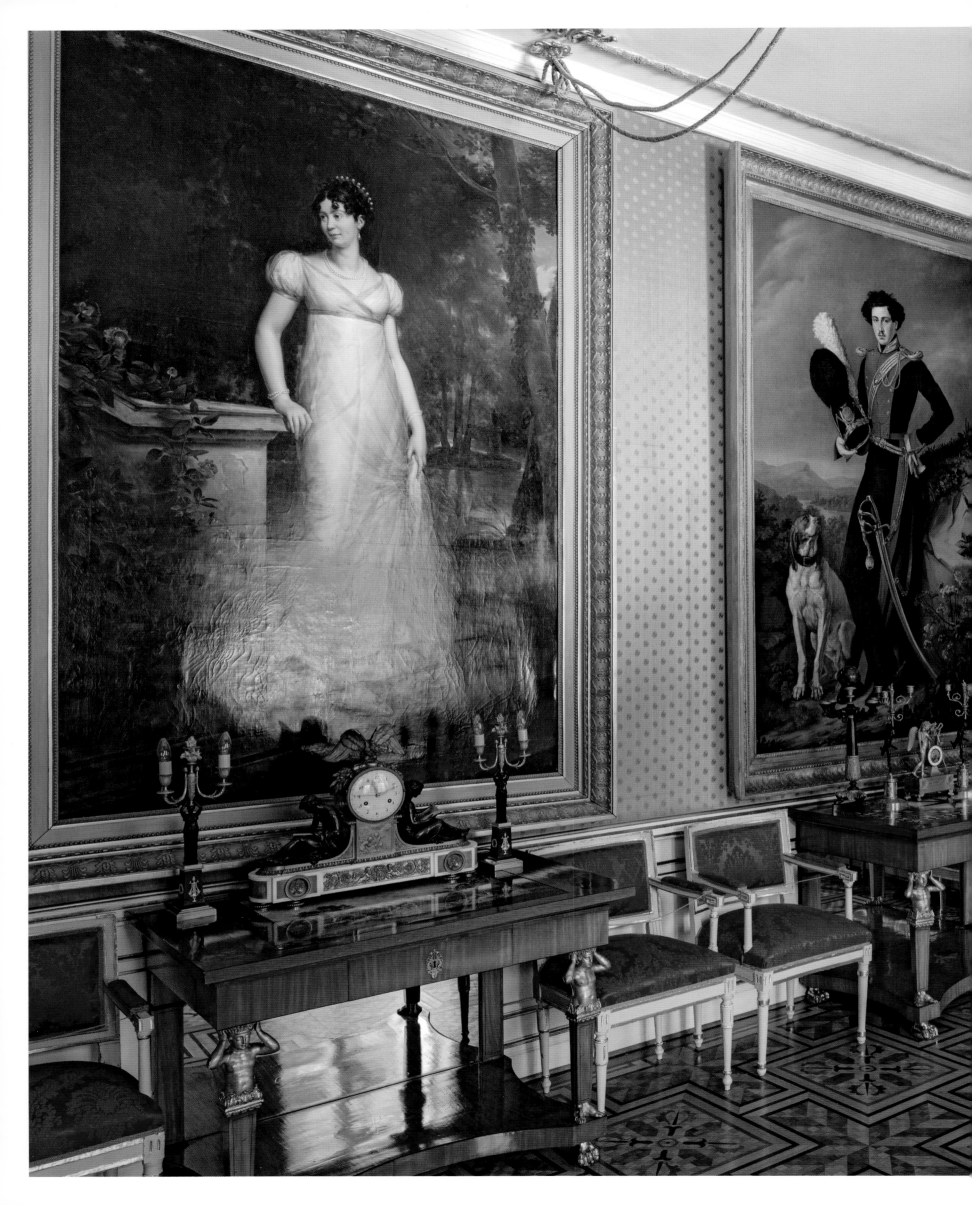

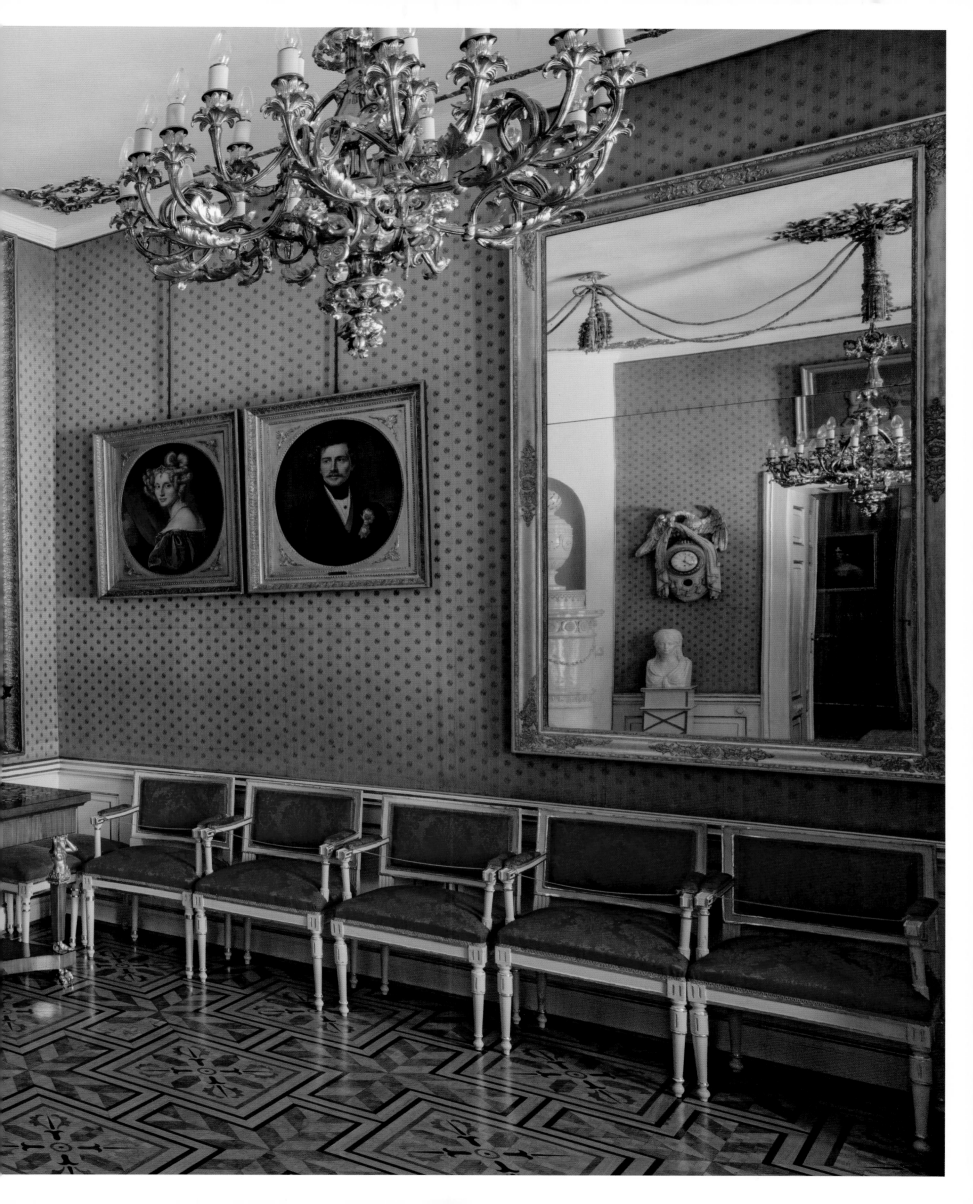

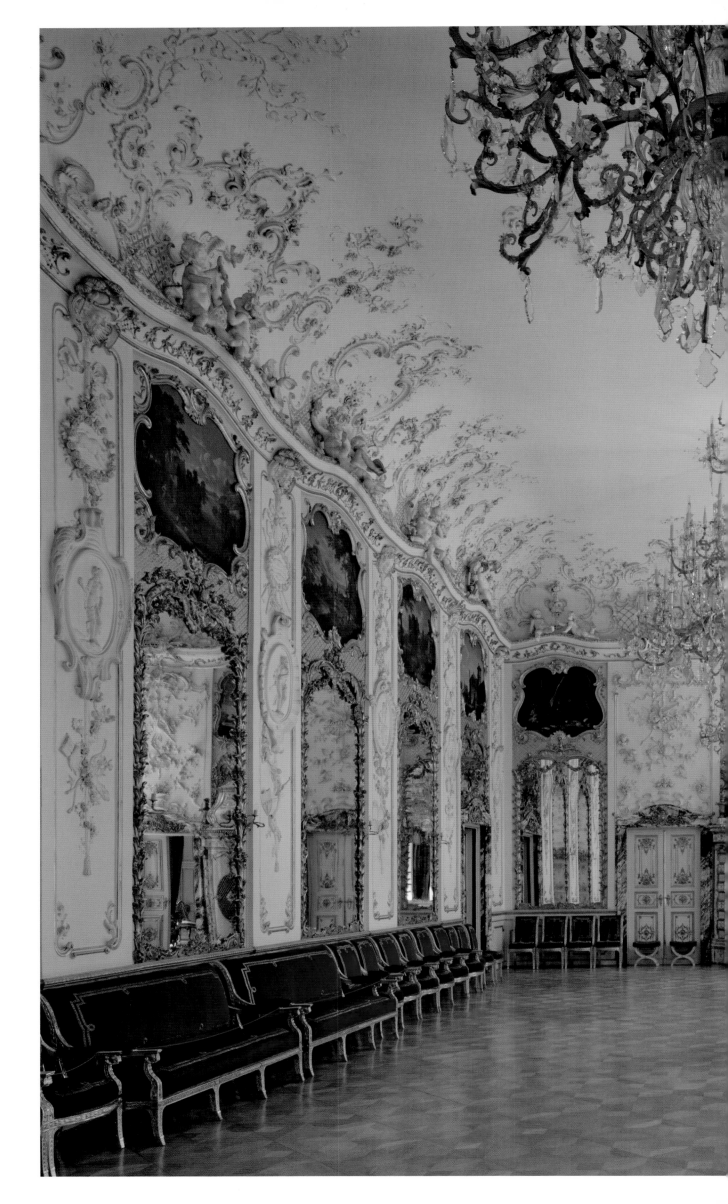

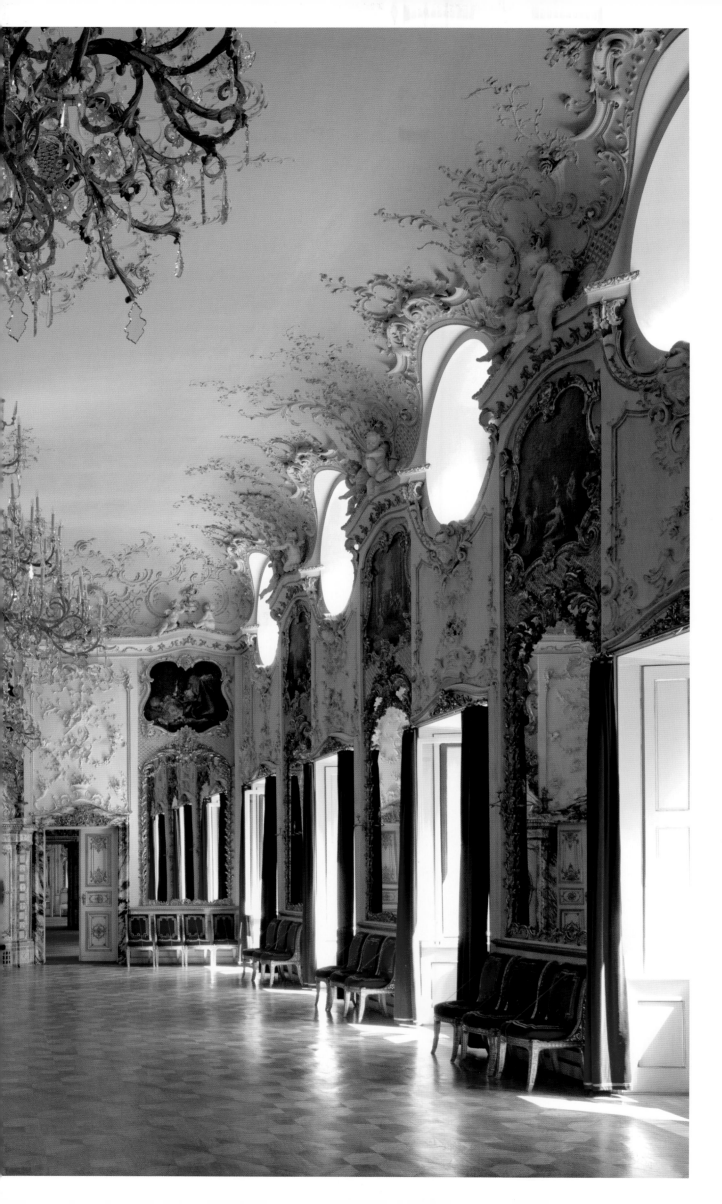

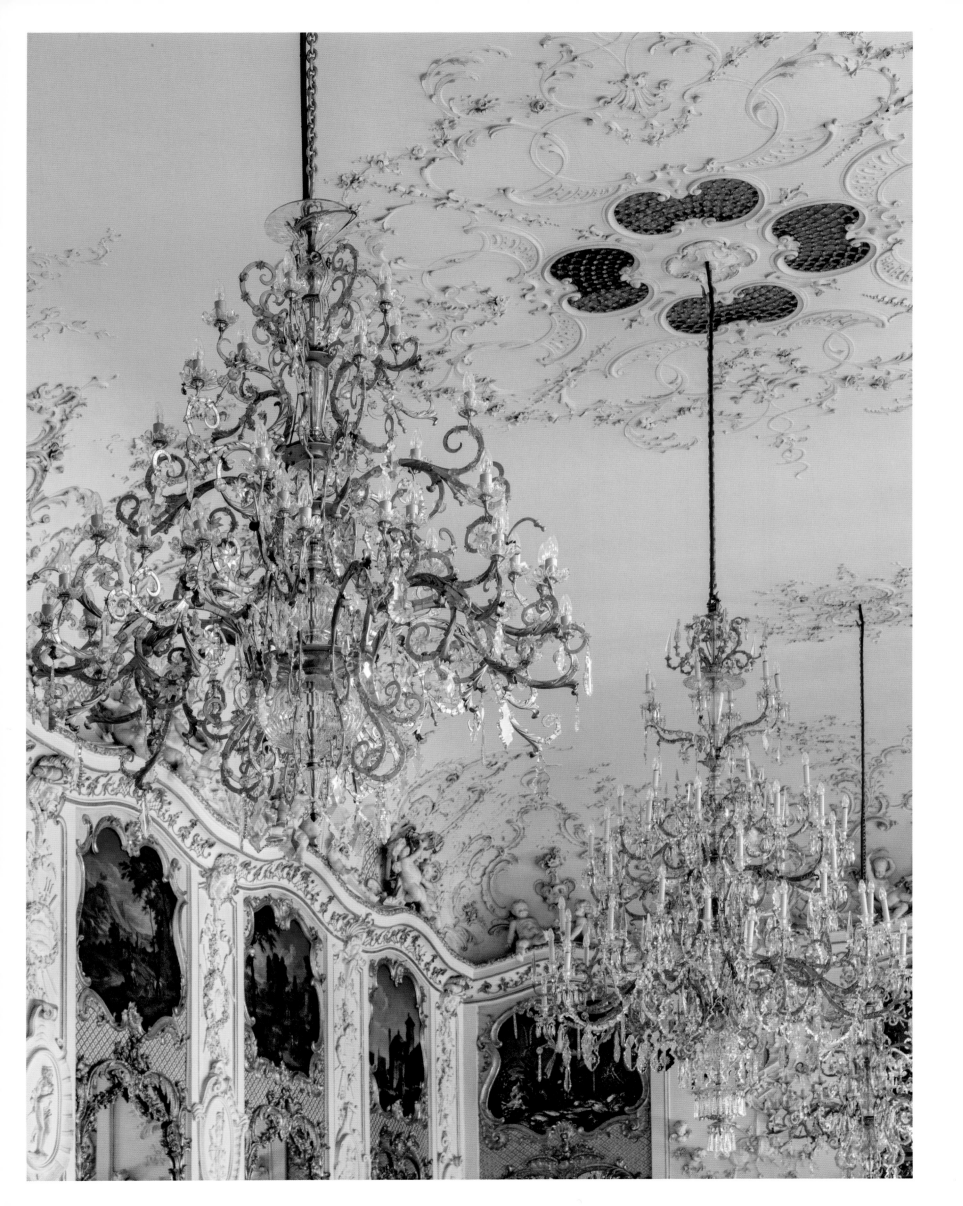

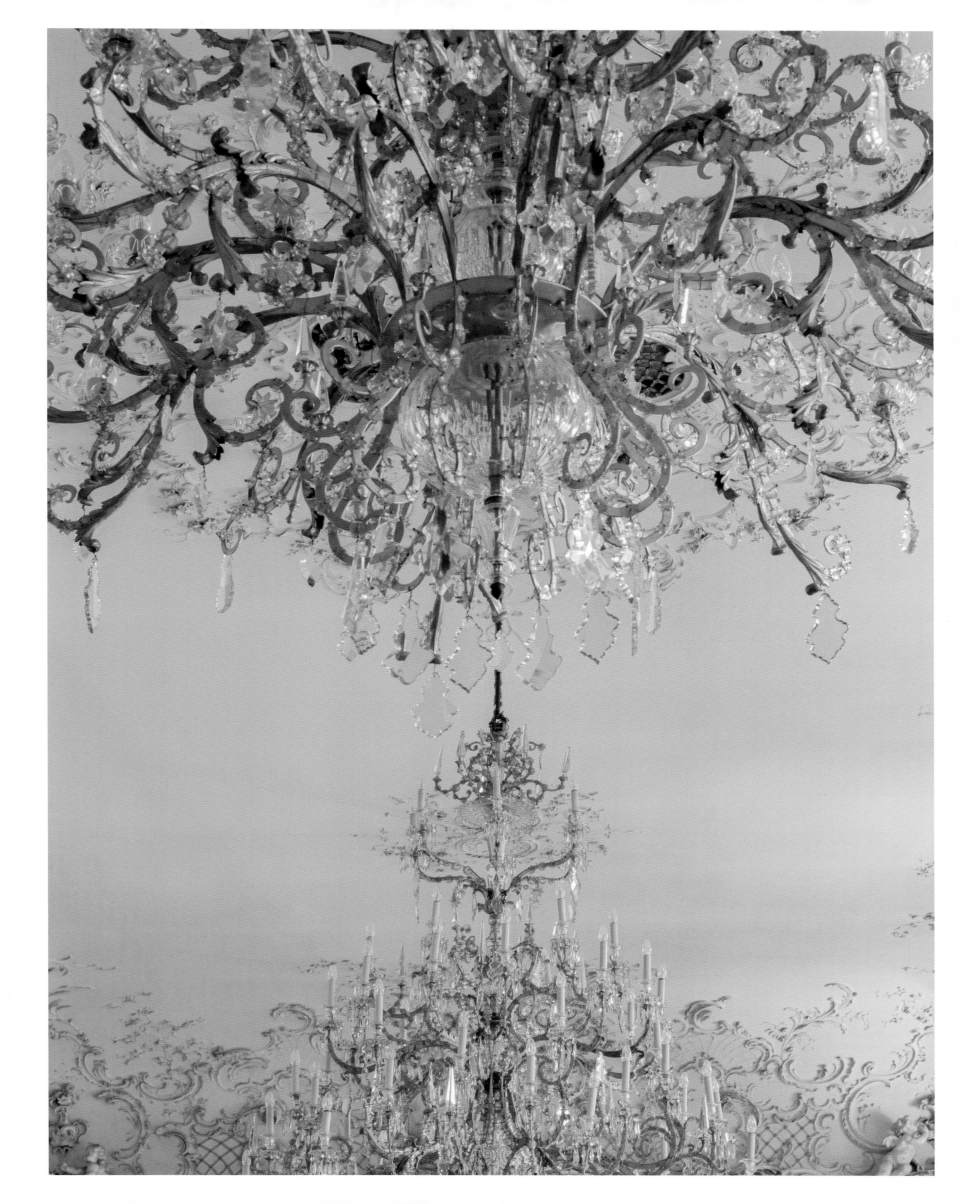

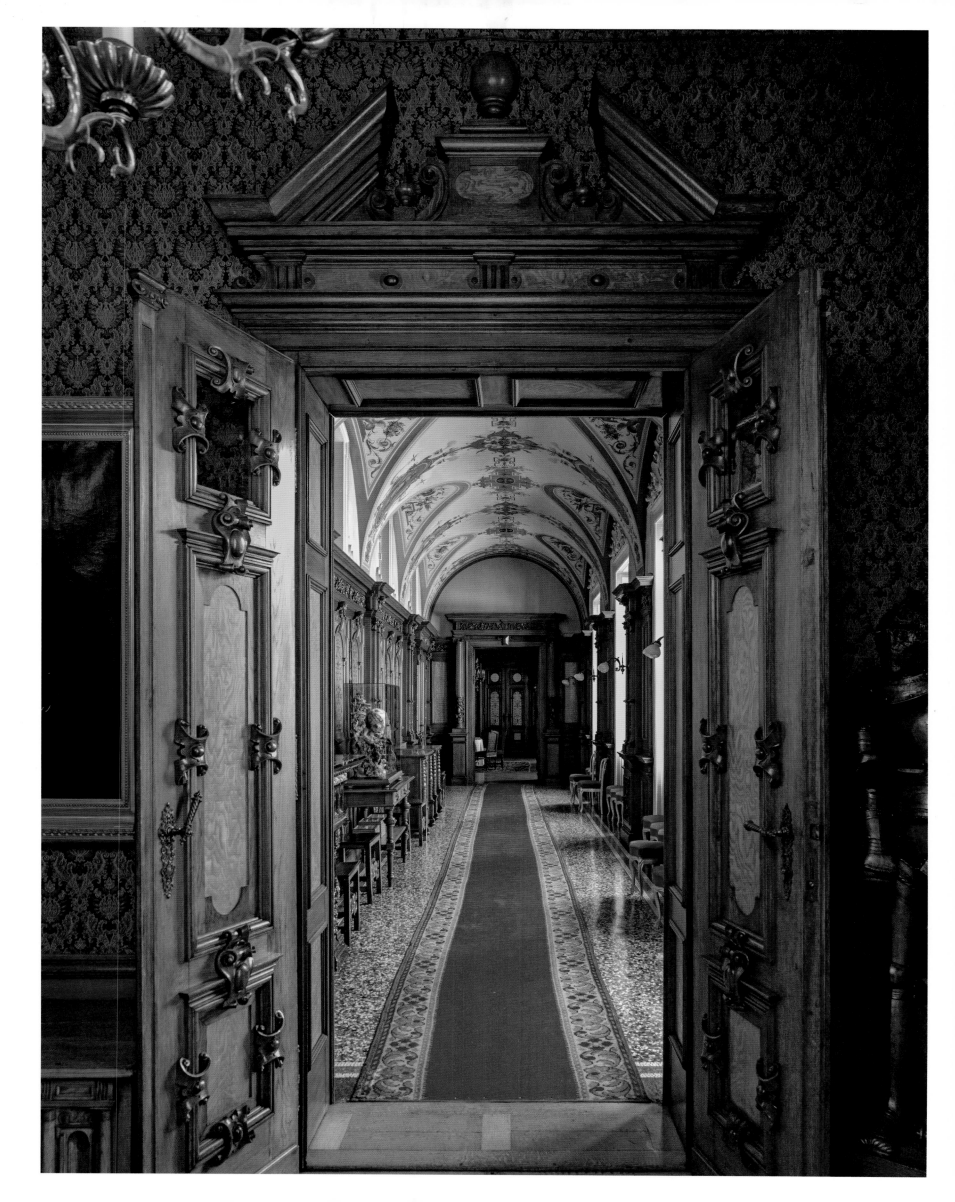

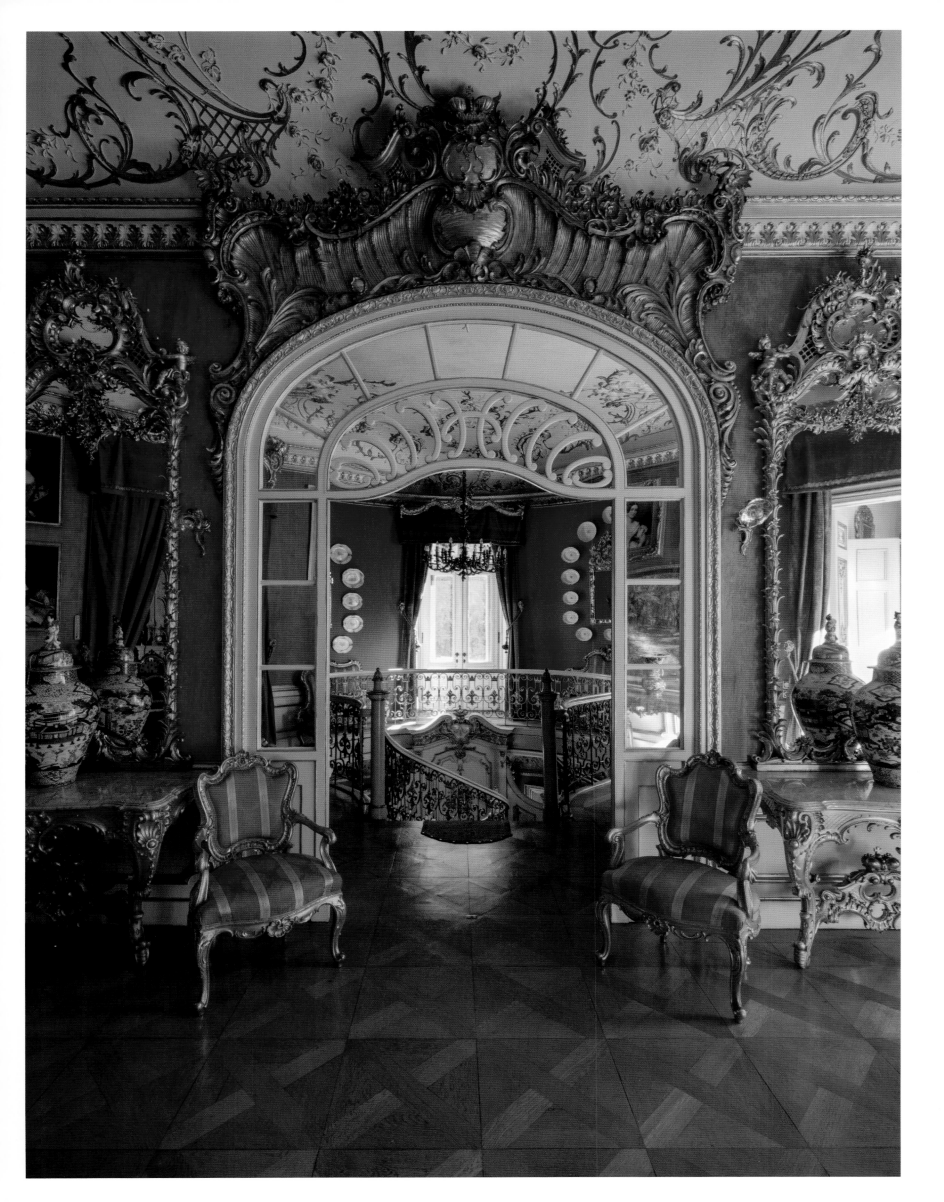

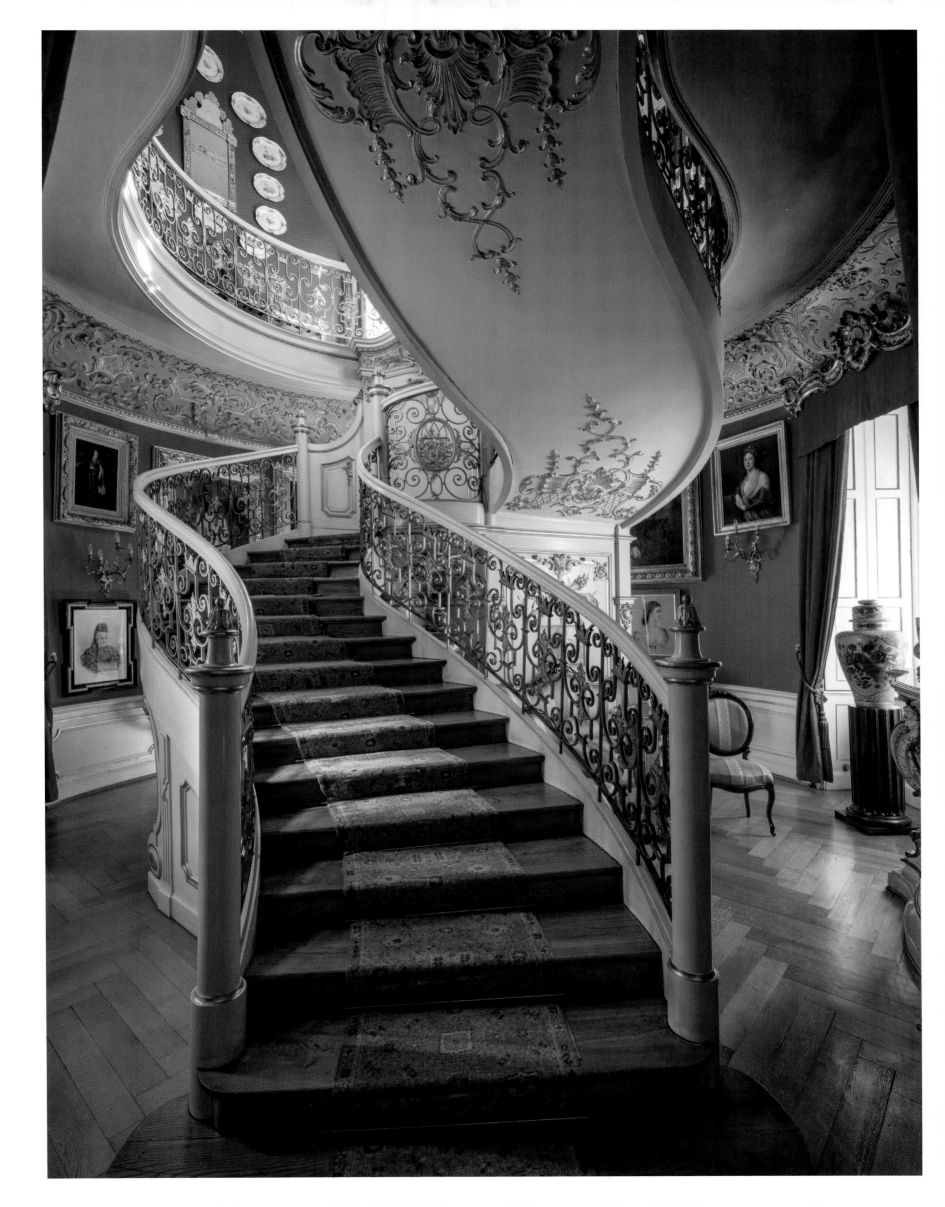

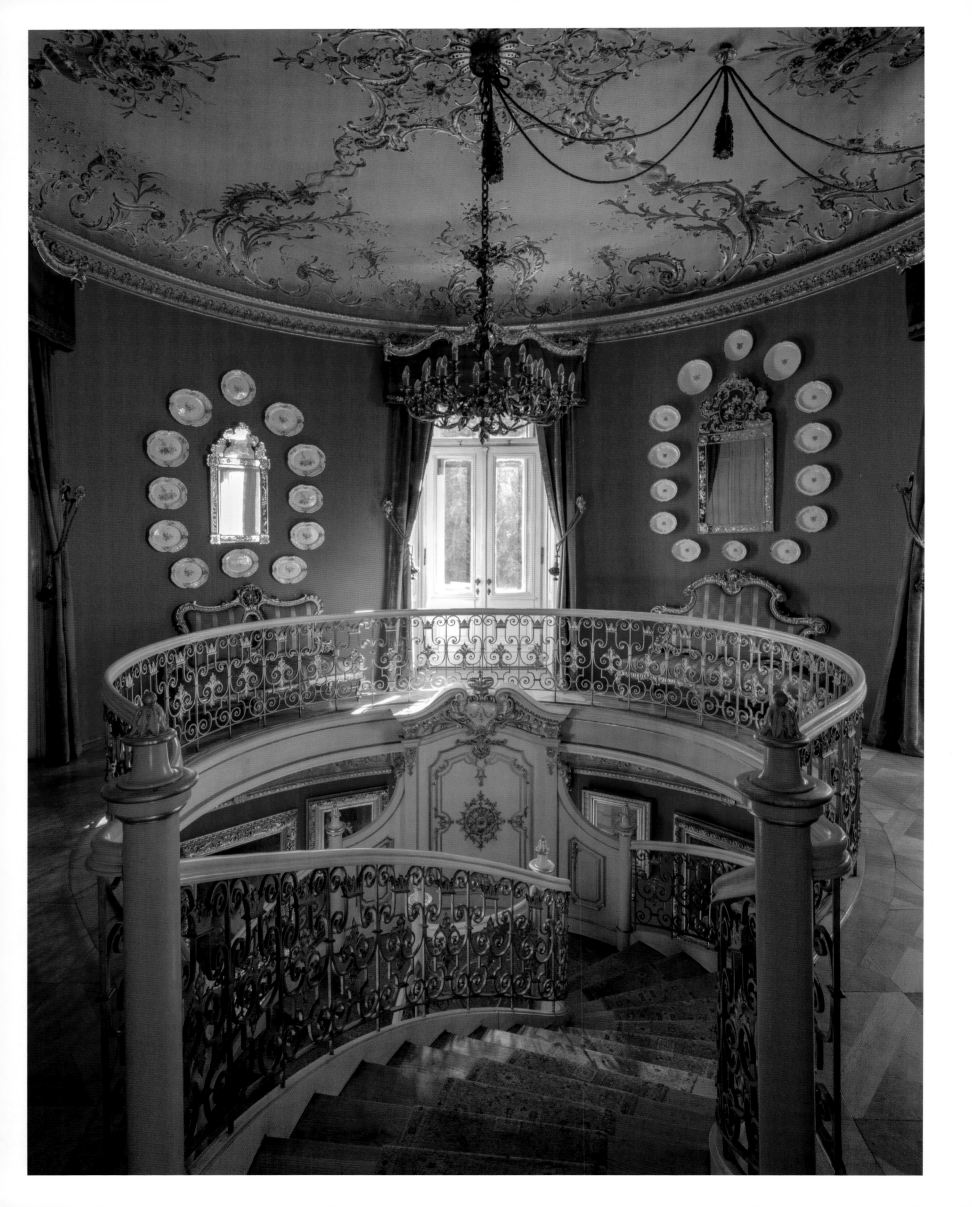

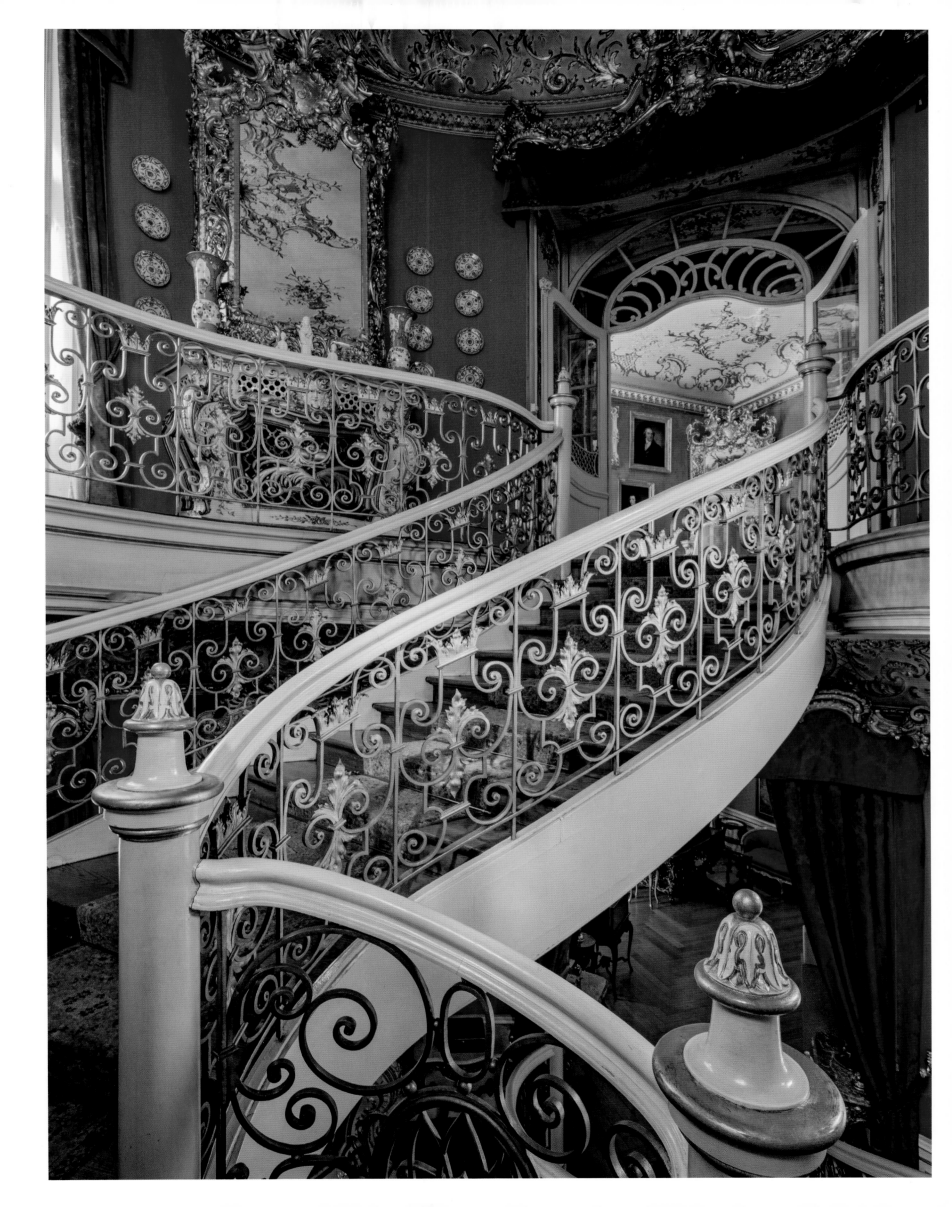

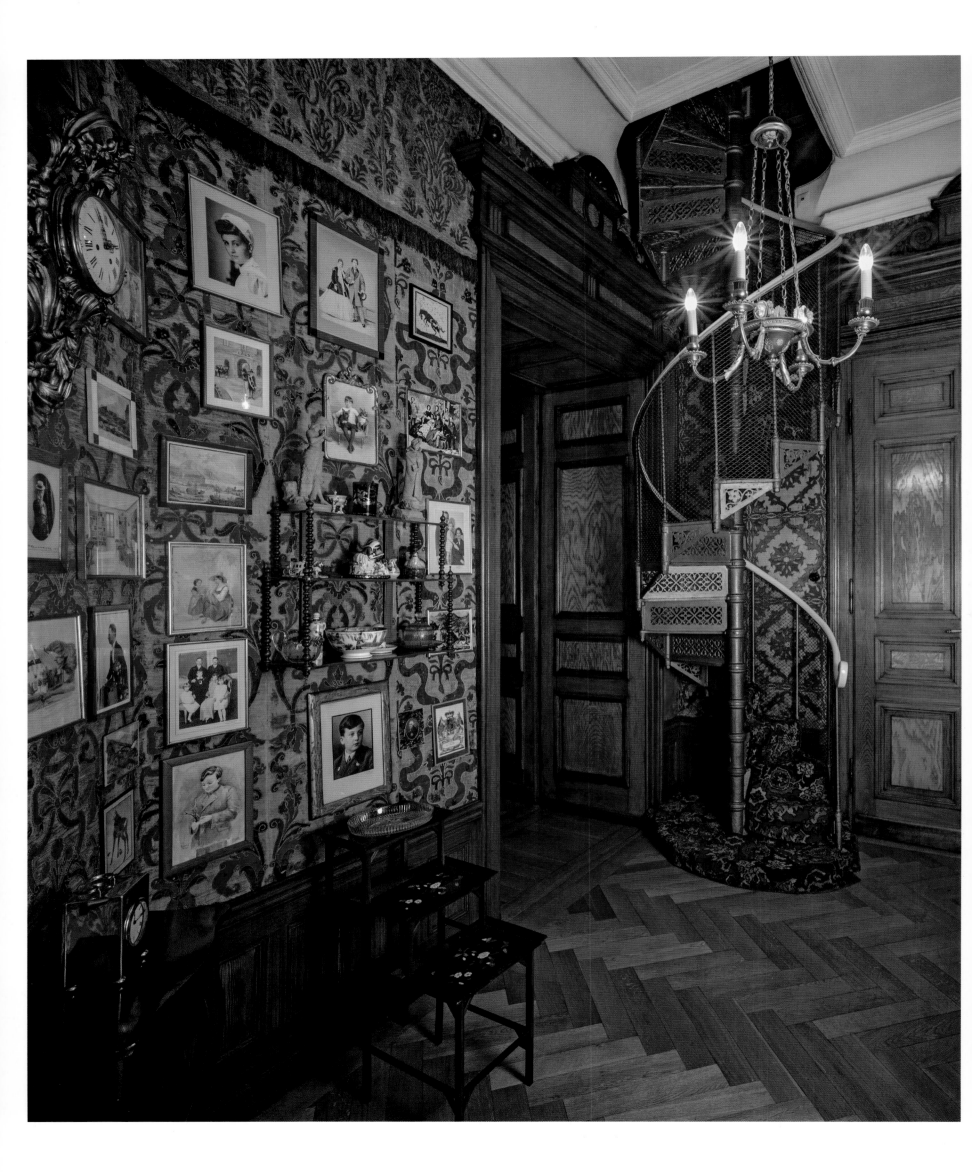

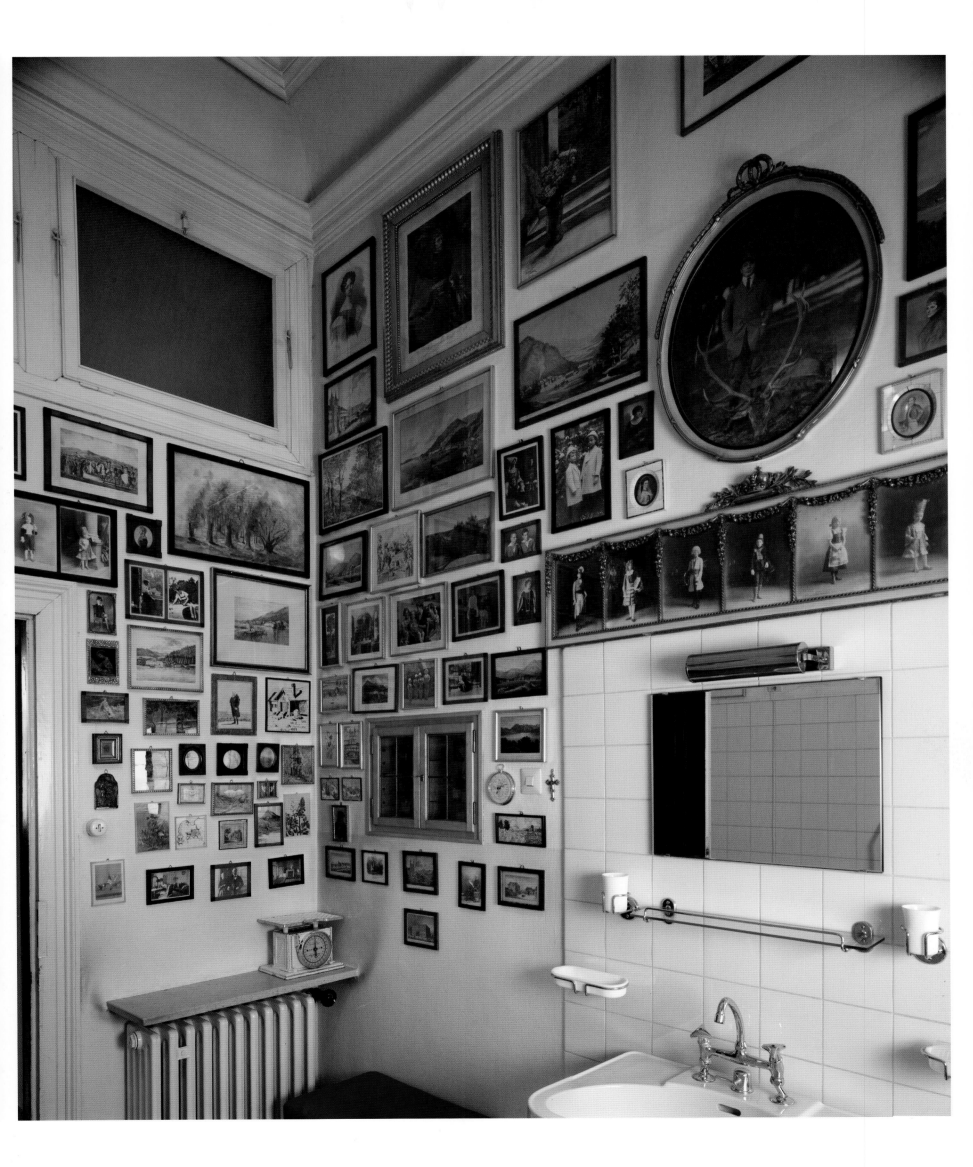

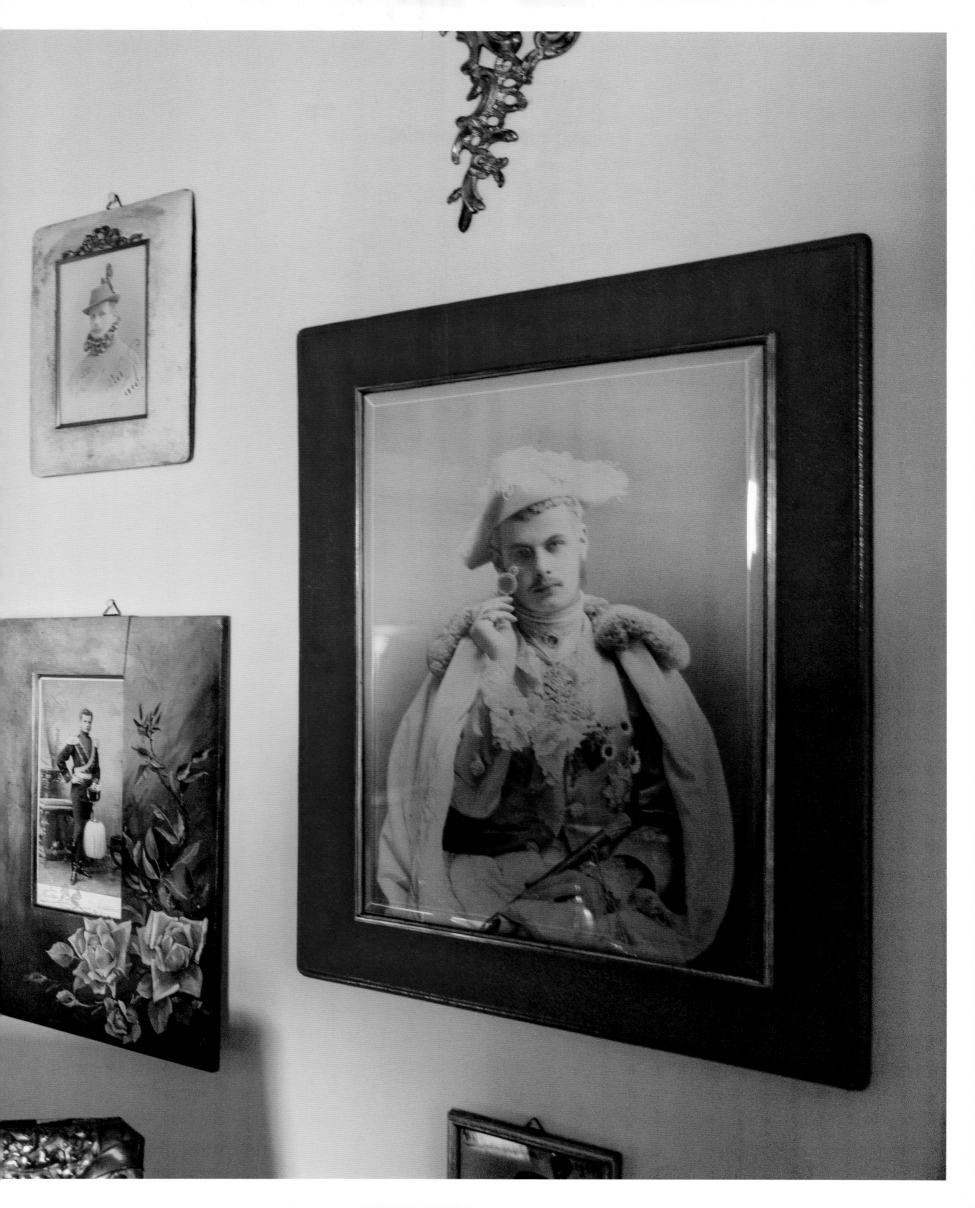

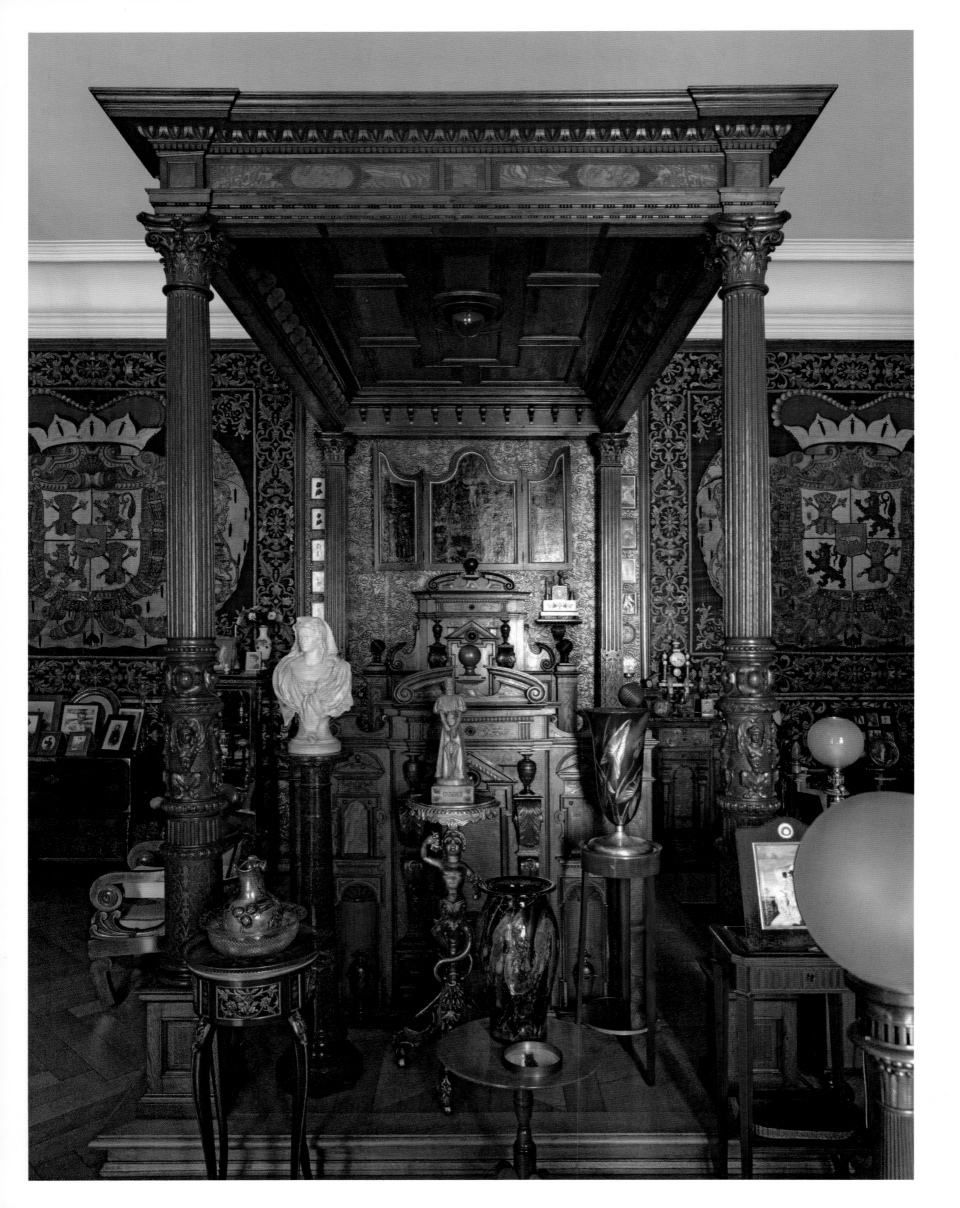

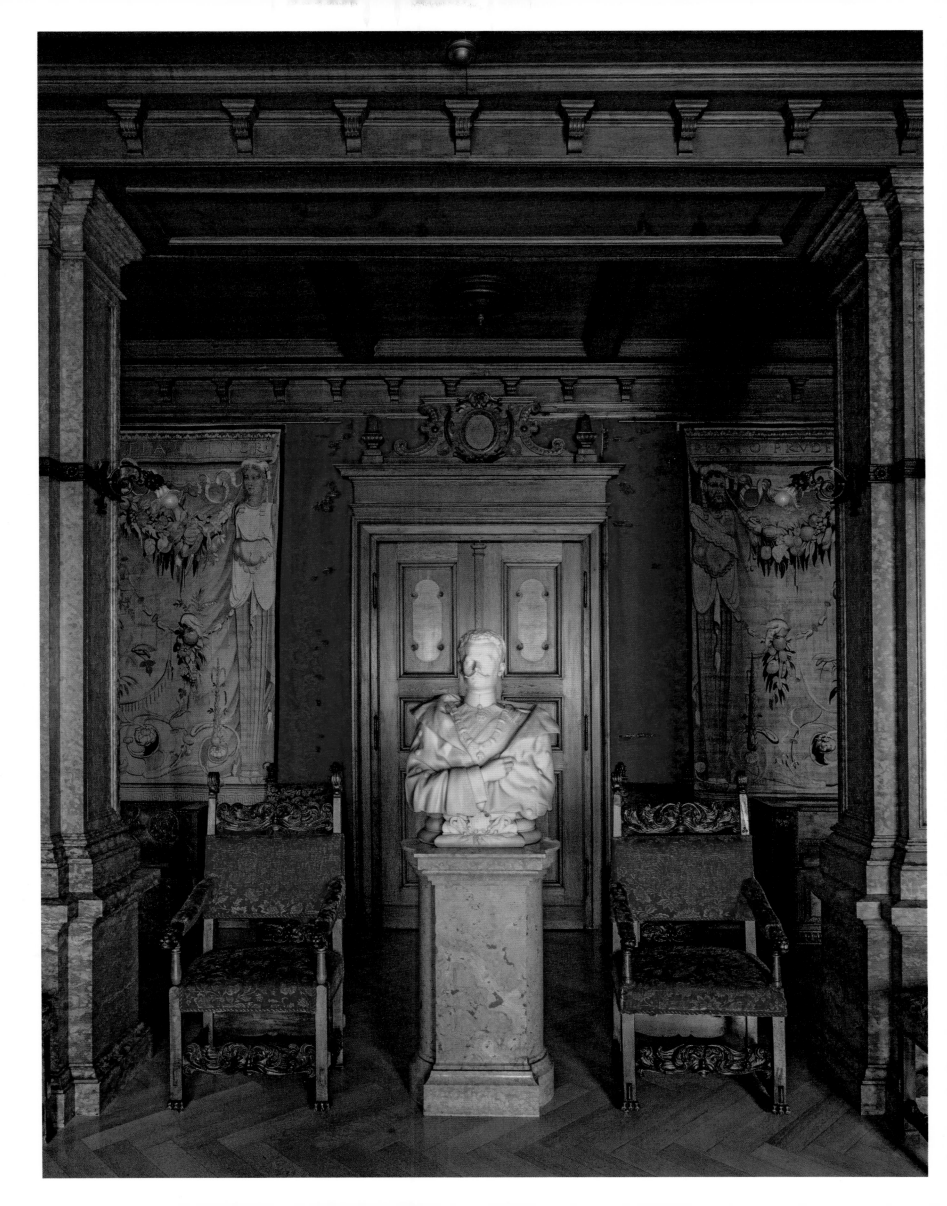

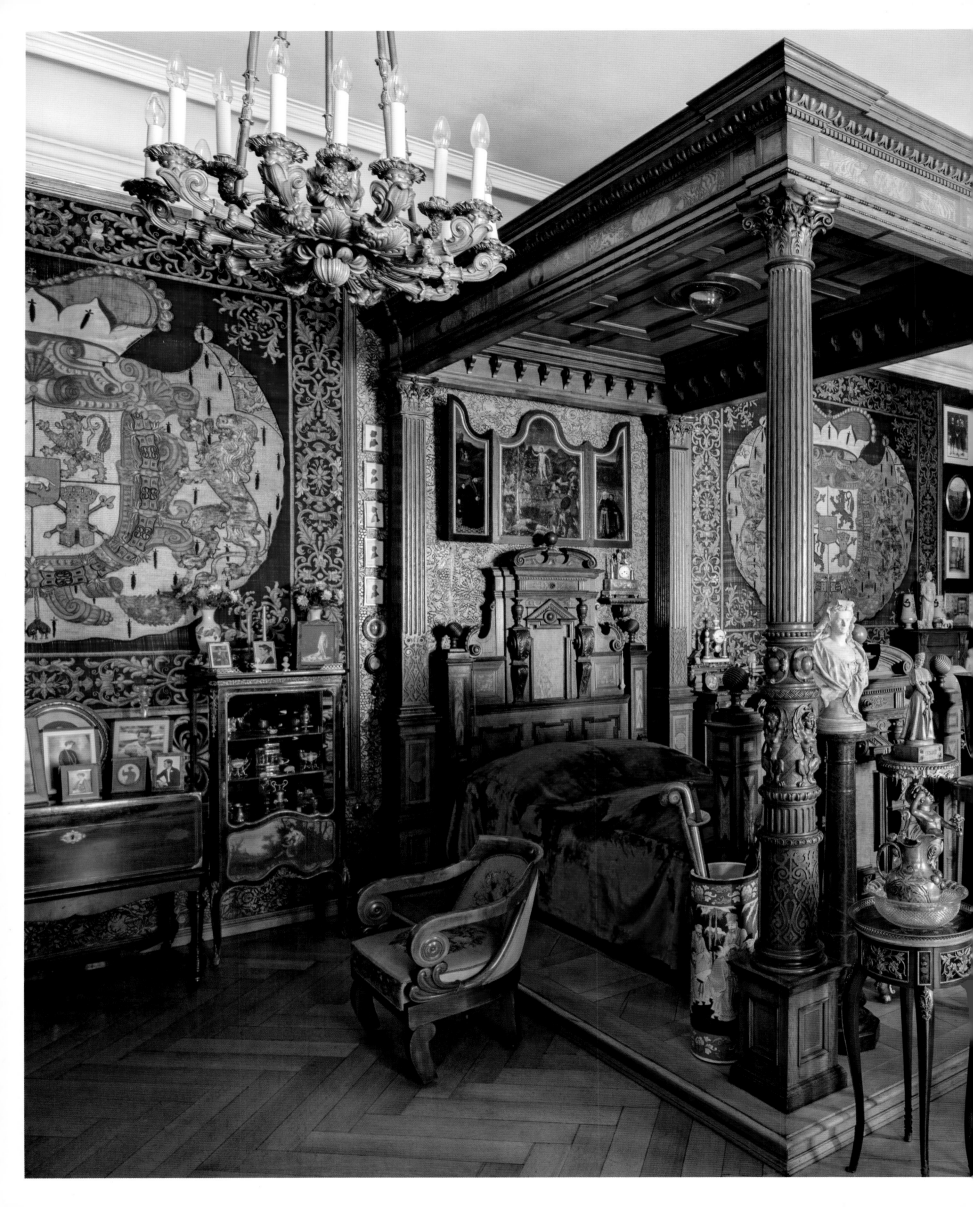

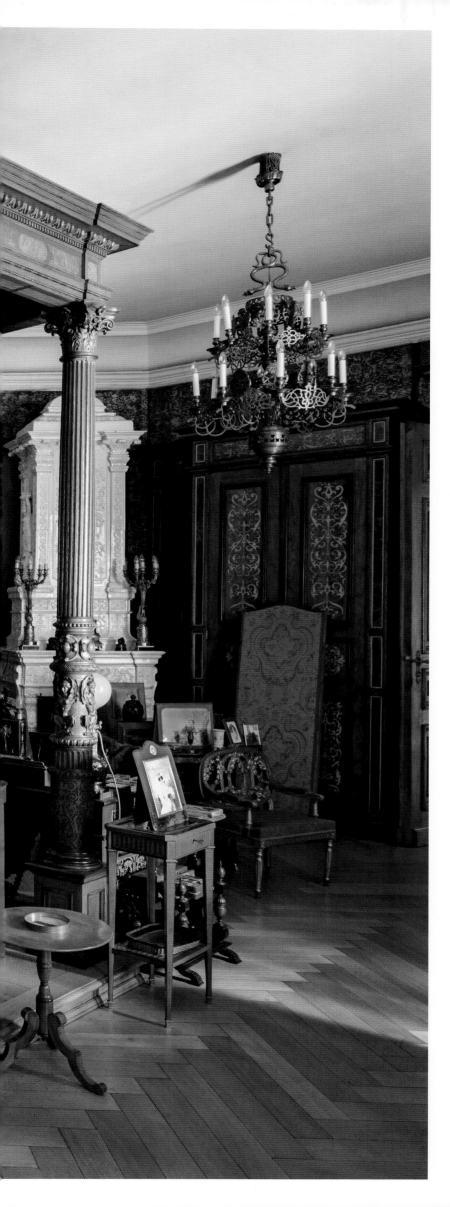

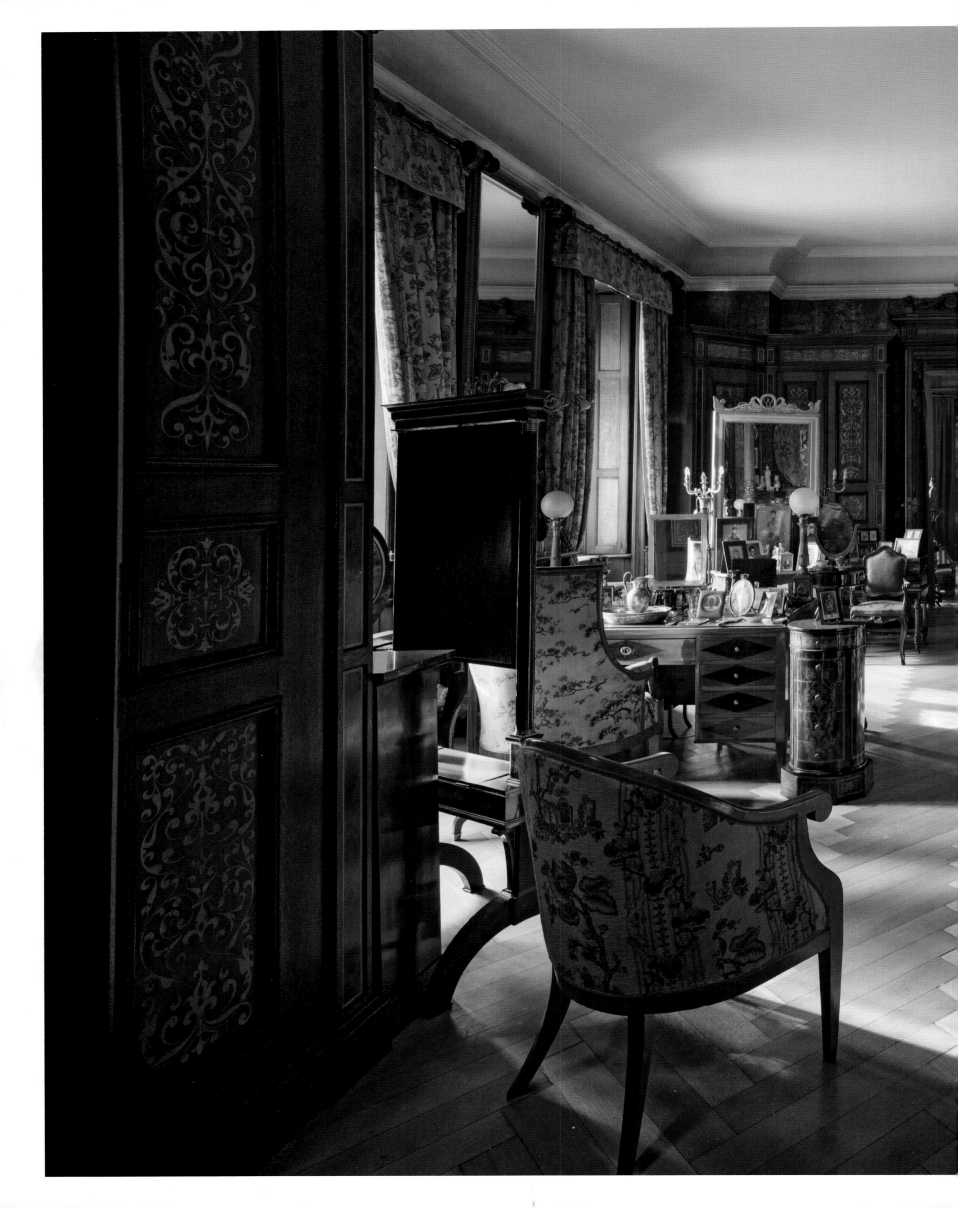

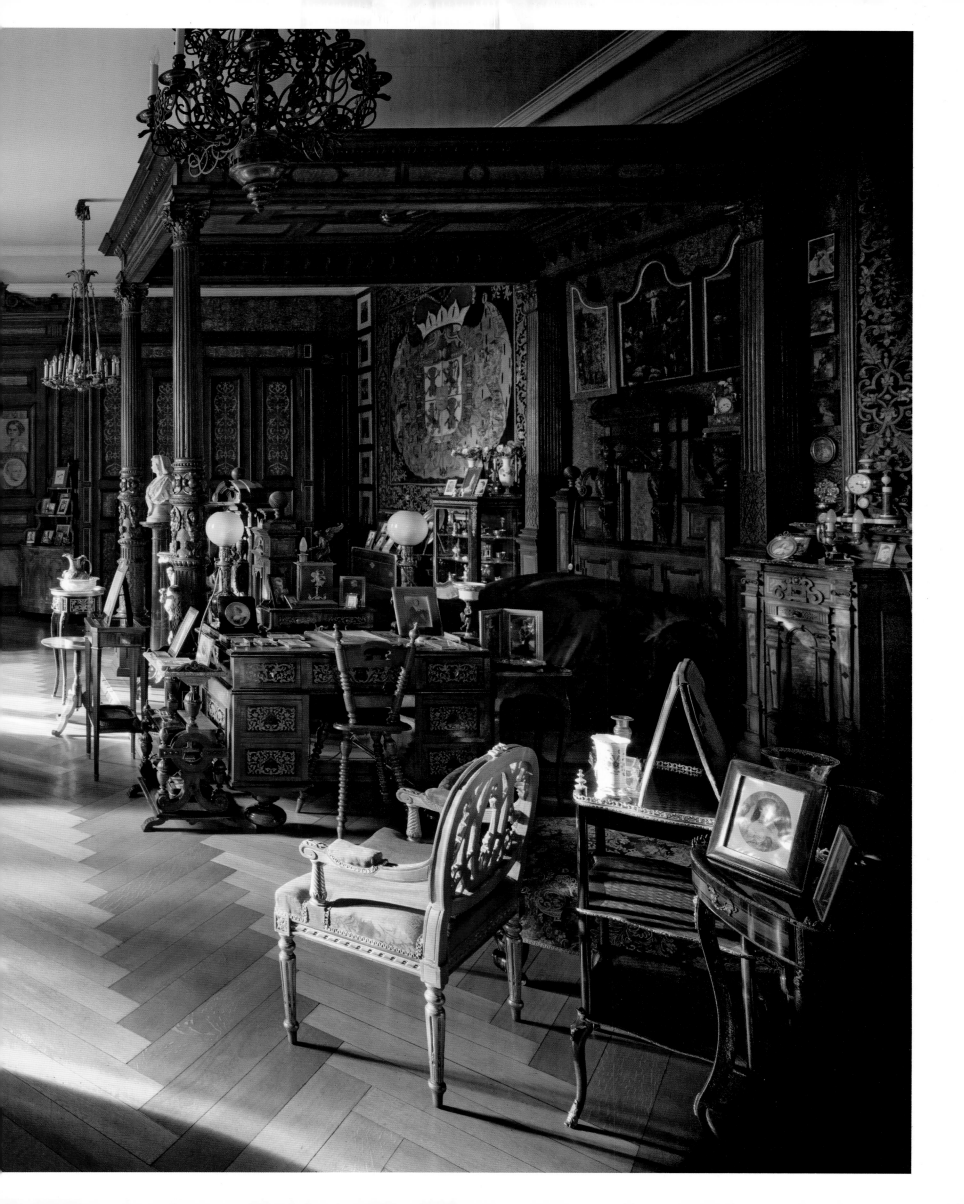

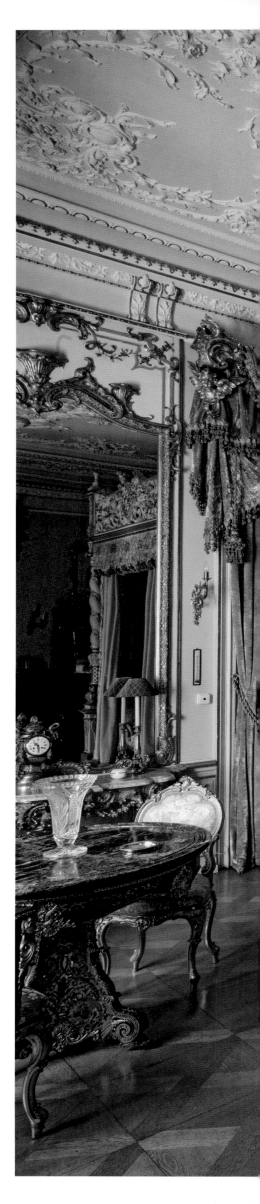

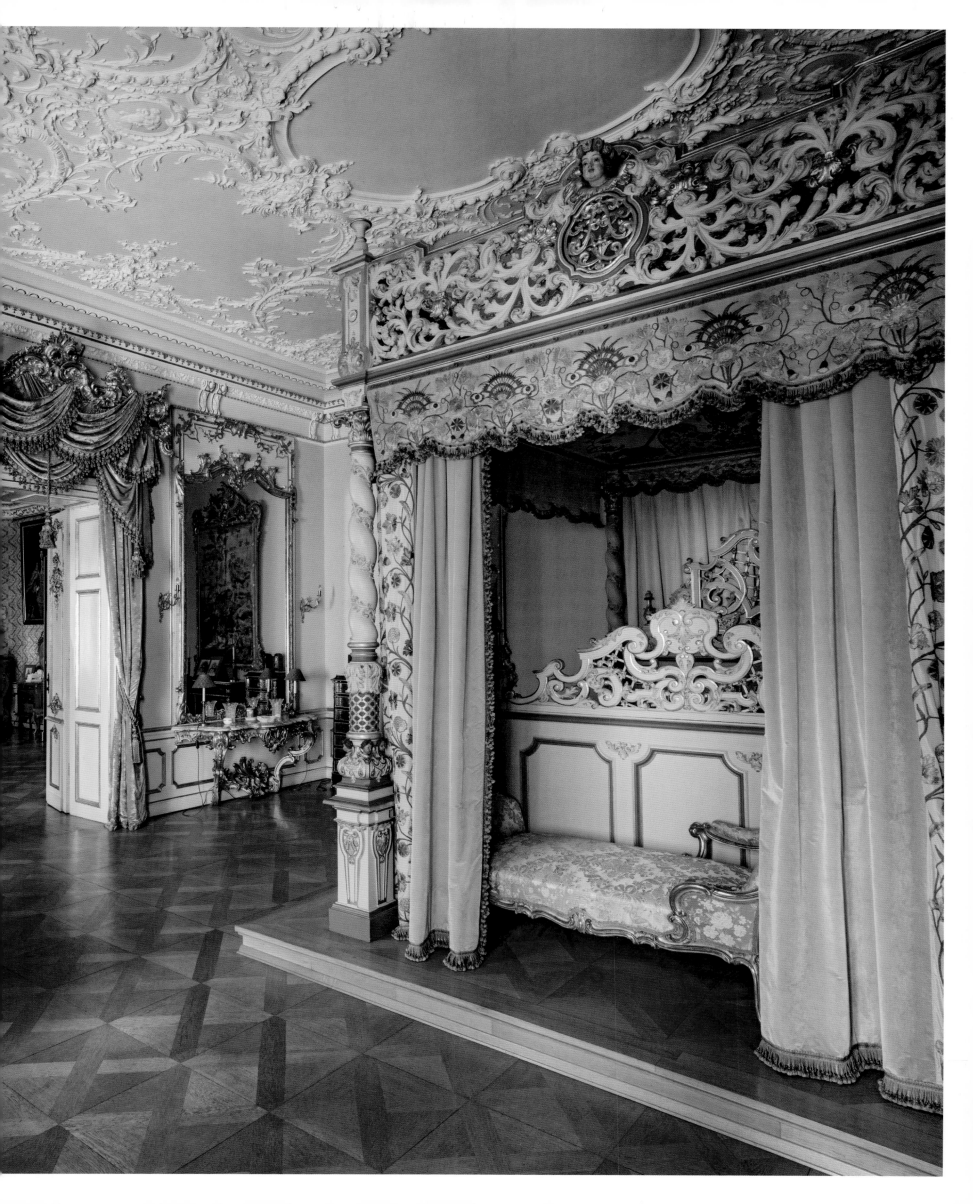

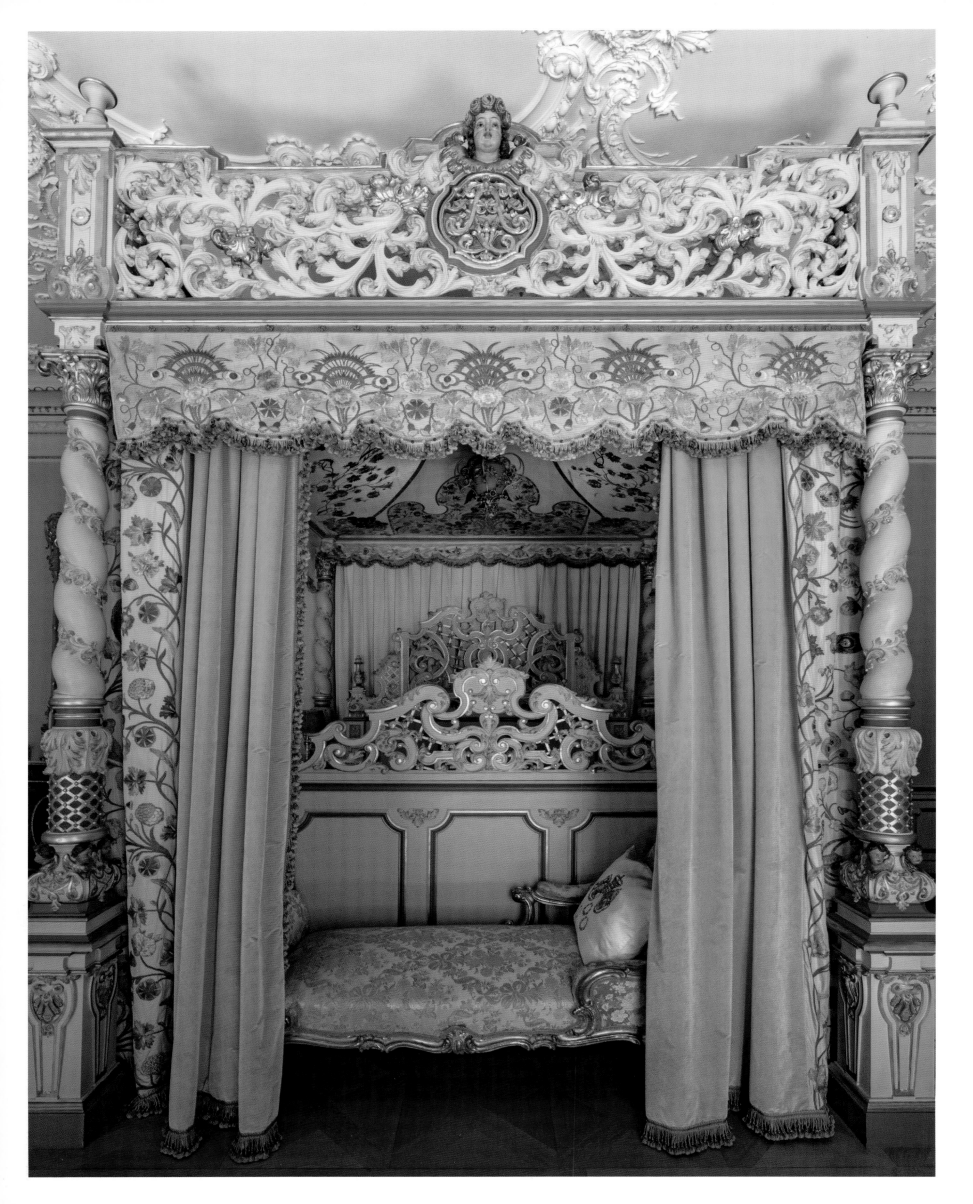

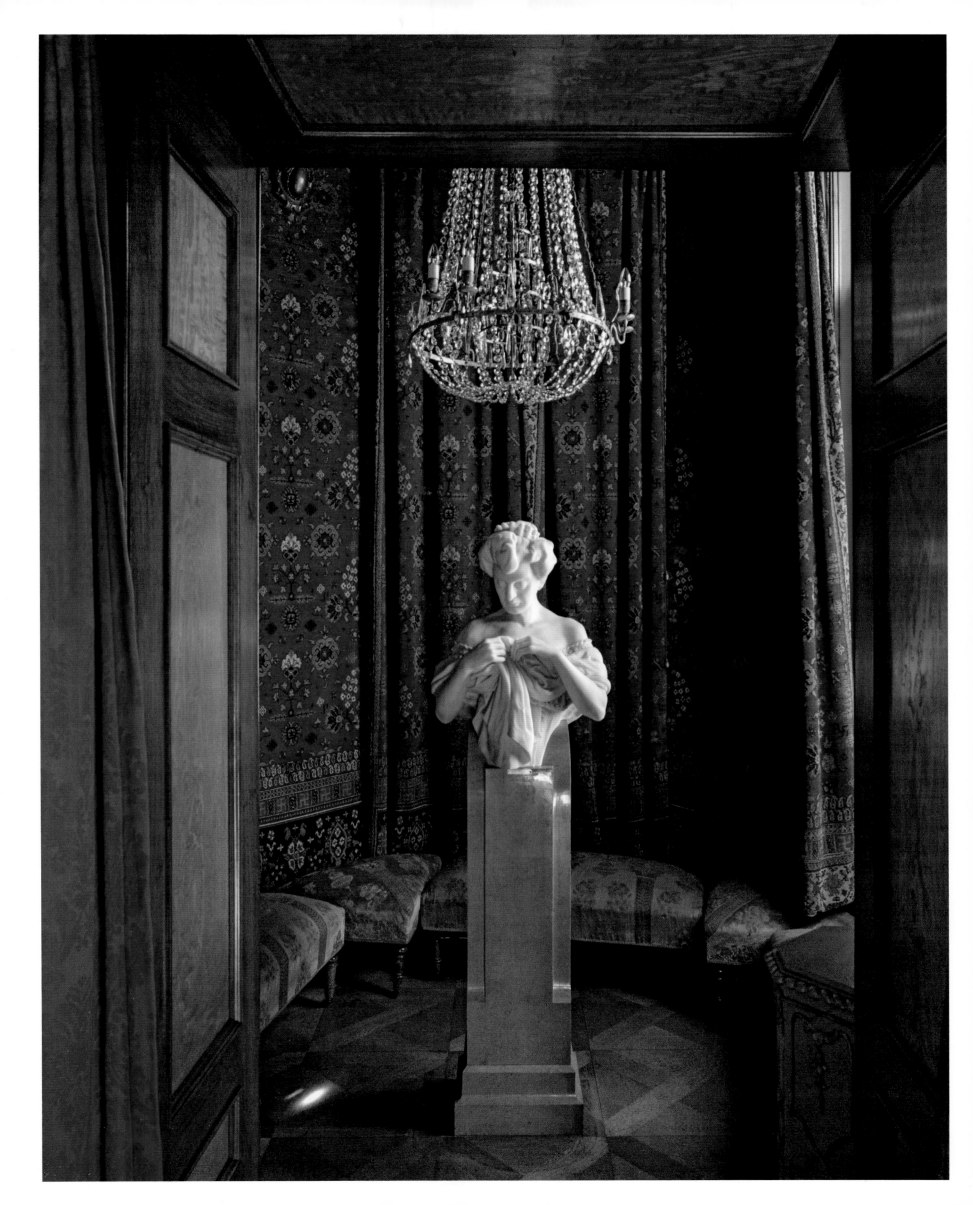

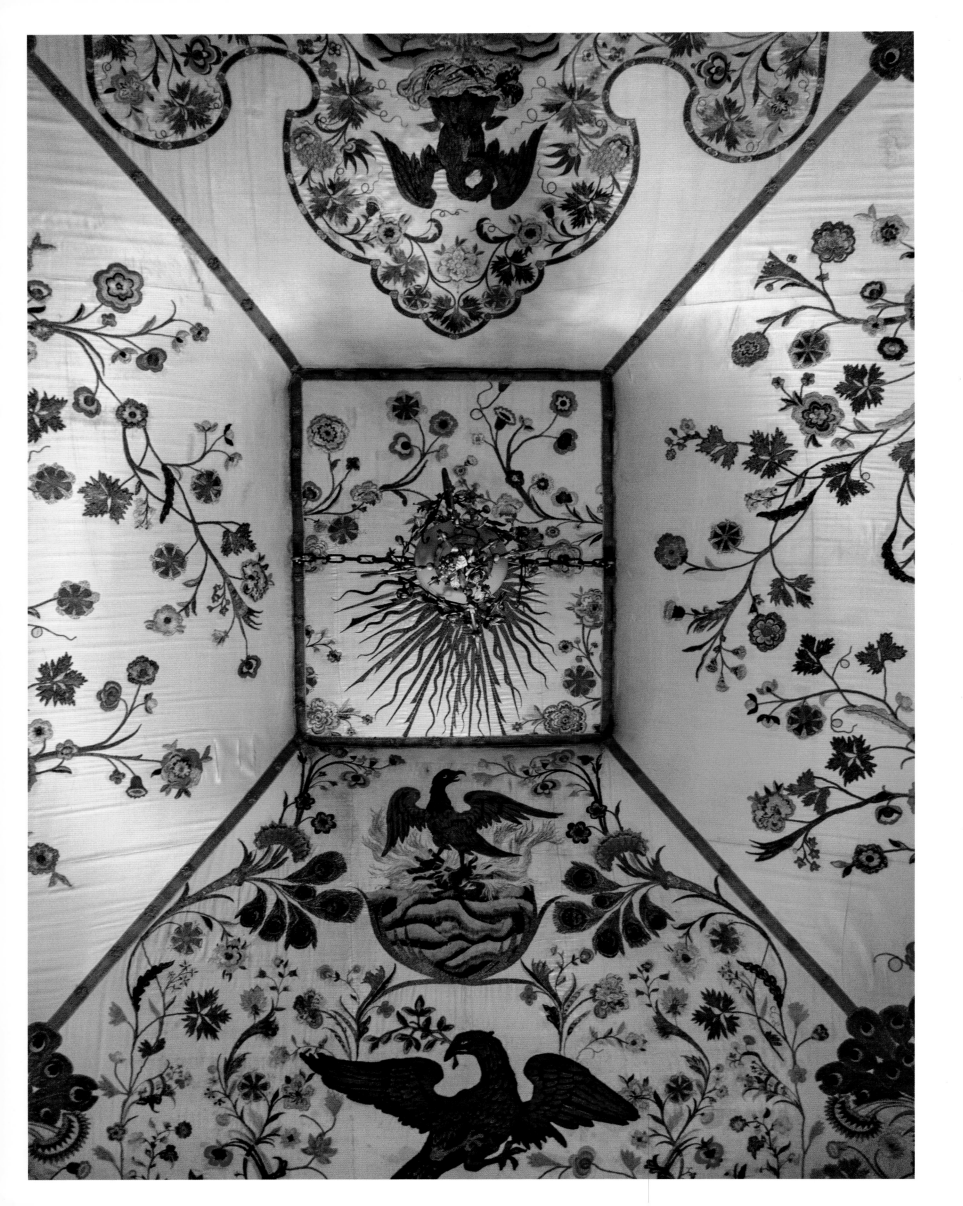

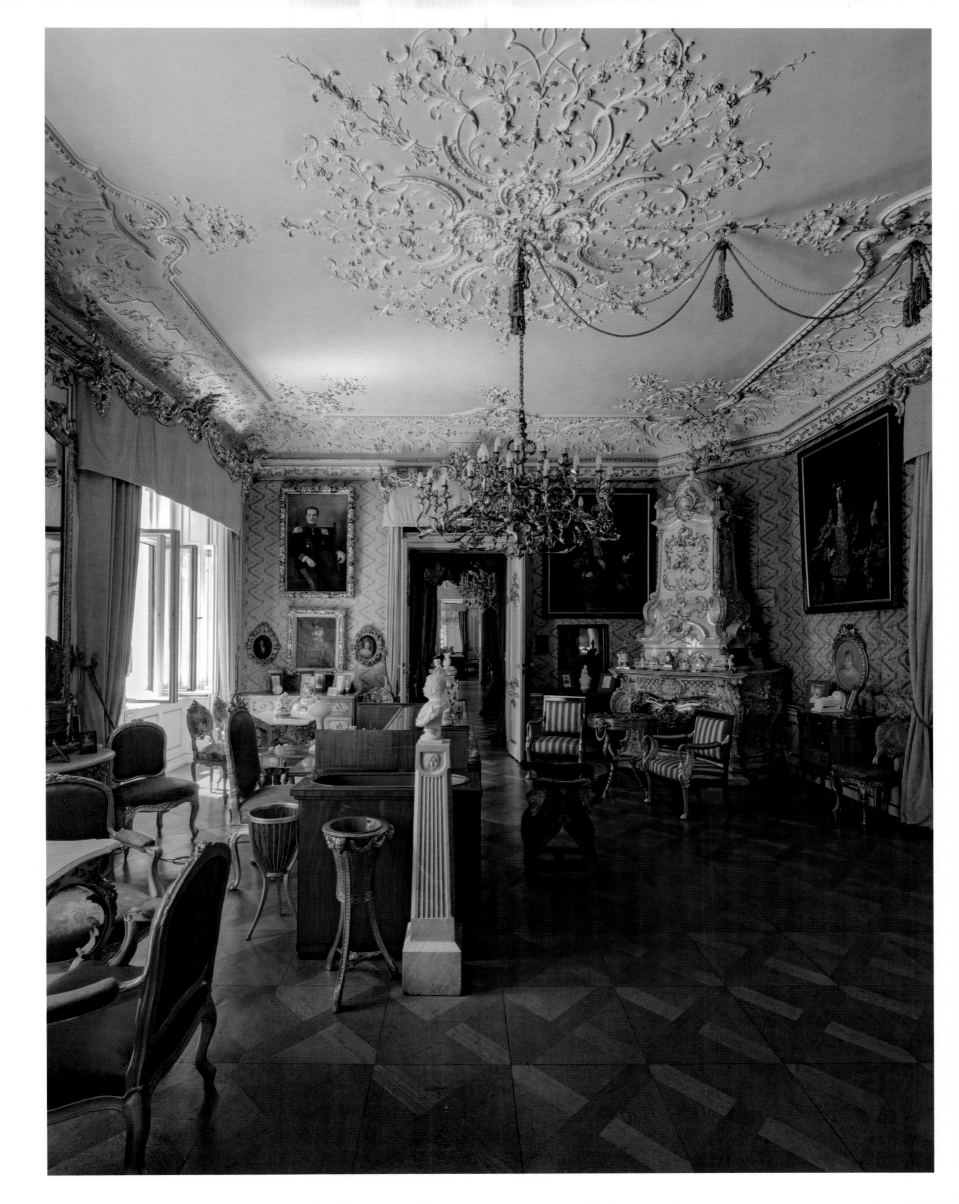

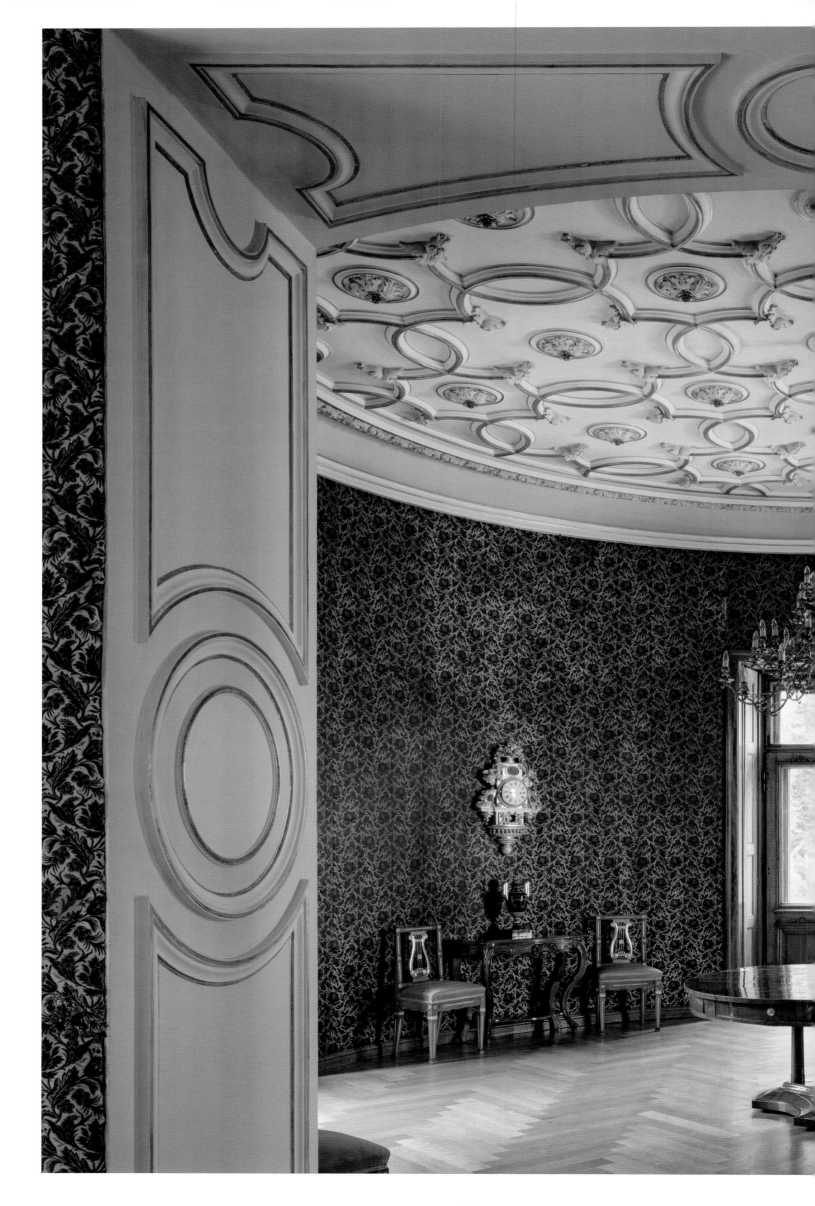

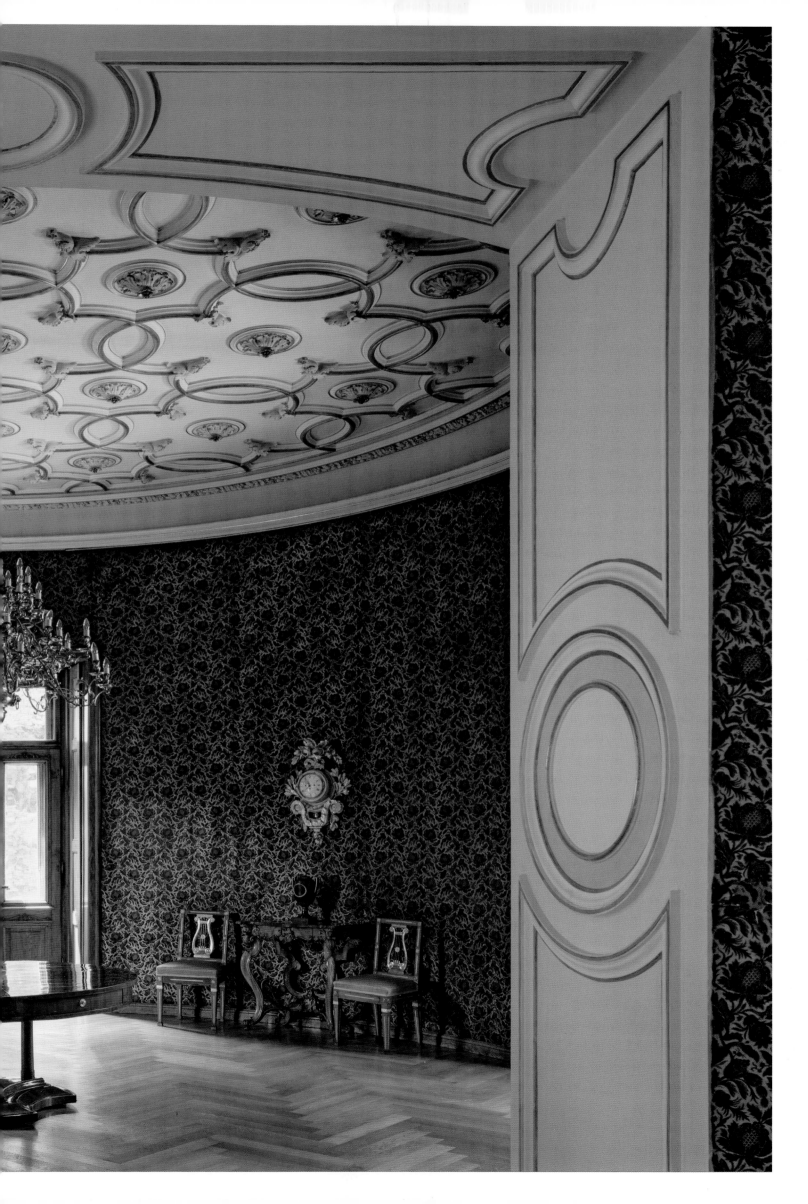

ST. EMMERAM PALACE IN REGENSBURG

A CONVERSATION BETWEEN PRINCESS MARIAE GLORIA THURN UND TAXIS AND SIR JOHN RICHARDSON

PRINCESS MARIAE GLORIA: What comes to your mind when you think of Regensburg?

SIR JOHN: *A palace, a fairy-tale palace, and not just another German schloss, as I had expected. A palace of infinite complexity and infinite variety, with layers of history— monastic and then secular, culminating in three centuries of Thurn und Taxis rule. Your princely family, which is quite unlike any other family in the world, is reflected in Regensburg. The Thurn und Taxis legacy is so disparate, it once touched most of Western Europe, and what's amazing is that, unlike other castles and palaces, St. Emmeram is still very much alive—all four wings of it. This is thanks, above all, to you, dear Gloria.*

My aim is to help people understand the history and to enjoy the splendor of the past and how Regensburg relates to some of the most shattering events in European history.

Yes, history haunts the place.

Don't forget that it all started in the eighth century, when Benedictine monks first came here to build a tomb for the holy abbot called Emmeram. They also built our beautiful cloister and the basilica. Even the monks' cells survive in the depths of the palace.

When did the Thurn und Taxis family actually acquire the property?

We never acquired the property. When King Maximilian I of Bavaria nationalized the postal service in 1806, the family lost the right to run it. At this time, he also secularized

all church properties and kicked out the monks. We were given the former abbey of St. Emmeram and the land that went with it as compensation for the loss of the postal service.

Hadn't the Thurn und Taxis always had their headquarters in Brussels? Or was it in Frankfurt?

Their first important headquarters was in the city of Mechelen in the Spanish Netherlands, which is now Belgium; and, of course, they also had a beautiful residence in Brussels. The church of Notre Dame du Sablon, located in the old part of Brussels, was built to be their family chapel.

After the War of the Spanish Succession in the early eighteenth century, France occupied the Spanish Netherlands and, therefore, the Thurn und Taxis, who were faithful servants of the German emperor, had to move their headquarters to Frankfurt. Their postal service spread throughout the Holy Roman Empire—that is, throughout a major part of Western Europe. The Thurn und Taxis had set up relay stations every fifteen kilometers, so letters could travel more rapidly than ever before. It became a family business in 1615 and, later, a hereditary right granted by the Habsburg emperor. Many of the "post" hotels you still see in Europe were originally relay stations.

Was the emperor satisfied with how the Thurn und Taxis ran the postal service? How did he show his gratitude? After all, the postal service was considered one of the wonders of Europe.

Oh yes! The emperor was very pleased, which is why he awarded the family princely titles in 1695.

Above: Archduke Joseph August of Austria (1872–1962), brother of Princess Margarete

What fascinates me is the extent to which the Thurn und Taxis family differed from other princely families. They were not landowners so much as businesspeople. But why did they ultimately move from Frankfurt to Regensburg?

Because the emperor ordered the prince to be his representative (*Prinzipalkommissar*) at the Perment Imperial Diet of Ratisbon in 1748. We still have the throne in the Throne Room, where diplomats paid tribute to him.

People unfamiliar with German history should bear in mind that "Ratisbon" is an antiquated English name for "Regensburg." Anyone unaware of this will not realize the enormous power that the emperor derived from the Diet and the enormous prestige that the Prince of Thurn und Taxis derived from being his representative.

Yes, it was an extremely prestigious and expensive appointment. It set the prince at the center of things, a position that gave him a critical advantage in terms of gathering information vital to the family's postal service.

Yes, it must have been very, very costly for the prince to hold court in Regensburg. As the emperor's representative, he presumably had to entertain representatives of other countries on a royal scale. That's why the family founded and financed the theater, right?

Exactly! But the theater was only one of numerous forms of entertainment, most of which were also open to the public. Since its heyday in the Middle Ages, Regensburg had become a sleepy little town. But the influence of this international society had a huge impact on its cultural and social life. The prince's court transformed Regensburg into a prosperous cultural and political center.

What happened to the Frankfurt palace? After all, it was built by Louis XIV's great architect, Robert de Cotte.

The family stripped the whole palace, including the stuccos and boiseries, prior to moving and then reestablished everything in Regensburg. Unfortunately, the beautiful T&T residence in Frankfurt was totally destroyed during World War II.

When the family arrived in Regensburg in 1748, their present palace was still a monastery. Where did they settle?

From 1748 to 1812 the princes lived and held court in two other Baroque buildings in Regensburg, which were completely redone and decorated for the family's private use as well as for the offices of the postal service. Some of the decoration has survived. The transformation of St. Emmeram from a monastery into a princely residence took almost a hundred years.

Isn't the courtly grandeur of the early eighteenth century still visible in one of the wings adjacent to the Carriage Museum?

Yes, but you have to remember that after my husband Johannes's death we faced colossal inheritance taxes. Some of our most valuable works of art had to be sacrificed to meet these demands. However, the Bavarian government is always ready to preserve its cultural heritage. The state promised to buy these treasures. As a result, we are now able to provide visitors with an array of magnificent silver, liturgical objects, historical jewels, and fabulous porcelain, handsomely displayed in our so-called Princely Treasure Chamber.

* * *

To my mind the greatest surprise at Regensburg is the architecture and magnificent interior design of the nineteenth-century wing. But, first, would you tell us about the romantic, beautiful princesses who haunt these spectacular rooms? Who else but Elisabeth, Empress of Austria, known as Sisi, and her sister, Helene, who inspired them. They star in portrait after portrait, in room after room. How they stand out from all the other stately images!

This is a romantic story and also a sad one.

What a fascinating woman and what a modern heroine—one might even say feminist—Sisi was! A free spirit who managed to escape the bondage of royal life, she roamed Europe in search of romance. She loved hunting and had a wild affair with George "Bay" Middleton, a famously dashing rider to hounds in Ireland. Her romance scandalized Victorian prudes—after all, she was the empress of Austria—but posterity sees her as a beloved icon. And how tragic her death was. She was stabbed by an anarchist. She was so tightly corseted that she was able to take several steps before collapsing.

Yes, but I don't think Sisi was the free spirit you have evoked. To my mind she was a lost soul, very capricious, always chasing one fantasy after another, none of which were fulfilled. I think she was running away from herself. The lost-soul aspect of Sisi's character was brilliantly captured by Romy Schneider in four wonderful films [1955, 1956, 1957, and 1972]. I've always said the government of Austria should have given a medal to Romy for portraying Sisi so sympathetically.

But, John, do you realize that Sisi's older sister, Helene, was originally the one chosen to marry Emperor Franz Joseph? But when he laid eyes on Sisi, he fell in love with her and changed his mind. Helene married Prince Maximilian of Thurn und Taxis instead. They were Johannes's great grandparents, and as you see, Helene turned out to be a woman of great taste.

One understands why her staterooms at Regensburg triumph over the bad taste of their time—over the mournful fussiness of so many of Queen Victoria's apartments, or the nouveau-riche vulgarity of Napoleon III's self-glorification, let alone Sisi's mad cousin and friend King Ludwig II of Bavaria, whose over-the-top theatricality and crazy, unfinished, Wagnerian follies date from the same time. If the spectacular rooms are still very much alive, it is because you and your great staff keep them in fantastic shape.

I was amazed to find that the vast suite of staterooms that Princess Helene inspired— rooms that are not open to the public—are ready to receive visitors. There are soap and bath salts in the gorgeously tiled bathrooms, and a telephone beside the massive columned state bed.

John, why don't you move into that room and sleep in the bed? It's all ready for you. The only trouble is that it's a very long way from the kitchen.

No, thank you, Gloria, I haven't brought the right garments. I'm afraid my wretched dressing gown would not be sufficiently grand. Earlier today I was prowling around the staterooms and took the liberty of opening one of Prince Albert I's wardrobes. I was not surprised to find it full of impeccably packed clothes, including a row of beautiful pre-1914 army overcoats. I also found, in the back of the wardrobe, a fantastic leopard-skin coat, which I immediately put on—and then I had myself photographed in it!

That shows you how men dressed in those days—much more strikingly and fancifully than today.

Tell us more about Helene in Bayern.

Like me, she had to run the Thurn und Taxis office until her underage son, Prince Albert I, could take over. It was the difficult time after the postal service had been nationalized, when the family had to transition to being owners of land and forestry properties. Sisi's splendor as empress of Austria may have motivated Helene to make Regensburg Palace as grand as her sister's palaces. This might explain why Helene, now that she had married a fabulously rich prince, could say to herself, "Well, I didn't get the emperor, but I am much freer and have ended up

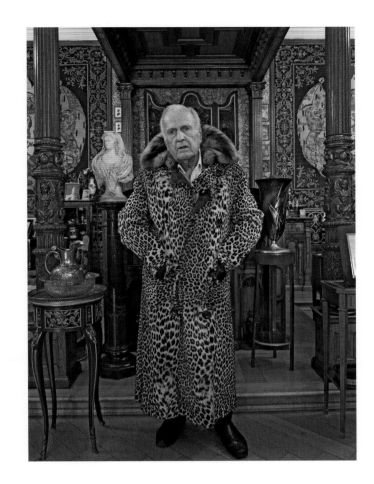

with just as much as Sisi." Yes, indeed, there was an element of sibling rivalry.

Princess Helene certainly knew her stuff, and she had one important advantage: She knew how to draw on the Bavarian genius for wood carving and the inherent talent for creating some of the most spectacular interiors in your palace. No gaudiness, no vulgarity, no boring pomposity. Another important point was that the Bavarian artisans managed to escape the imprint of the Industrial Revolution, which had left a mechanical touch on late nineteenth-century decoration. Thank God there was no central heating; otherwise we would not have the spectacular porcelain stoves that play a key role in room after room. Princess Helene's lighthearted Bavarian neo-Rococo taste can be seen at its most elegant in a spiraling staircase that twirls upward to the floors above. It is very touching how the grandeur gives way to a small, white attic room, where she could escape the formality of life below. This is an astonishingly daring treatment of a relatively small space.

This great staircase is the subject of one of Todd Eberle's most dramatic photographs.

What happened after Helene passed away in 1890? How did Prince Albert, Helene's son, cope with World War I?

After the death of his mother, Albert and his wife, Margarete [Archduchess of Austria], had to face a rather difficult and different life. World War I spread misery all over the country. Both the prince and the princess dedicated their lives to helping the poor as well as the wounded soldiers, whom they put up either in their own princely houses or on their property. More and more wounded soldiers reached Regensburg, but there was no more space to house them. So Albert constructed a hospital for surgery, and he kept soldiers there until they had fully recovered. Margarete, who was a trained nurse, worked in the operating room every day for free. Apart from her vast charity work, she was an acclaimed painter and sculptress, and also a great horsewoman. Her portrait busts and religious sculptures can be seen in her fascinating, art-filled studio, and scattered throughout the palace.

So it was Prince Albert who founded the famous soup kitchen?

Yes, in 1923 he opened the kitchen, which served a hot meal to the poor every day. Today we still provide around three hundred hot meals a day to the economically disadvantaged.

* * *

To change the subject, let's discuss what happened during World War II. Gloria, remind me how the Nazis, who hated most of the princely families, treated the Thurn und Taxis? Wasn't your father-in-law, Prince Karl August, arrested by the Nazis?

The Nazis forced Prince Gabriel, the eldest son of Prince Franz Joseph, into the army and immediately packed him off to Stalingrad—a death sentence. Johannes's father, Prince Karl August, was next in line, you see, and he was fearless in terms of his hatred of the Nazis. Eventually, one of his foresters betrayed him by calling the Gestapo and accusing him of speaking out against the Nazi government—and, worse, listening to the BBC. So the poor man was arrested despite the intervention of [António de Oliveira] Salazar . . .

Salazar, the Portuguese dictator?

Yes, you see, both Johannes's father and uncle had married daughters of the King of Portugal. This enabled the Thurn und Taxis to invoke Salazar's help. Alas, Salazar was unable to prevent Karl August from being incarcerated in a Nazi jail. He was not freed until the end of the war.

When did he die?

In 1982. He was an extraordinary man, very reactionary and averse to keeping up with modern times. In his later years, his life revolved around his passion for his parrots and one blackbird—what you would call a crow. They all squawked and screeched. If you wanted to have a conversation with him in his drawing room, you had to scream, not only to drown out the birds but also to get through to make yourself heard. The old prince was very deaf.

Speaking of family, John, let's talk about my husband, Johannes. I know you must have many vivid memories of him. Remember, he took me on as a young girl from a noble family in Saxony who had been driven from their castle by the Russians. I am the person I am today thanks to his strong character, his phenomenal personality, and his outrageous wit.

Johannes was one of the most fascinating and complex people I have ever met. He lived life to the extreme in so many different ways. People are apt to remember him for only one aspect of his multifaceted character—his genius for devising elaborate practical jokes, scenarios that would generate laughter as well as dismay. Innate naughtiness was to blame, but then too he took after his father, who was known for his reactionary stance and his contempt for twentieth-century vulgarity, ostentation, and lack of respect for the noble traditions of the past.

Despite his penchant for outrageous pranks, Johannes shared his father's respect for good manners. One had to know Johannes well to perceive his intellect and his goodness, which were buried deep inside him. He told me once that his father, Karl August, had told him, "If ever you see a Jew, anyone with a yellow star on his chest, I want you to cross the road, shake him by the hand, and introduce yourself to him." Johannes made a point of doing that.

For all Johannes's eccentricities and extravagances, he was, at heart, a surreal

mixture of the royalist privilege of the past and the crazy, modernist, somewhat Andy Warhol–ish Pop lifestyle of the present. These very different tendencies were united in him and formed his character.

In a curious way, Johannes reflects the layers of this vast house. He was, on the one hand, an ultraconservative Catholic but, on the other, hugely open to modern ideas and ways of life.

How did you meet Johannes?

In the summer of 1979 I was at a café in Munich with two friends; we were about to go to a concert by Supertramp. Before we left, Johannes walked in, came over, and joined us. After talking for a bit he said, "Let your friends go and I'll take you to dinner." We got on like a house on fire. Soon we were inseparable.

After two or three weeks, he took me to Regensburg. I didn't know much about his background or his home, but I was curious. After all, he was a fun guy to be with. God knows, the palace turned out to be rather intimidating; however, when I met my future father-in-law, we got on very well and he approved of me. Princess Maria Anna, Johannes's mother, had died in 1971. In due course, Johannes took me to Mexico, Brazil, and Saint Moritz, where he proposed in February 1980. We got married in Regensburg and made our way to the basilica in the family's state carriage, which is the central exhibit in the palace's magnificent Carriage Museum.

* * *

Tell me about your own wonderful rooms in the palace. They are so original—such a contrast to the rest of the palace. They are contemporary but also lavishly decorated— almost as colorfully as some of the staterooms. Like the staterooms, they are hung with portraits, but your portraits are by Warhol, Balkenhol, and Schnabel. Likewise, your way-out Catholic imagery, which is all the more striking in light of the magnificent Catholic artifacts elsewhere in the palace. I love the evidence of your intense faith, which fills your bedroom.

My own apartment was decorated in 1990 by the interior designer Gabhan O'Keeffe.

When Sao Schlumberger first saw my apartment, she immediately hired Gabhan
to decorate her famous Paris apartment.

*Yes, but you have also enlivened some of the staterooms with contemporary masterpieces.
I was astonished when you suddenly switched on Bill Viola's dazzling video installation.
A huge waterfall that becomes a conflagration turns a great circular hall into a mind-
blowing experience. And the video portraits of each of you . . . at first, I didn't recognize
that the faces move and that these portraits are actually videos. Formality is exorcised.*

Yes, I want my collection to animate the grandiose past. As you say, it [the past] lives,
and I want it to go on living at Regensburg. That is why I invited Todd Eberle to take all
of these photographs. He is above all a marvelous architectural photographer. I wanted
to find someone who would lose himself in this amazing palace, and one of Todd's great
qualities is his curiosity. I gave him keys to every part of the building so that he could
wander off and take these gorgeous pictures.

*You couldn't have found anyone better. Todd's photographs remind me of Braque and
Picasso in their unapologetic one-point perspective. For me it was a great experience,
accompanying him as he worked at Regensburg and seeing so many of his discoveries
through his exceedingly perceptive eyes.*

* * *

My principal responsibility has been to supervise the organization of the palace, not least
the summer music festival and the Christmas market, which runs for four weeks in the
center court and garden of the palace. I'm the one who started these cultural ventures.
If we have three hundred thousand visitors a year, it is mainly because I promote the
events myself. Whenever there is a chance to go on TV or to give an interview, I will talk
about our castle, what happens next, and my life here. As a result, I've sort of become a
public figure. This has helped enormously to bring lots of tourists to Regensburg, and it
continues to attract so many people.

It must be a huge effort to sustain the cultural heritage, no?

Well, yes, it is the honorable duty that I have inherited from Johannes's ancestors, and

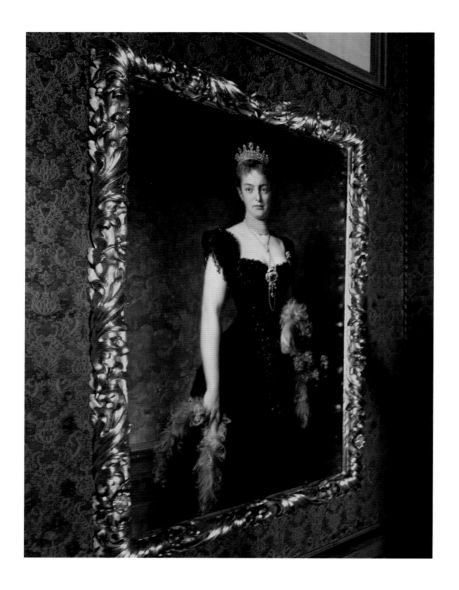

it is the duty that I am handing over to my son. Albert II is particularly interested in promoting scientific research in order to bring to light and make available the vast quantities of valuable documents within the historical archives and library. He sponsors master's and doctoral study programs on different historical subjects that touch upon the Thurn und Taxis legacy. This opportunity is very attractive to a lot of students in Germany.

Wasn't the library, founded in the eighteenth century, also a donation to the public?

Yes, in 1787 it was one of the first libraries of its kind, open to the public, as it still is today. The main room has frescoes by the famous painter Cosmas Damian Asam and houses a magnificent collection of rare books and historical manuscripts. The library is fully staffed and our librarians preside not only over the family and postal archives but also over an important collection of musical manuscripts and one of the largest pre-philatelic and T&T stamp collections in the world.

Your greatest achievement is to have saved the fortune after Johannes's death. If not for you, who knows what might have been its fate.

Well, that's true, no doubt. Thurn und Taxis was reanimated by me. When I took over, everything was on the brink of being lost, thanks to lousy management. Poor Johannes was unaware, but luckily I was able to manage the turnaround.

Above: Princess Margarete Thurn und Taxis (1870–1955)

How courageous you were to climb down from your gilded cloud to salvage Johannes's rickety financial empire. You abandoned your electric guitar for a computer and took to studying business, corporate law, and estate management. I remember you proudly telling me that you had made the family's undertakings work again. Little by little everything has come back to life. On top of everything else, you had three children to raise. How did you manage, having to wear so many hats?

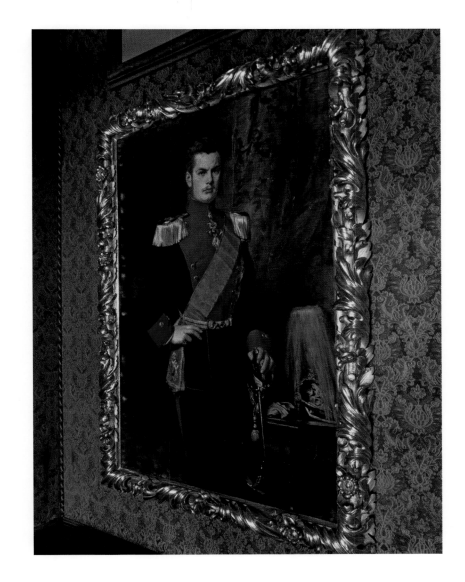

Well, I sort of used my "housewife brain." I tried to keep things simple, to cut costs, and to sell businesses that were losing money. It was pretty straightforward. Also, my children gave me strength and comfort during that time, as did, of course, my faith in the Catholic Church.

True, but, dear Gloria, I have difficulty seeing you as a housewife.

Why? The house is big, but I still see myself mainly as a housewife. Also, I had great role models in the Thurn und Taxis family. After all, I'm the fourth Thurn und Taxis widow who has had to take over and manage the house through difficult times. It is great fun, a pleasure, and an honor, but it's also a hell of a lot of hard work.

* * *

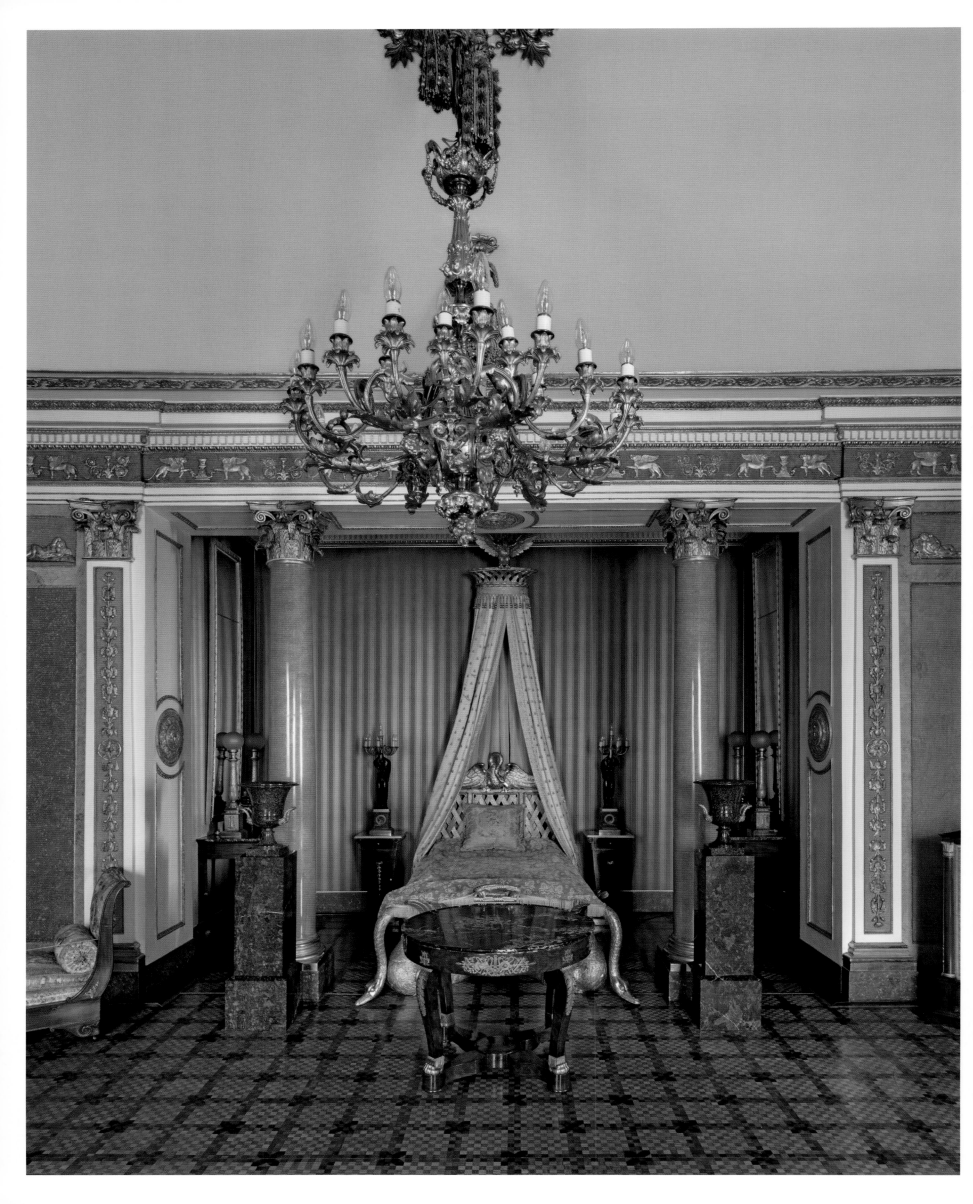

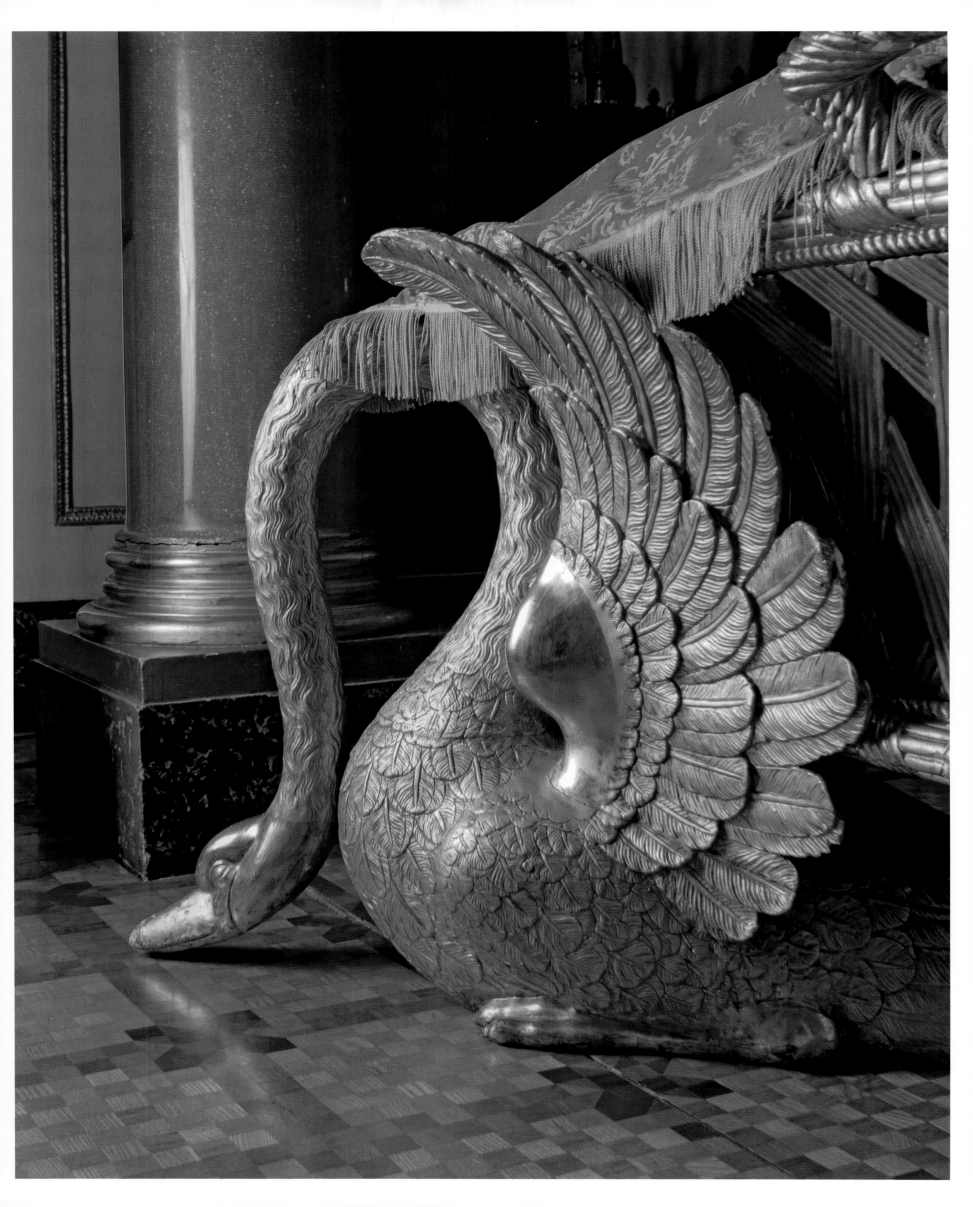

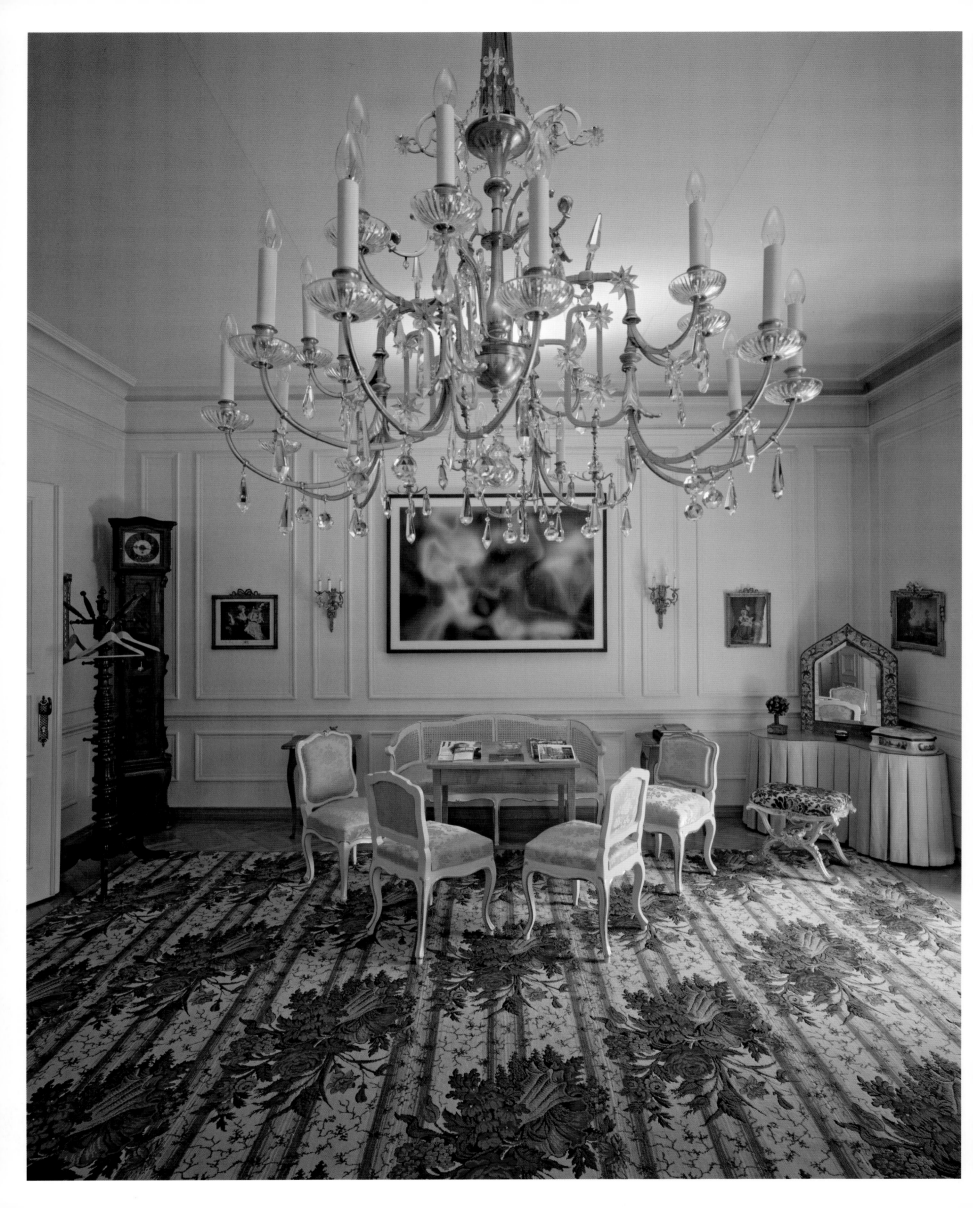

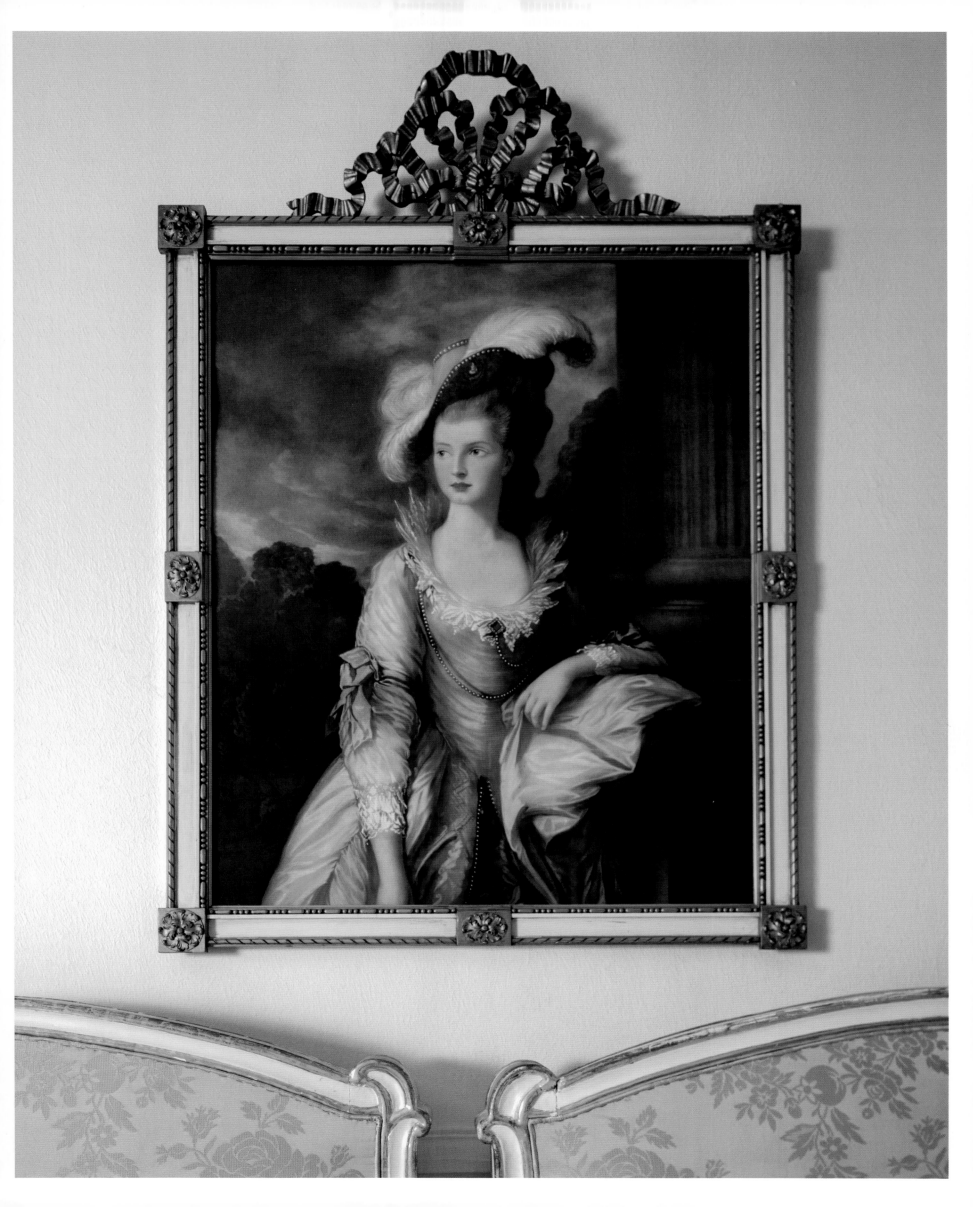

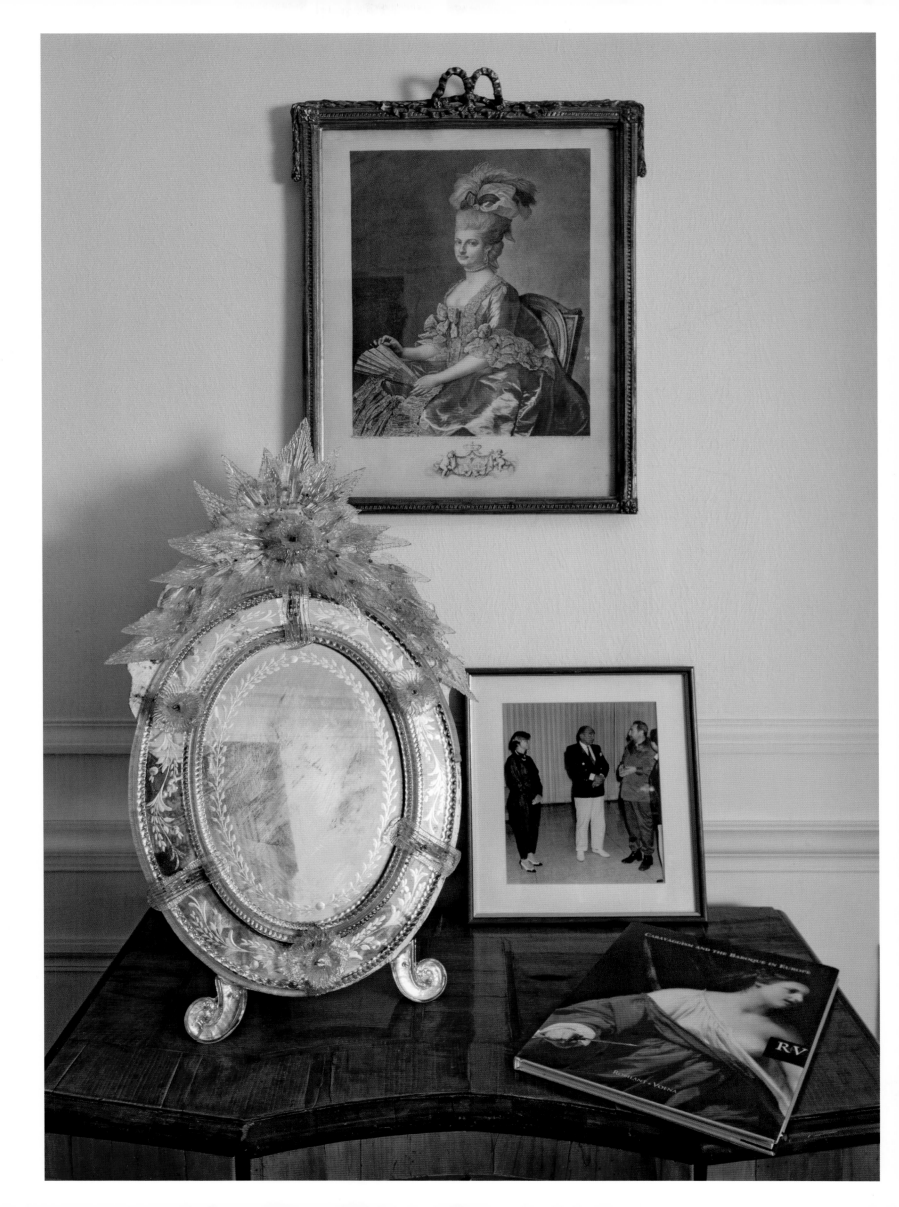

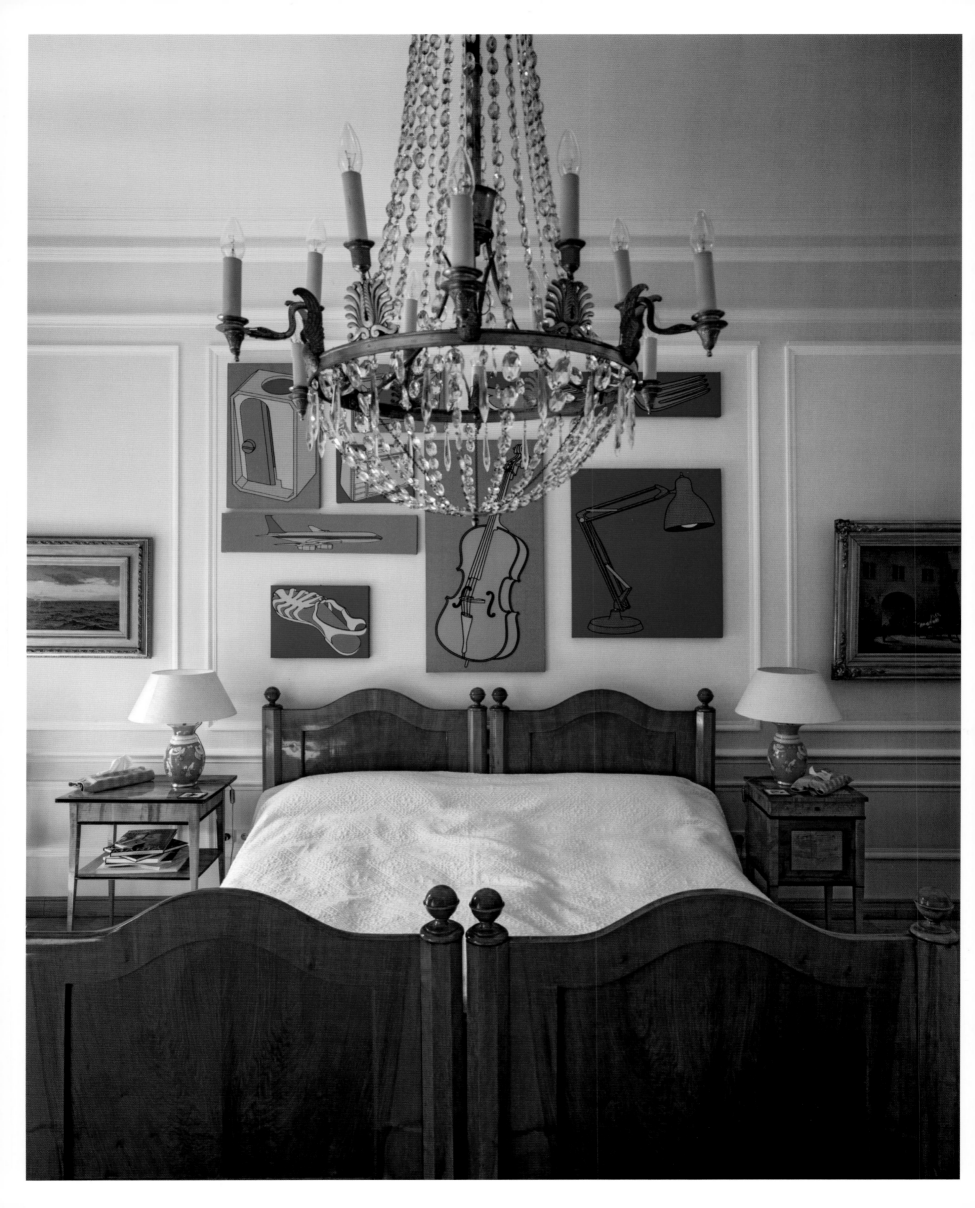

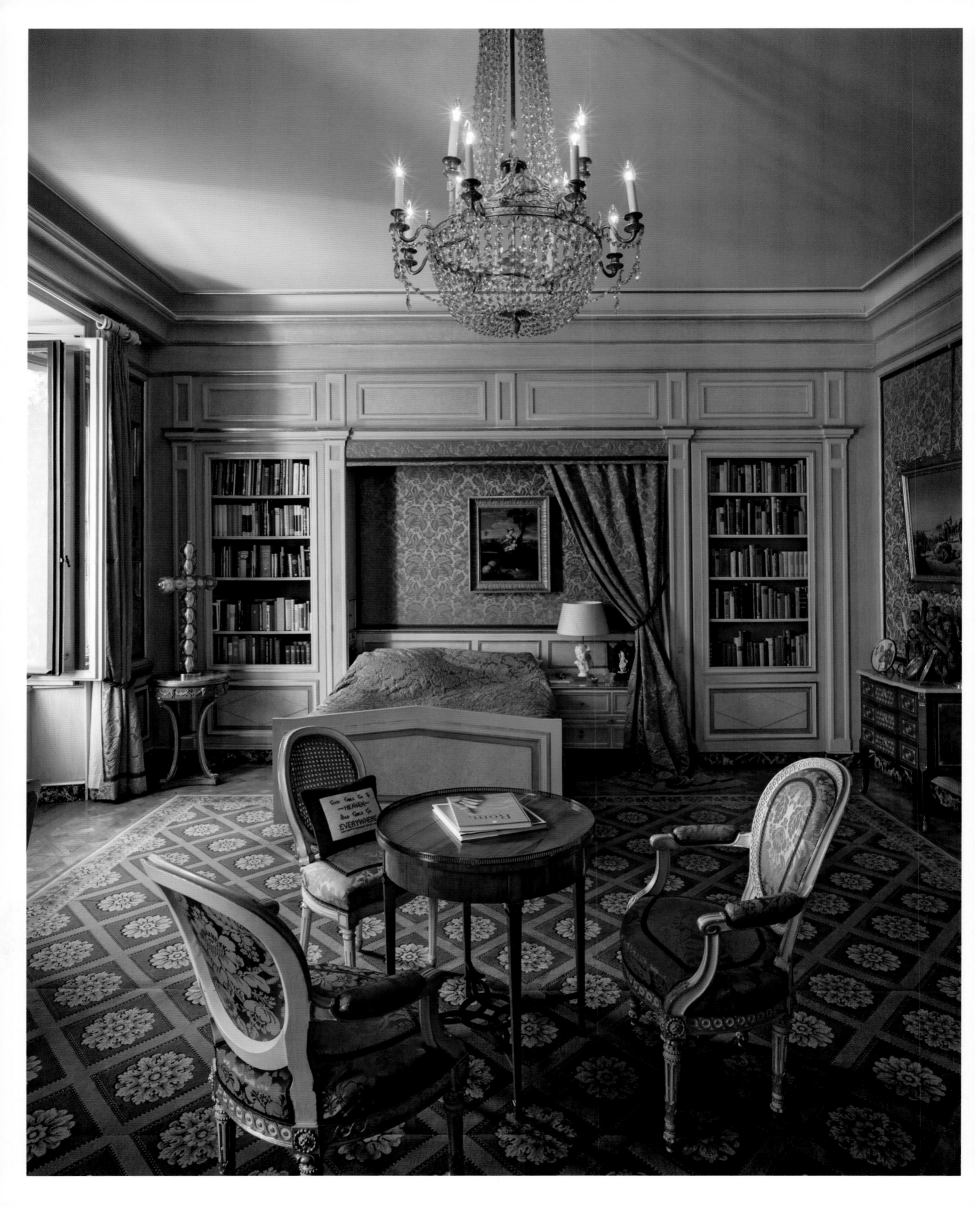

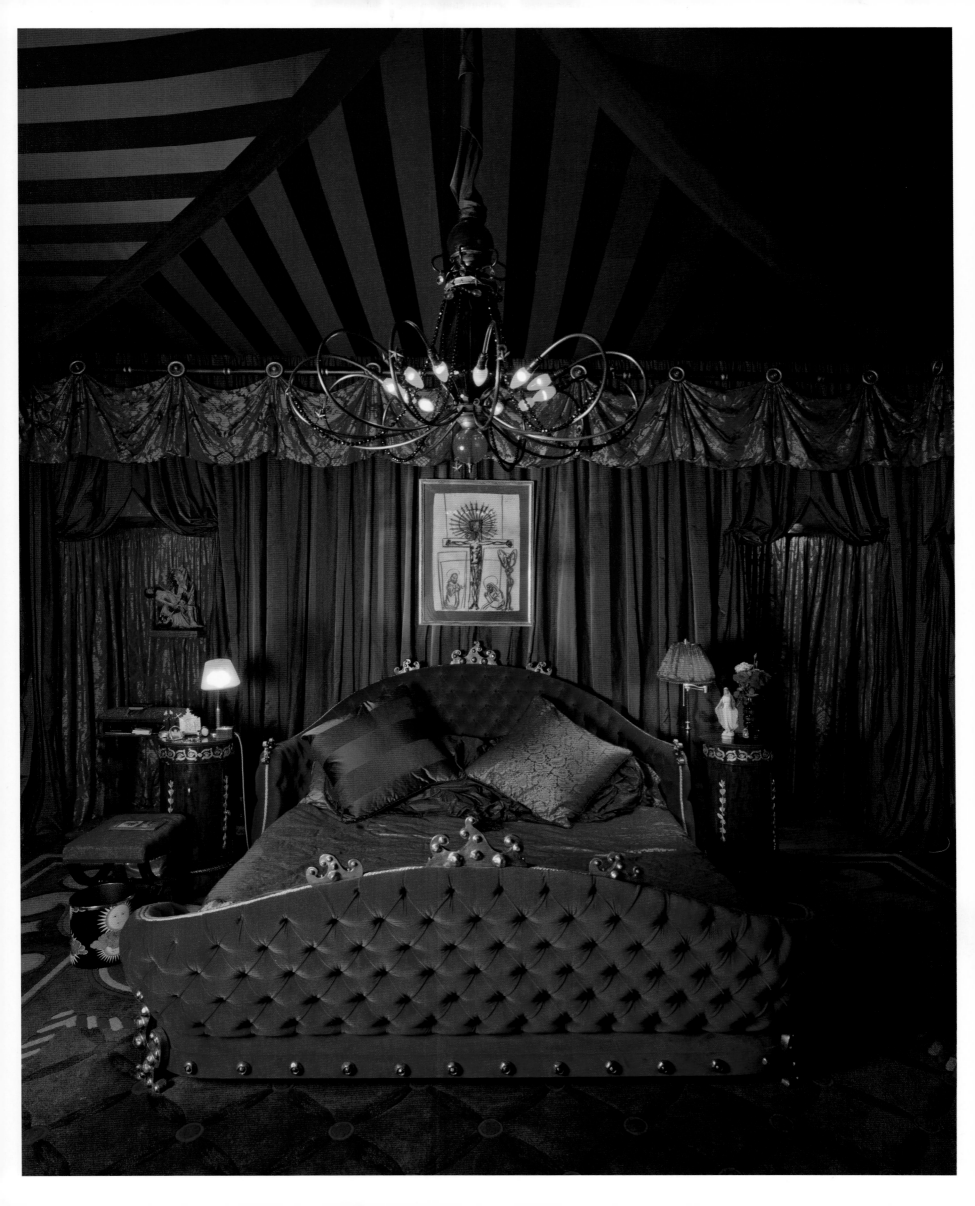

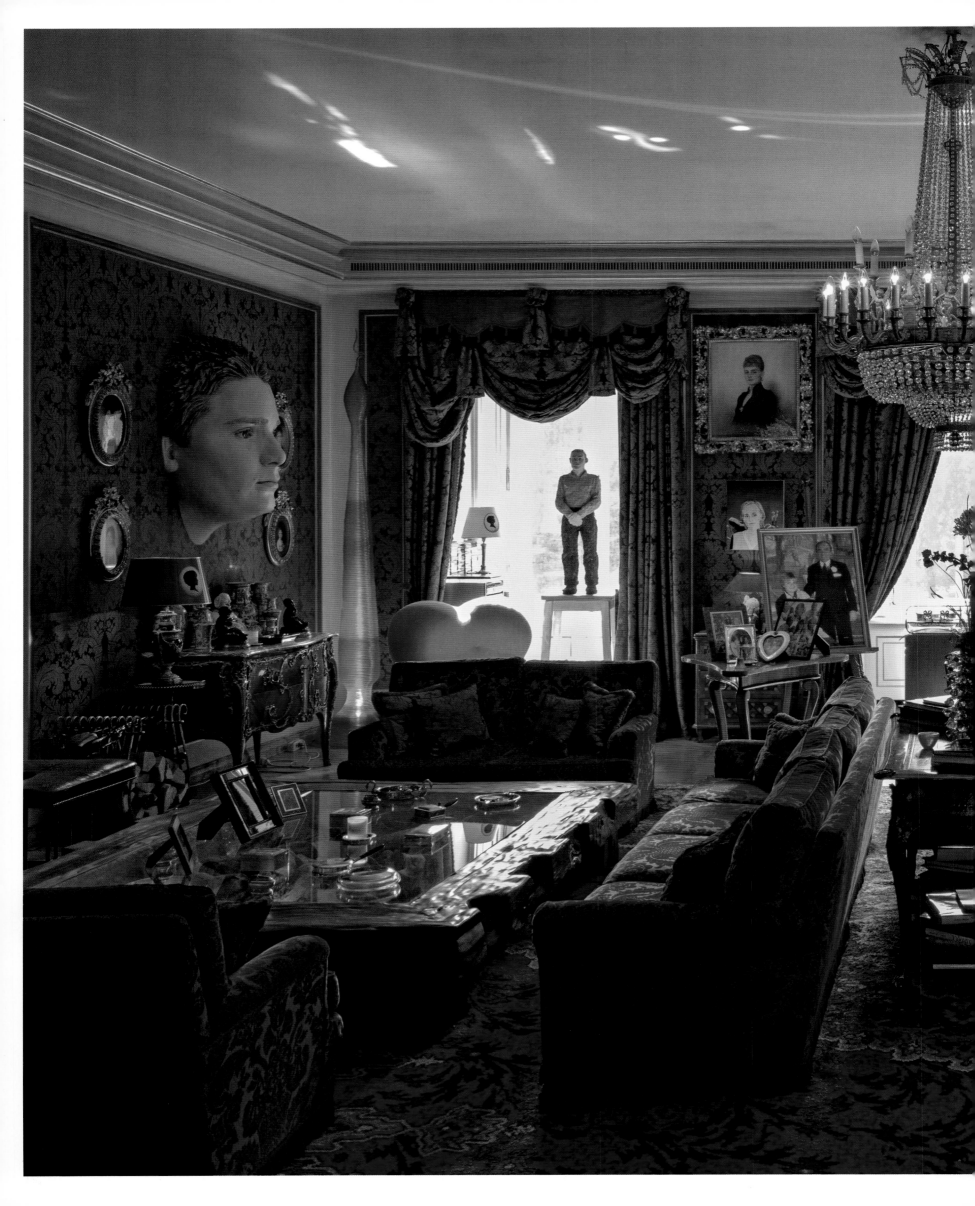

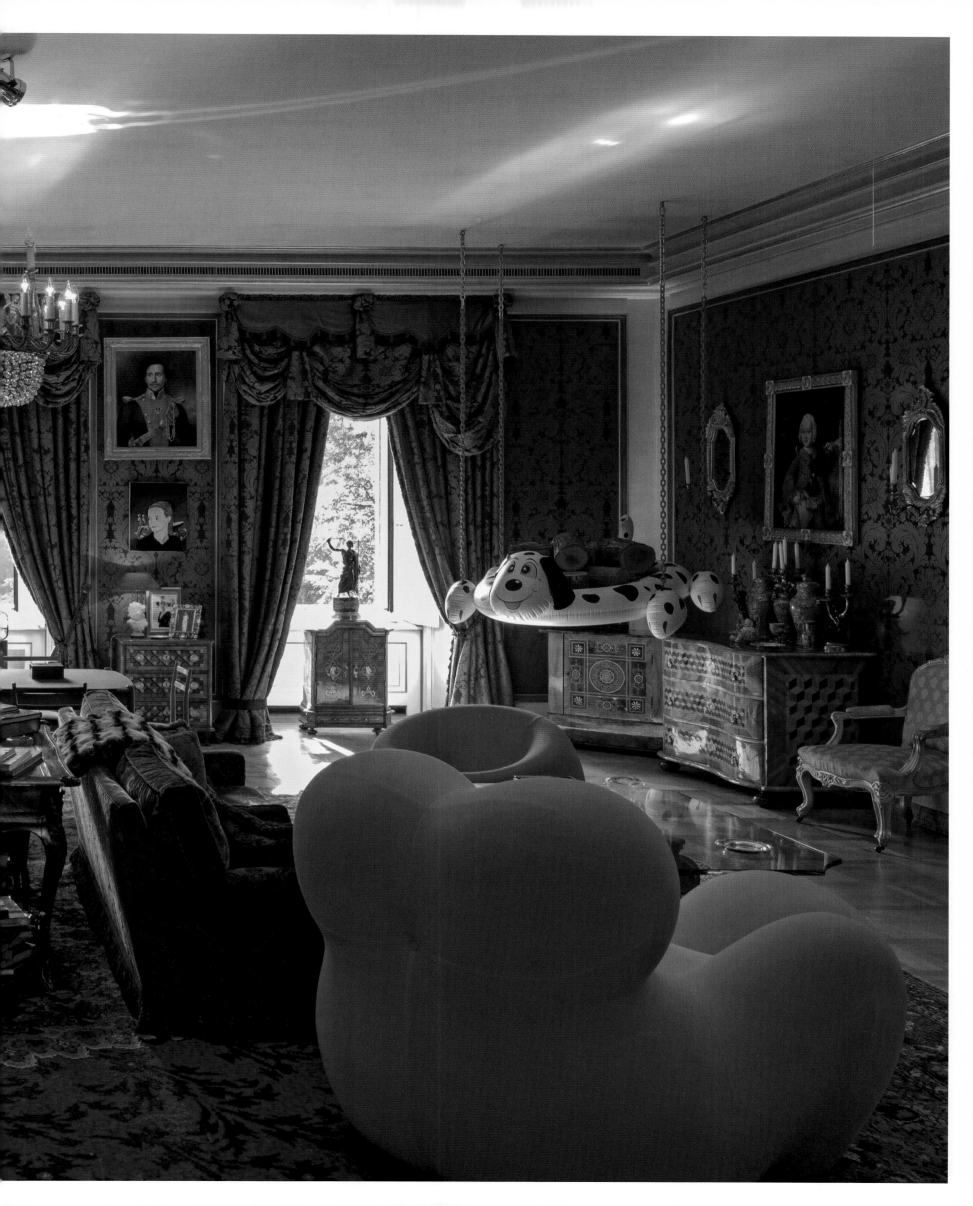

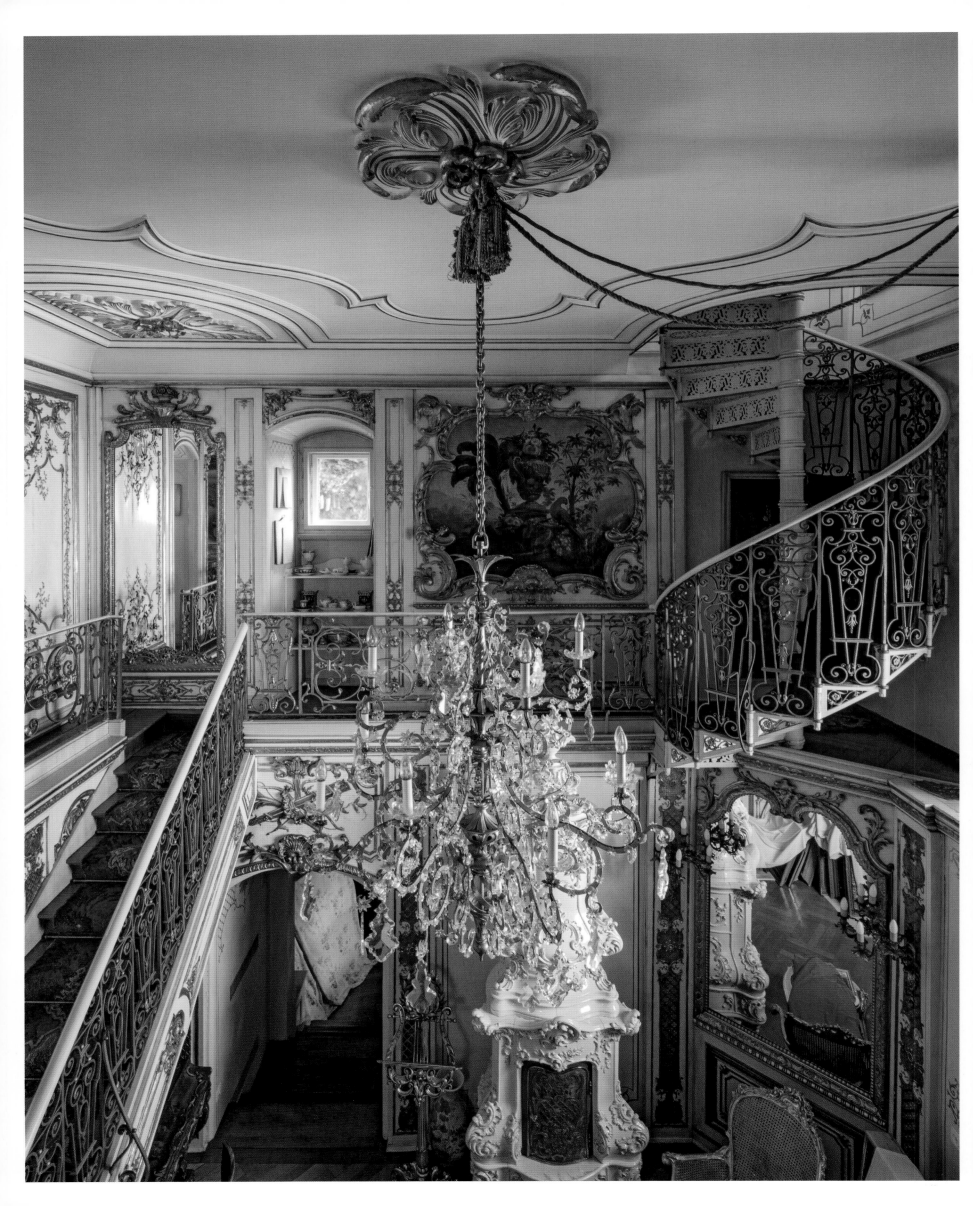

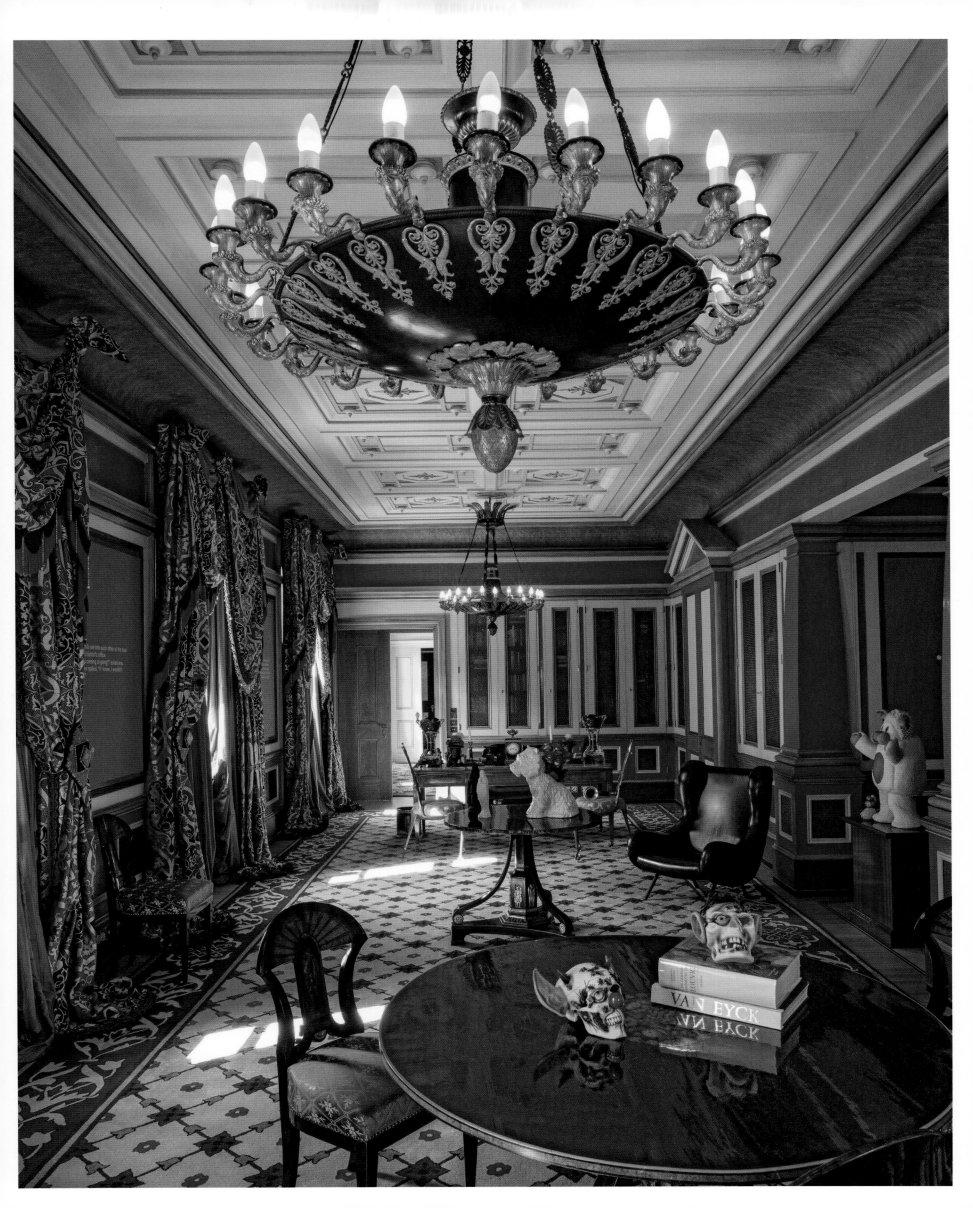

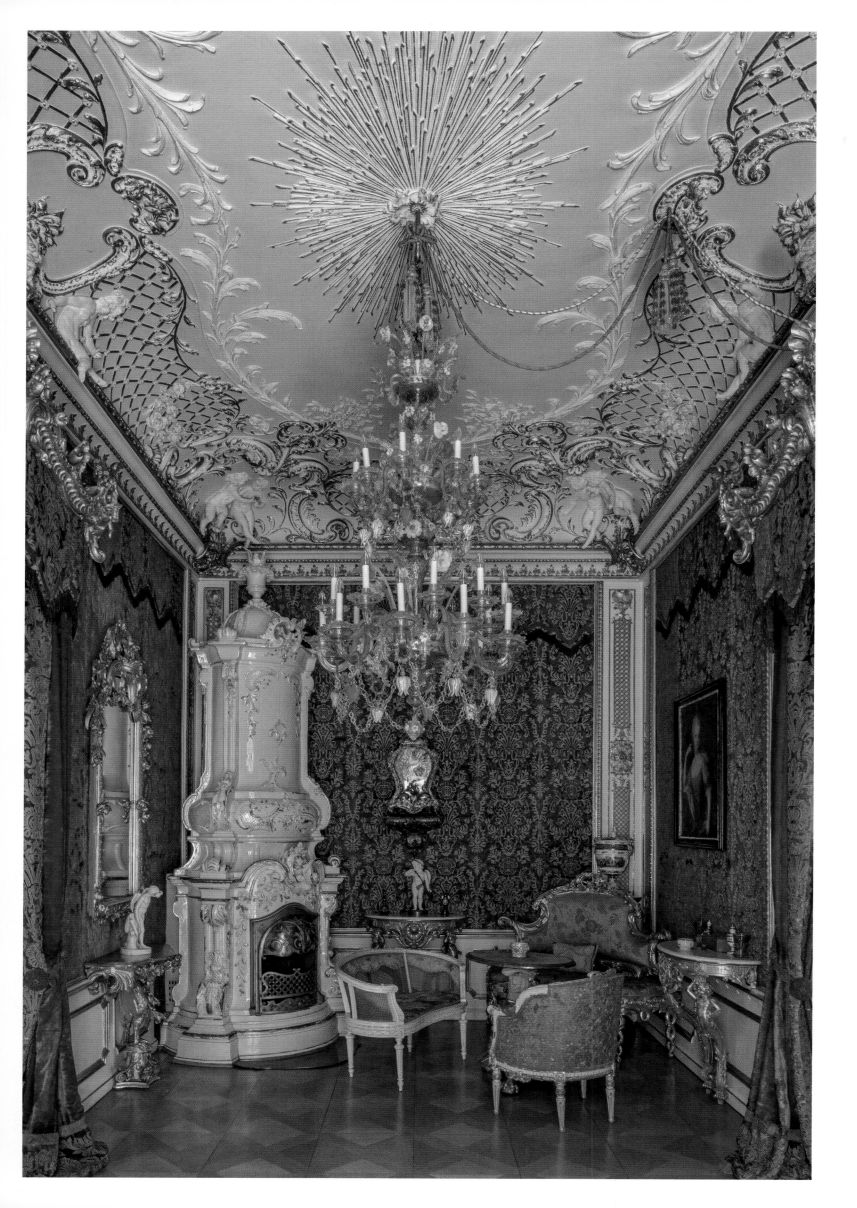

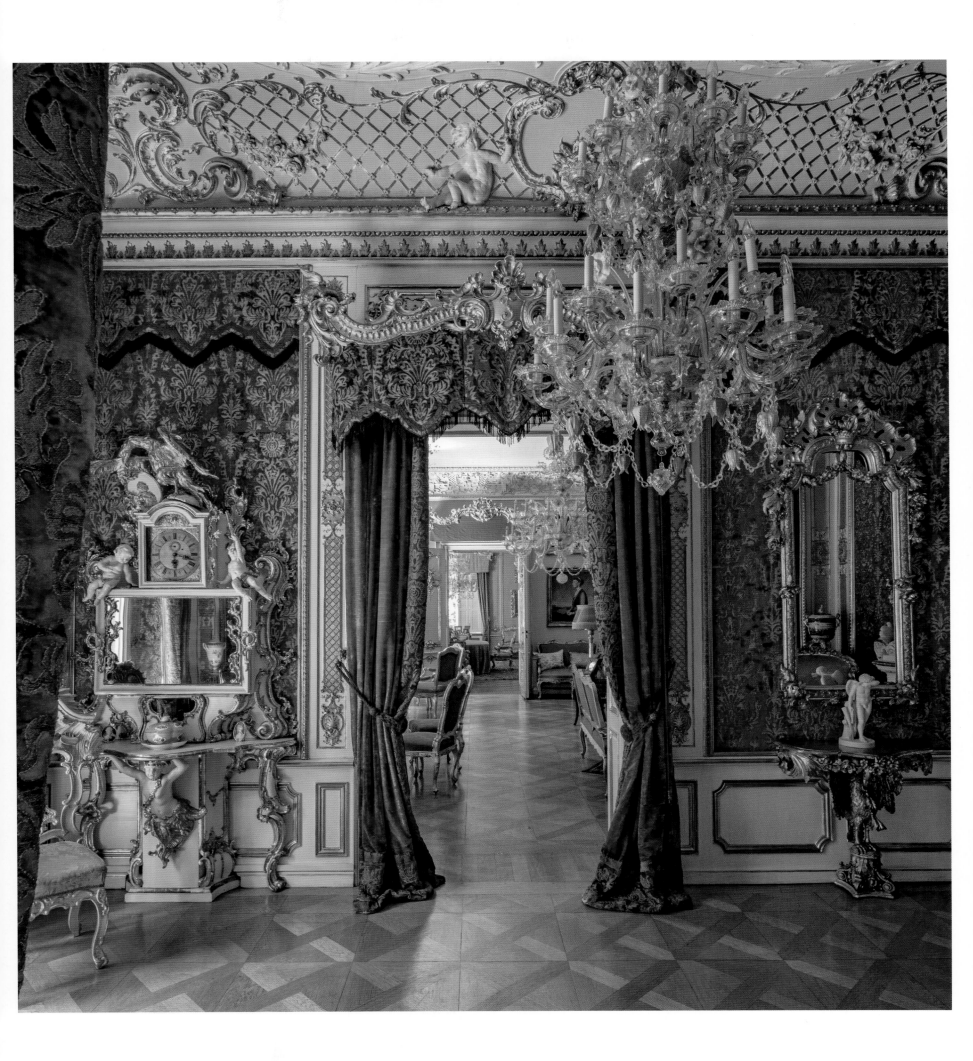

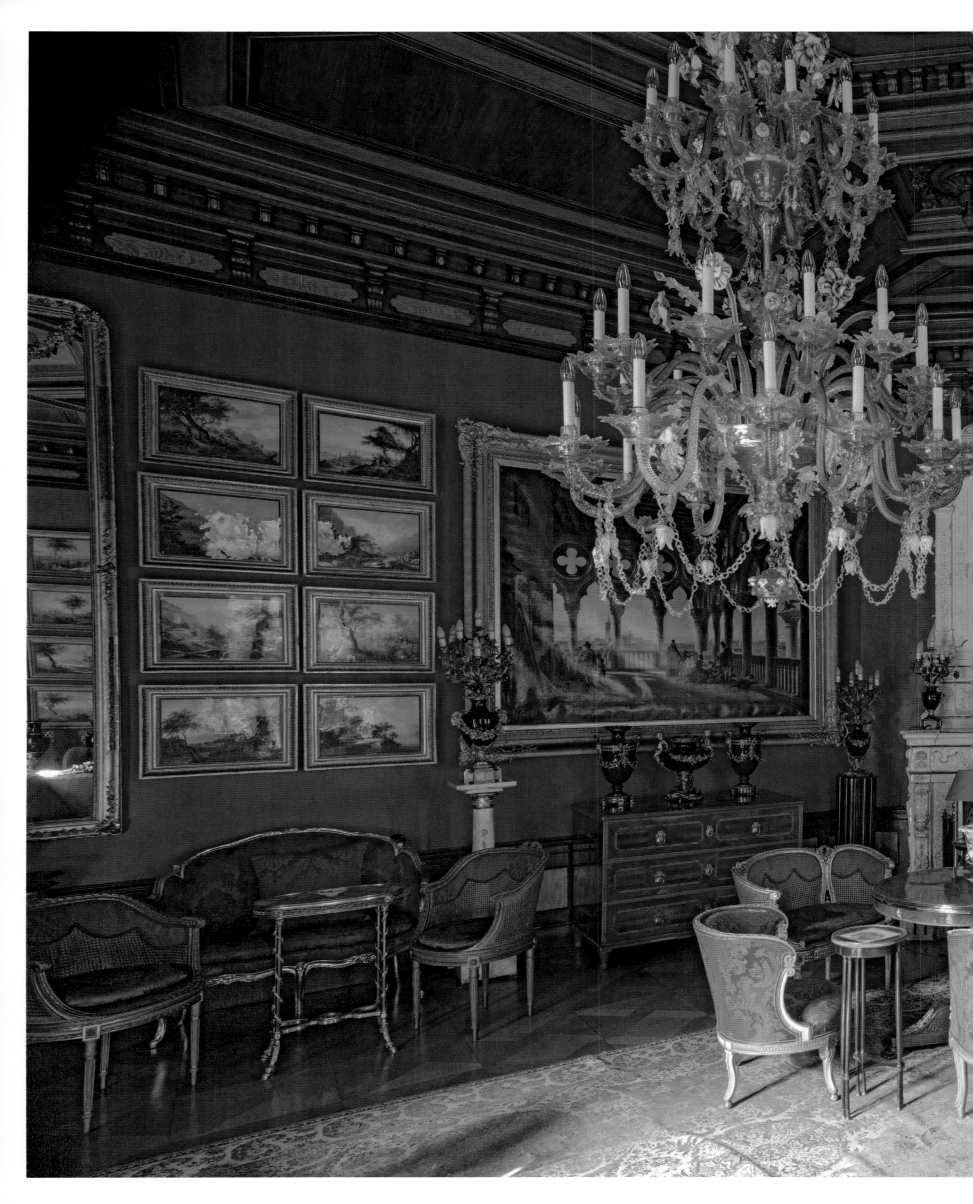

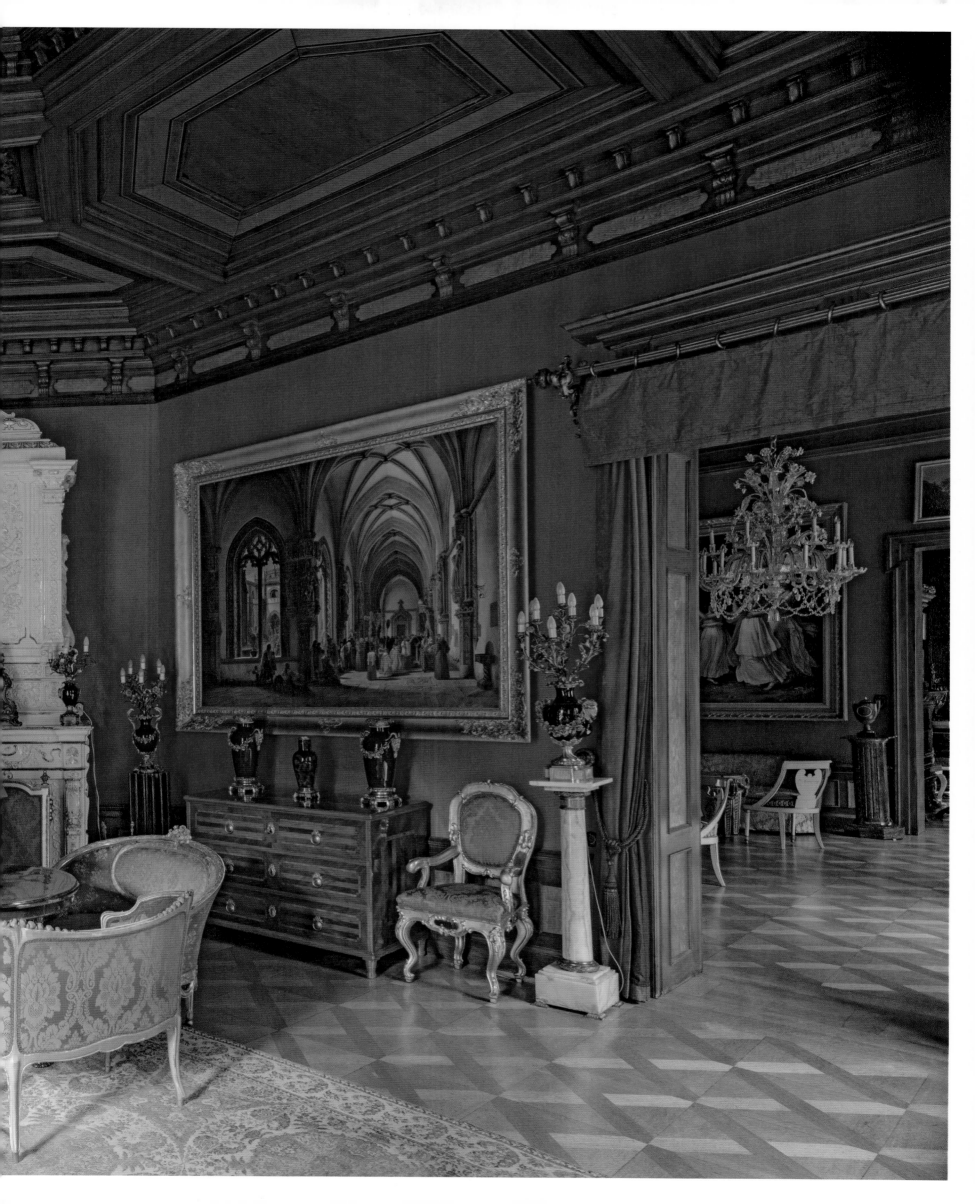

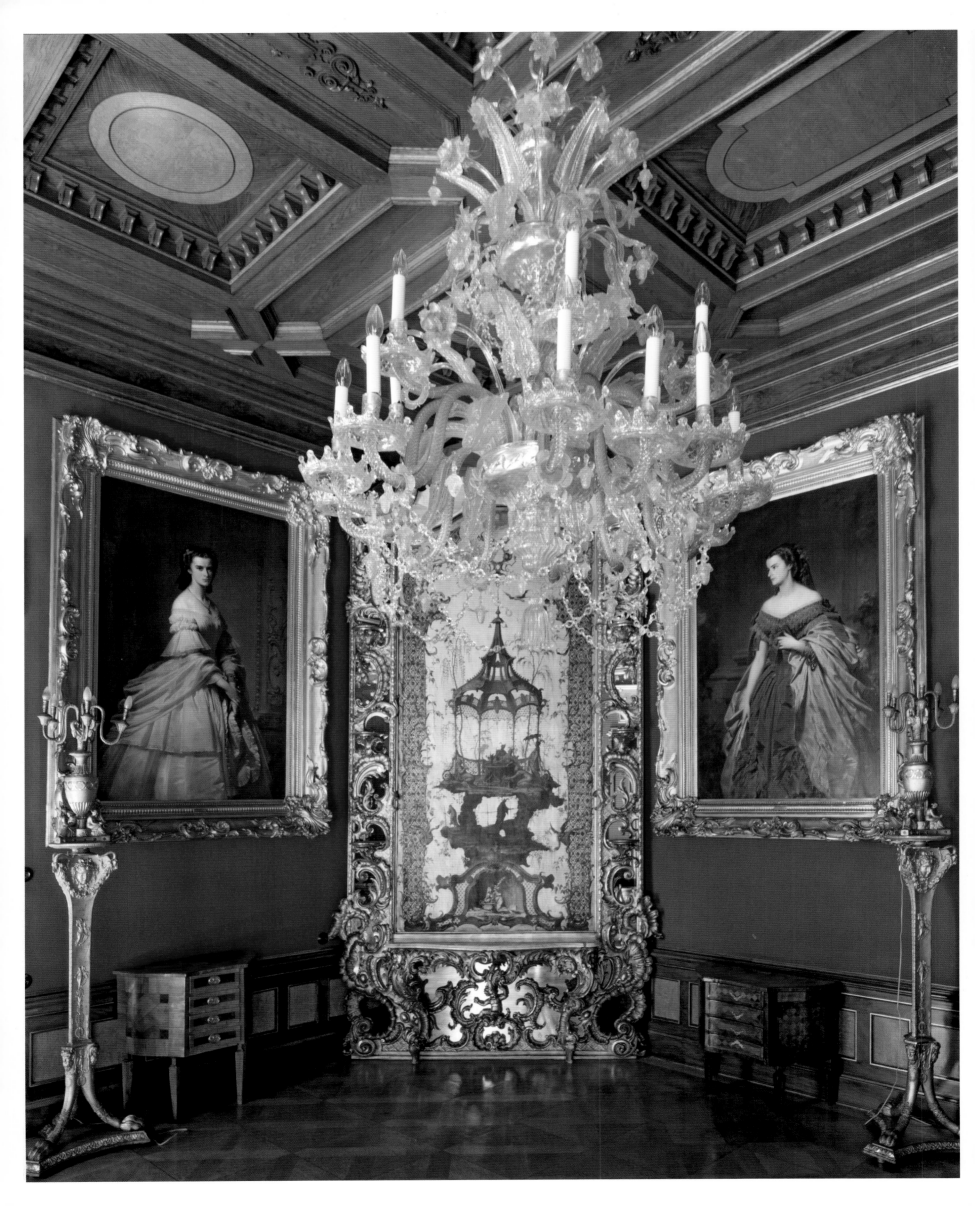

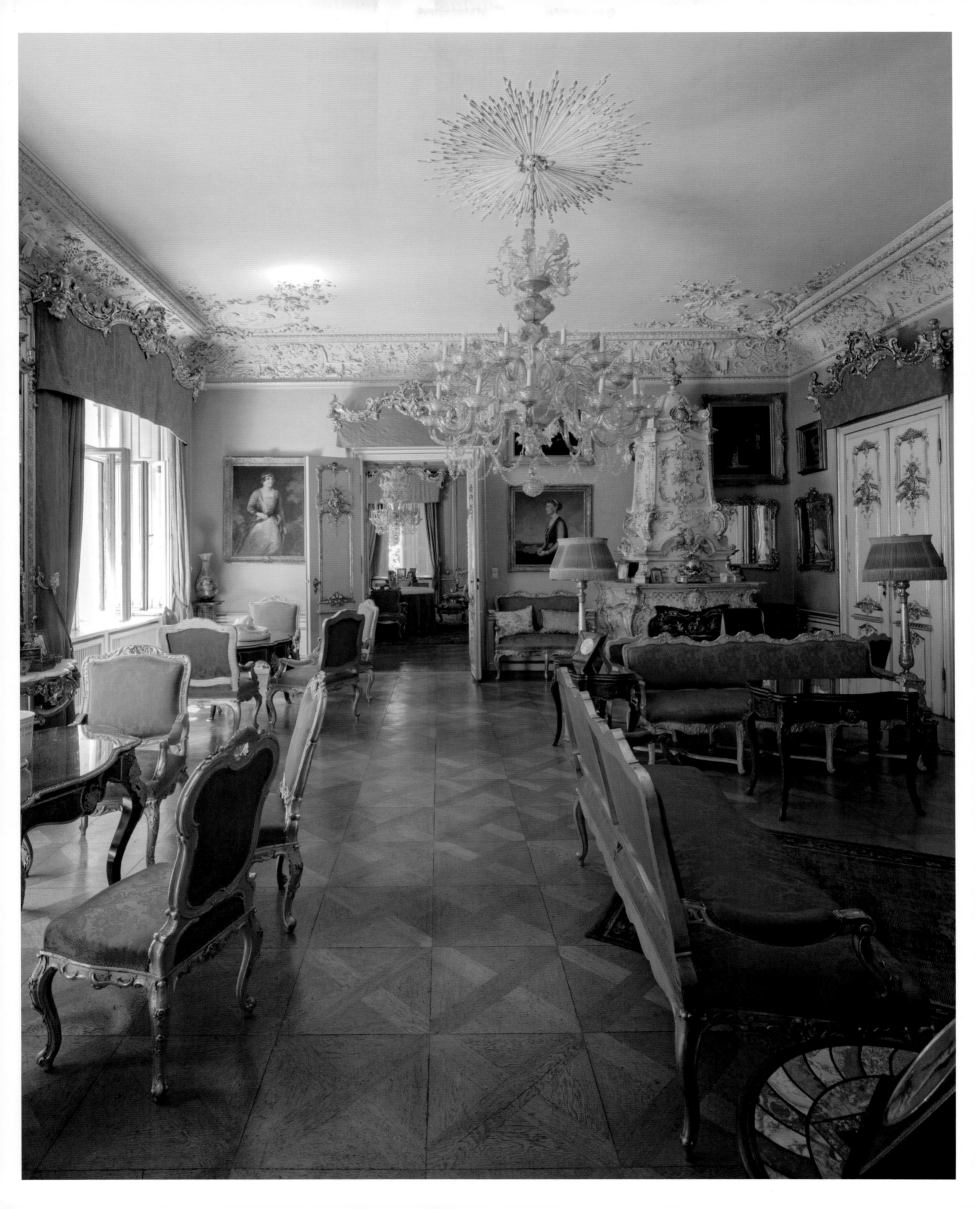

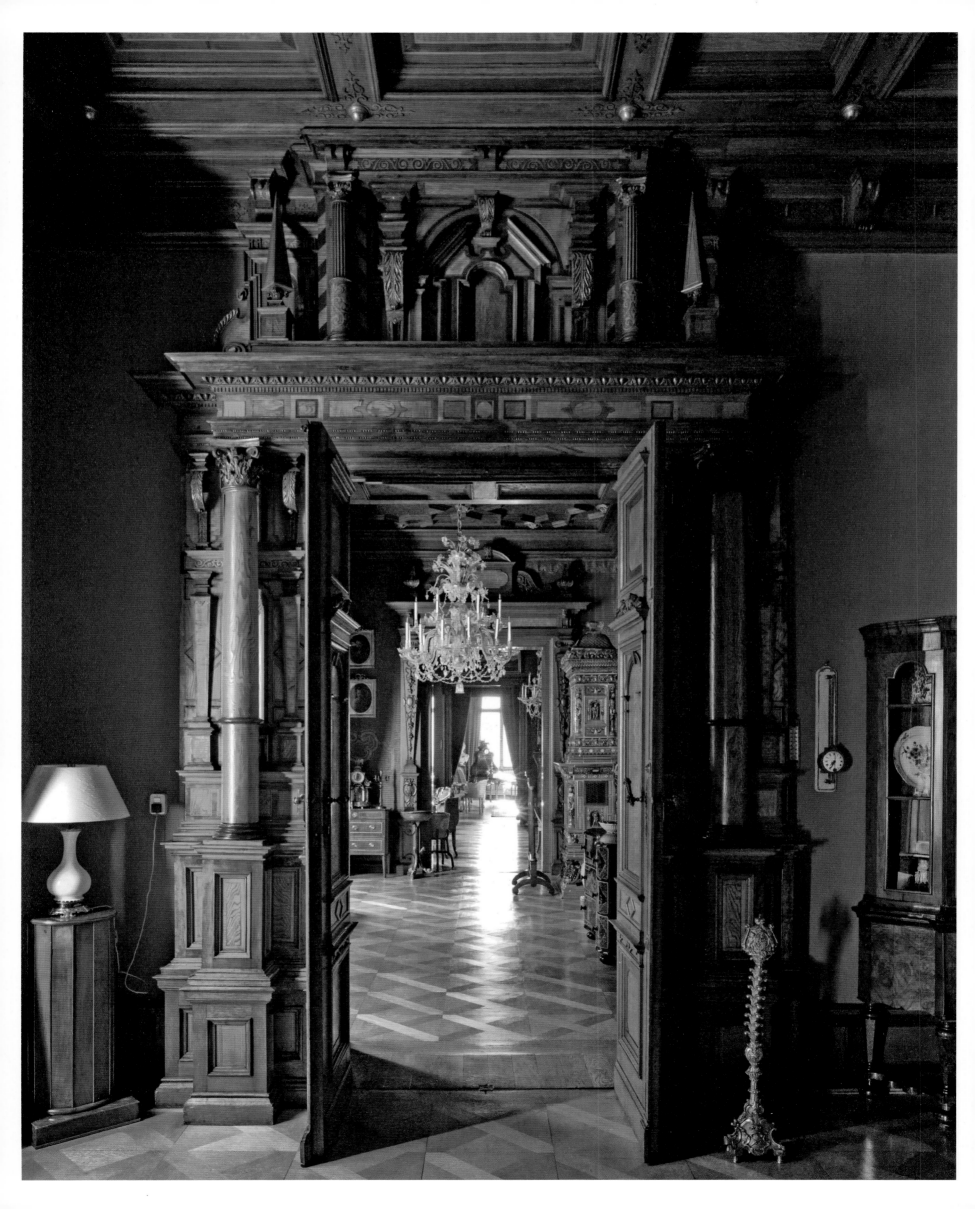

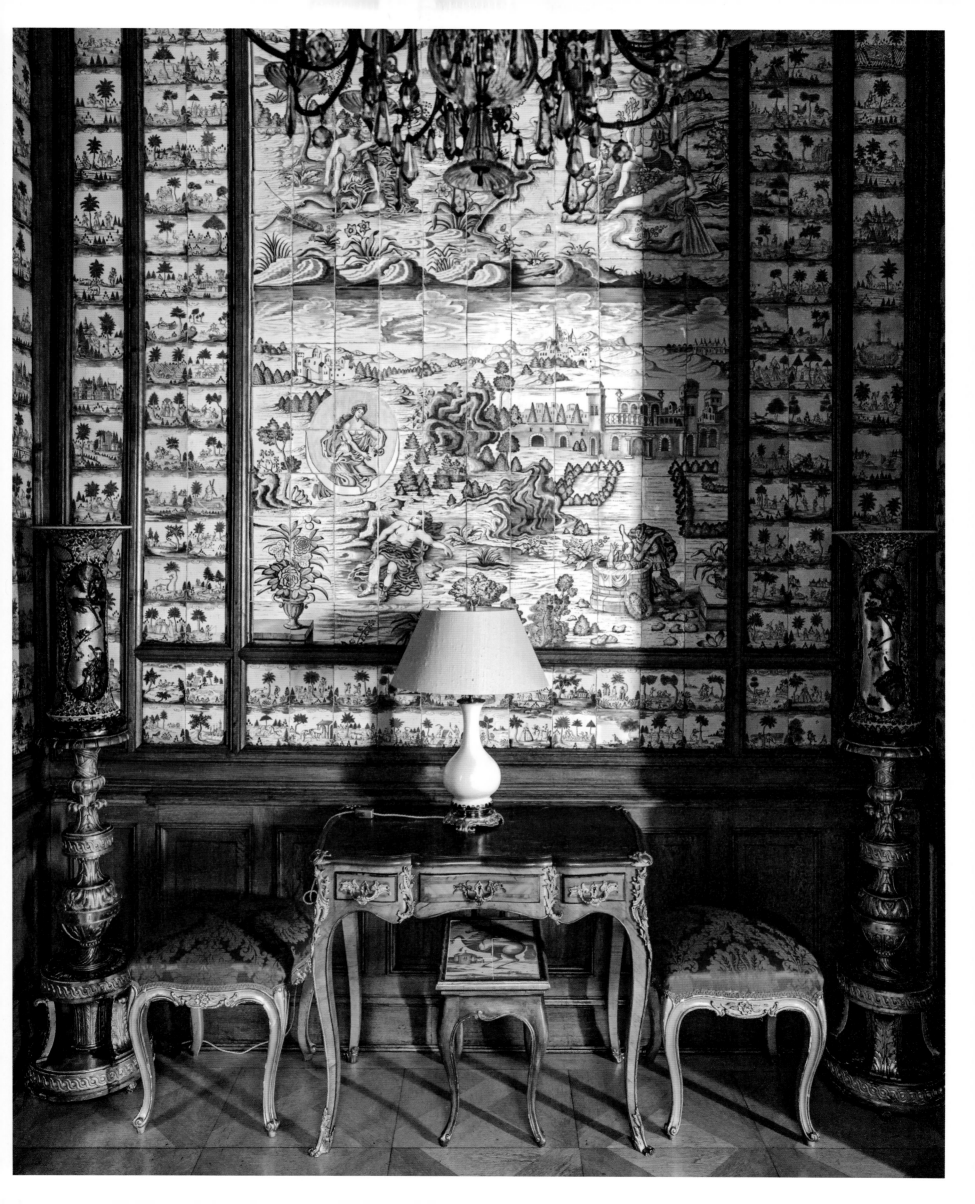

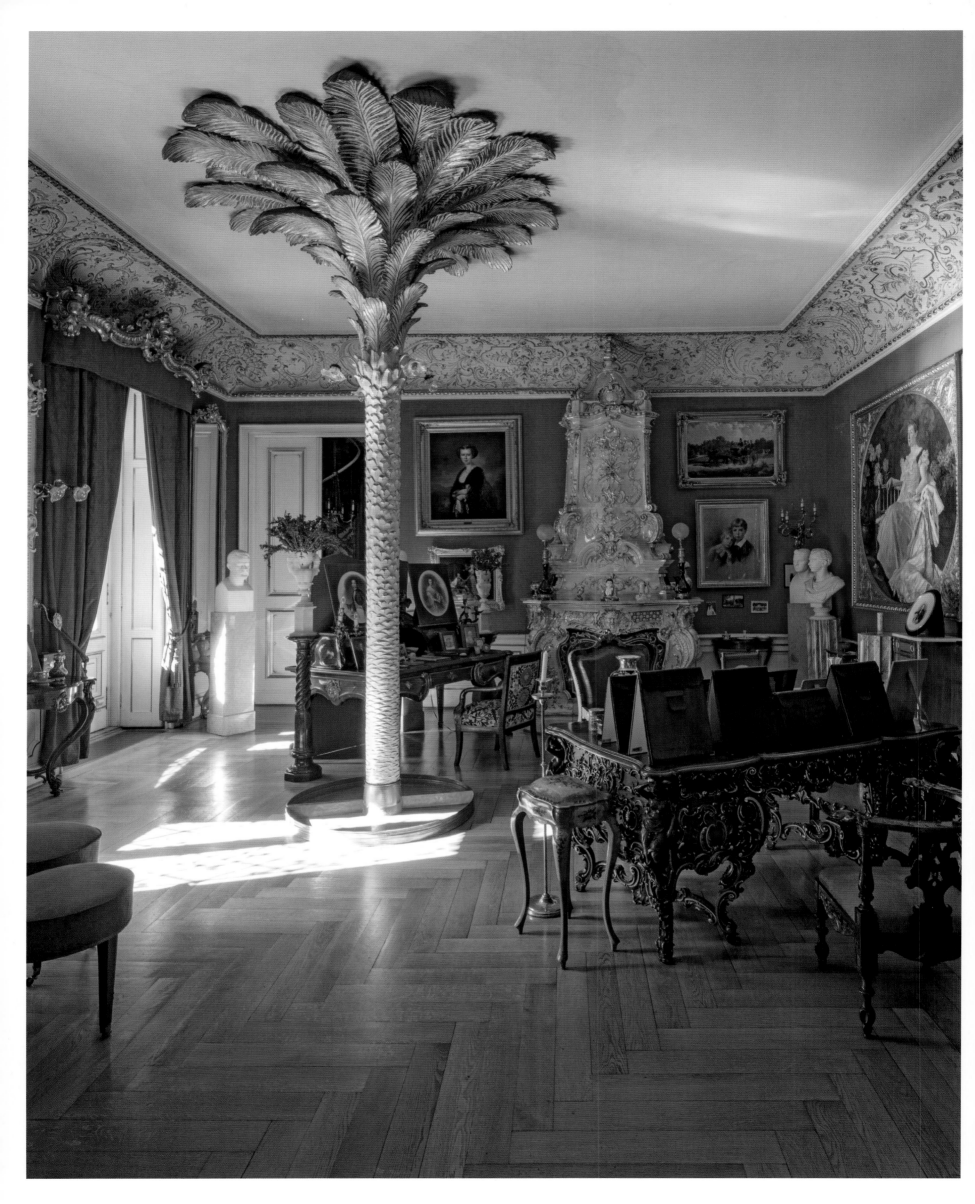

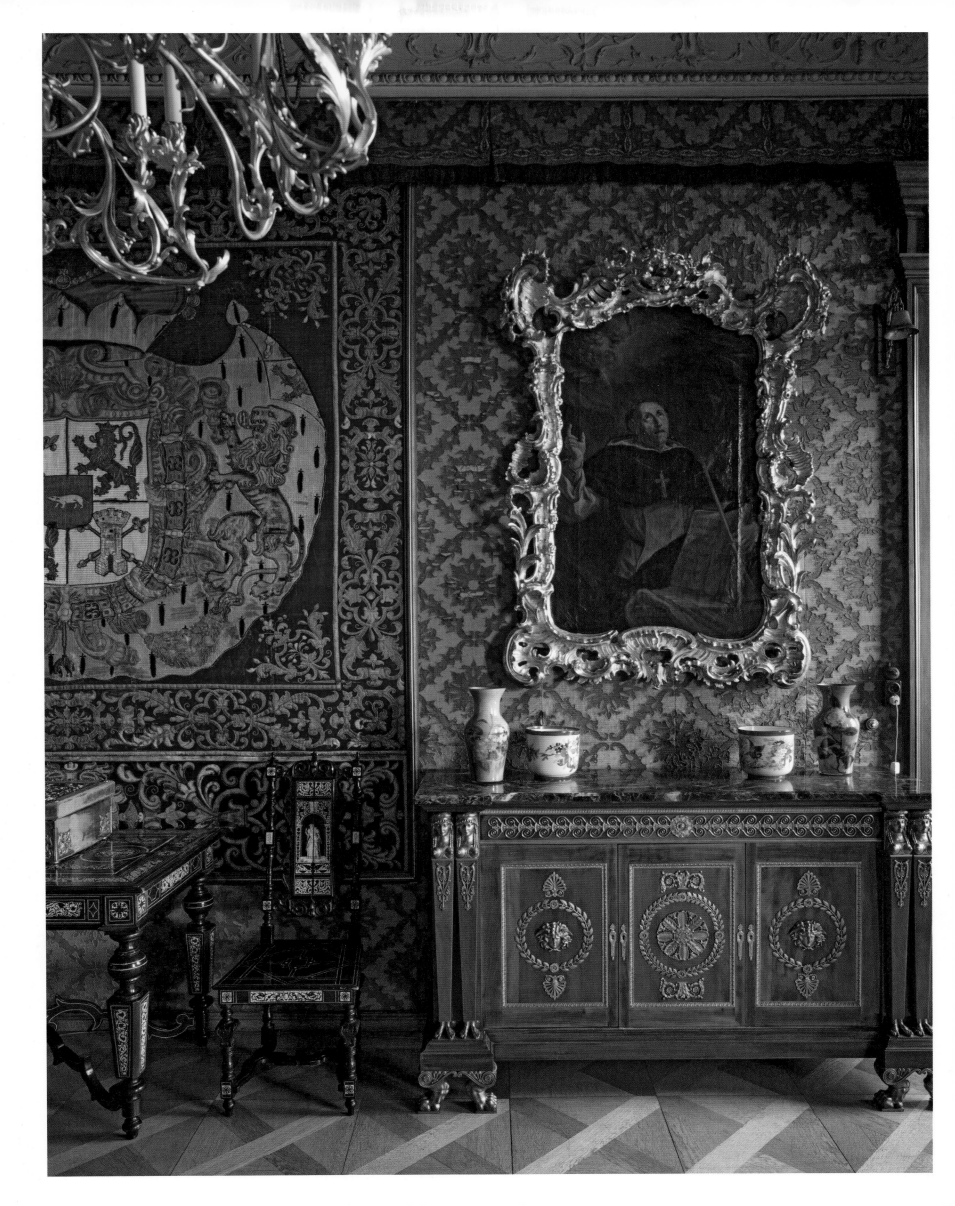

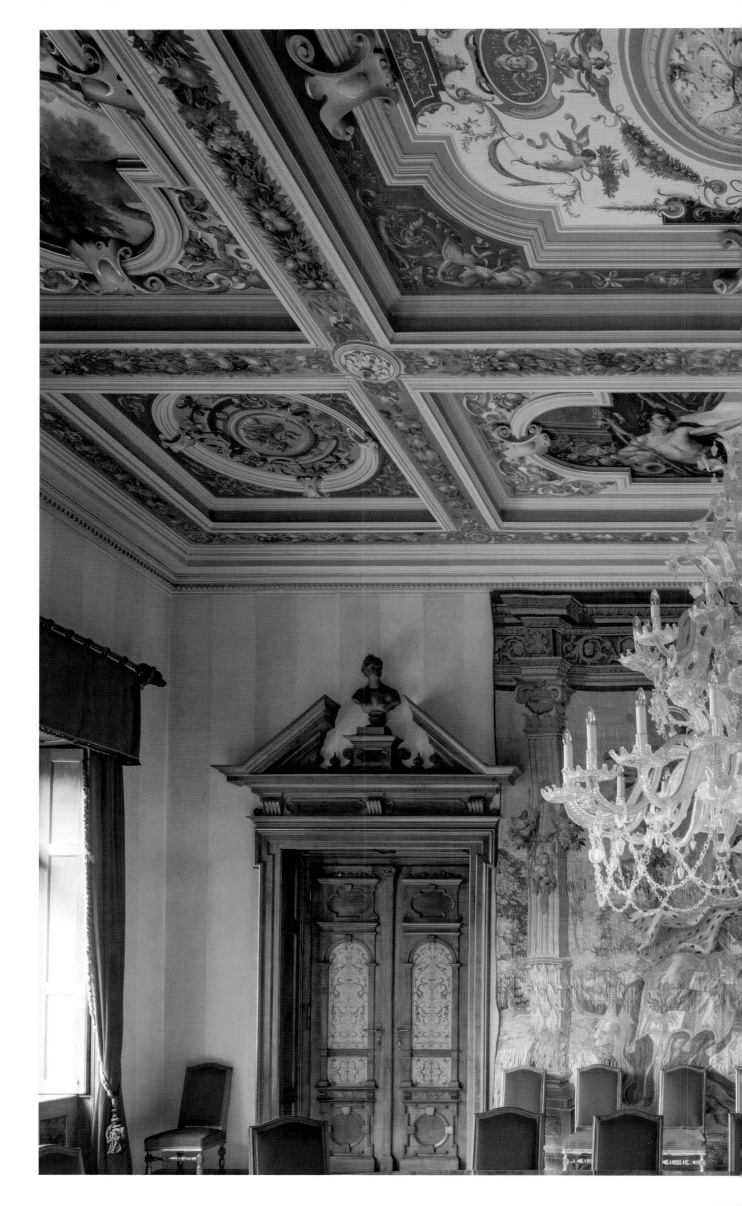

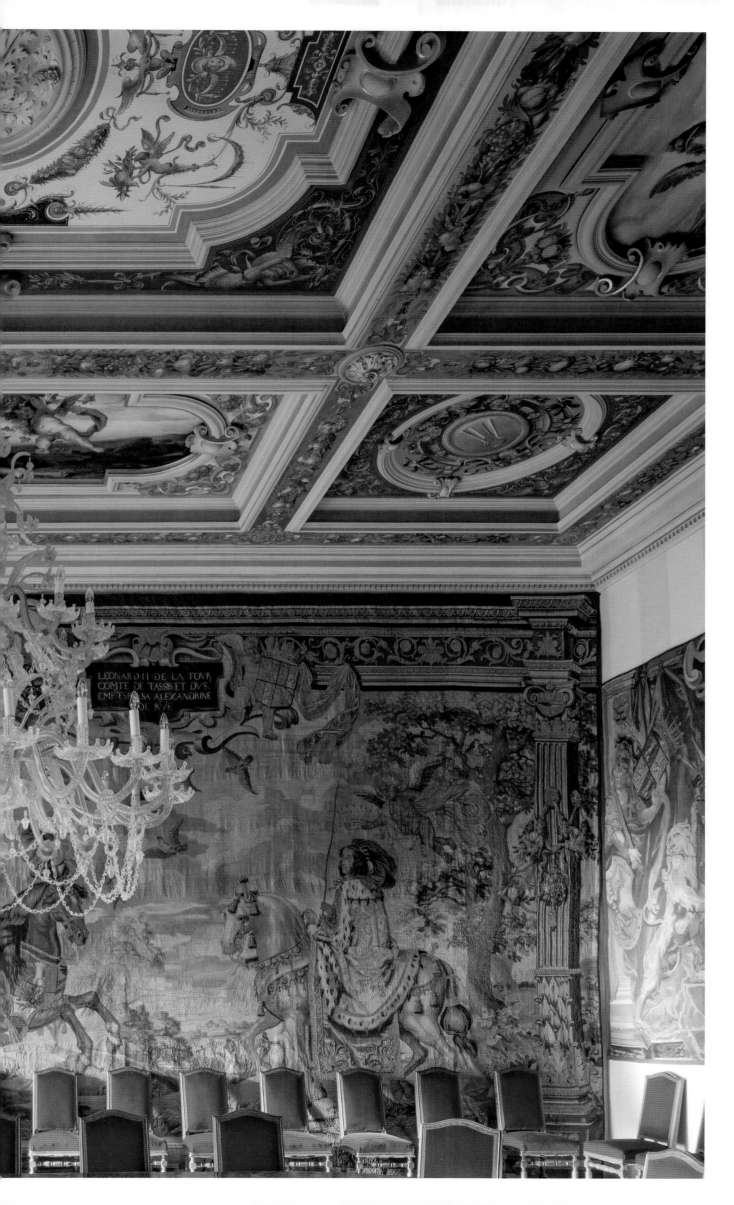

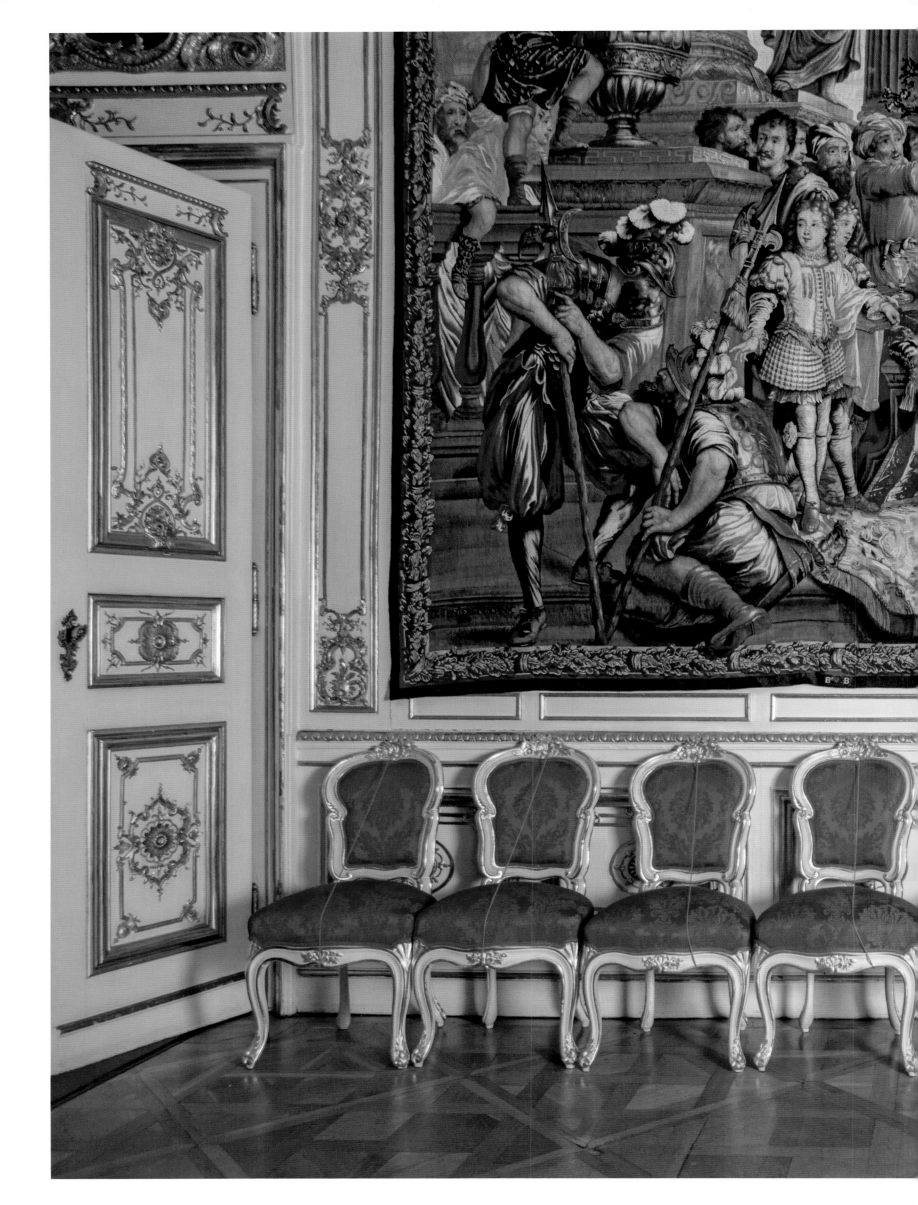

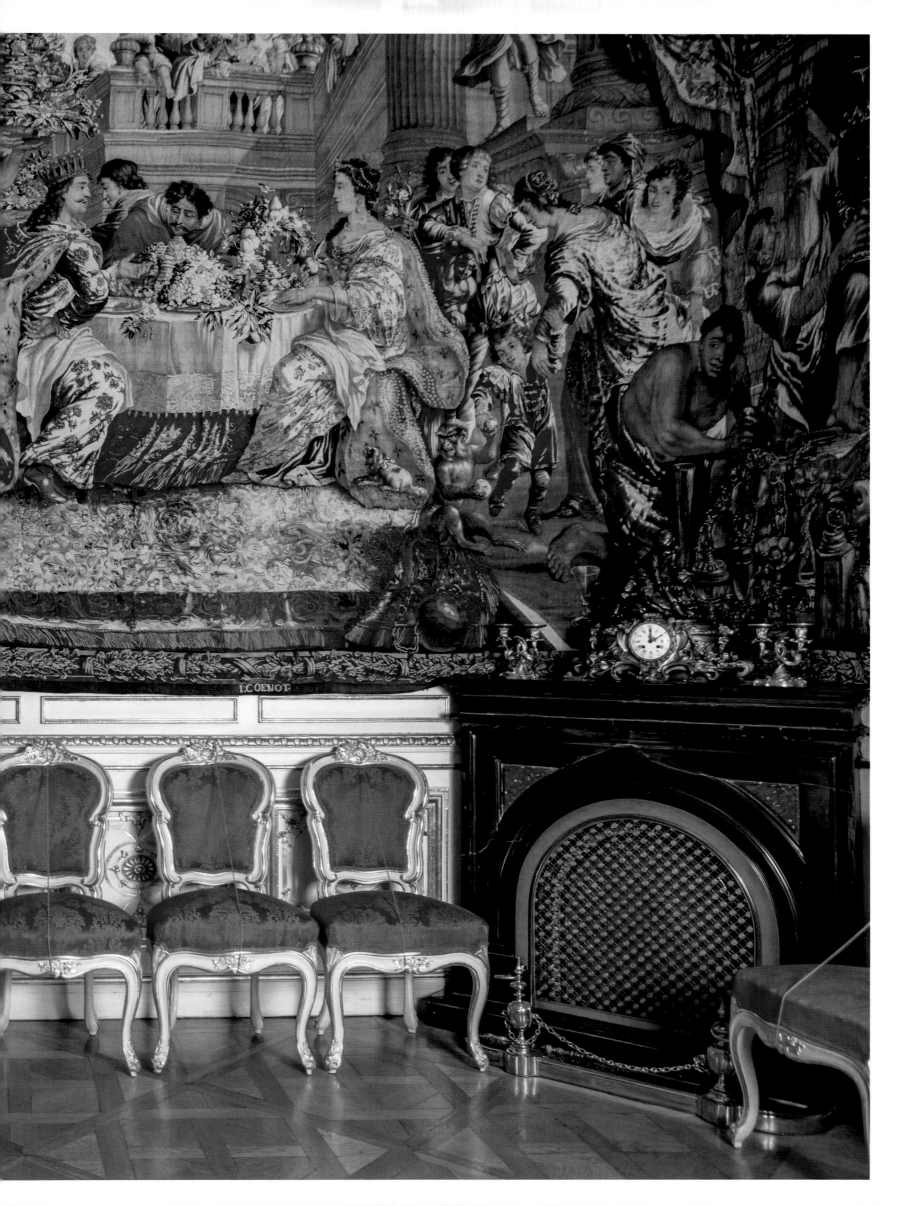

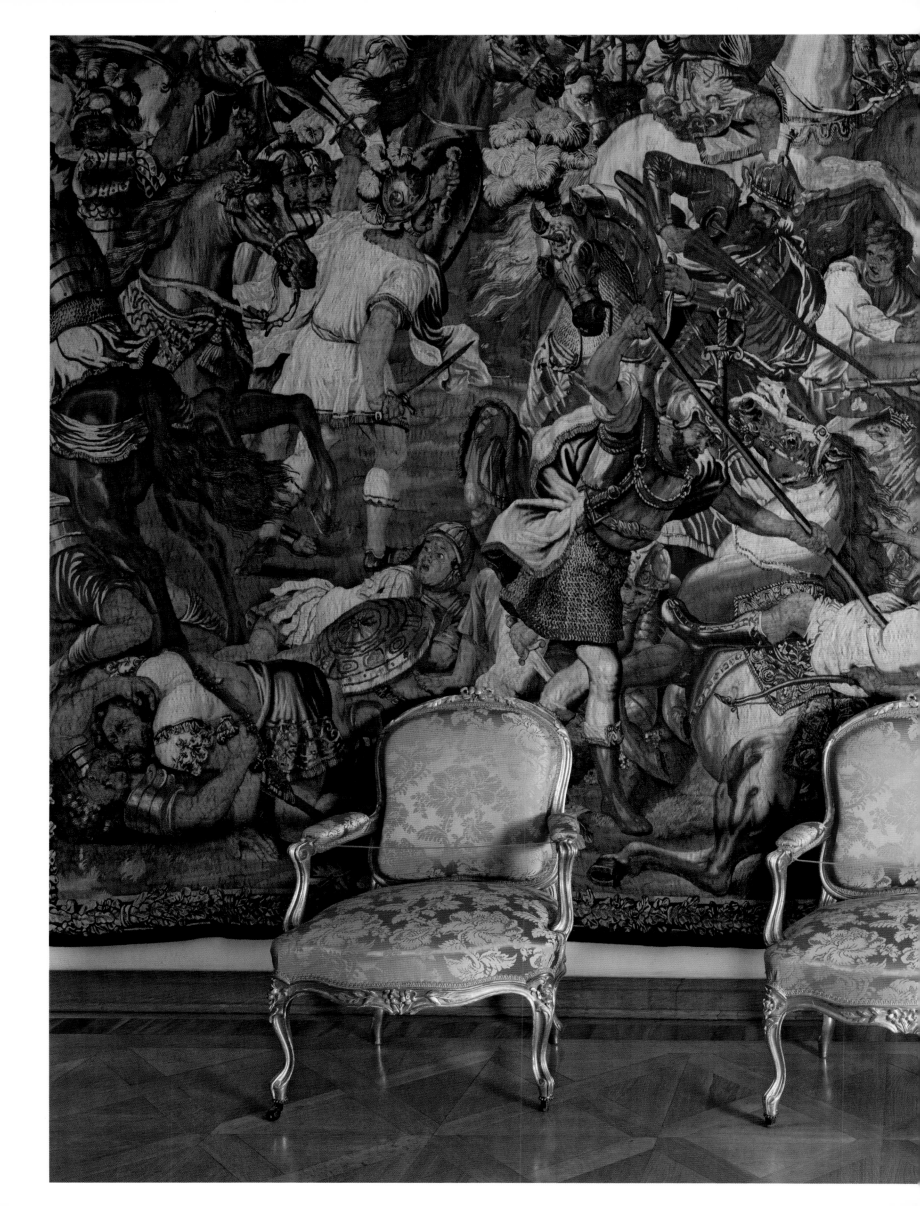

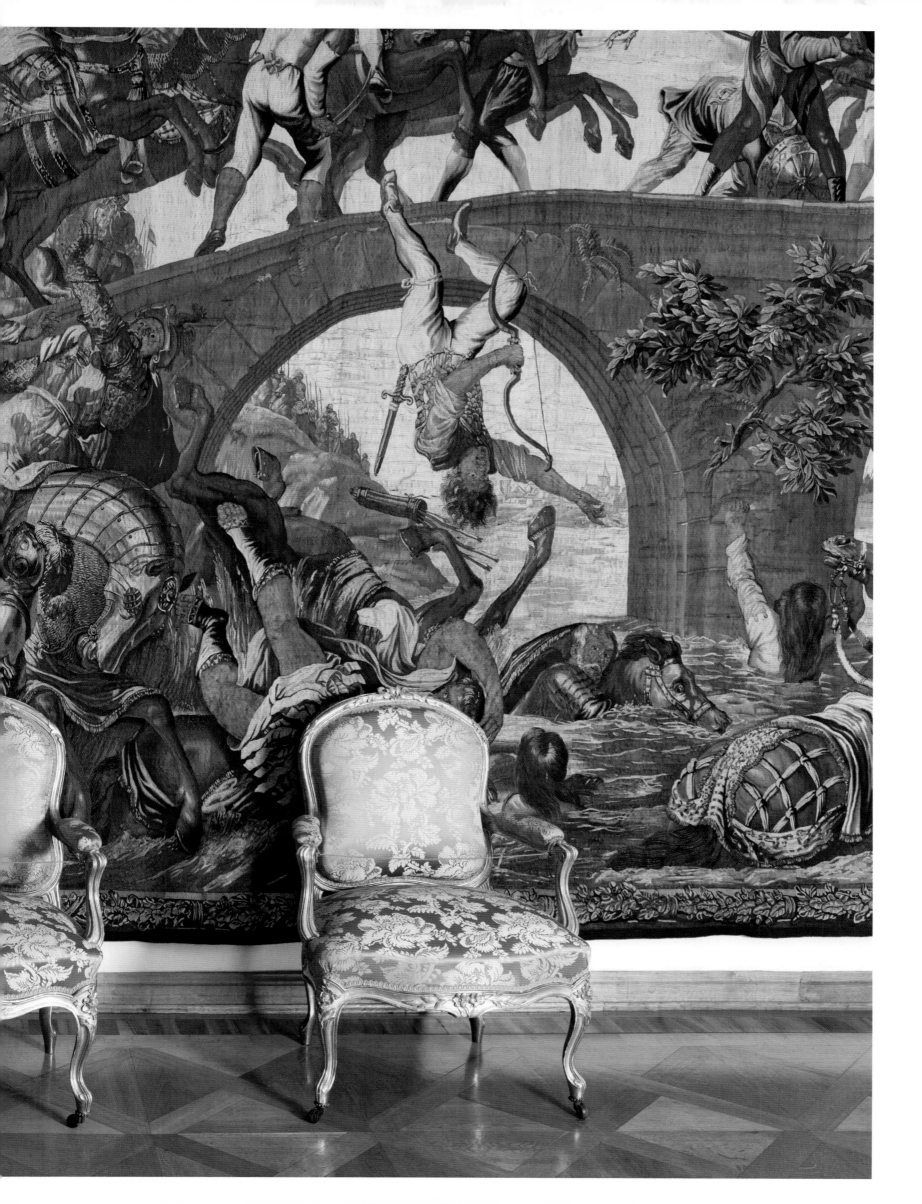

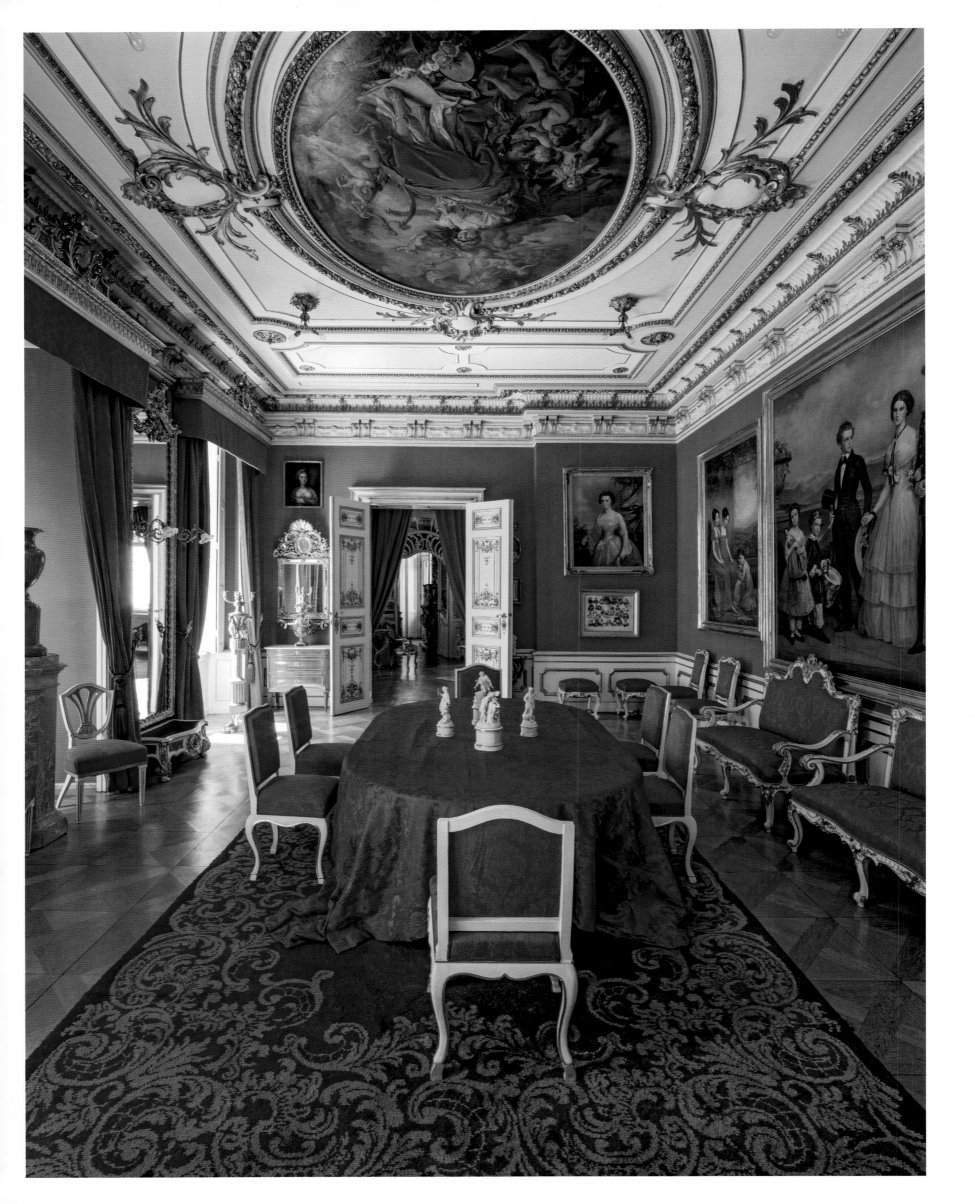

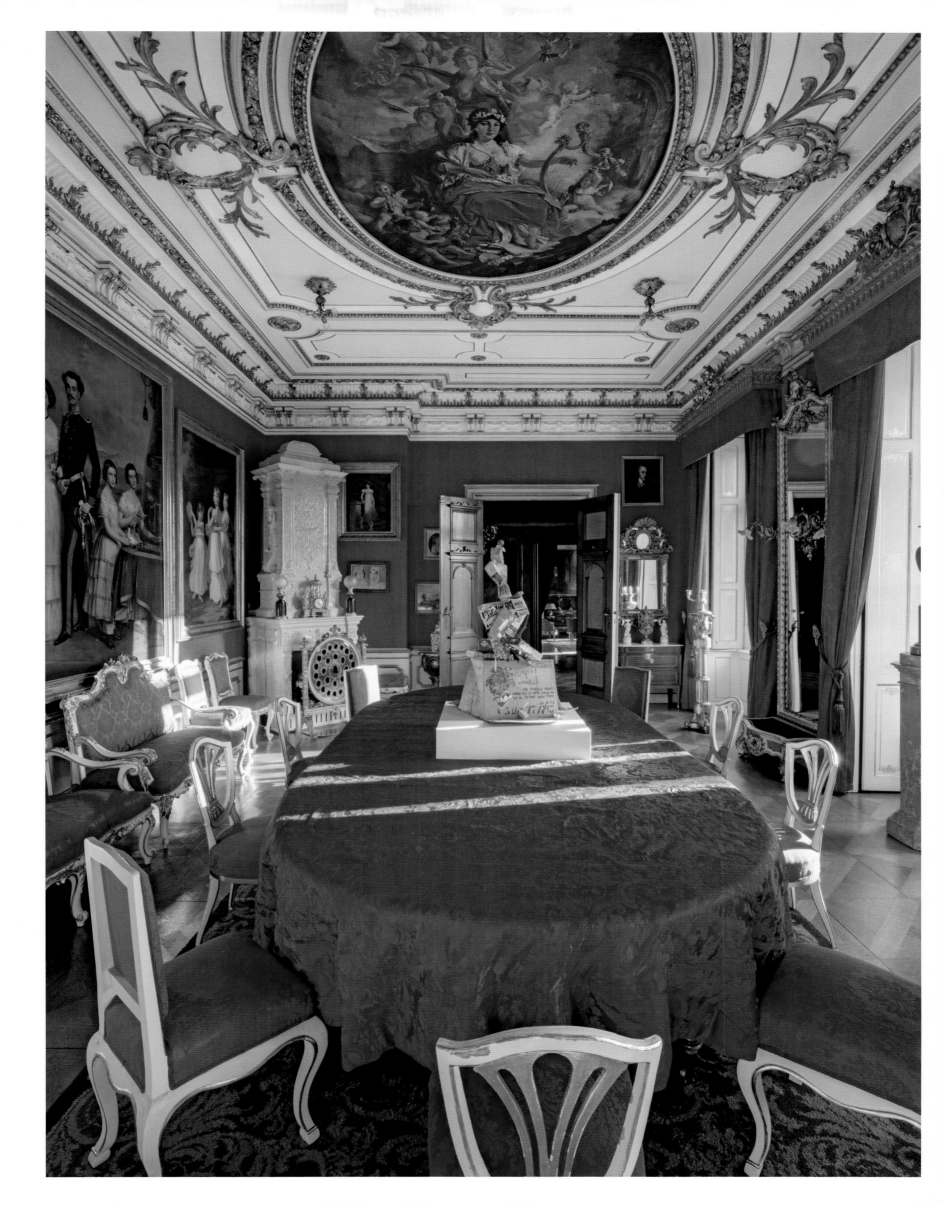

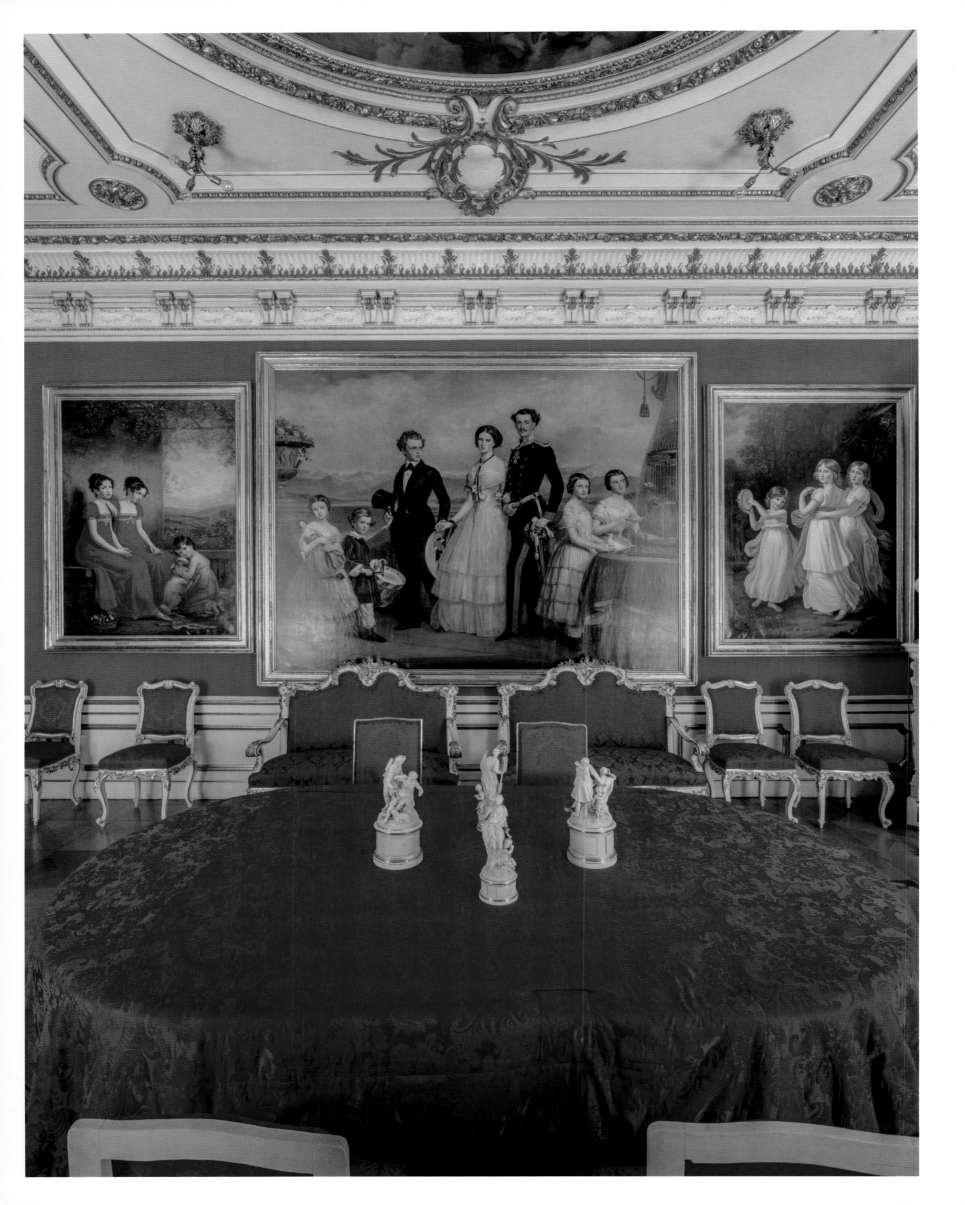

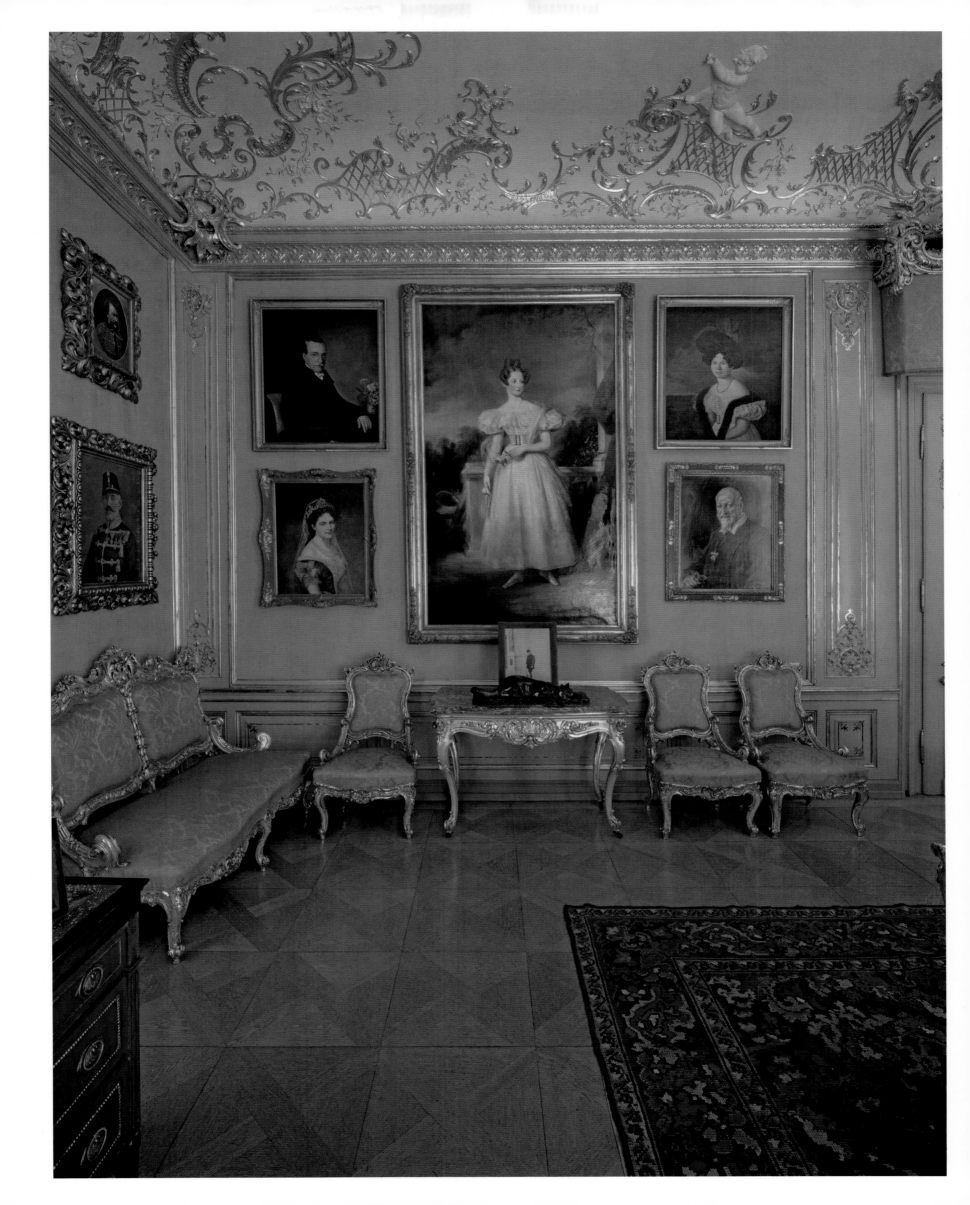

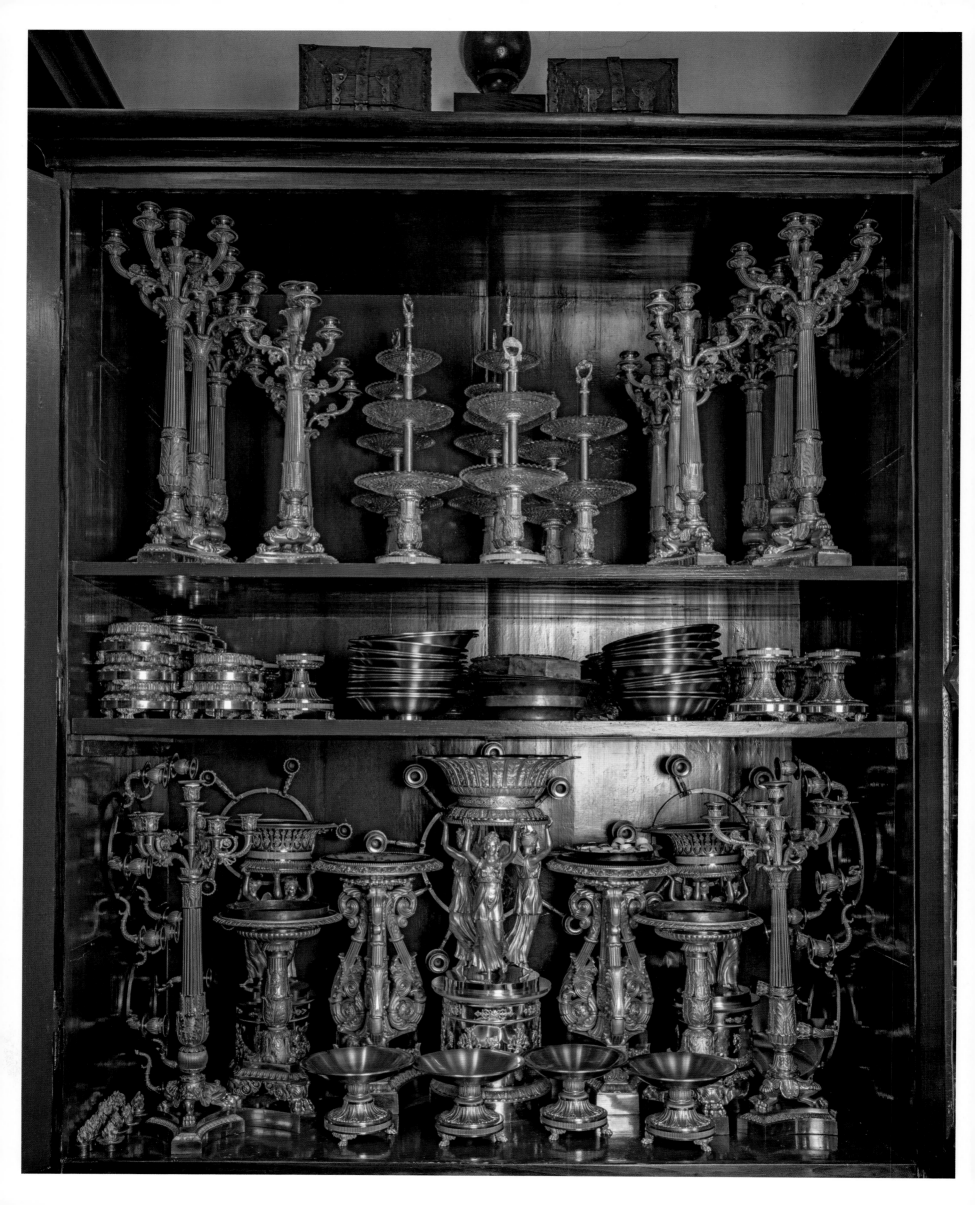

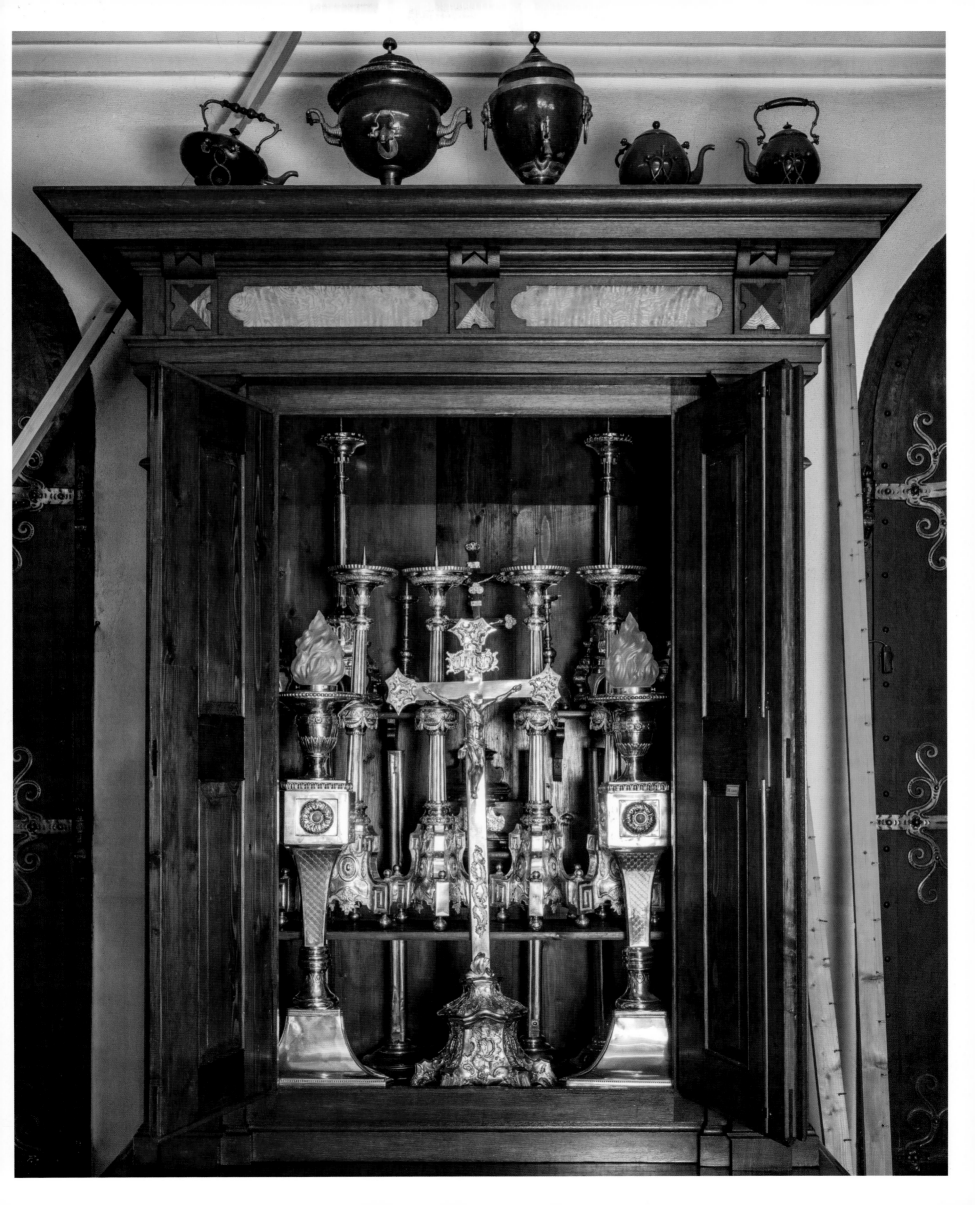

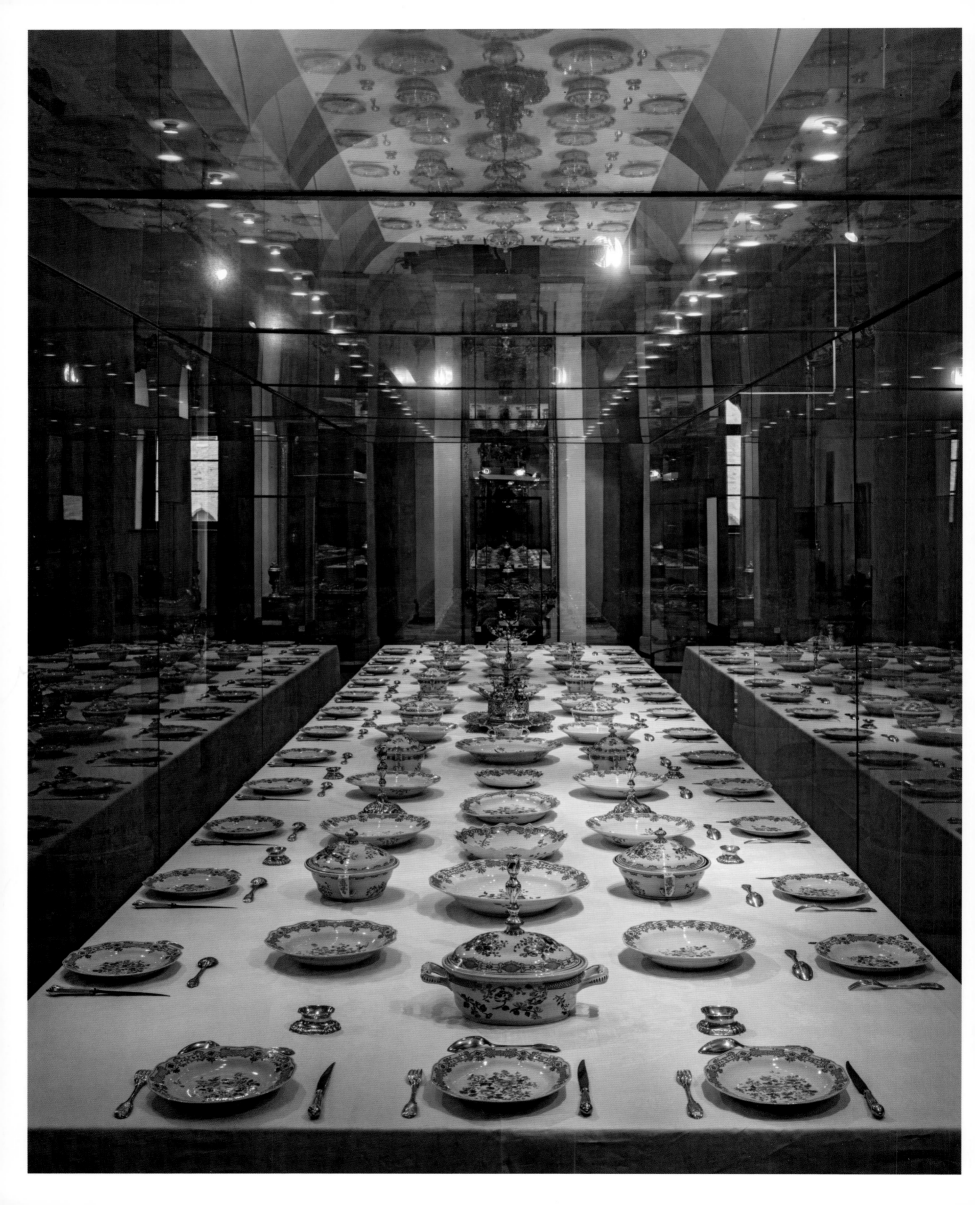

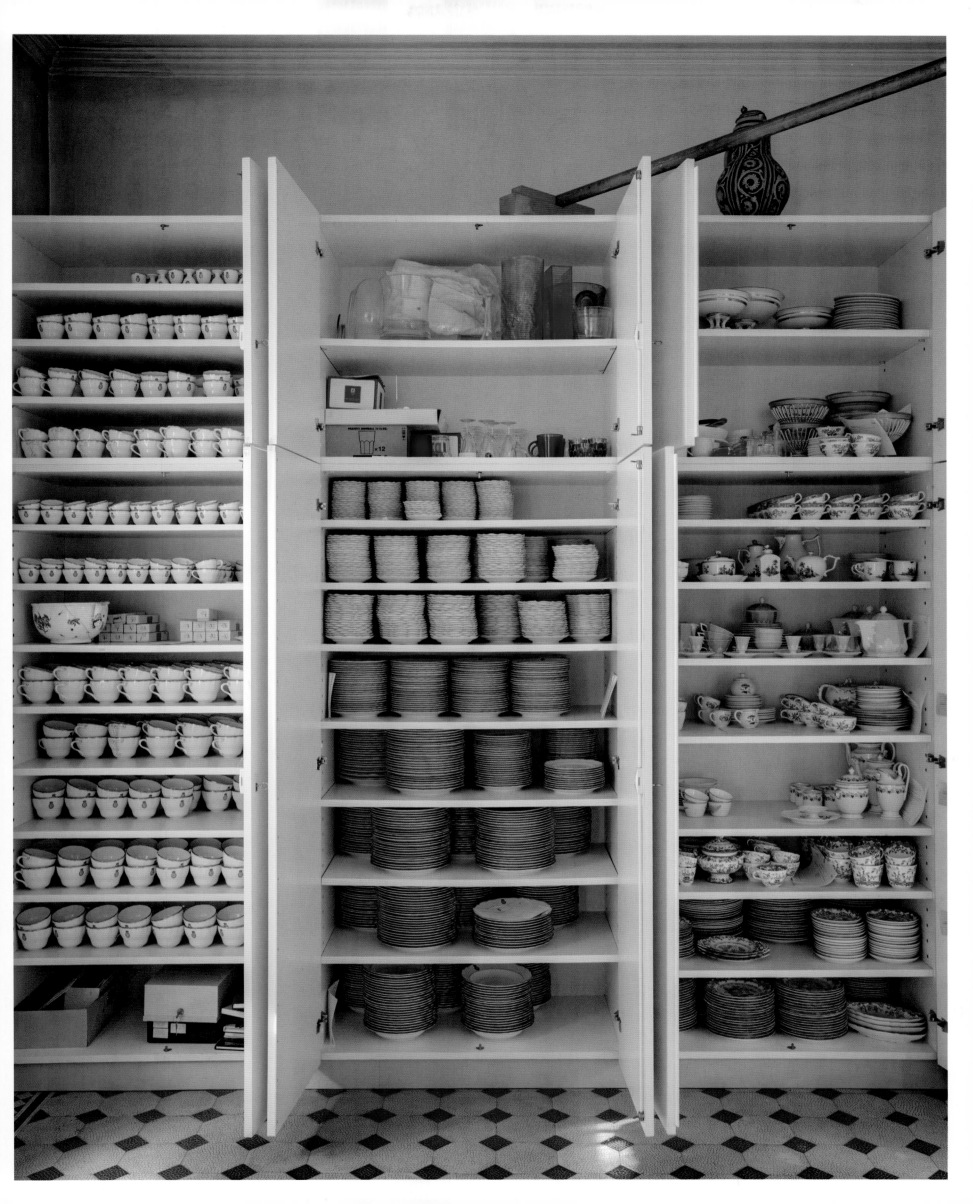

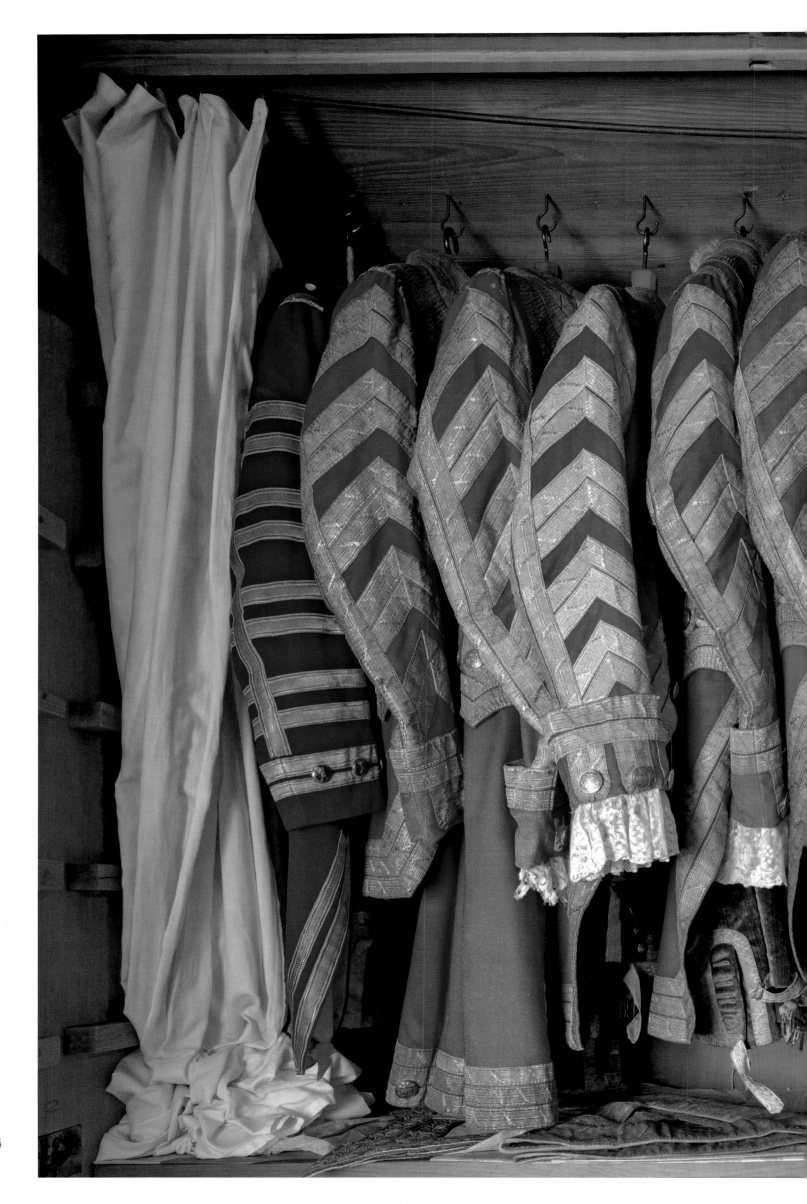

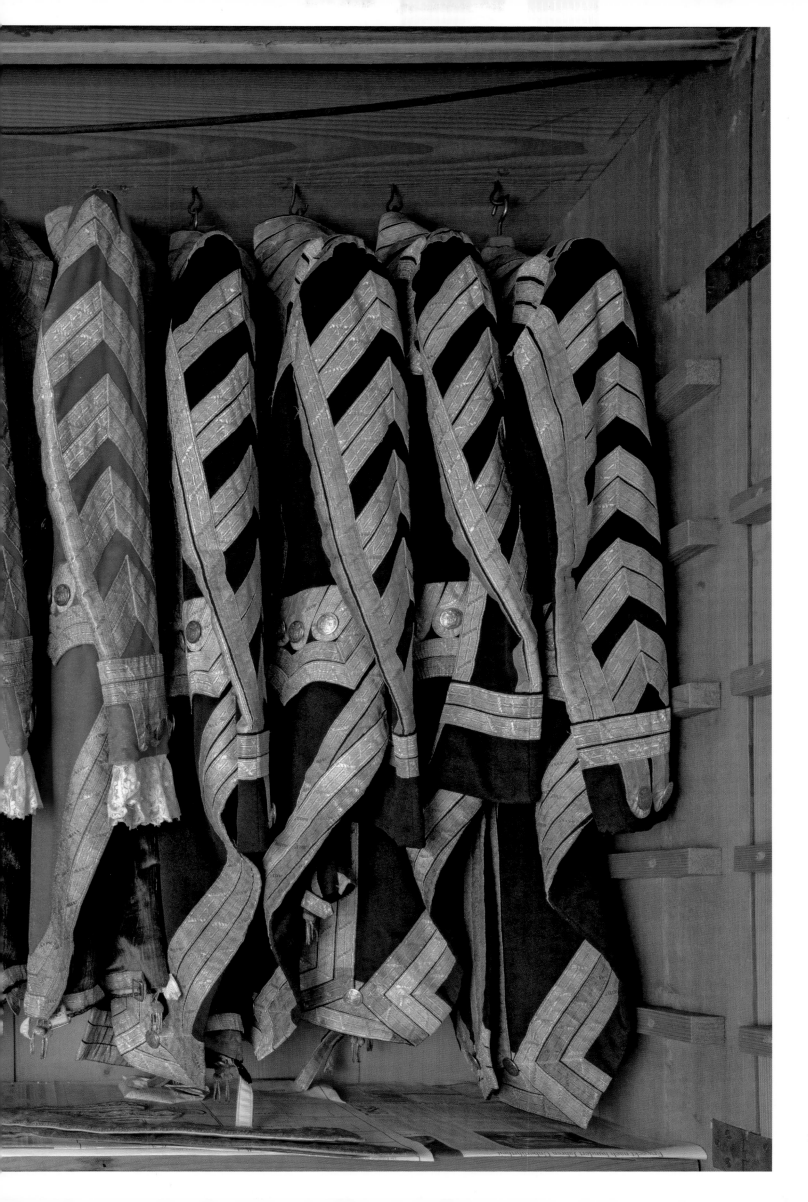

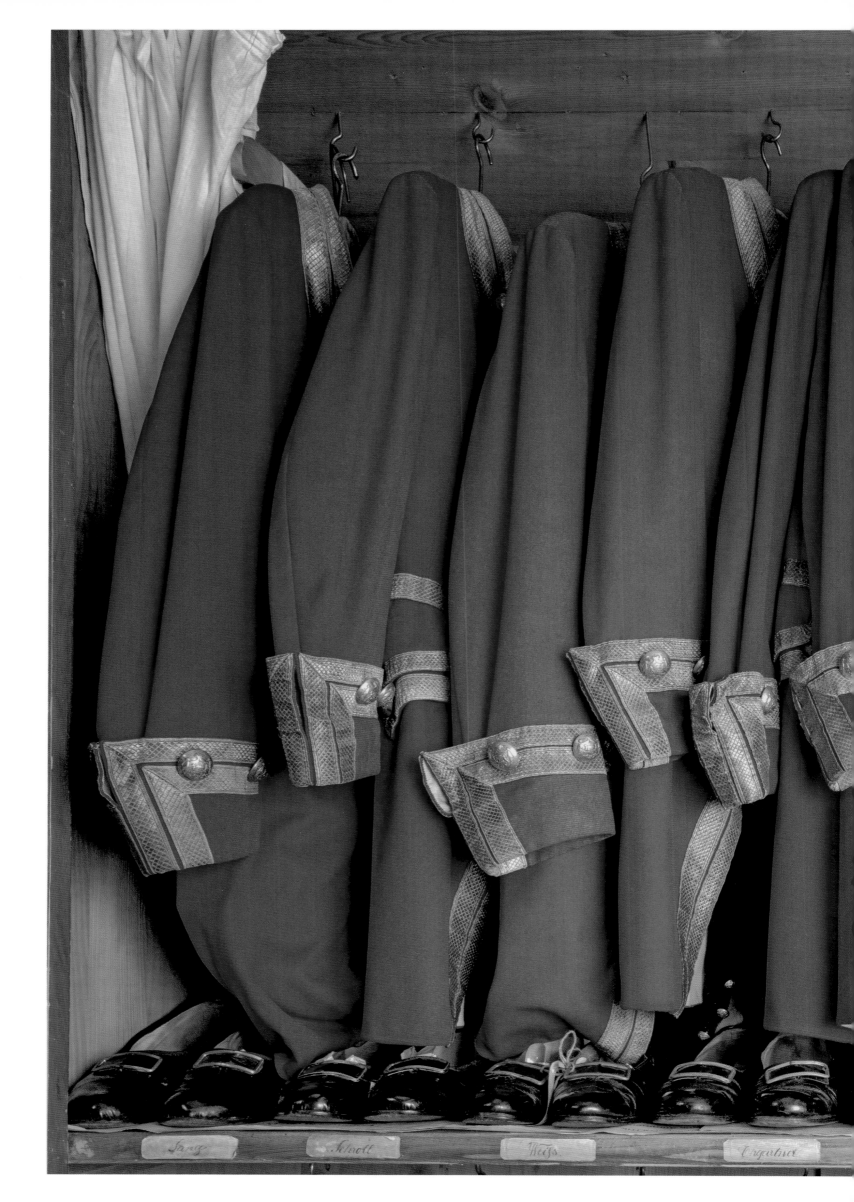

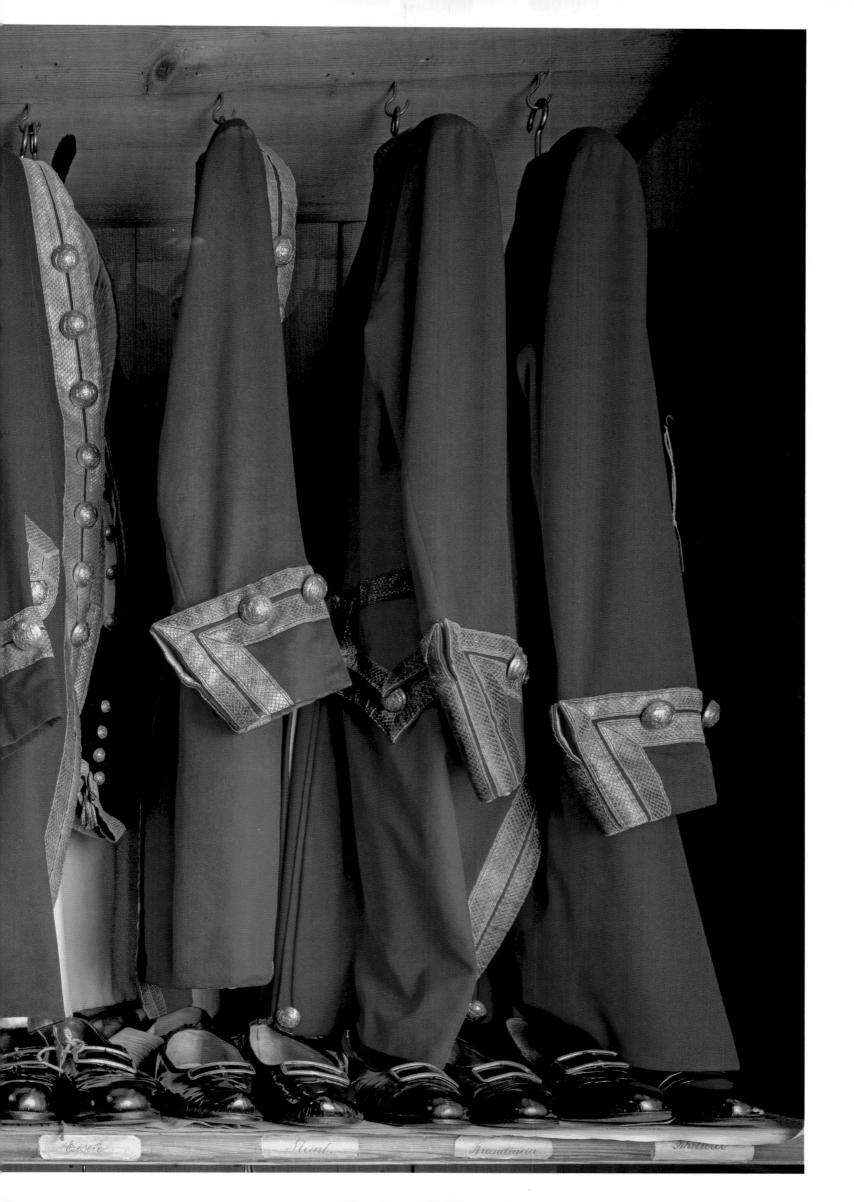

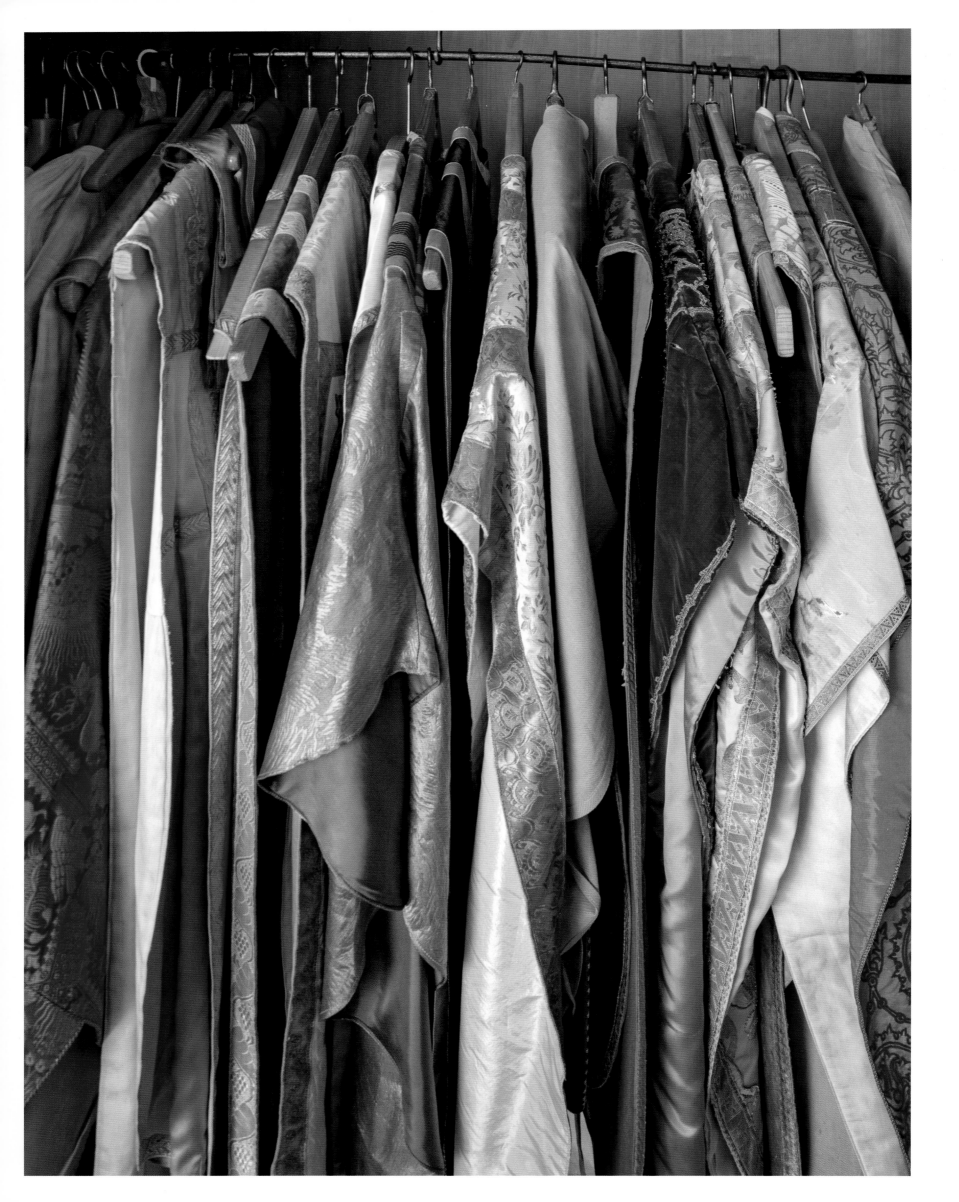

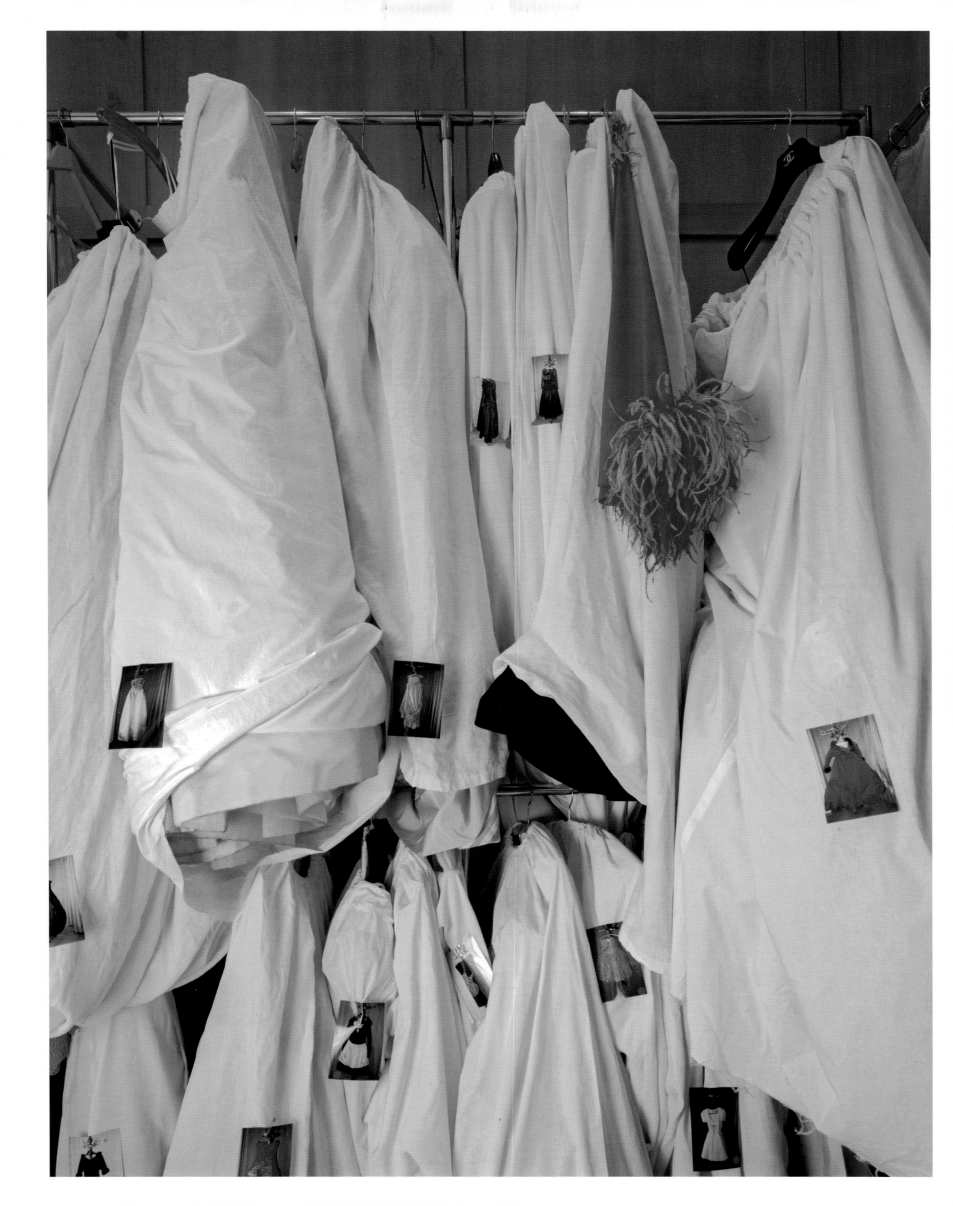

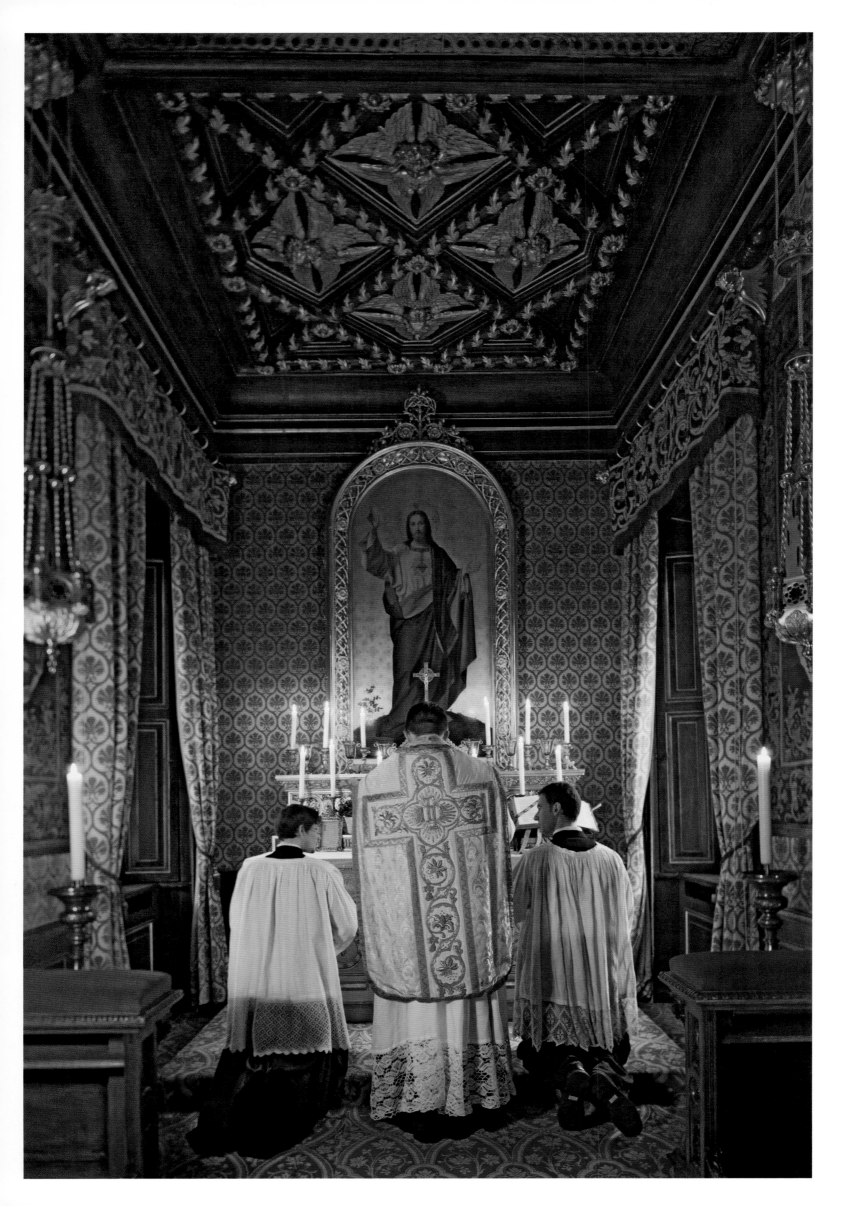

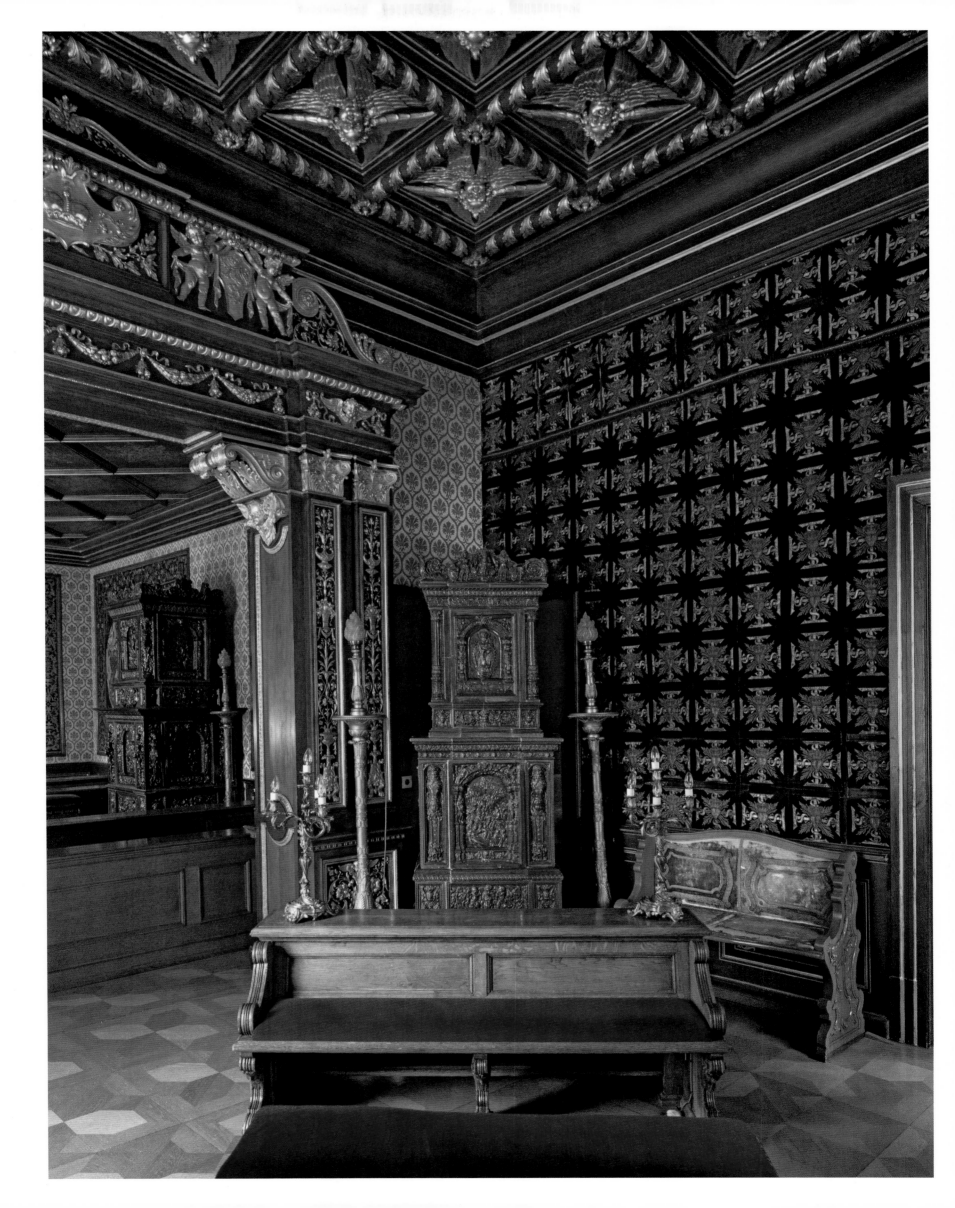

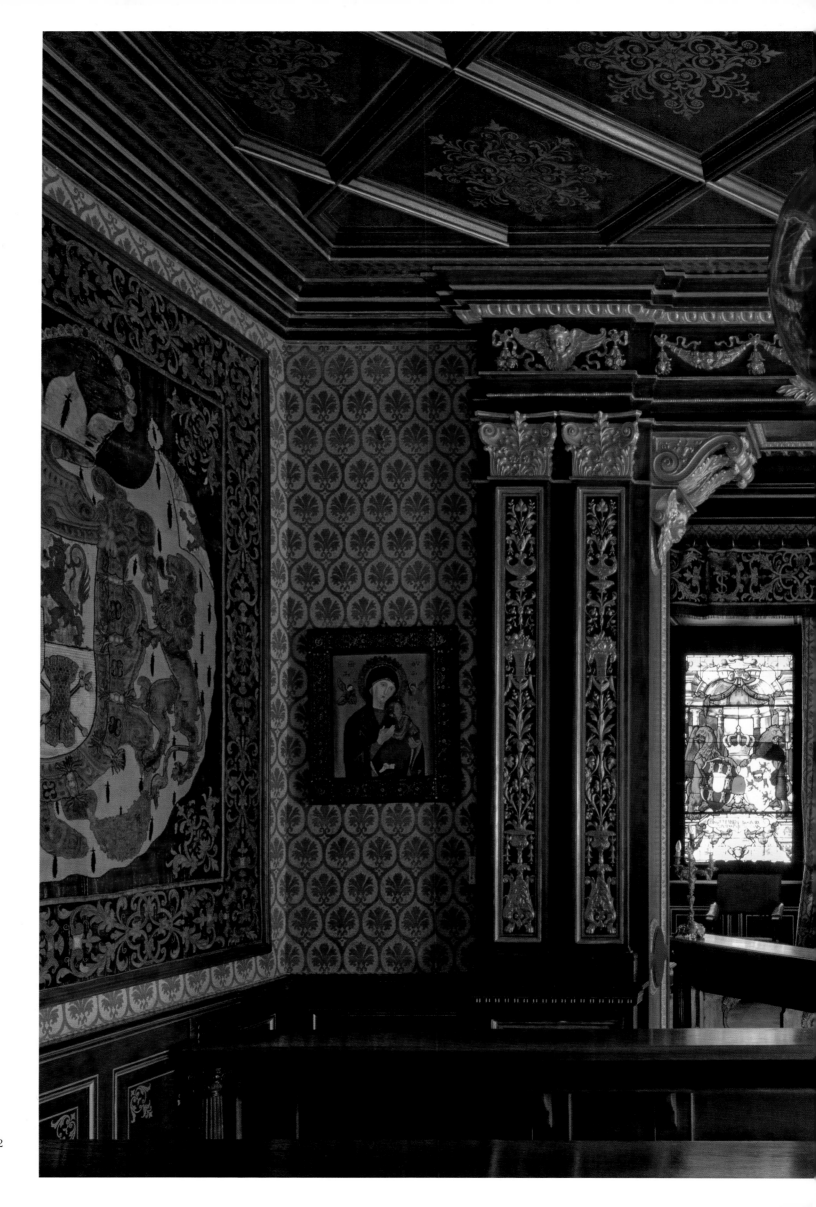

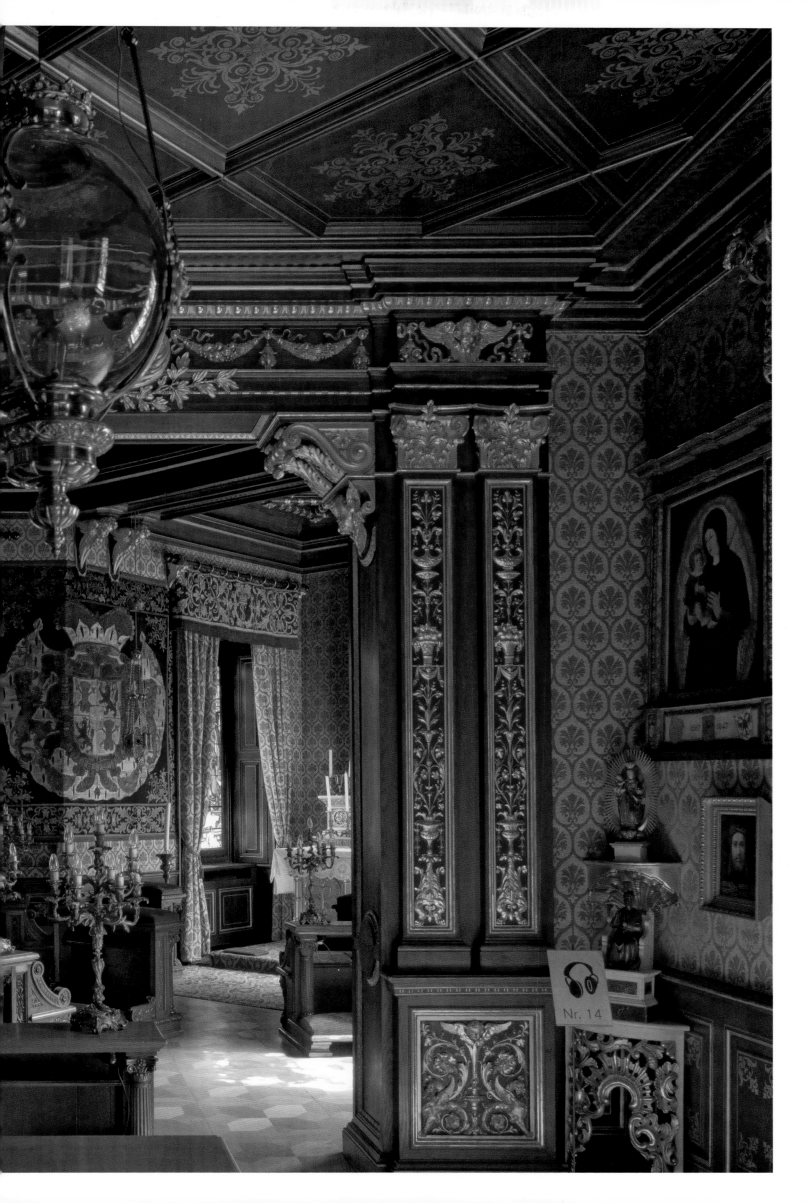

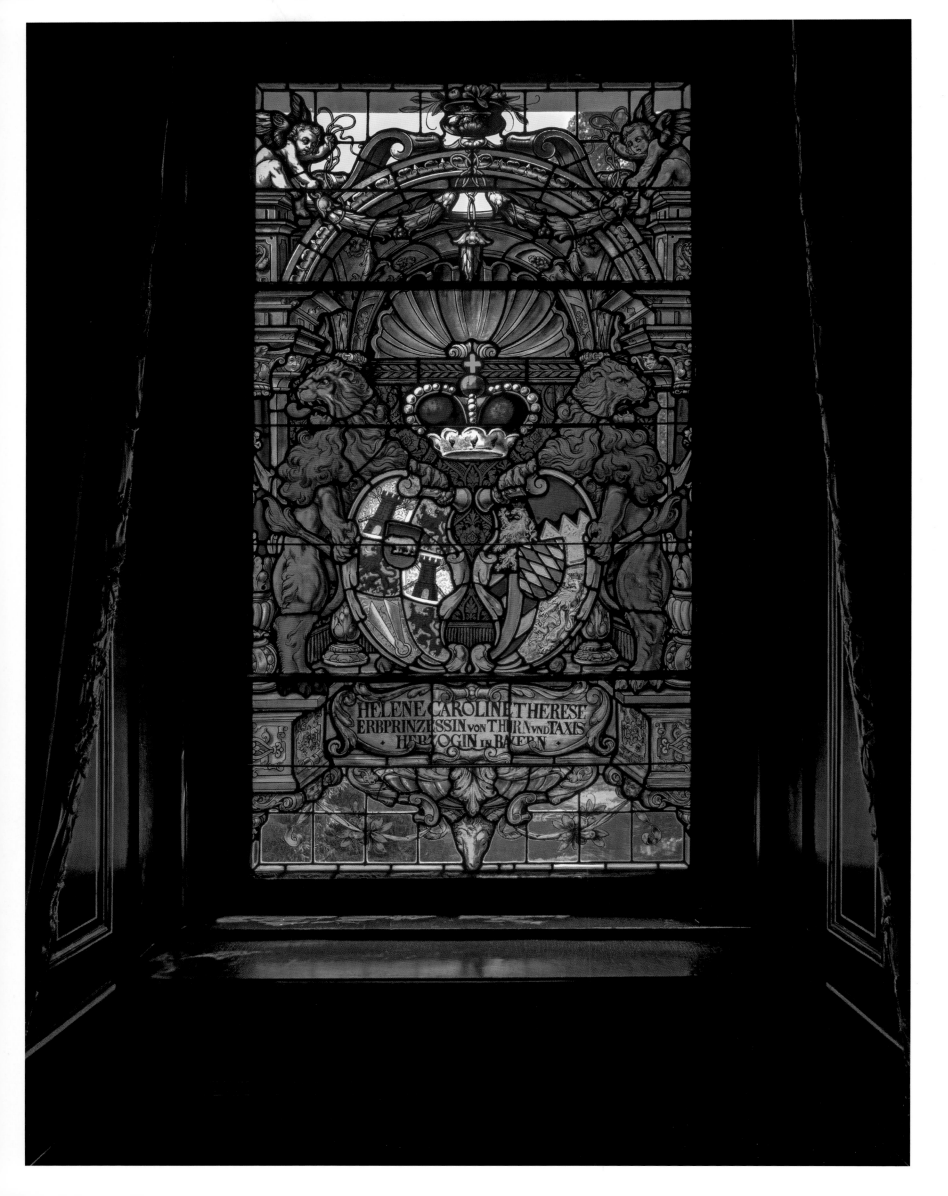

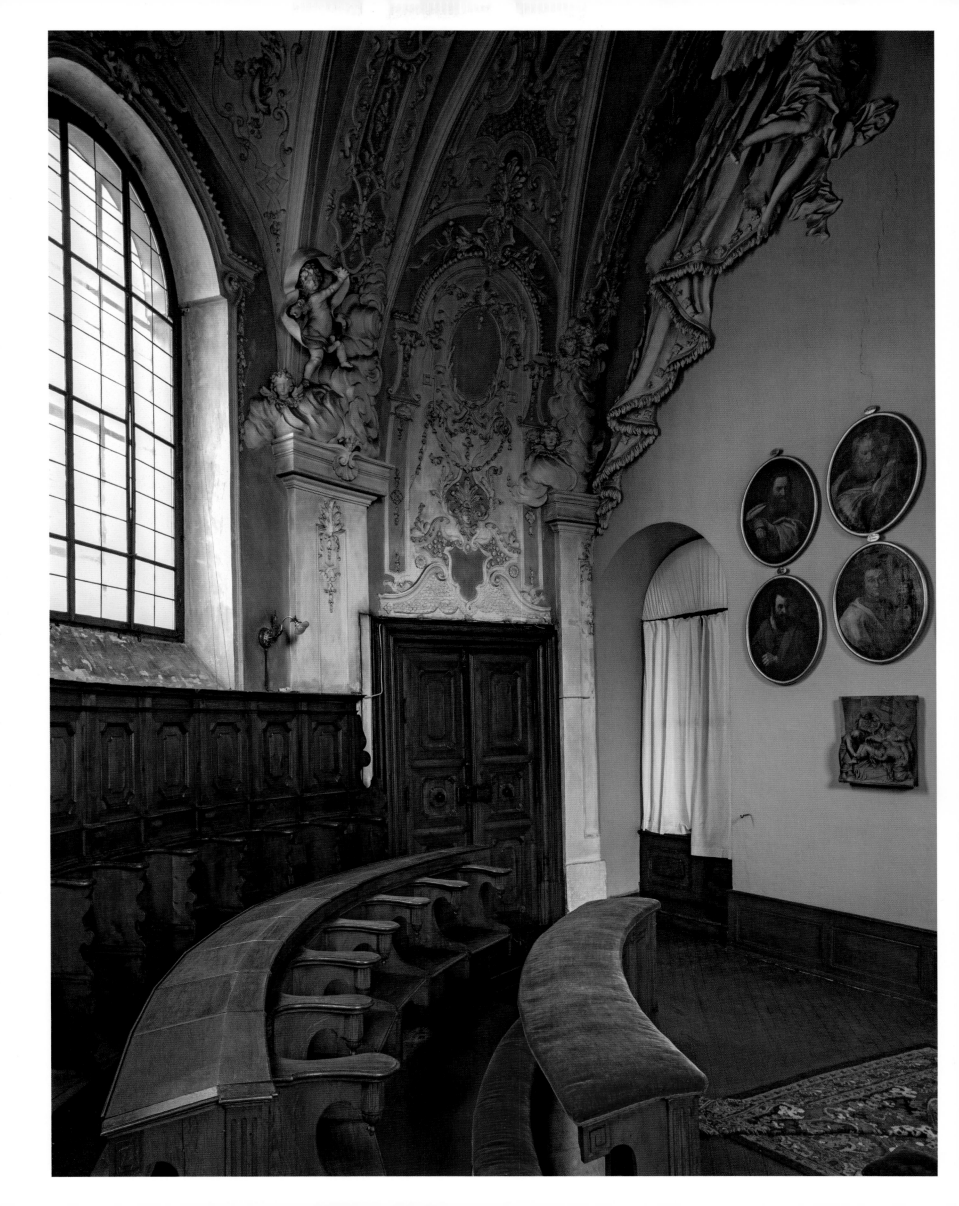

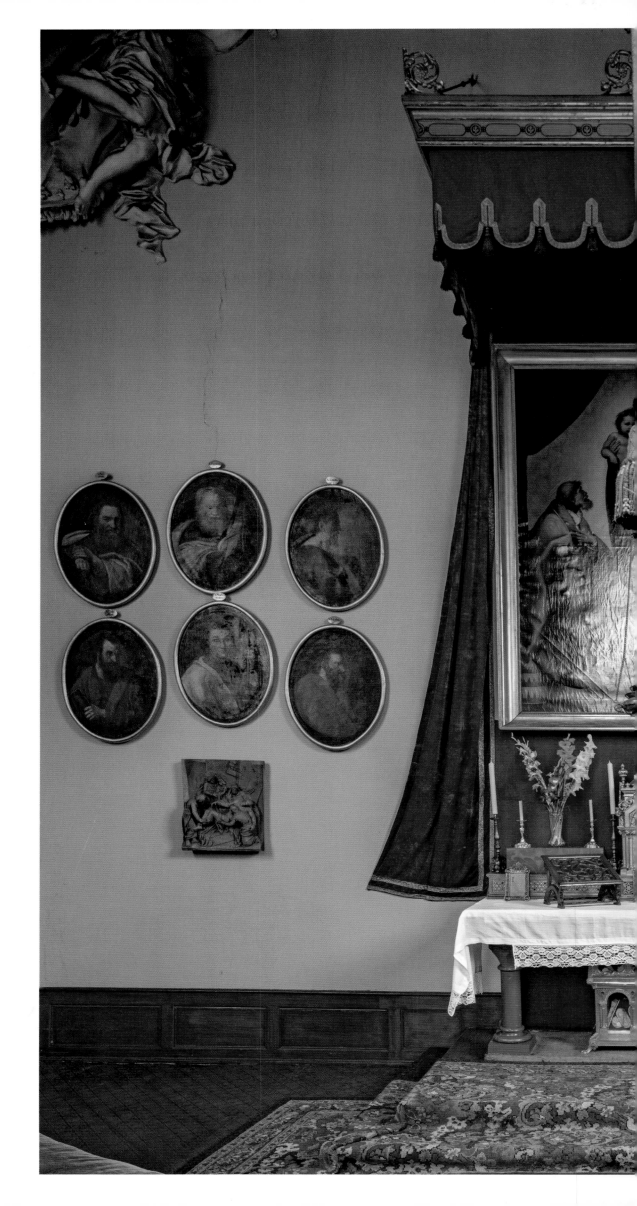

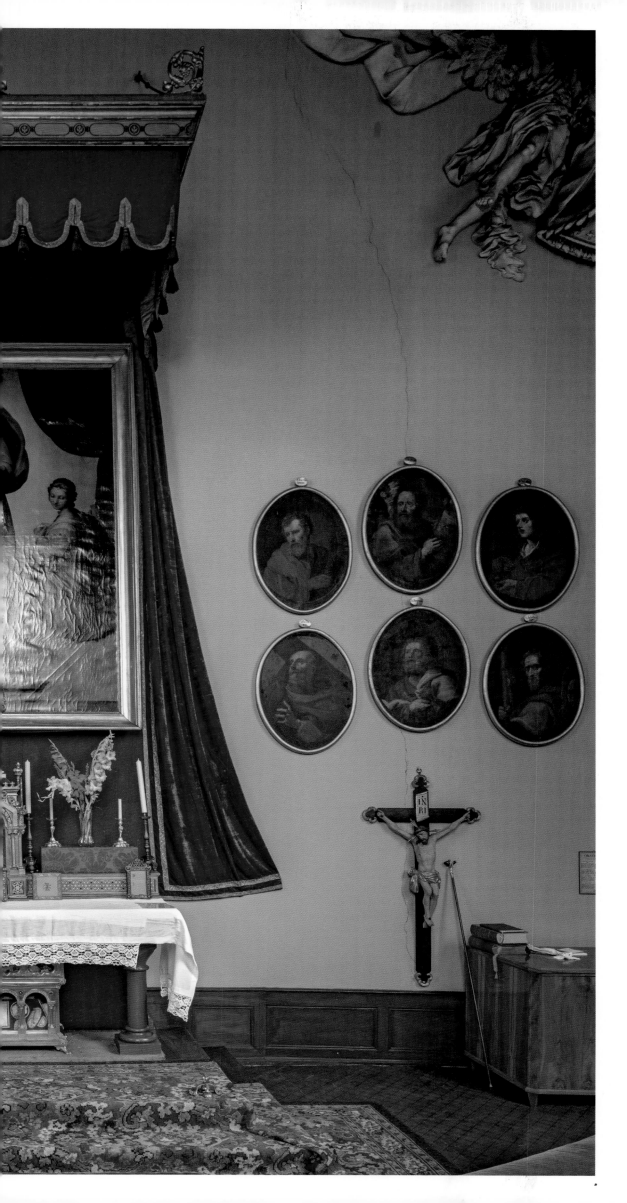

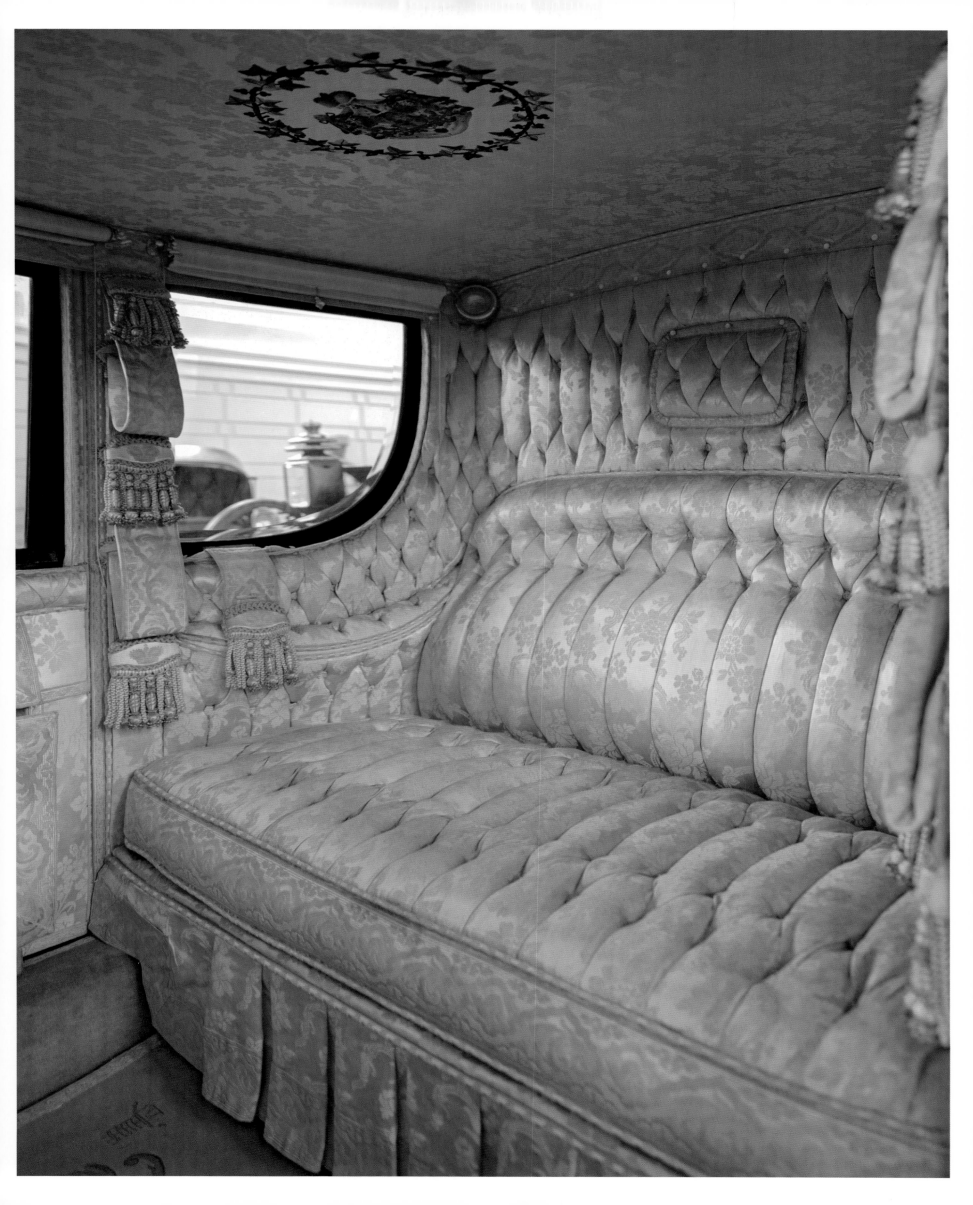

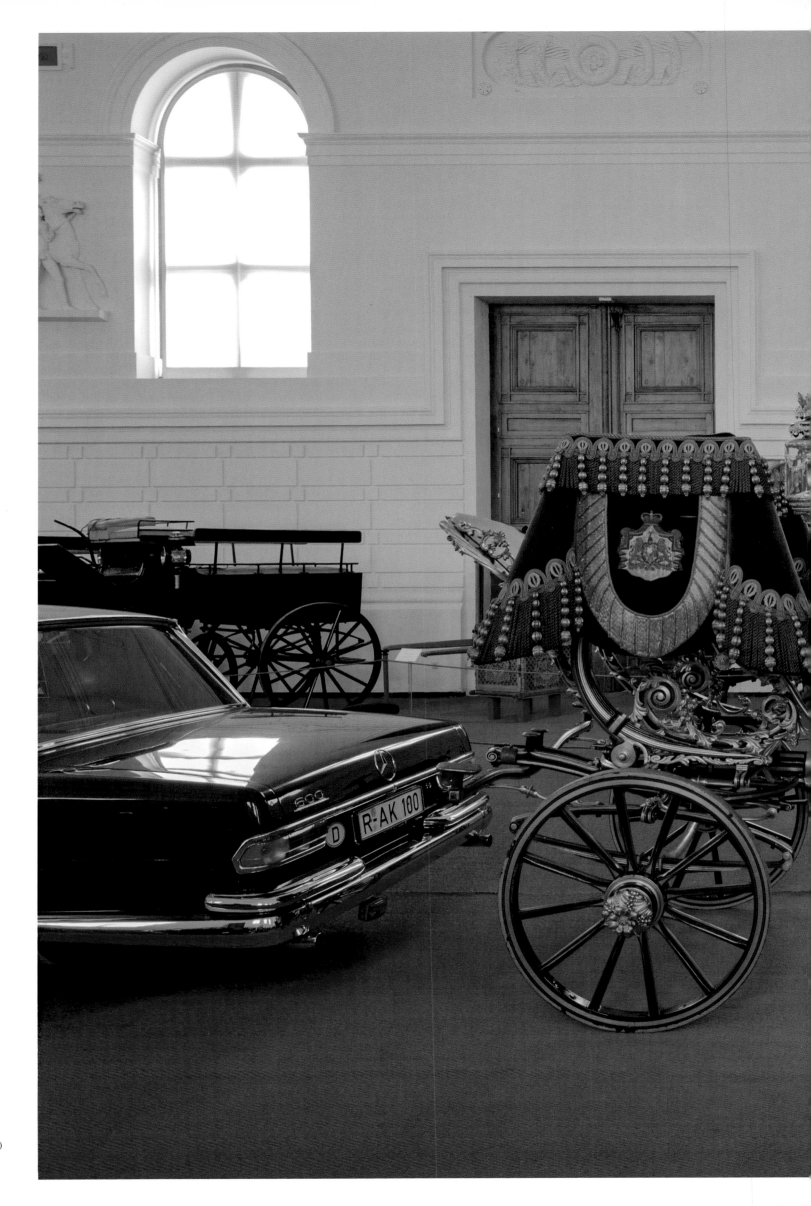

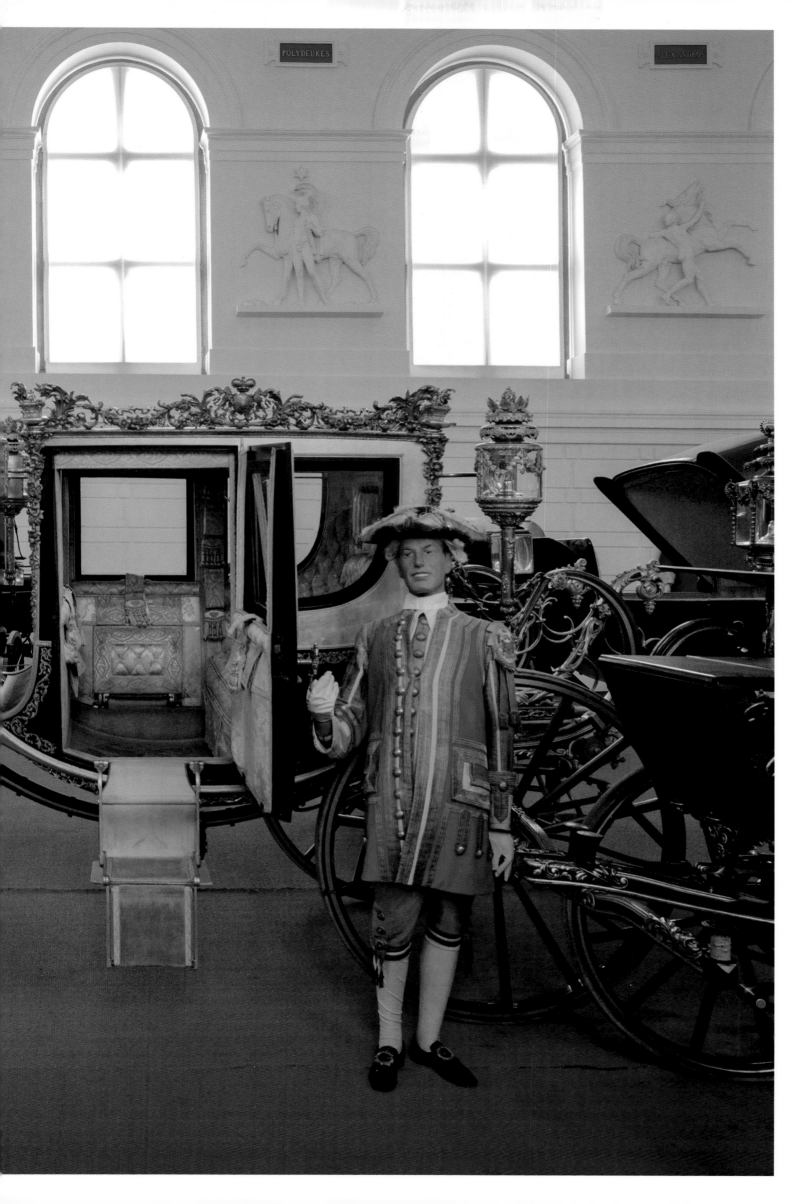

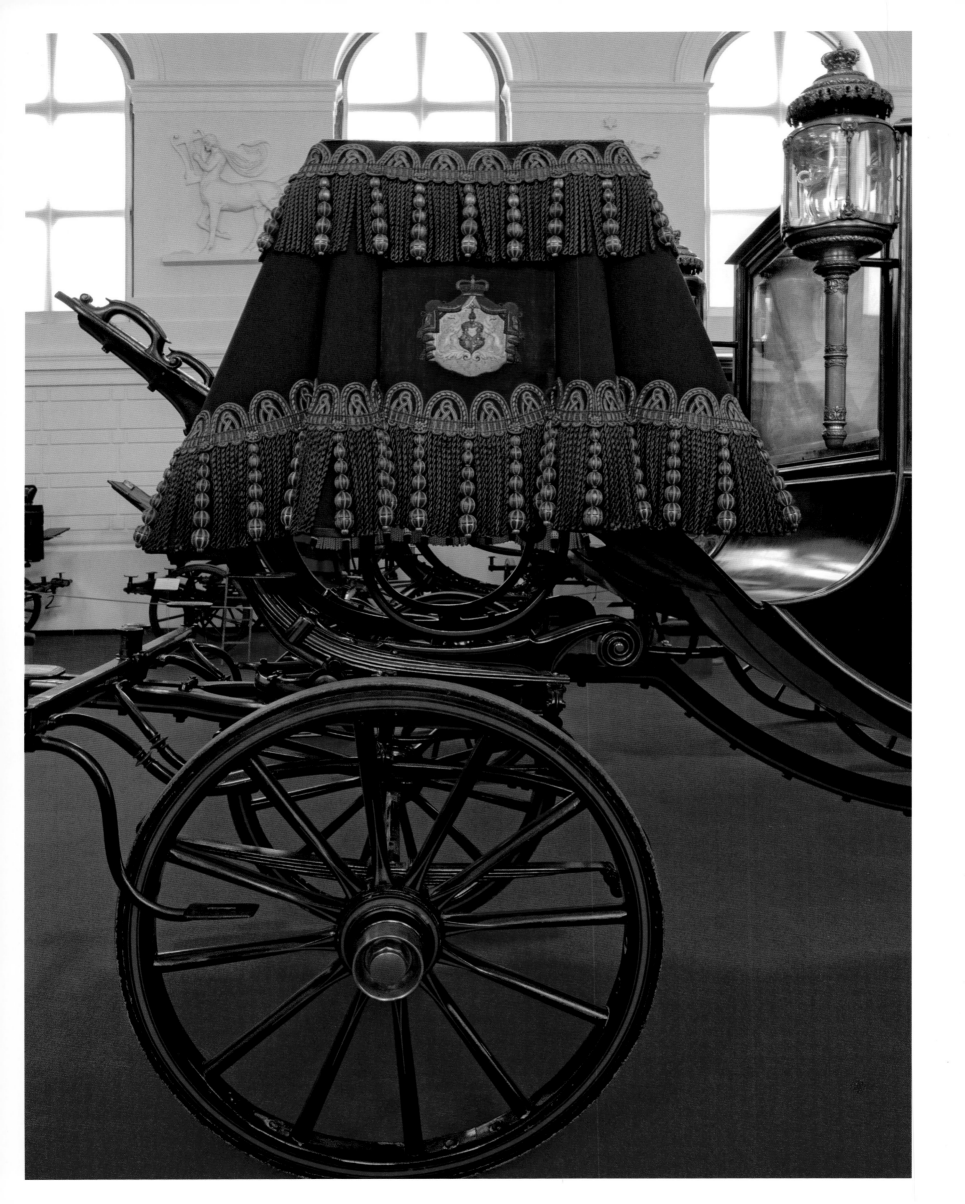

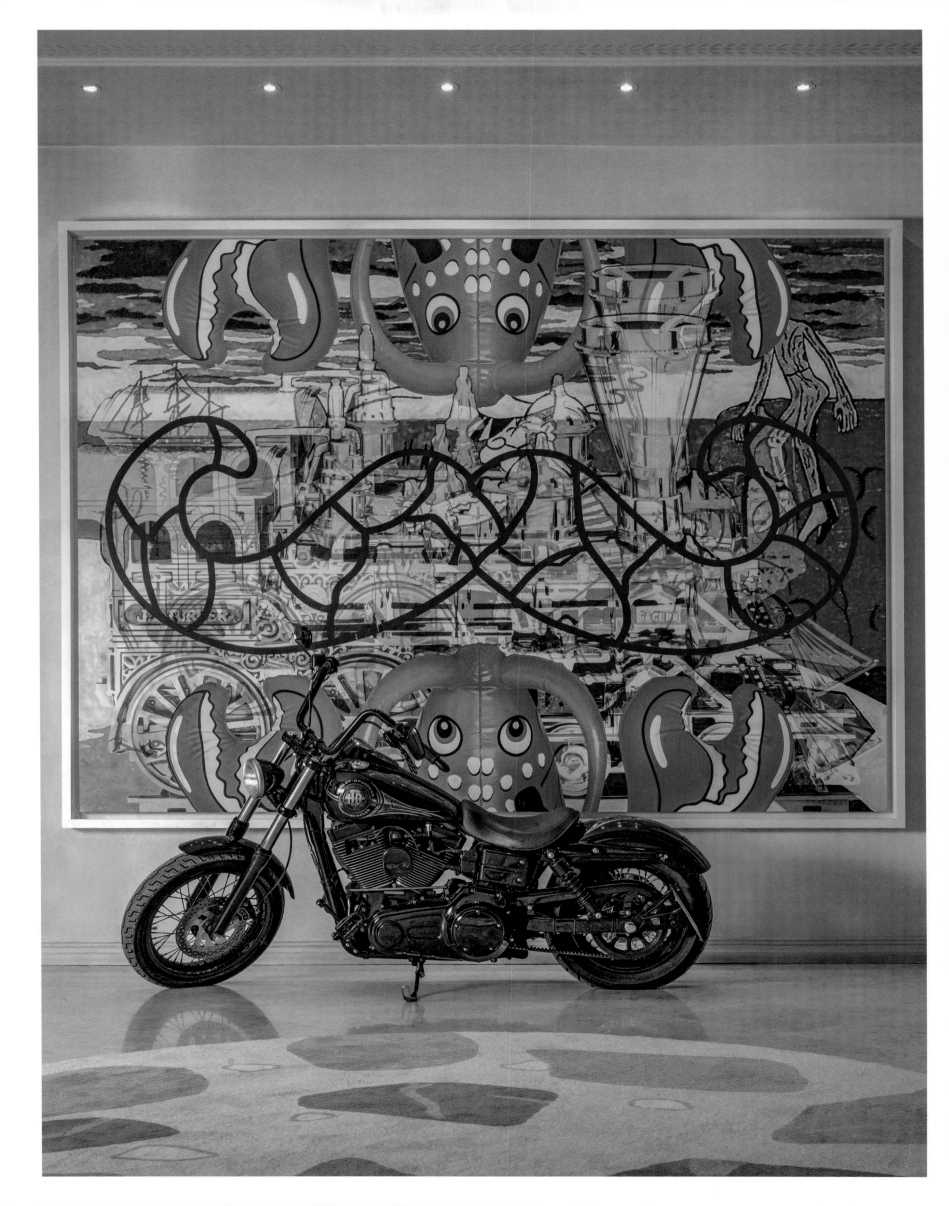

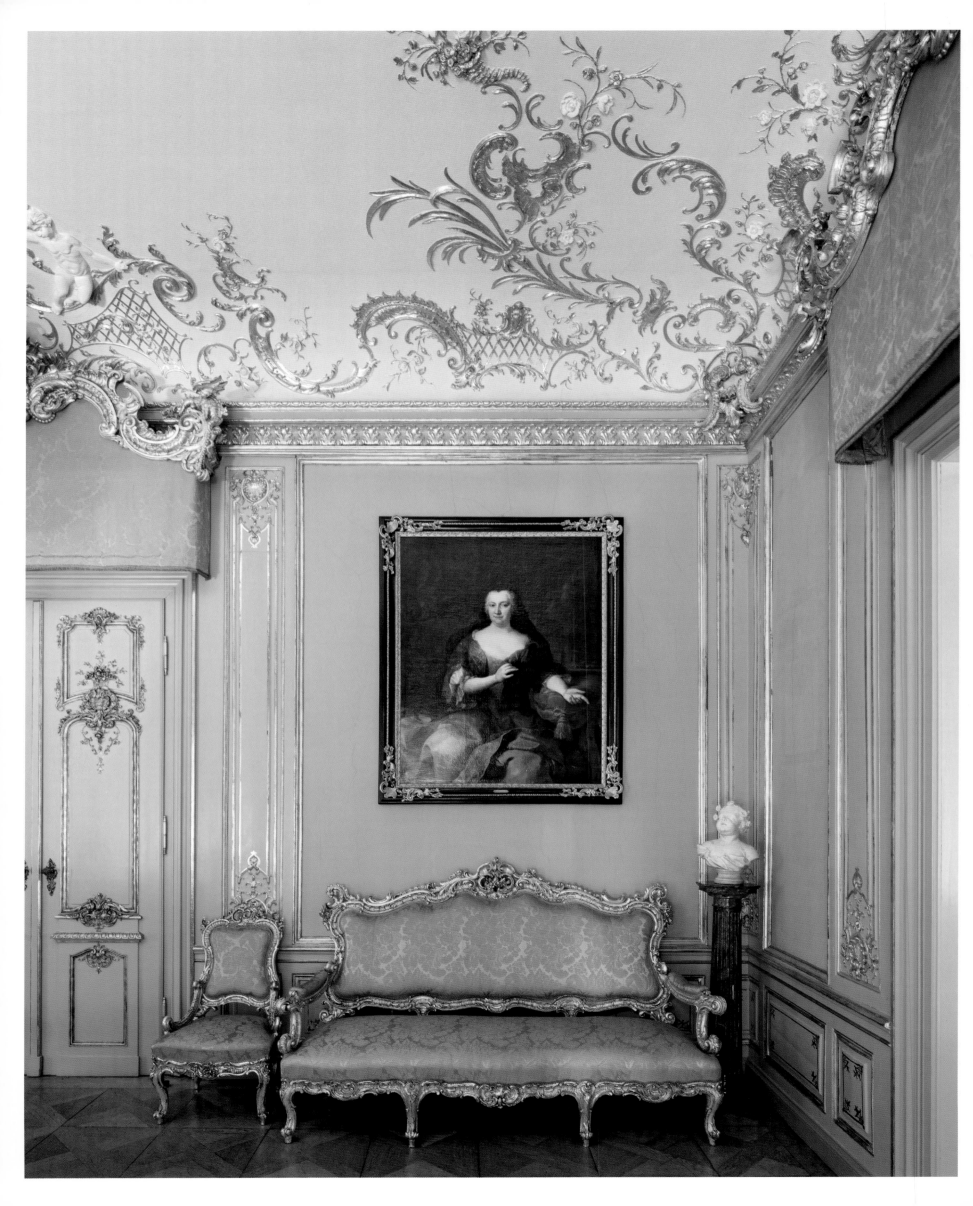

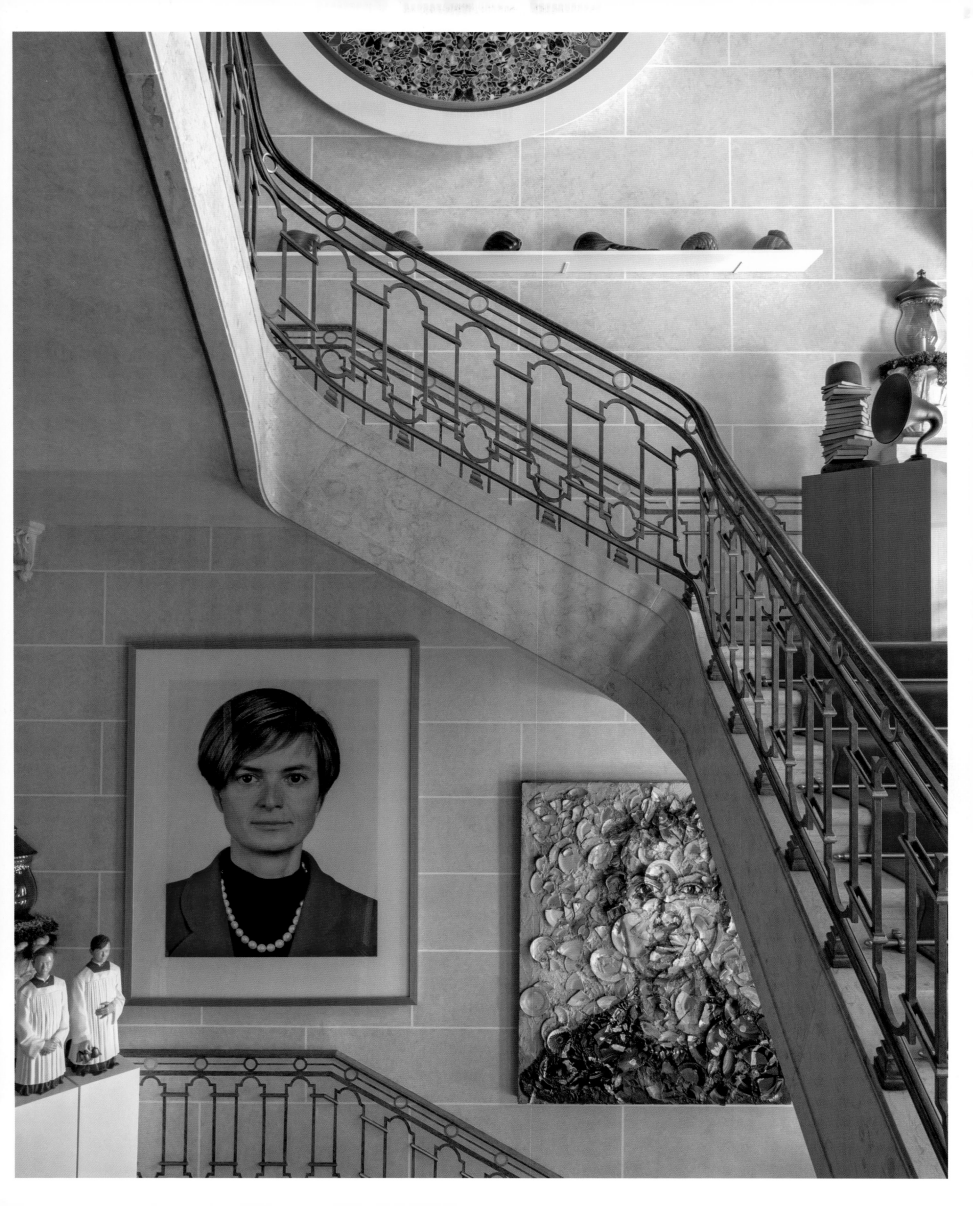

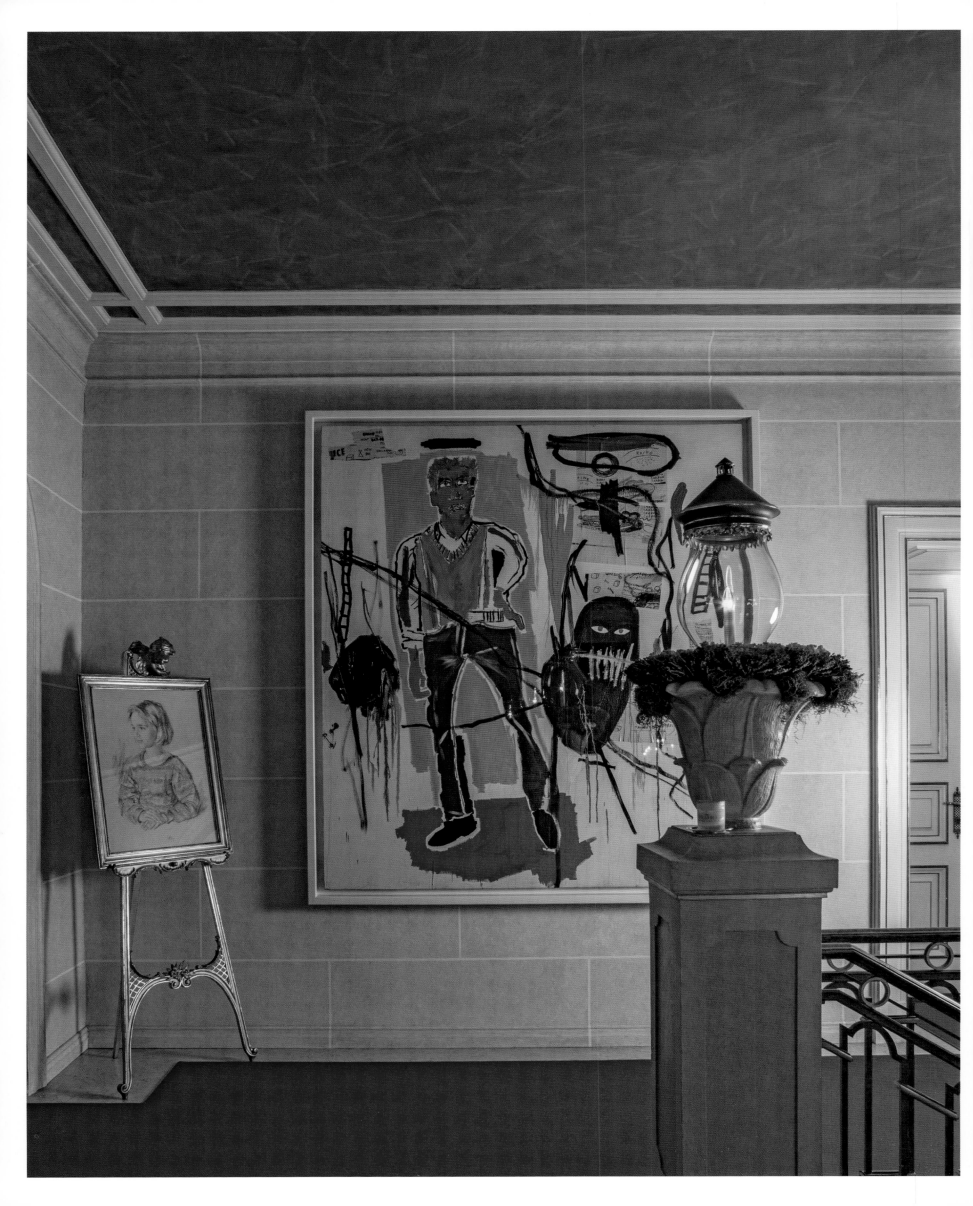

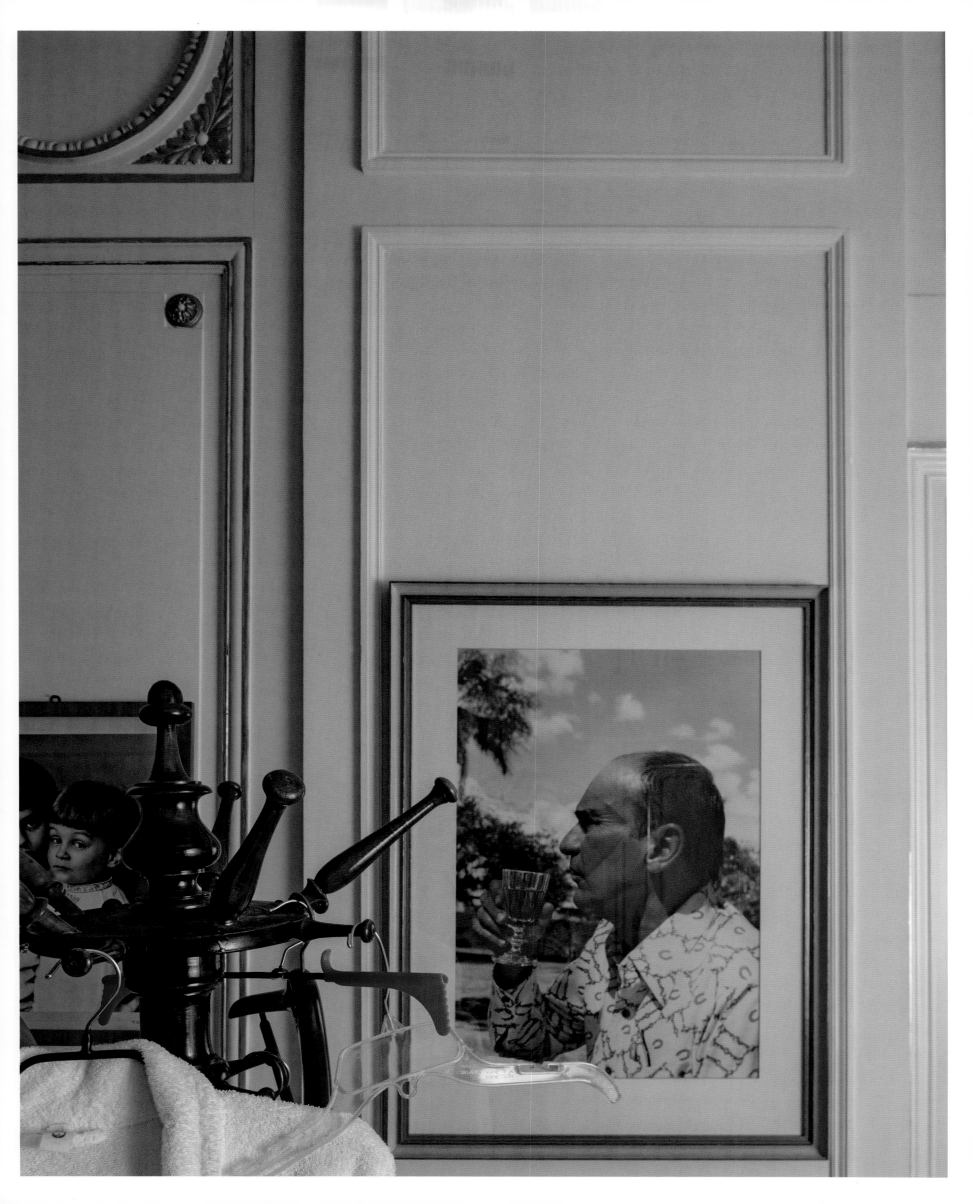

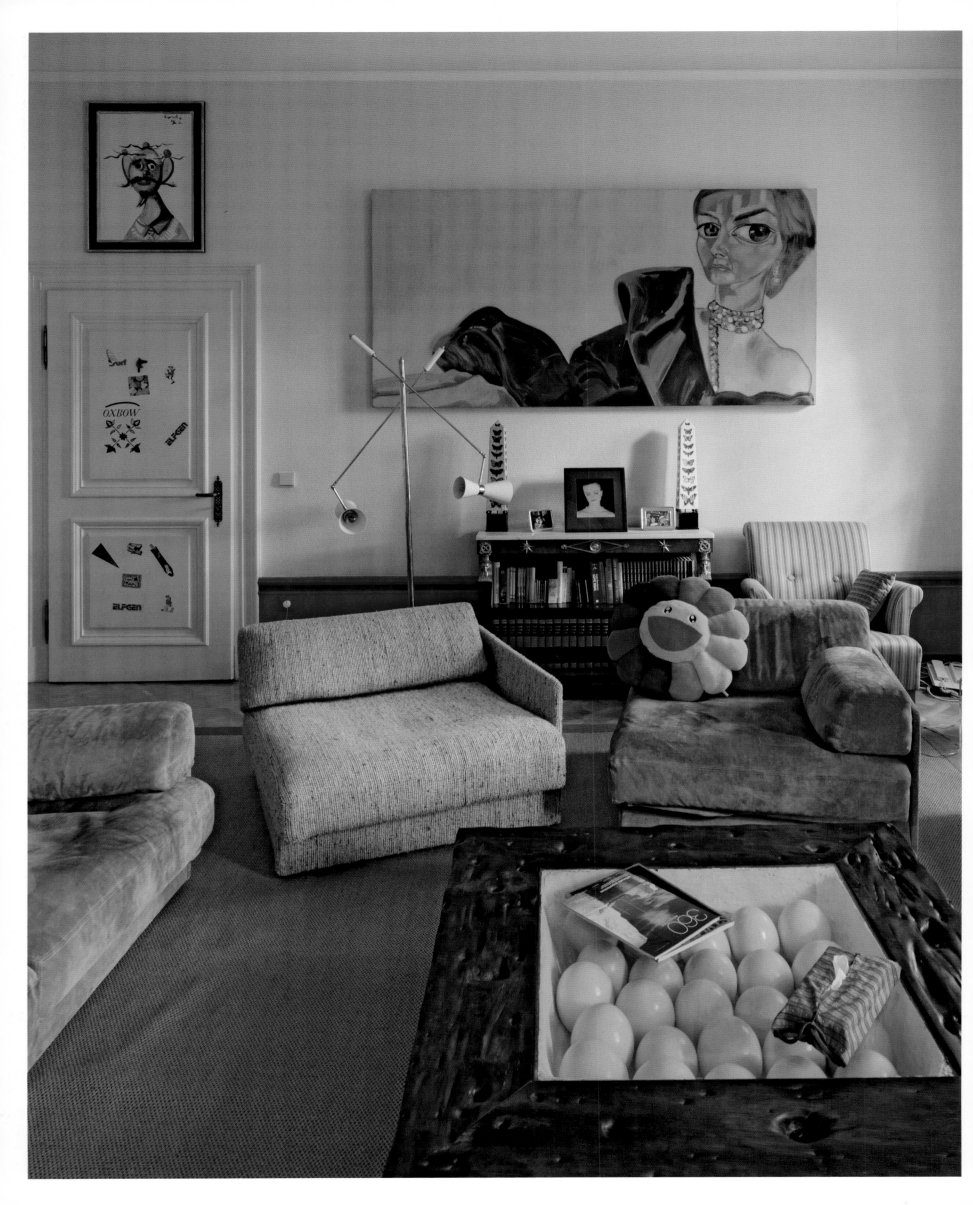

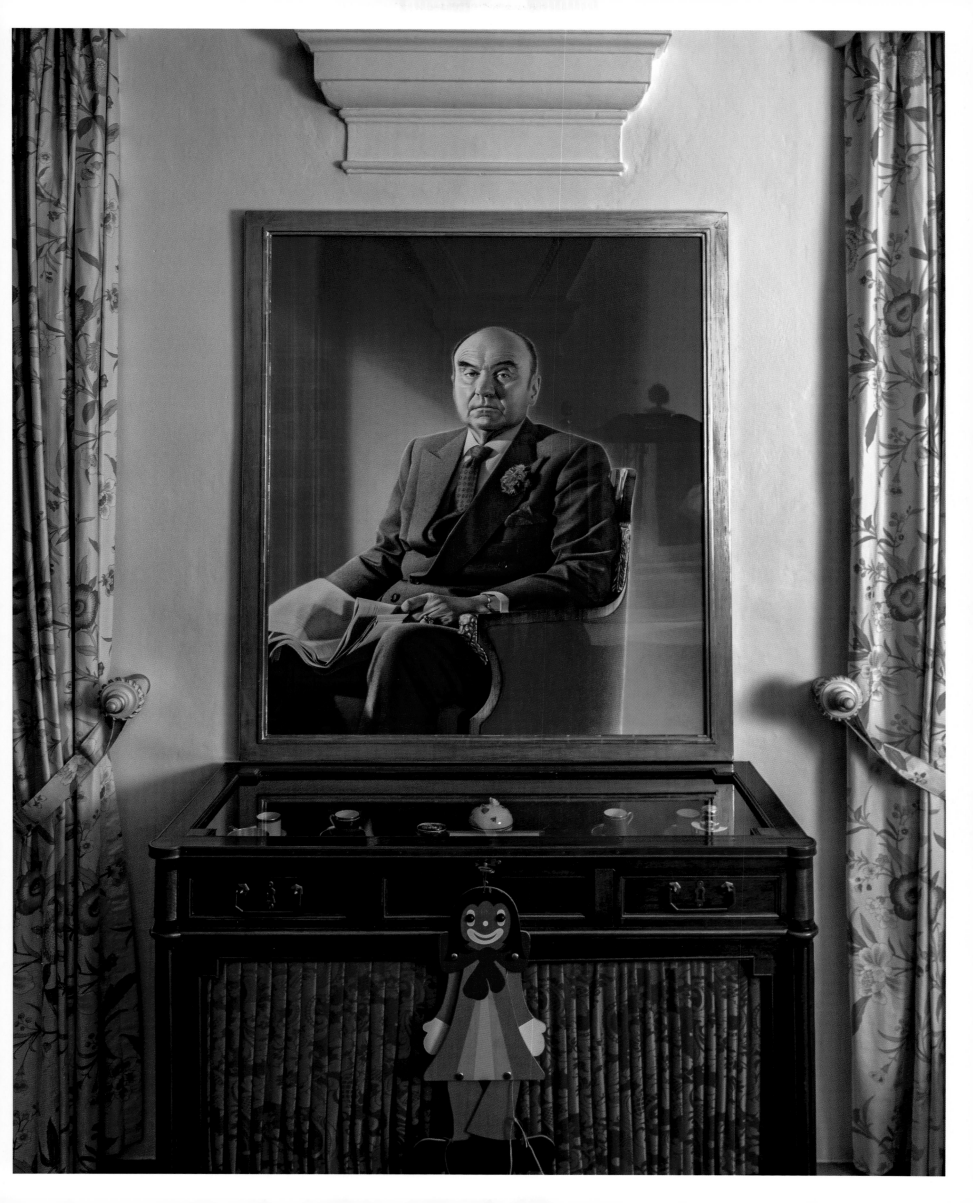

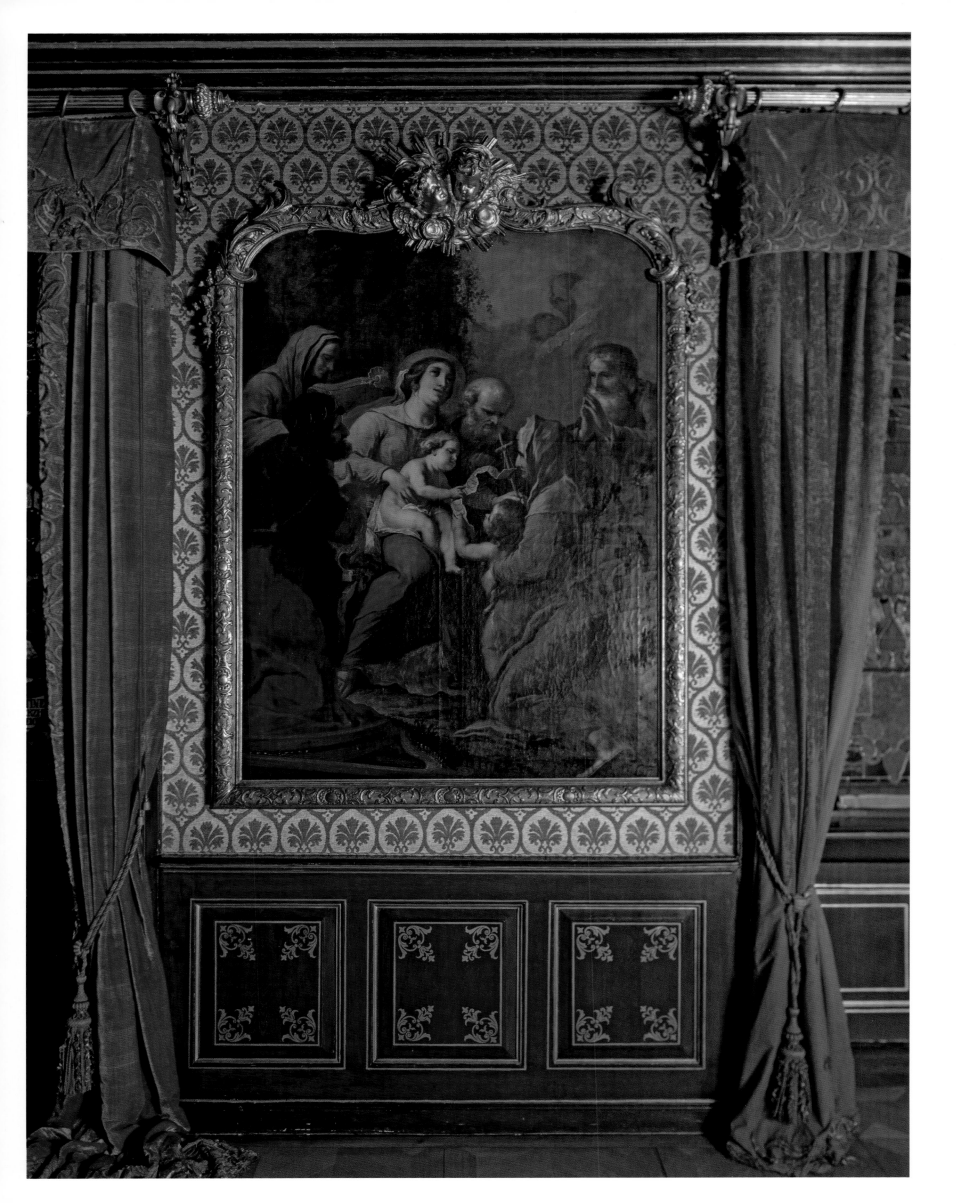

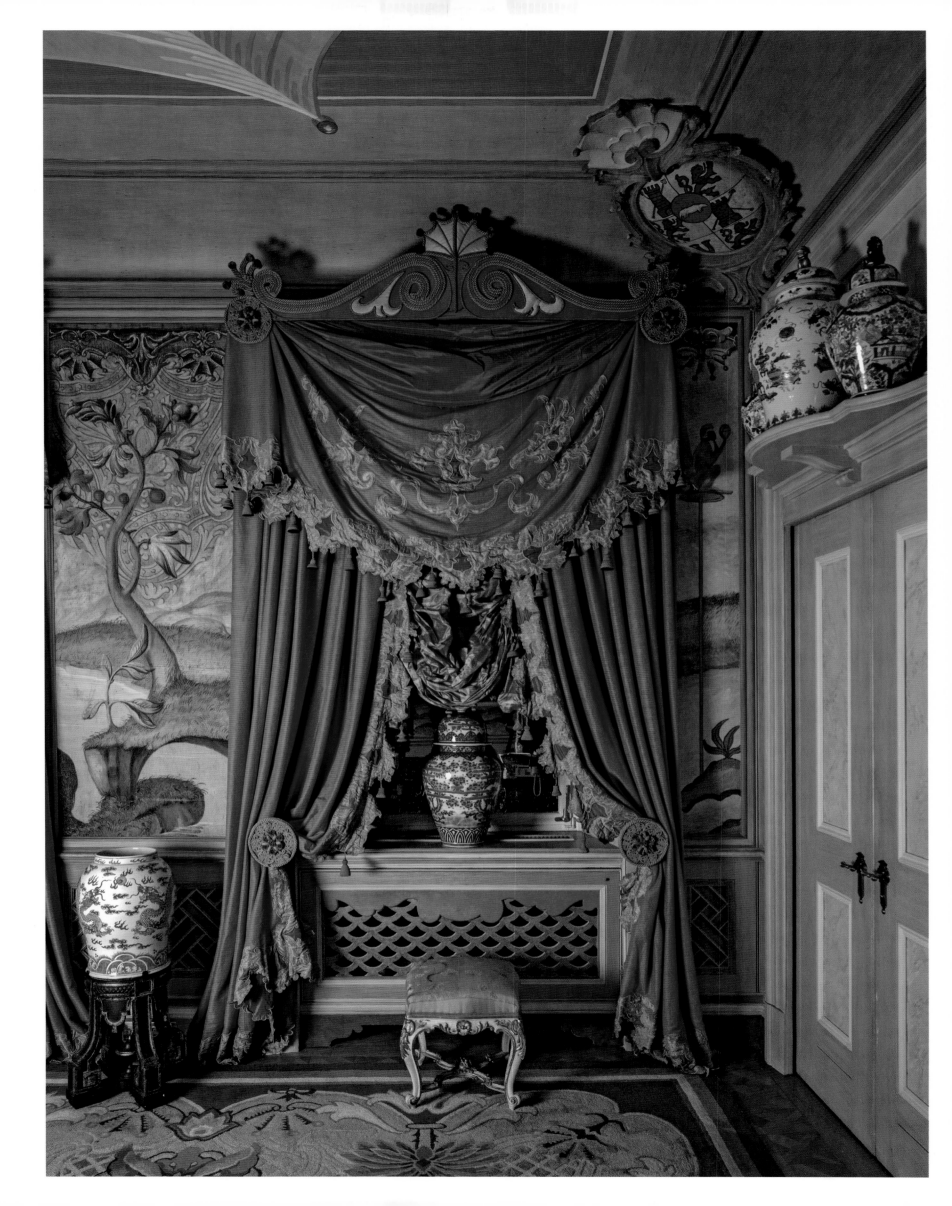

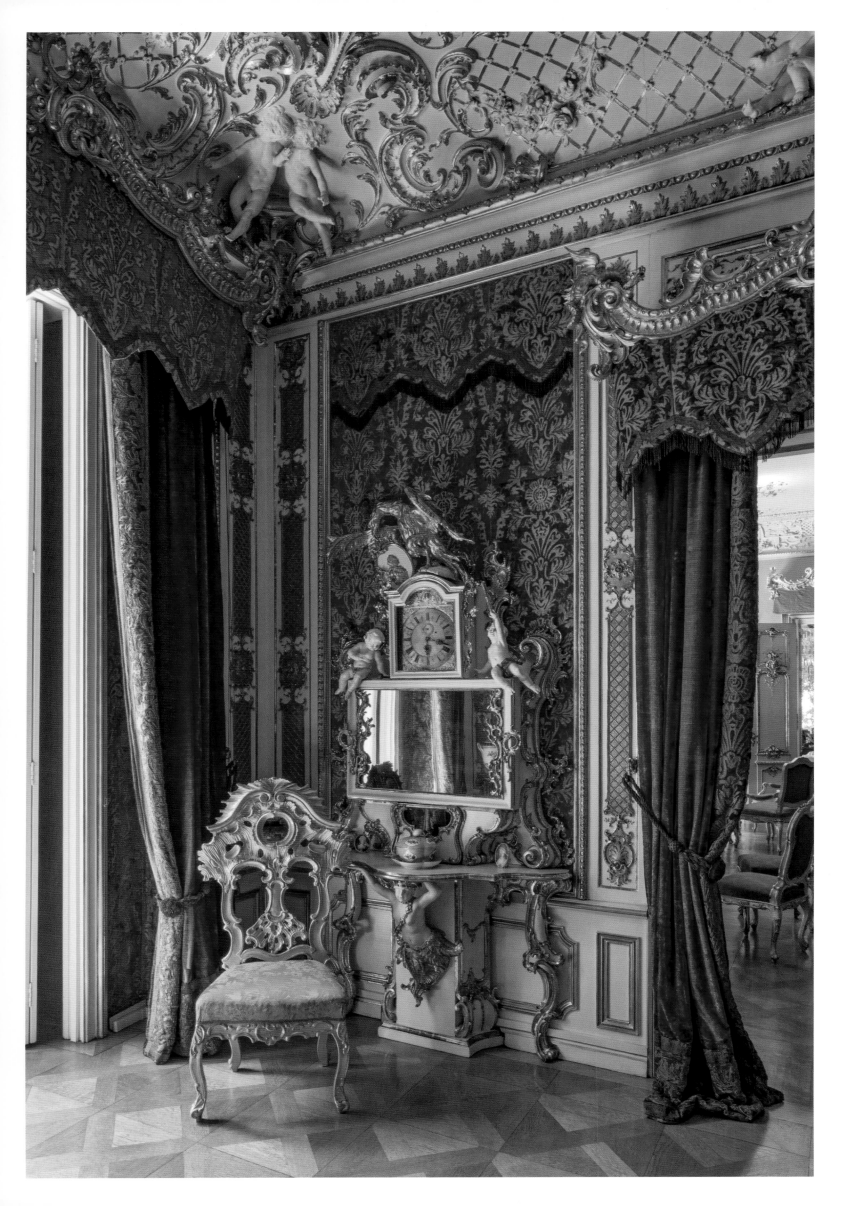

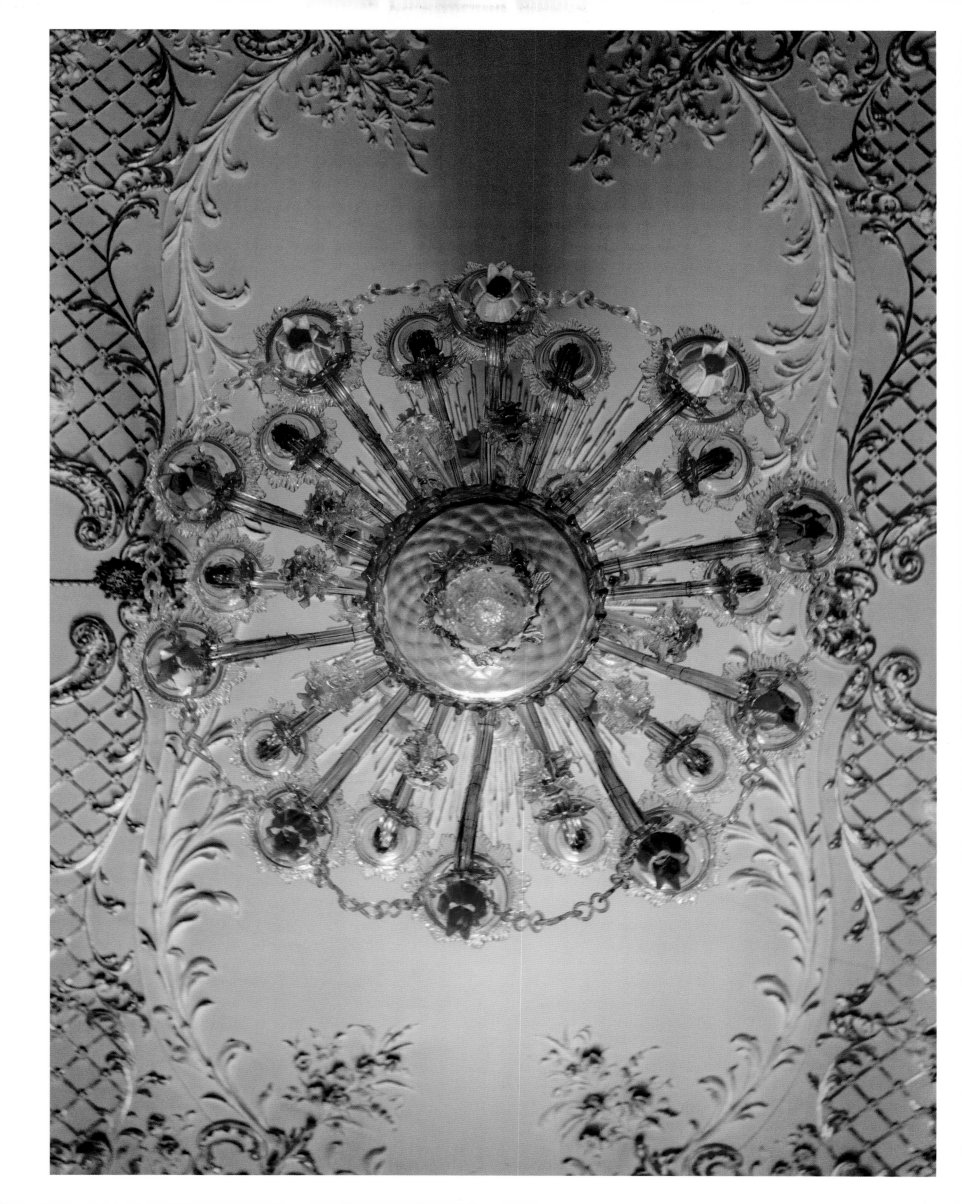

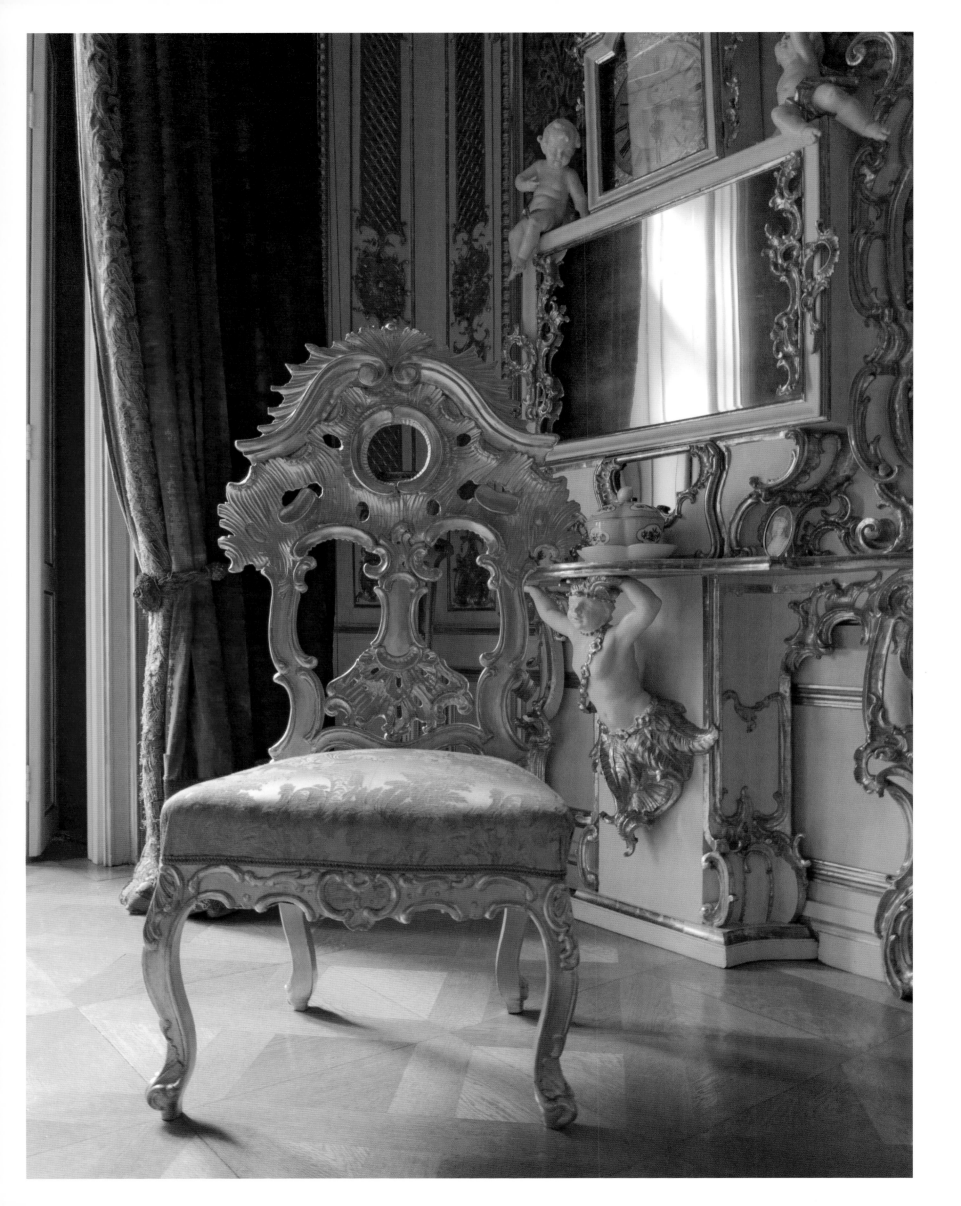

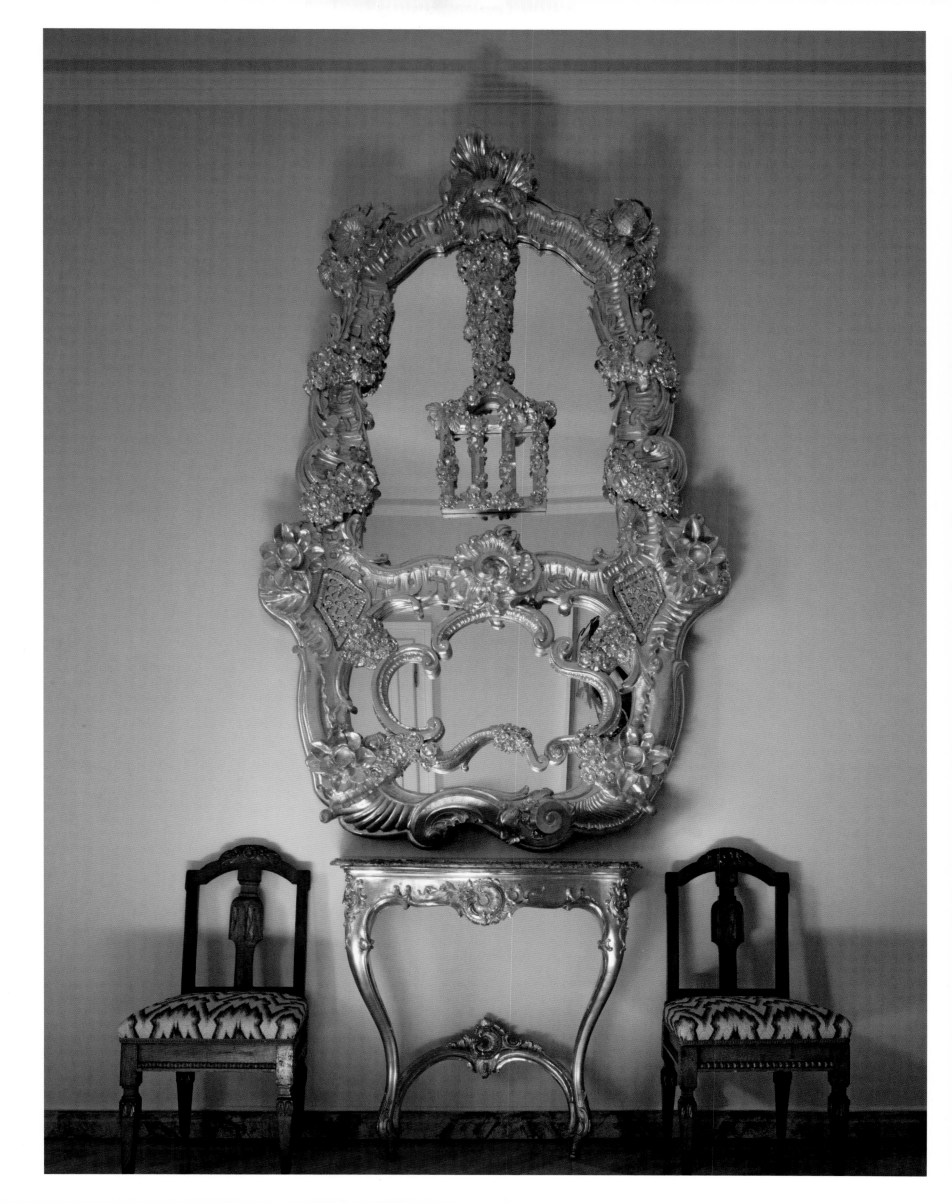

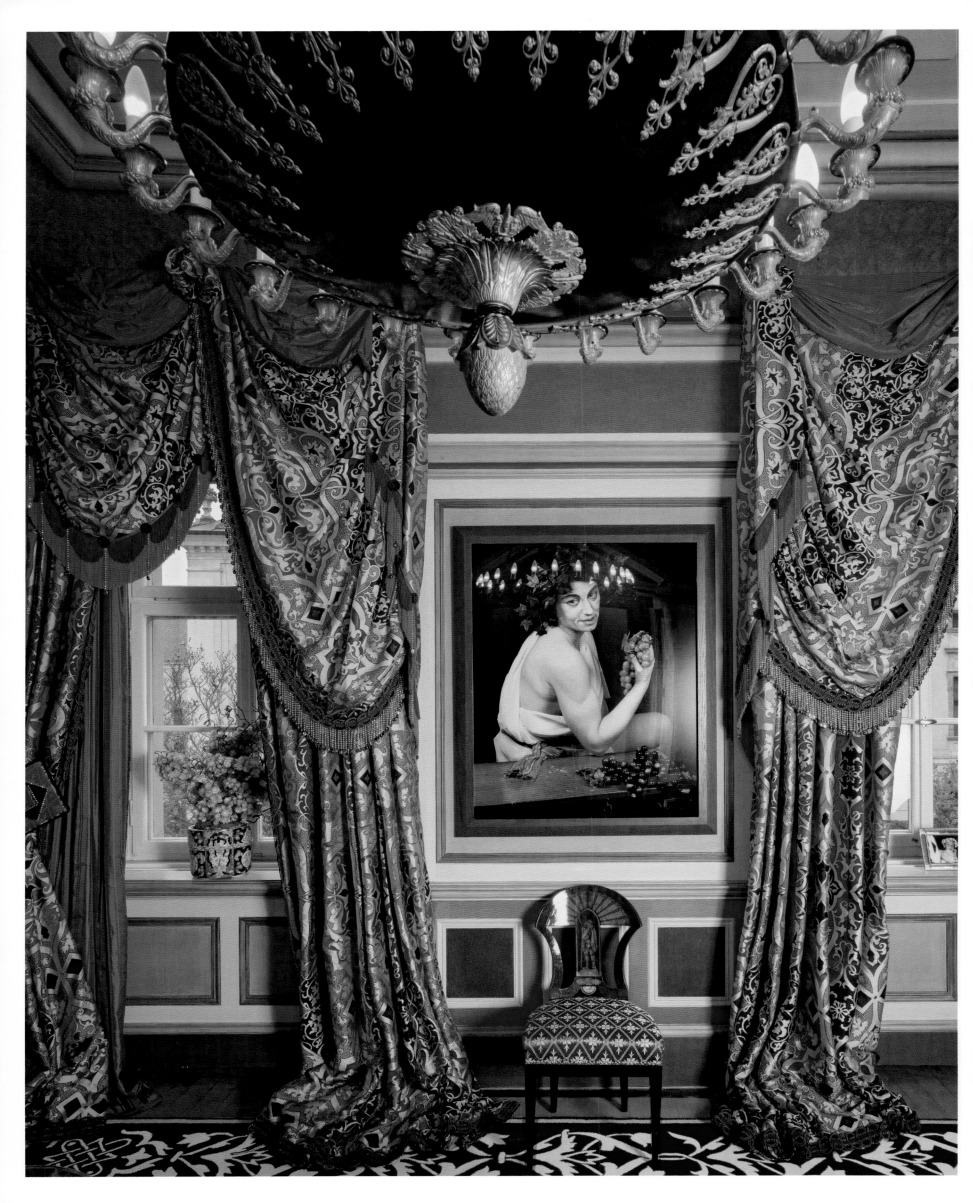

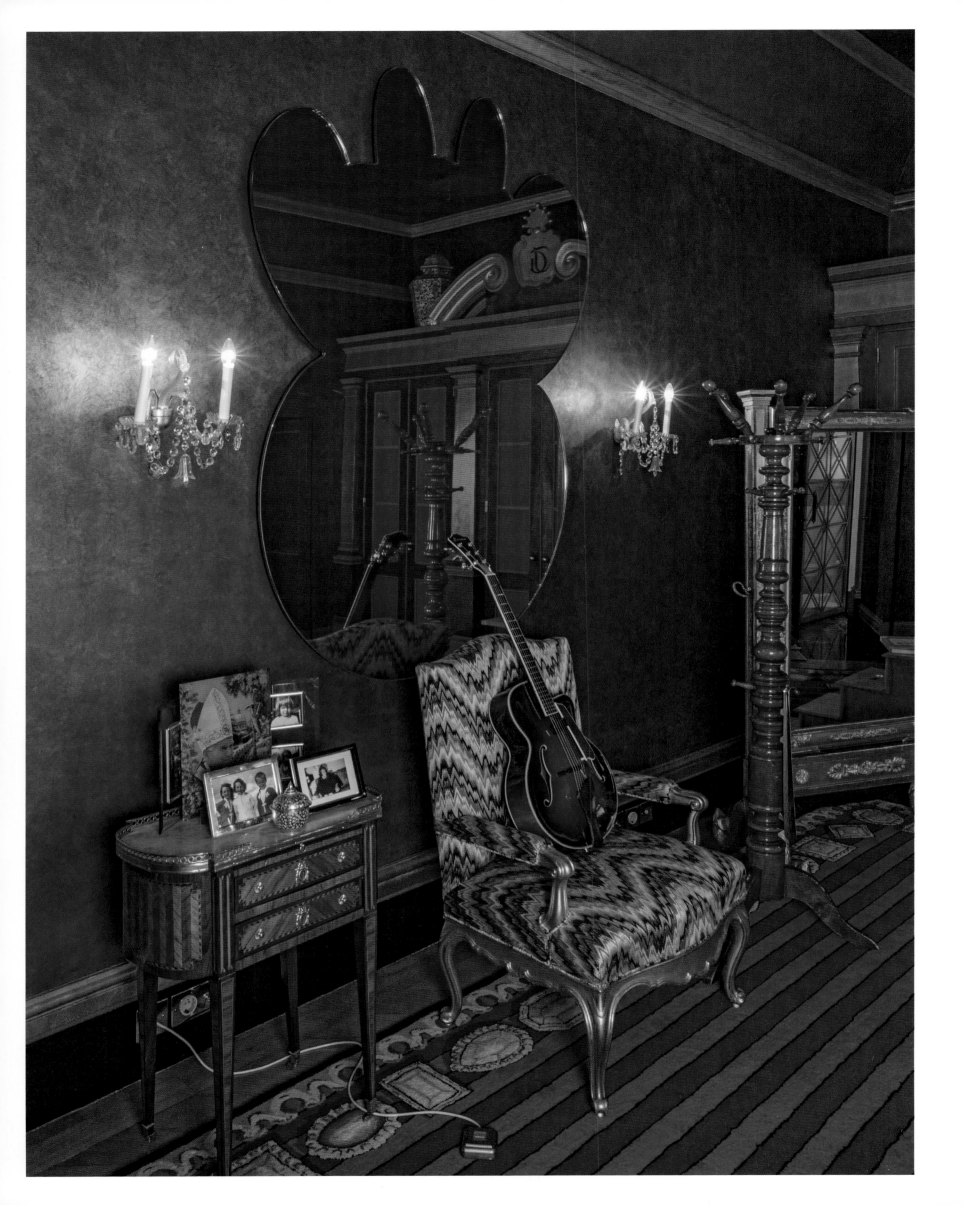

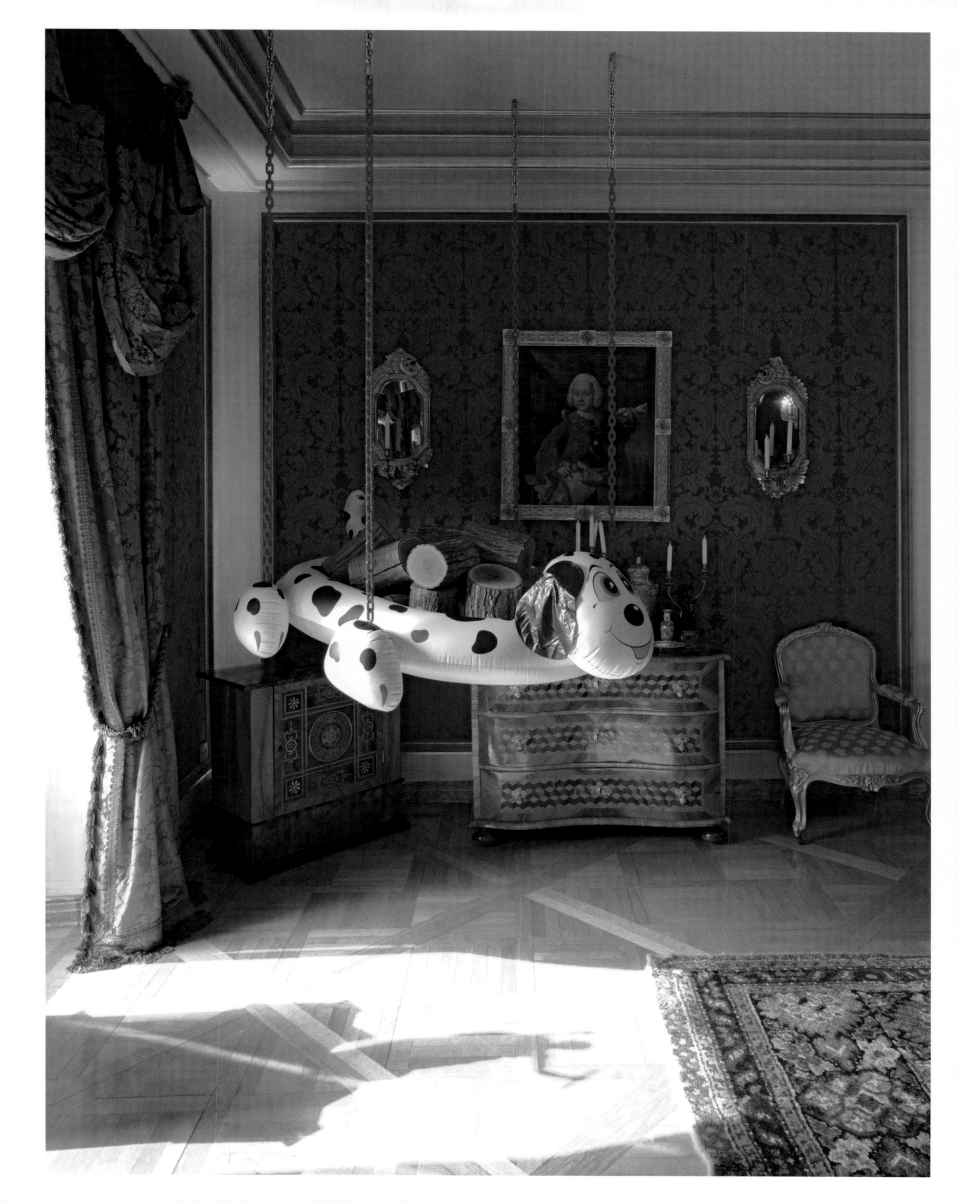

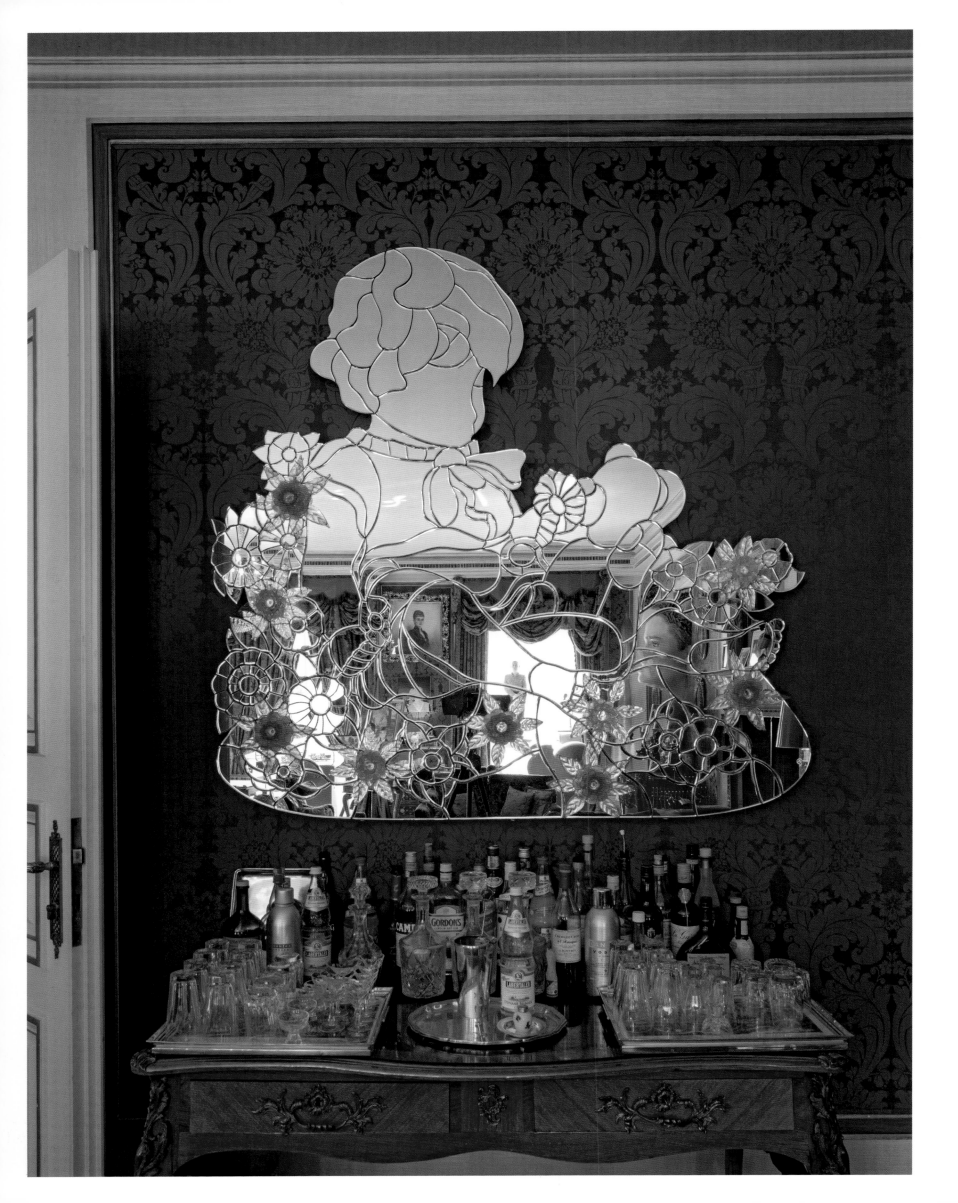

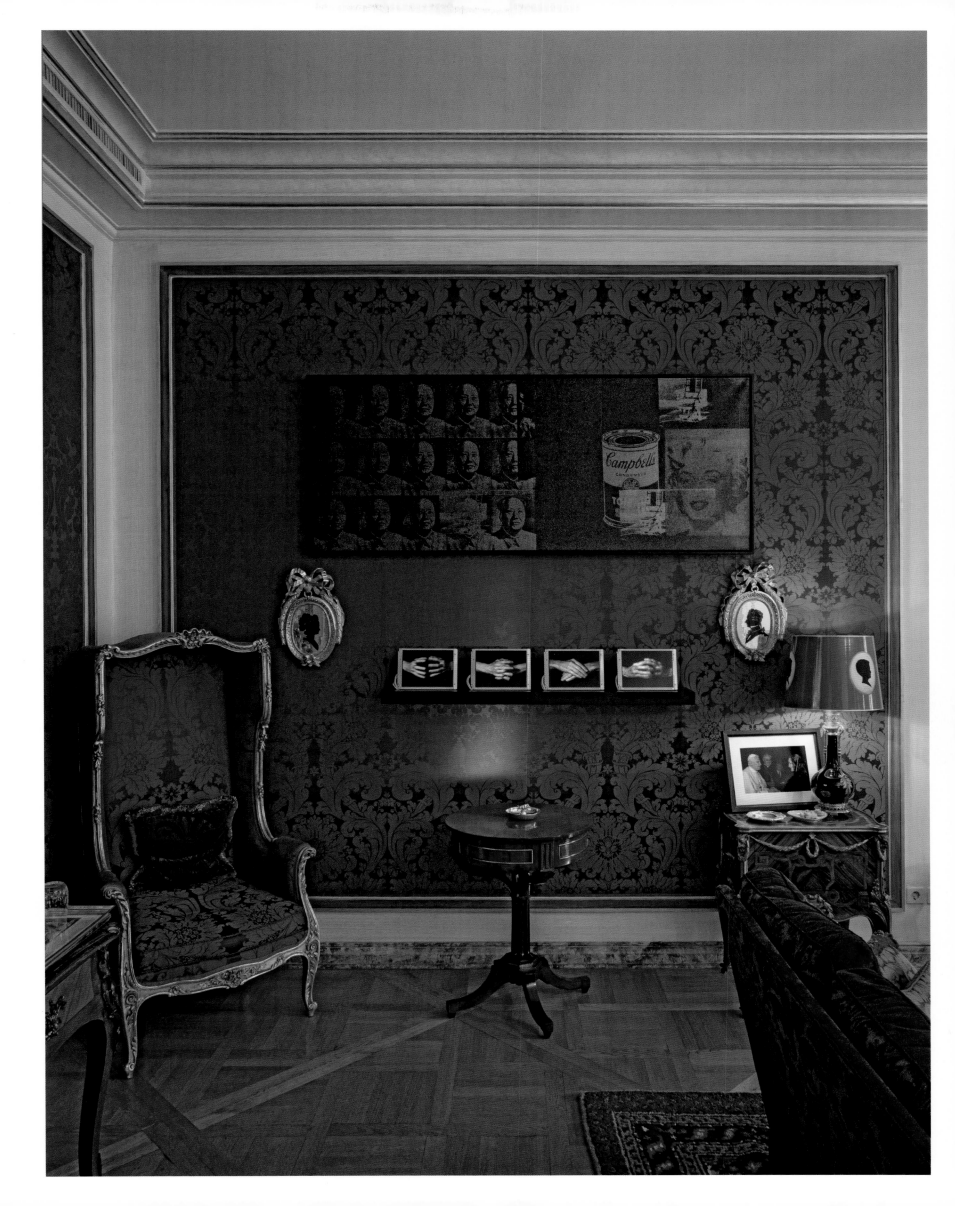

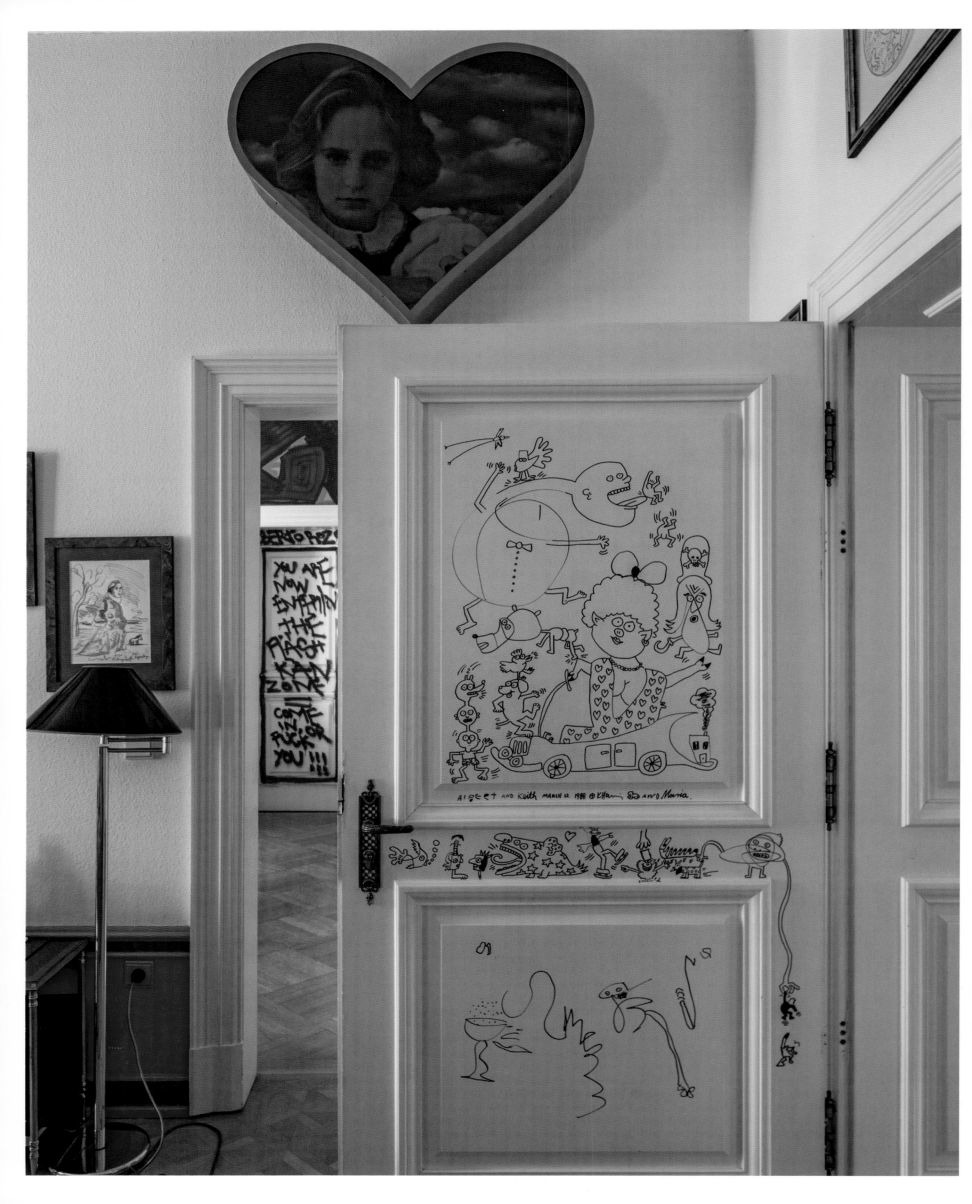

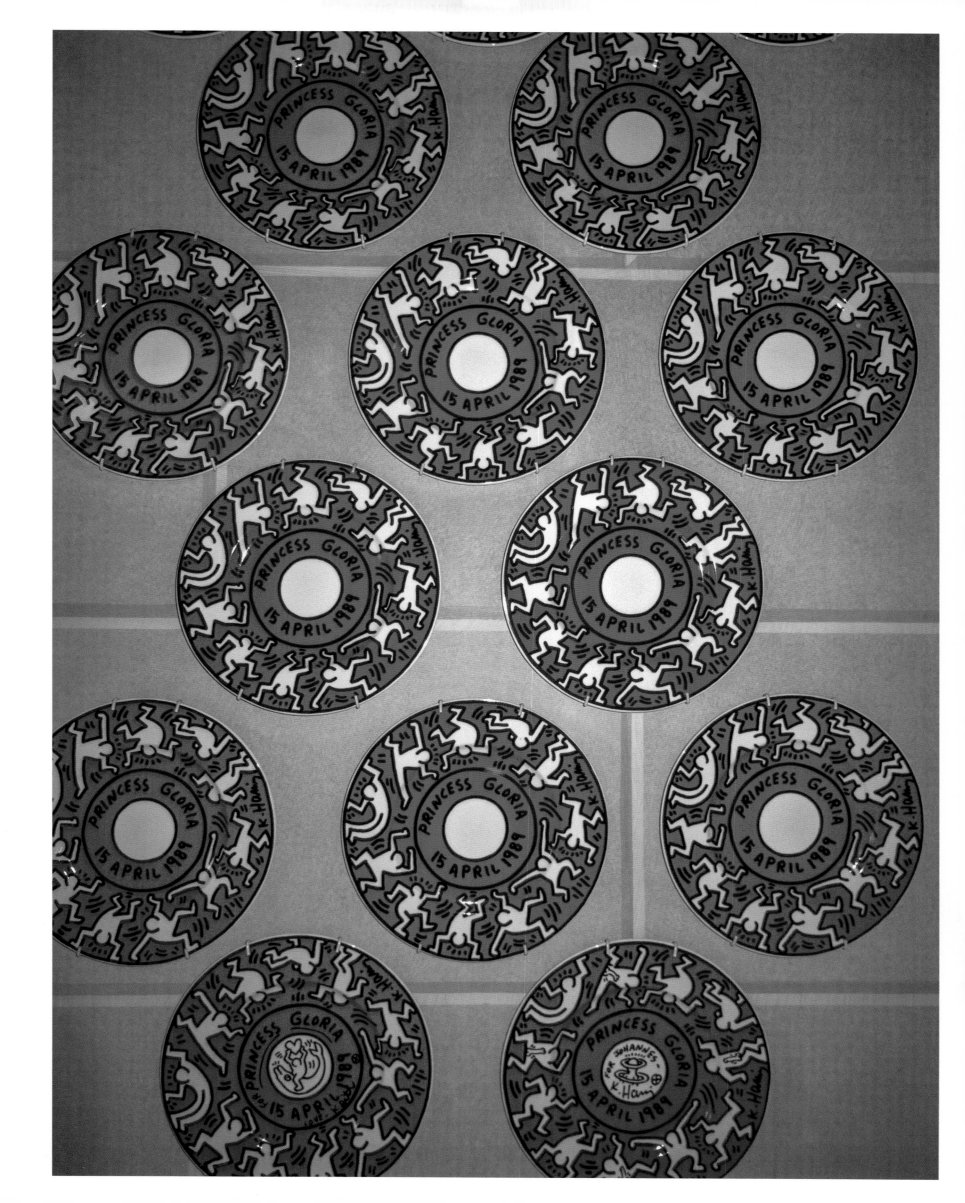

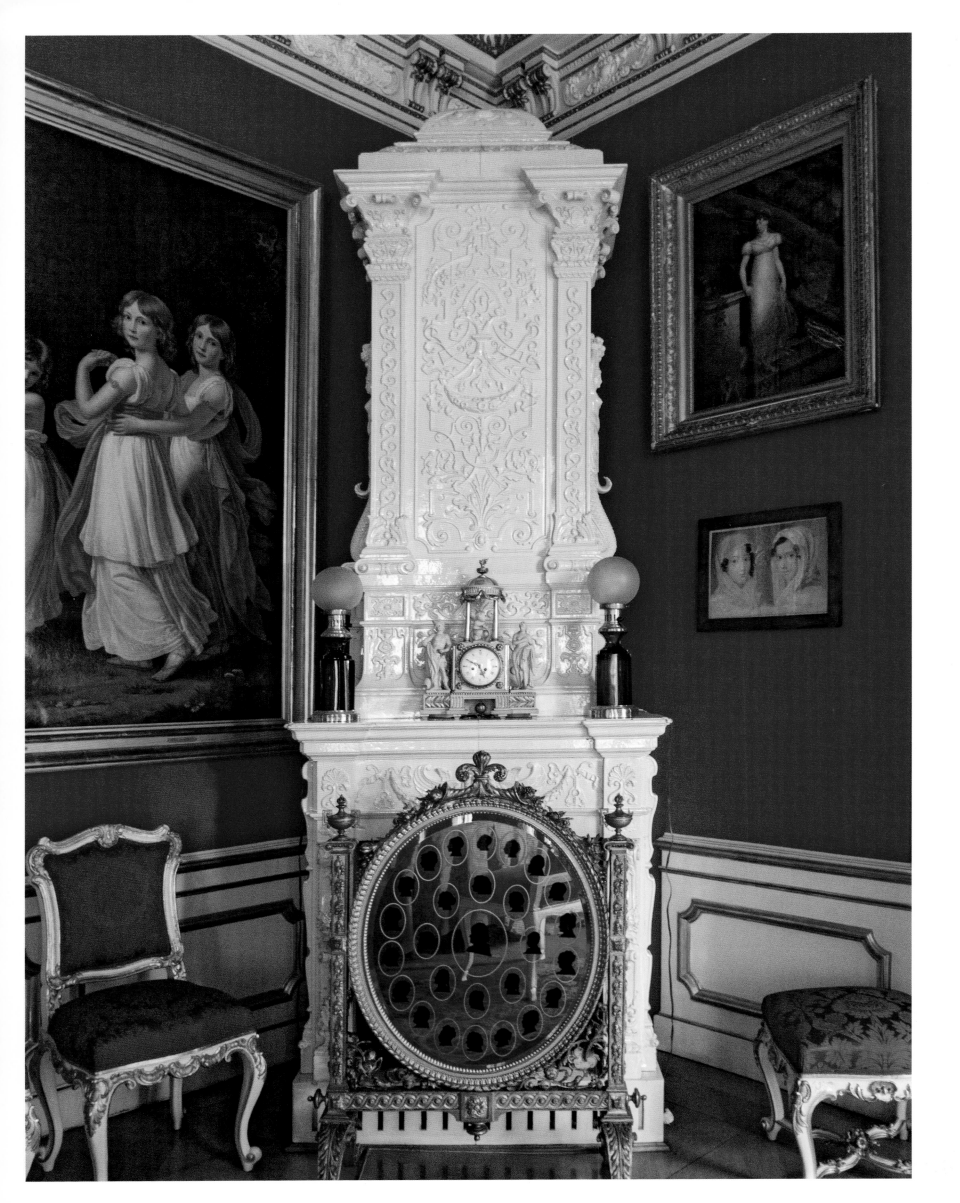

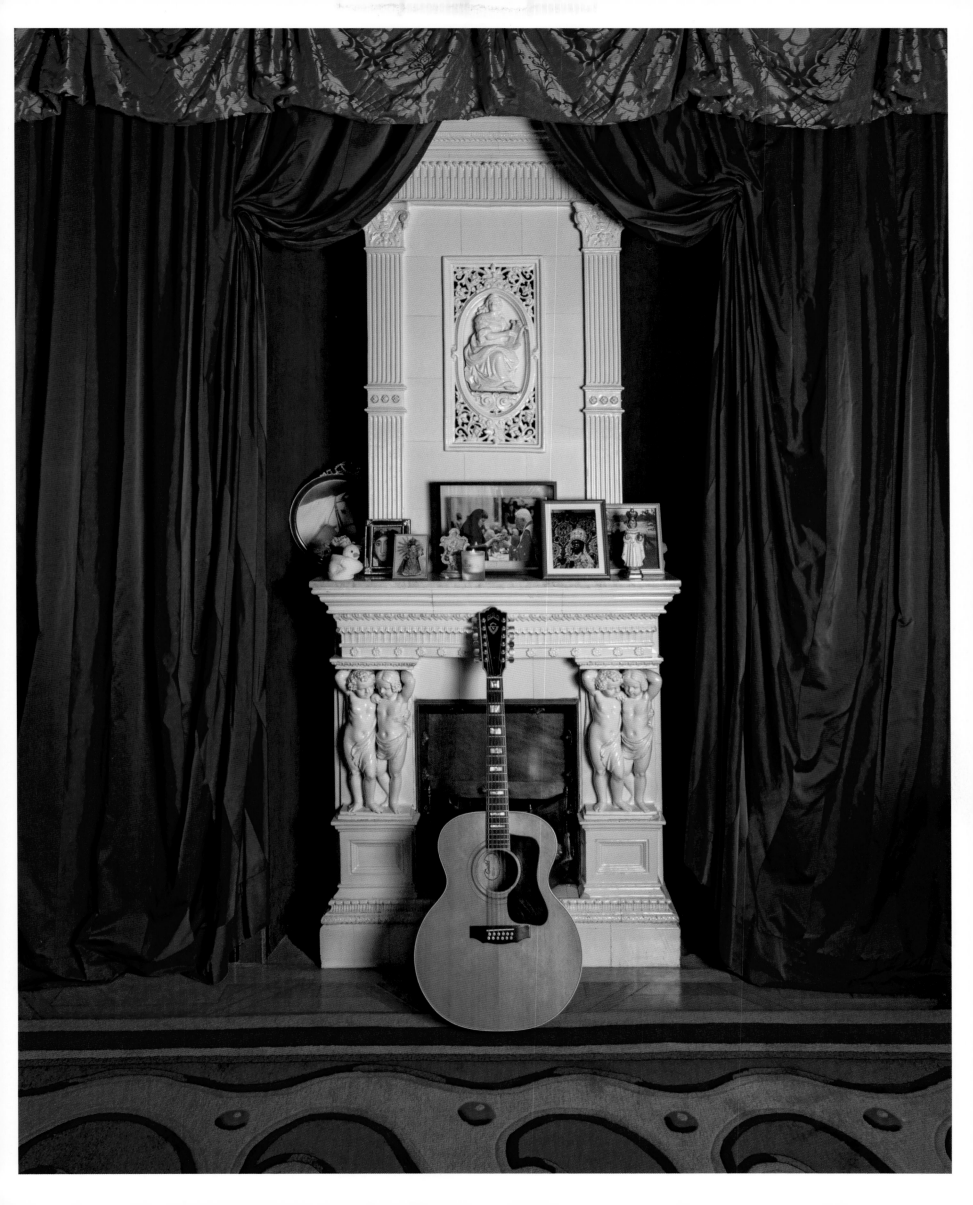

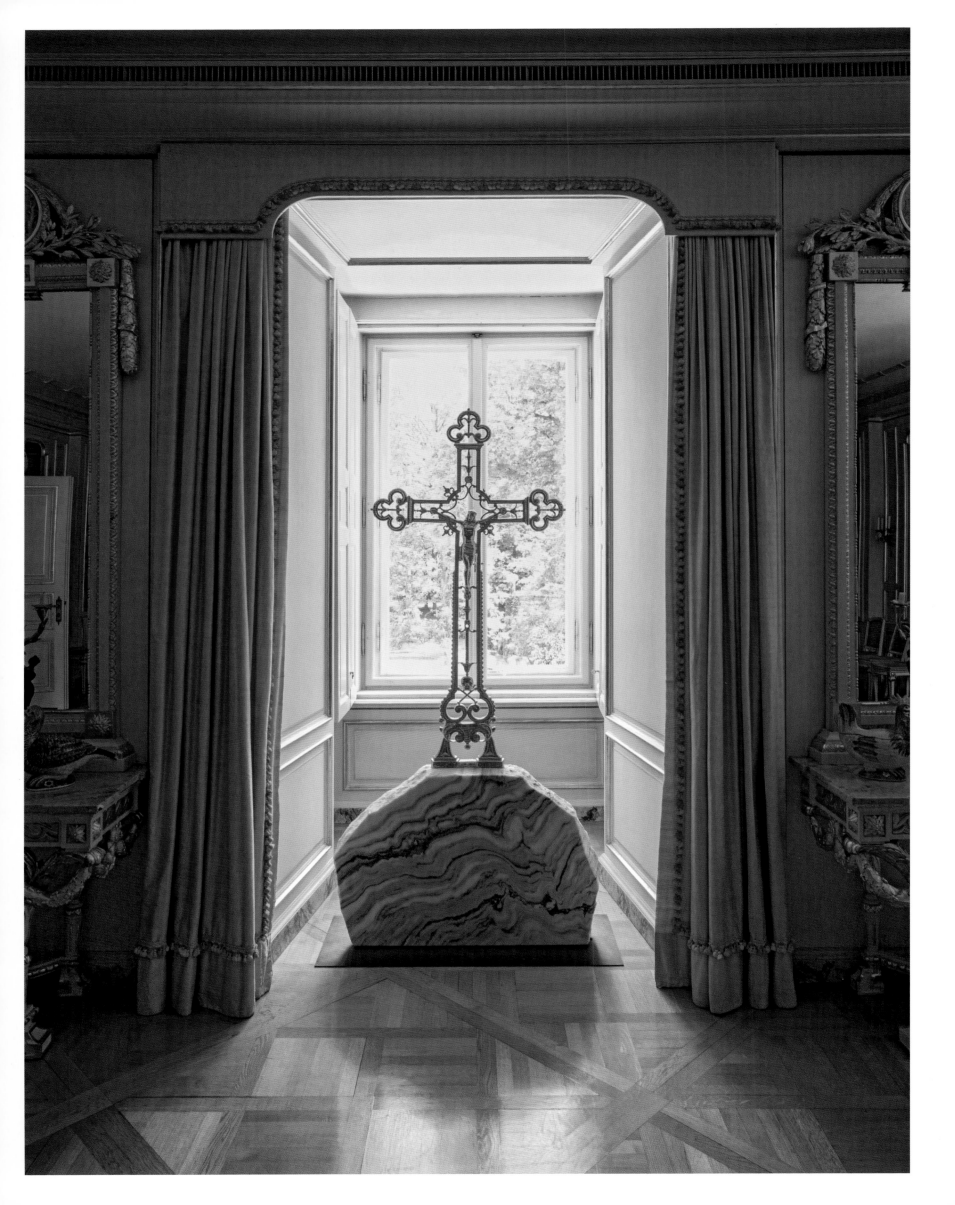

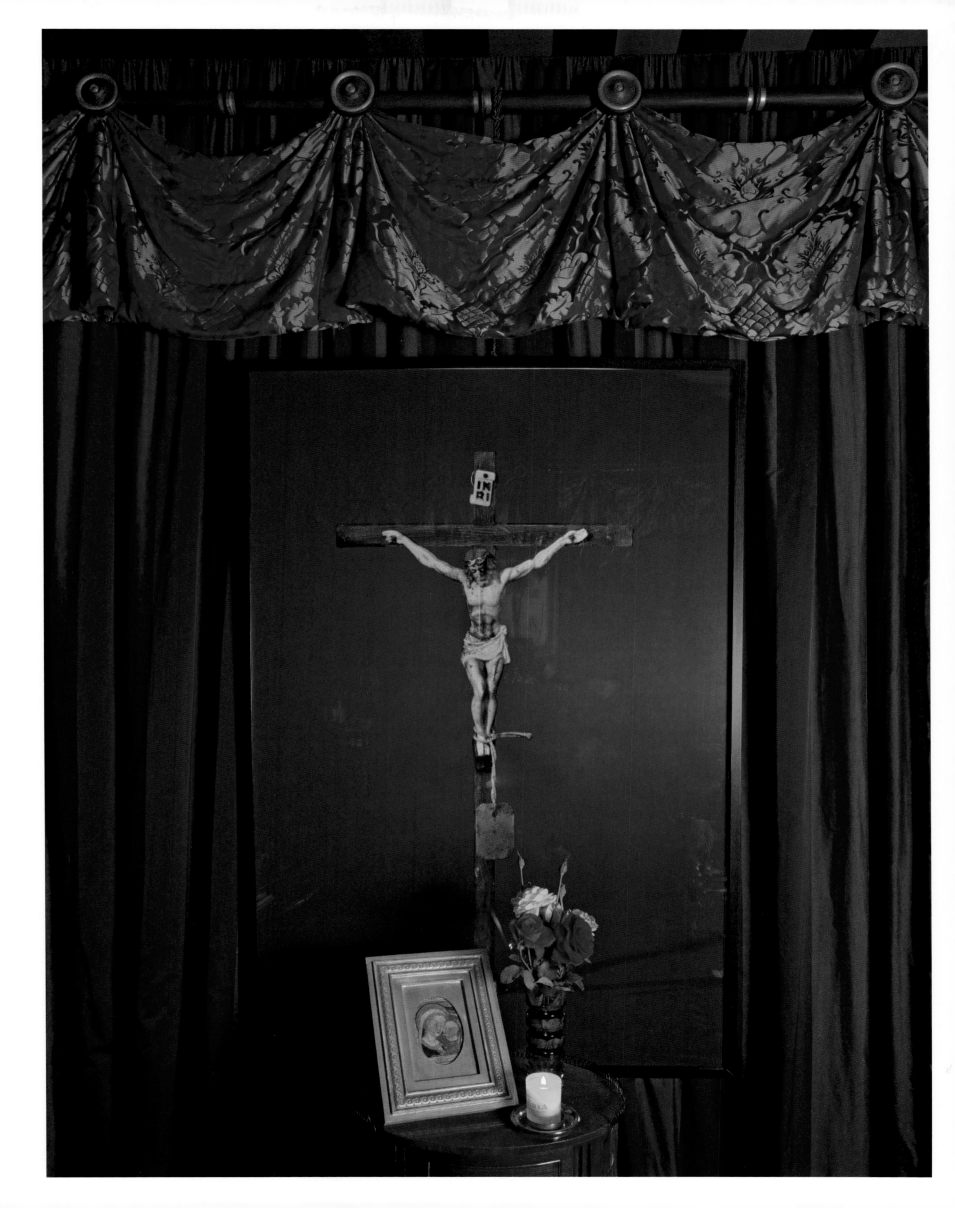

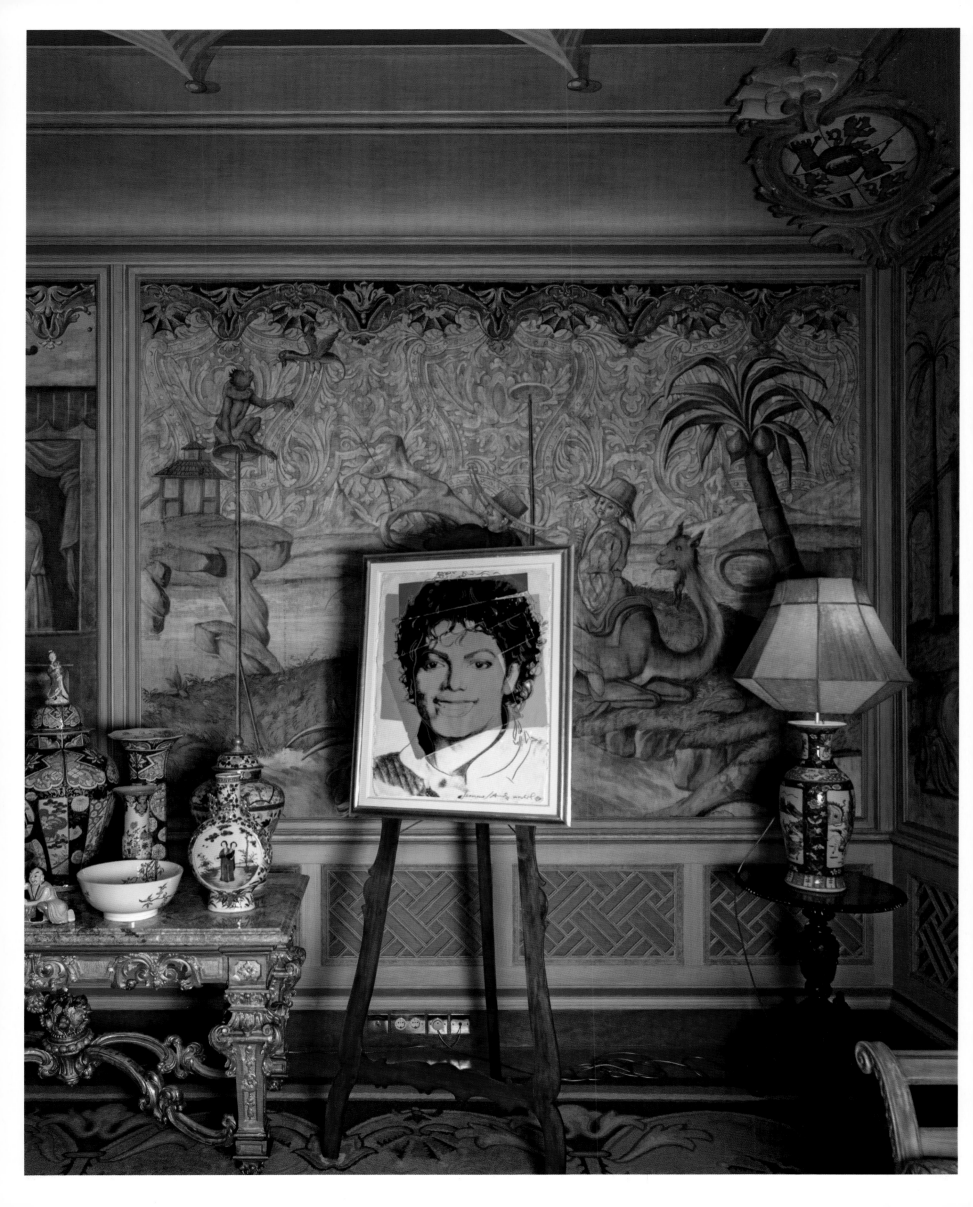

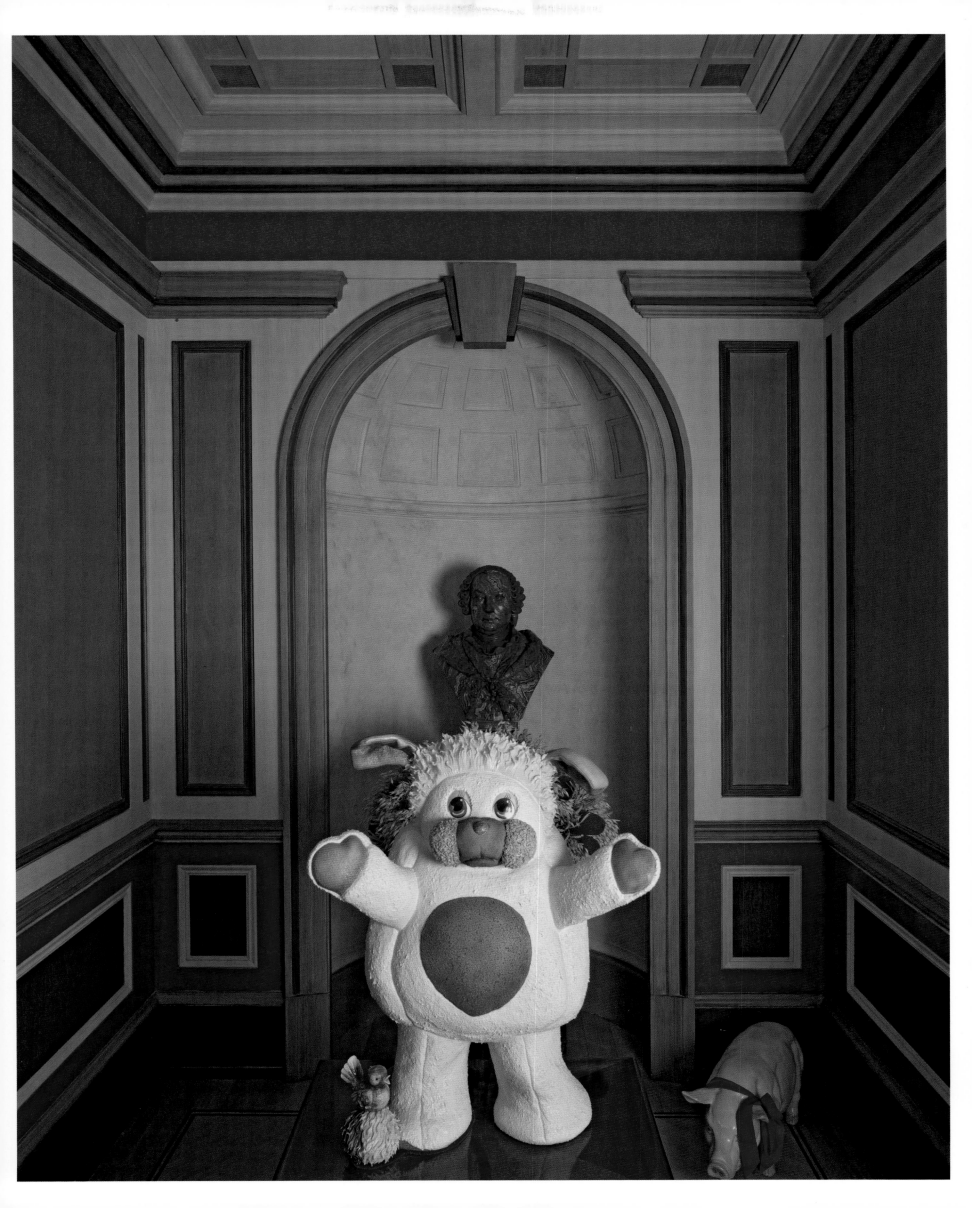

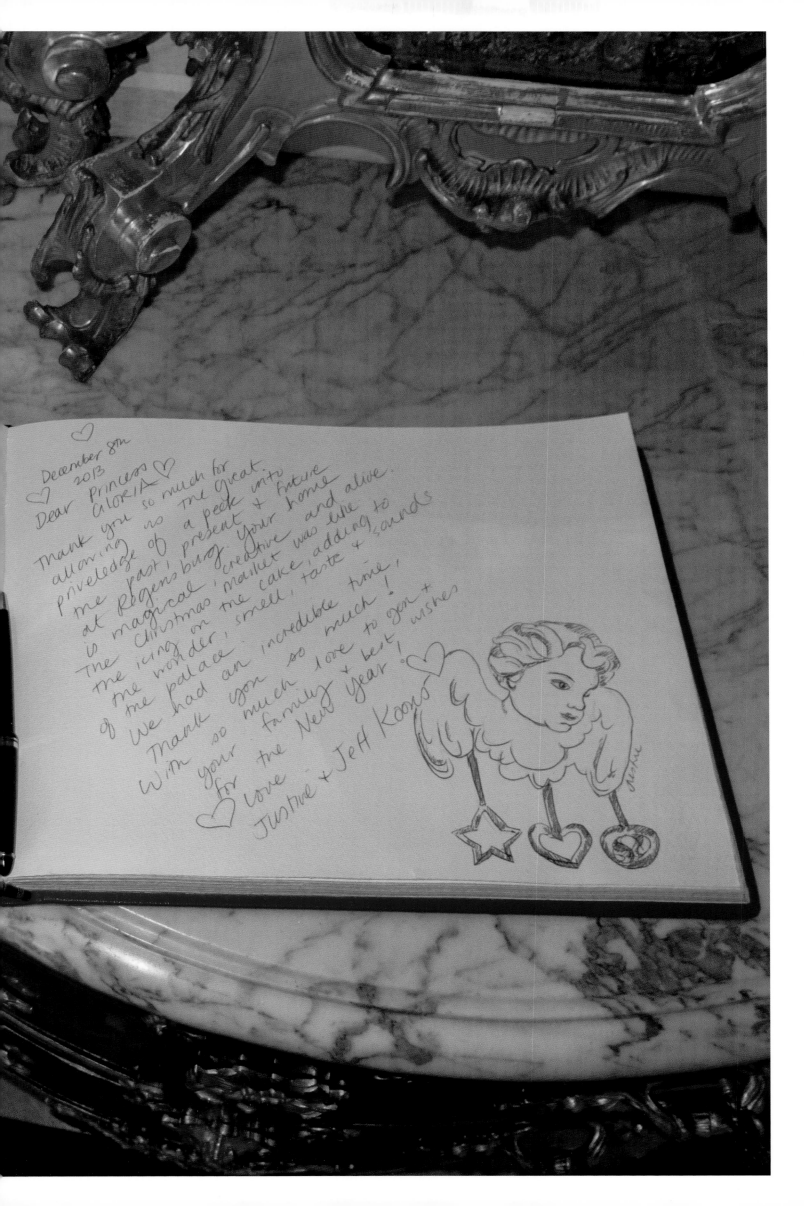

December 8th
2013
Dear Princess
GLORIA
Thank you so much for
allowing us the great
priveledge of a peek into
the past, present + future
at Regensburg. Your home
is magical, creative and alive.
The Christmas market was like to
the icing on the cake, adding to
the wonder, smell, taste +
of the palace
We had an incredible time!
Thank you so much!
With so much love to gen +
your family + best wishes
for the New Year!
Love
Justine + Jeff Koons

191

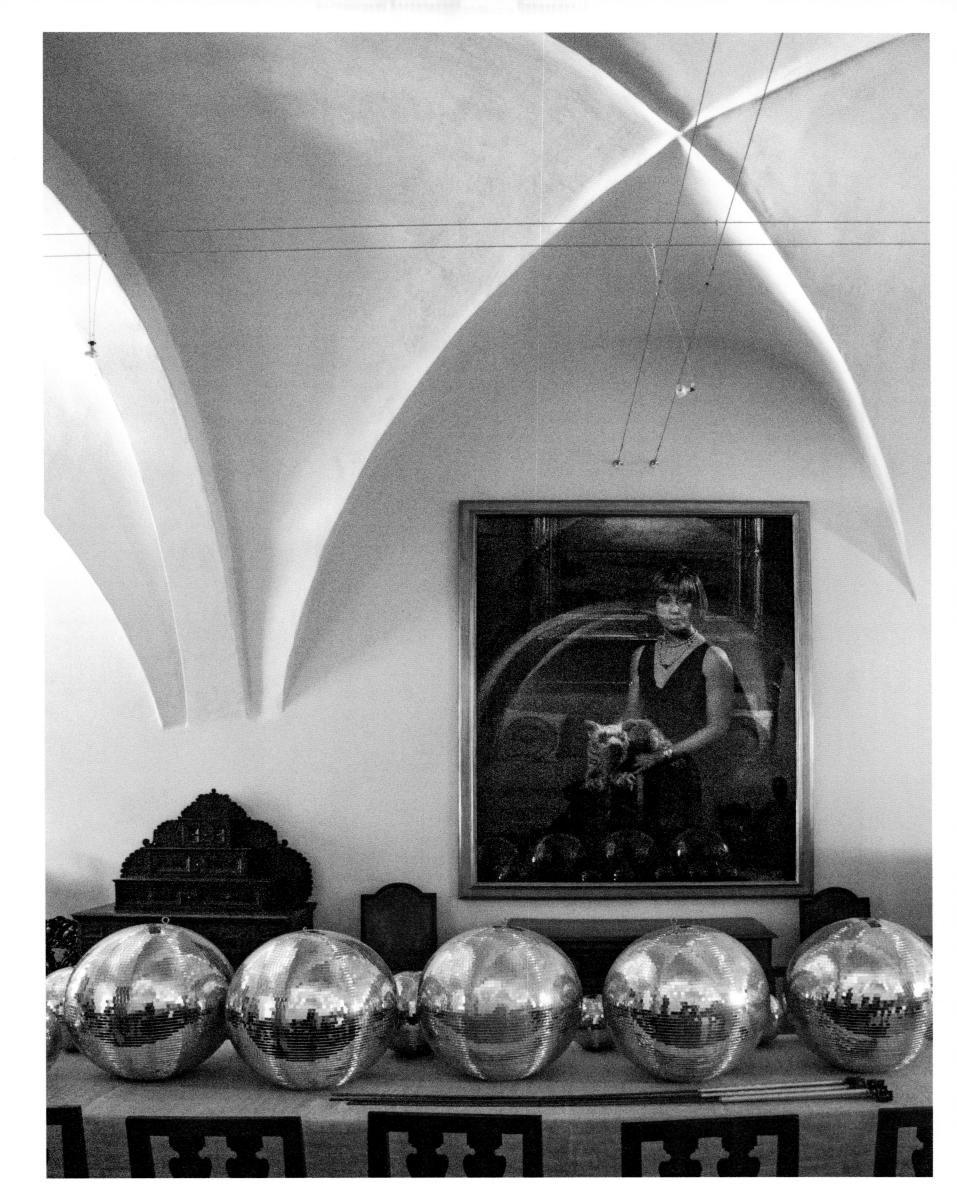

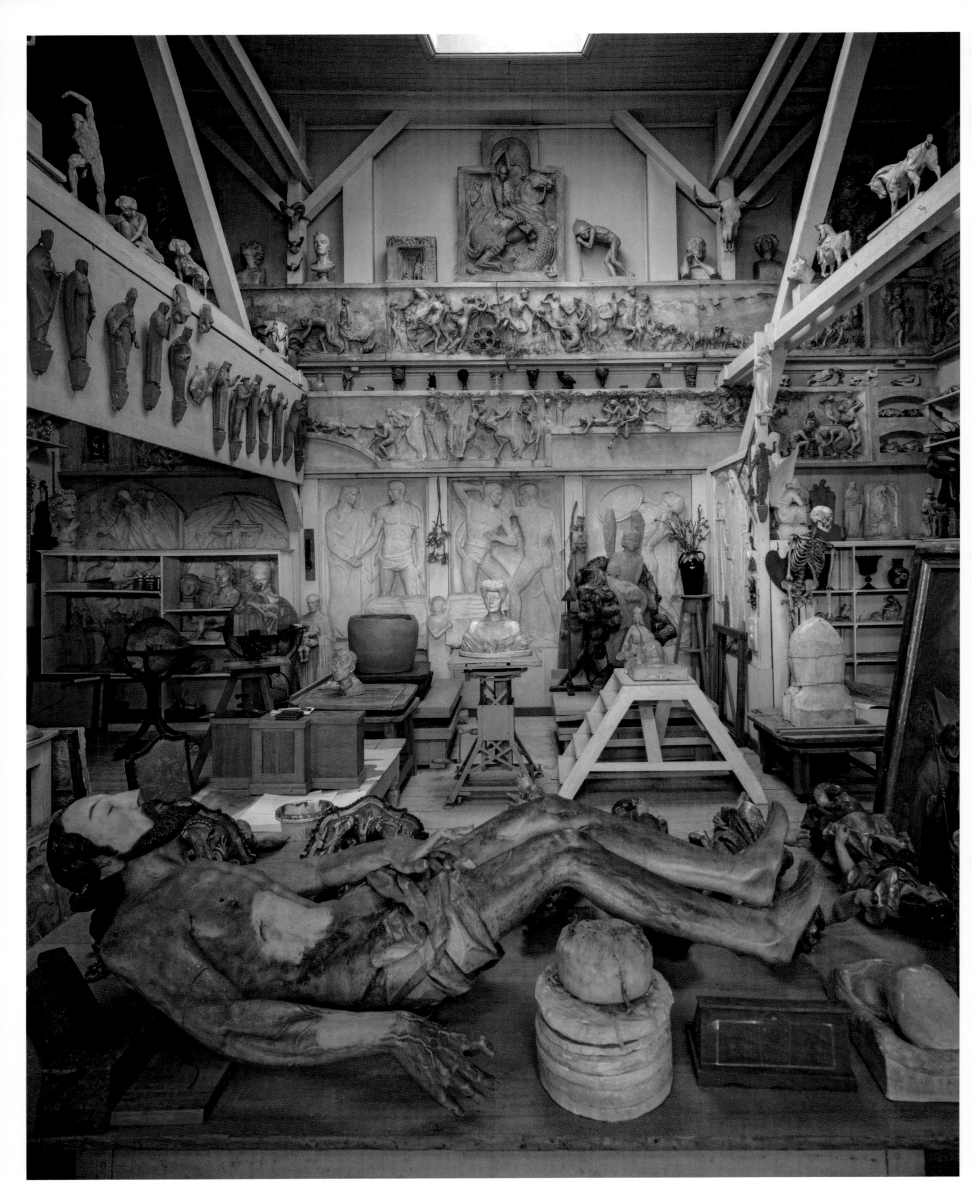

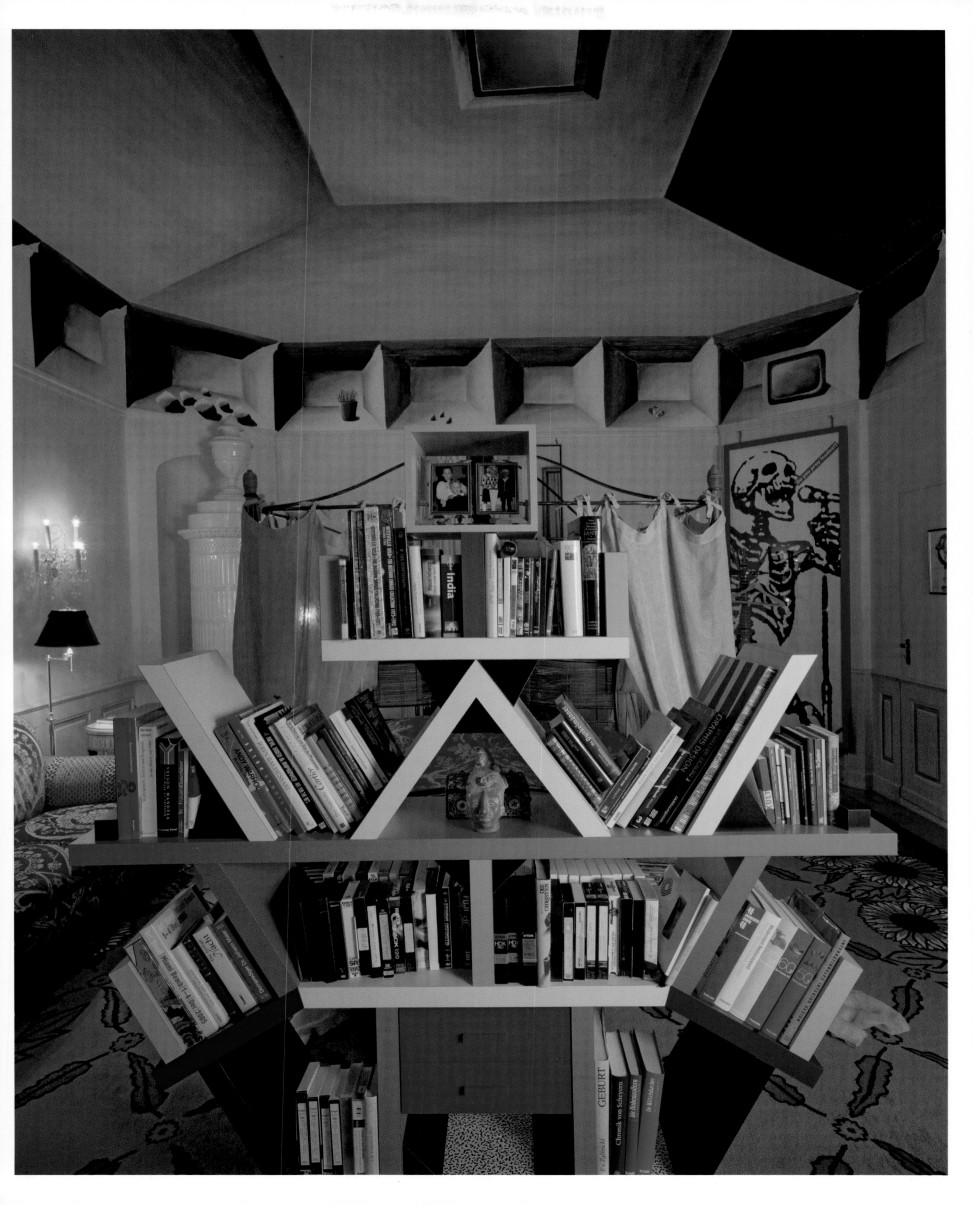

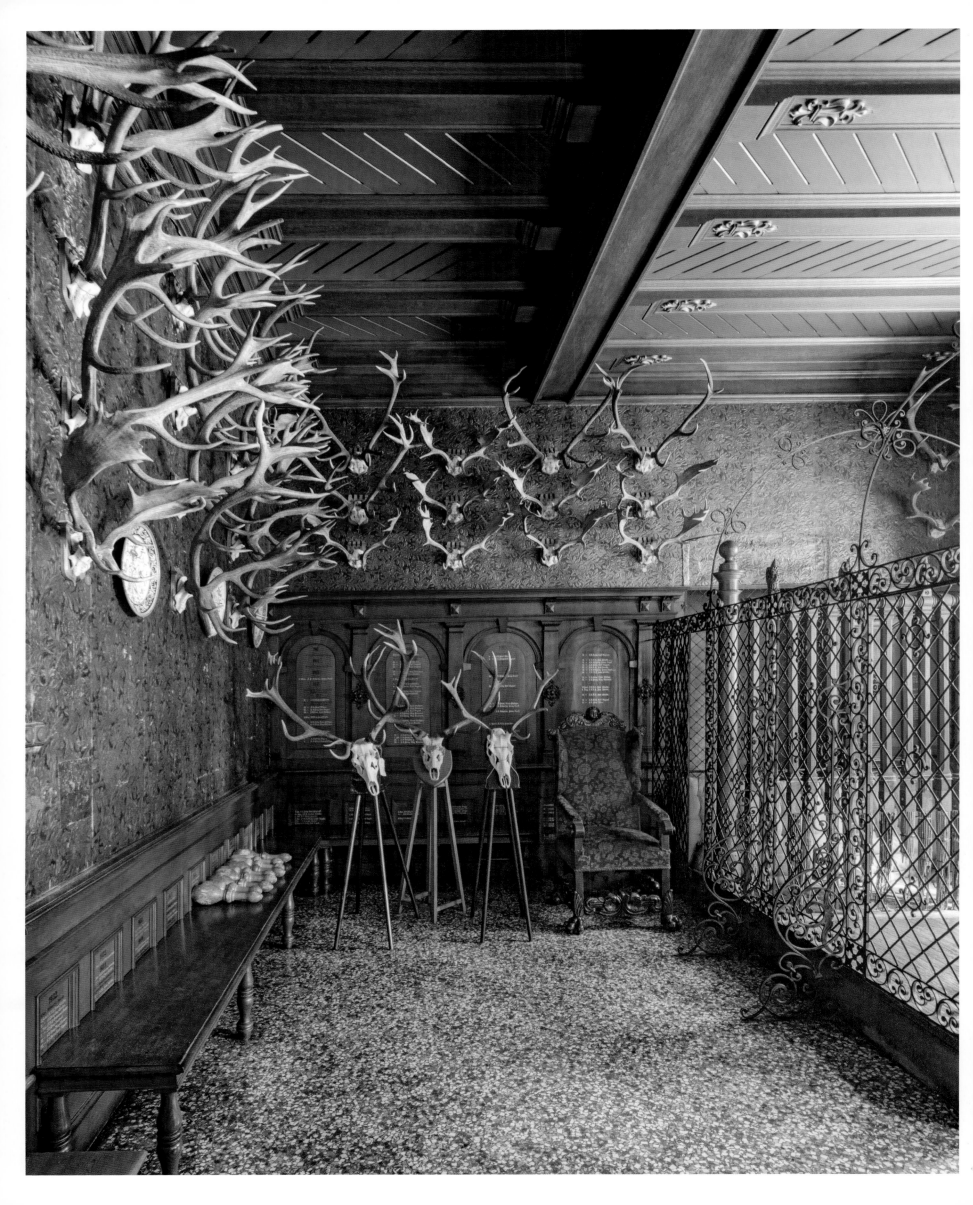

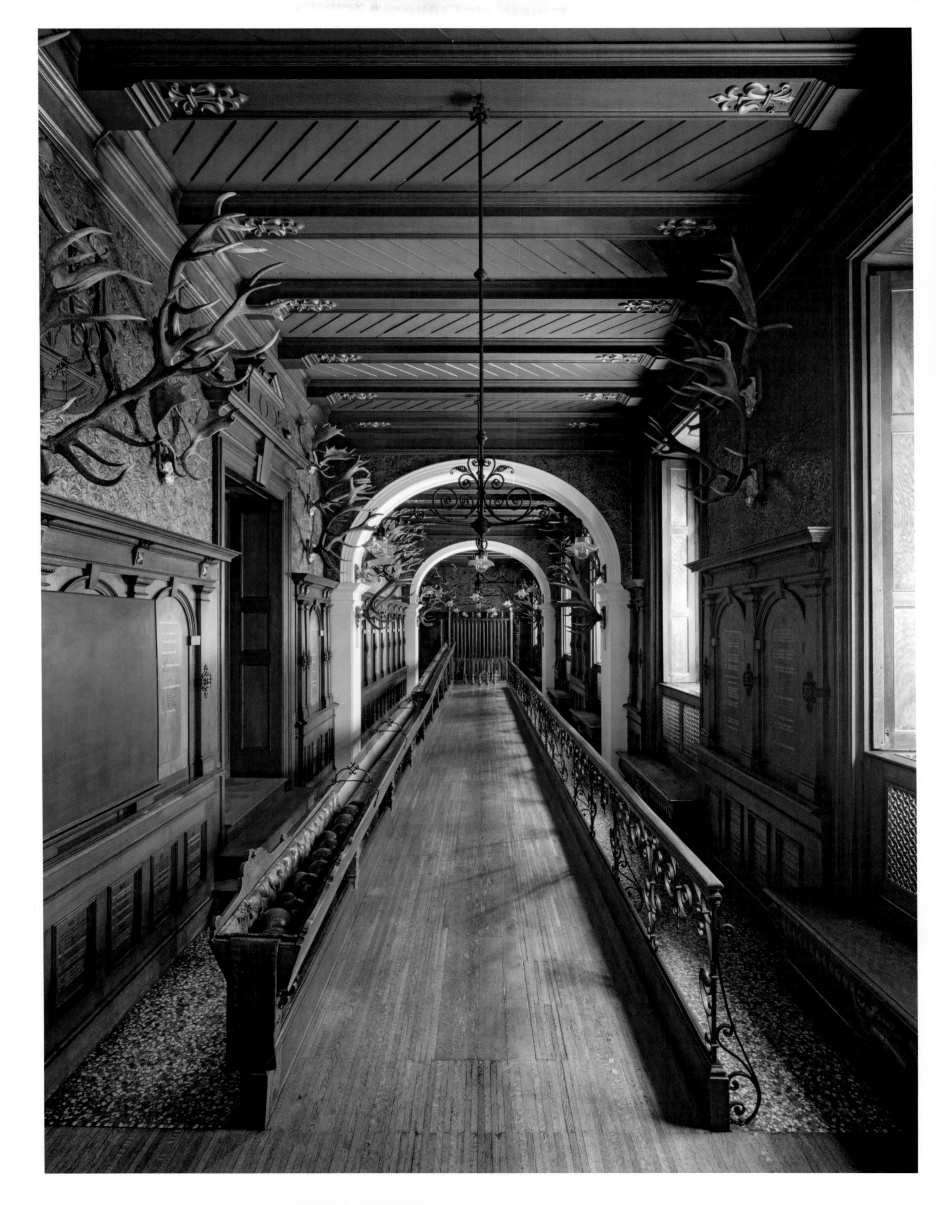

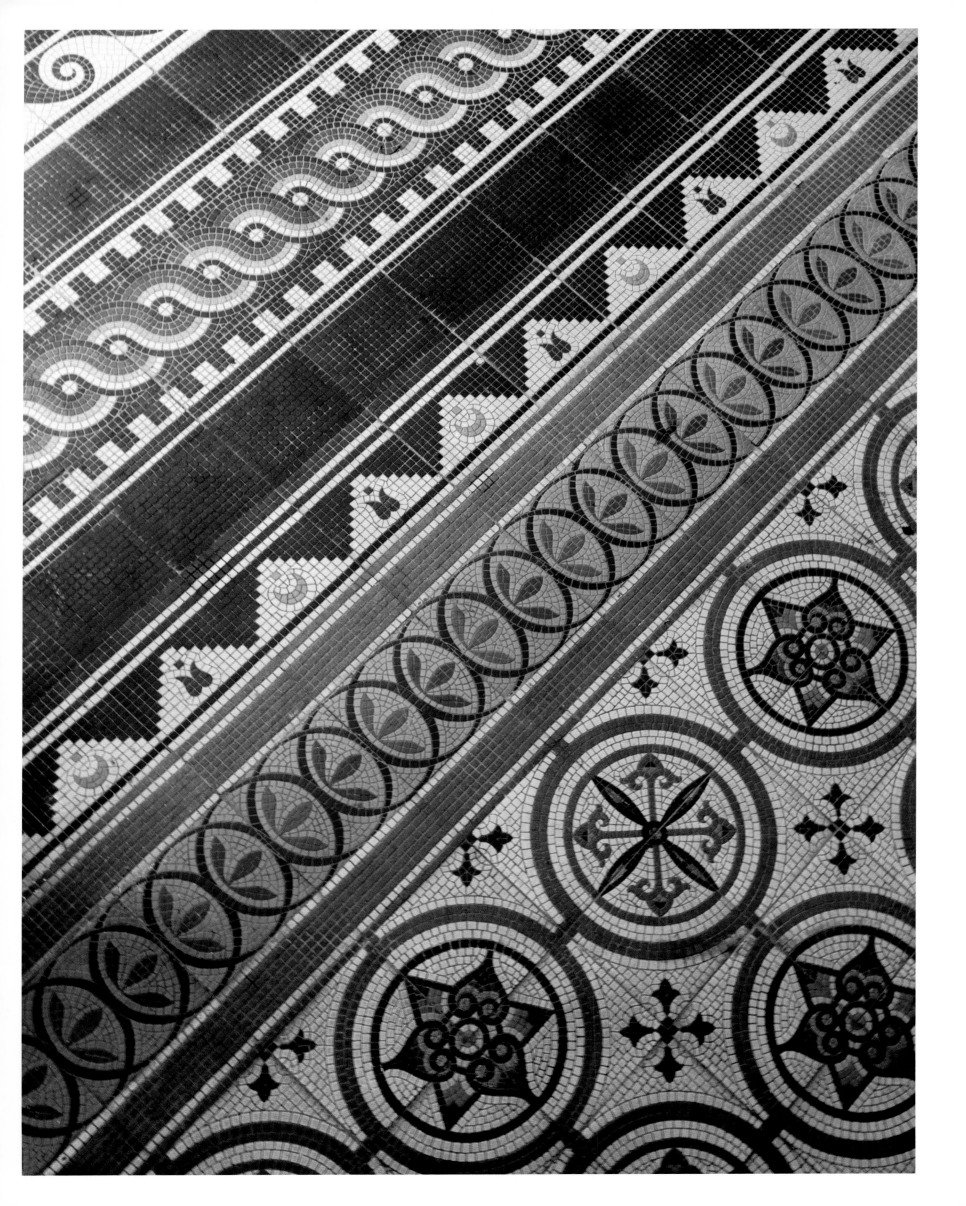

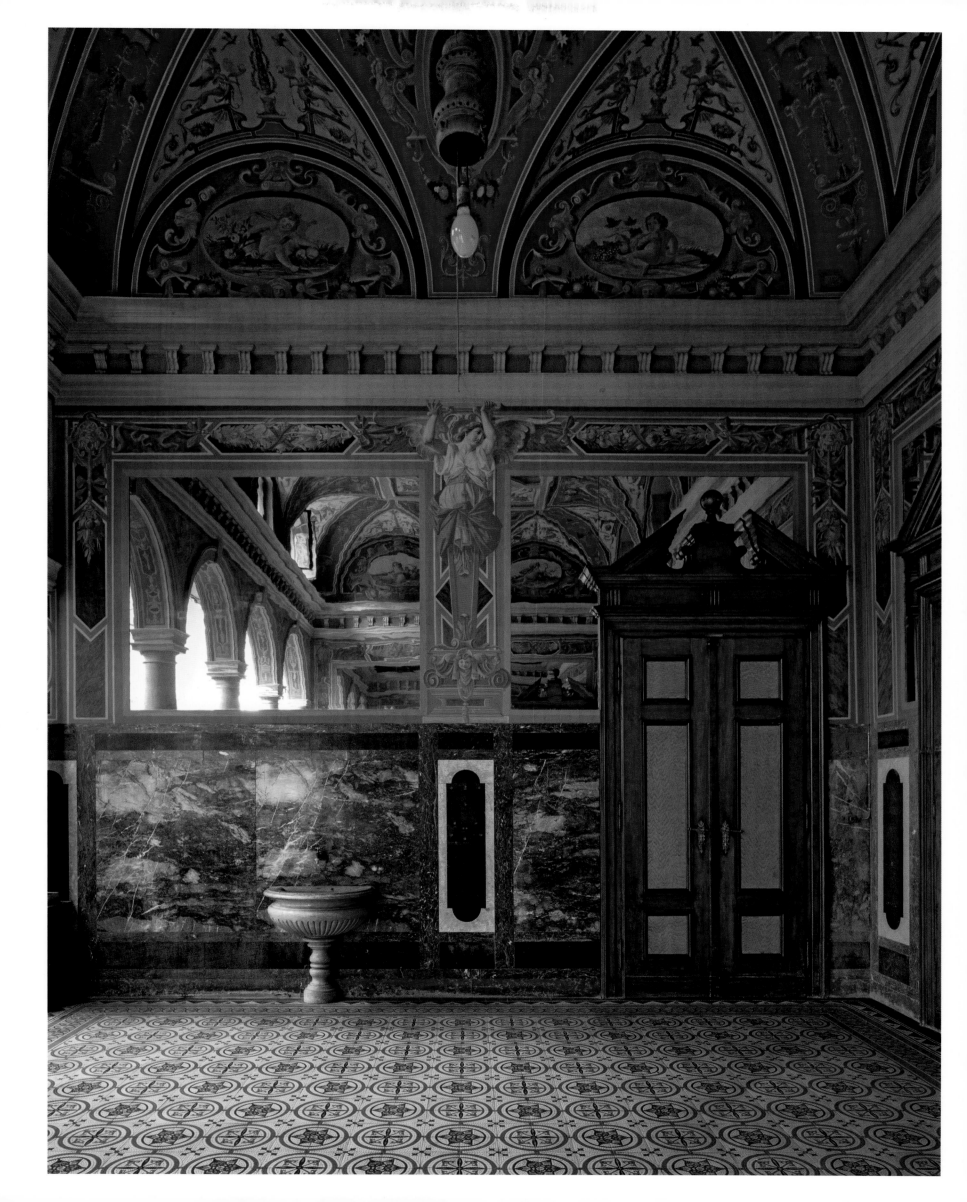

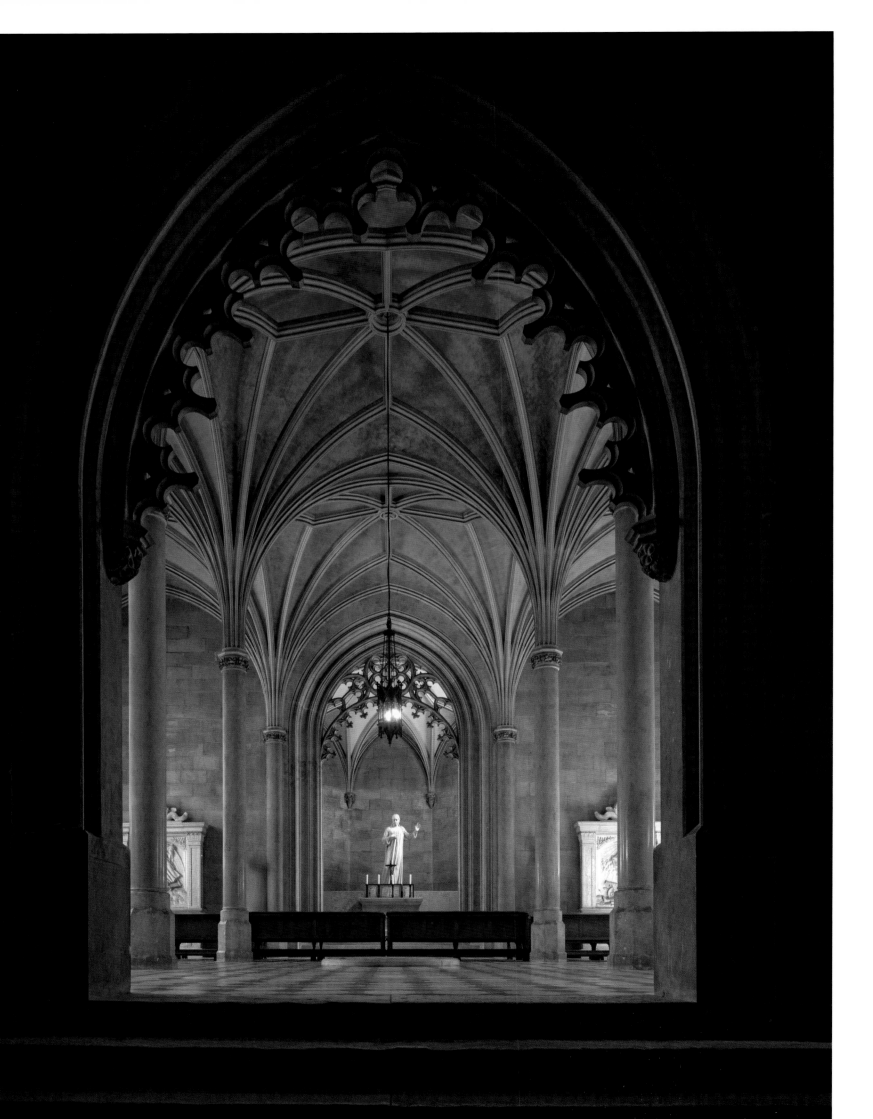

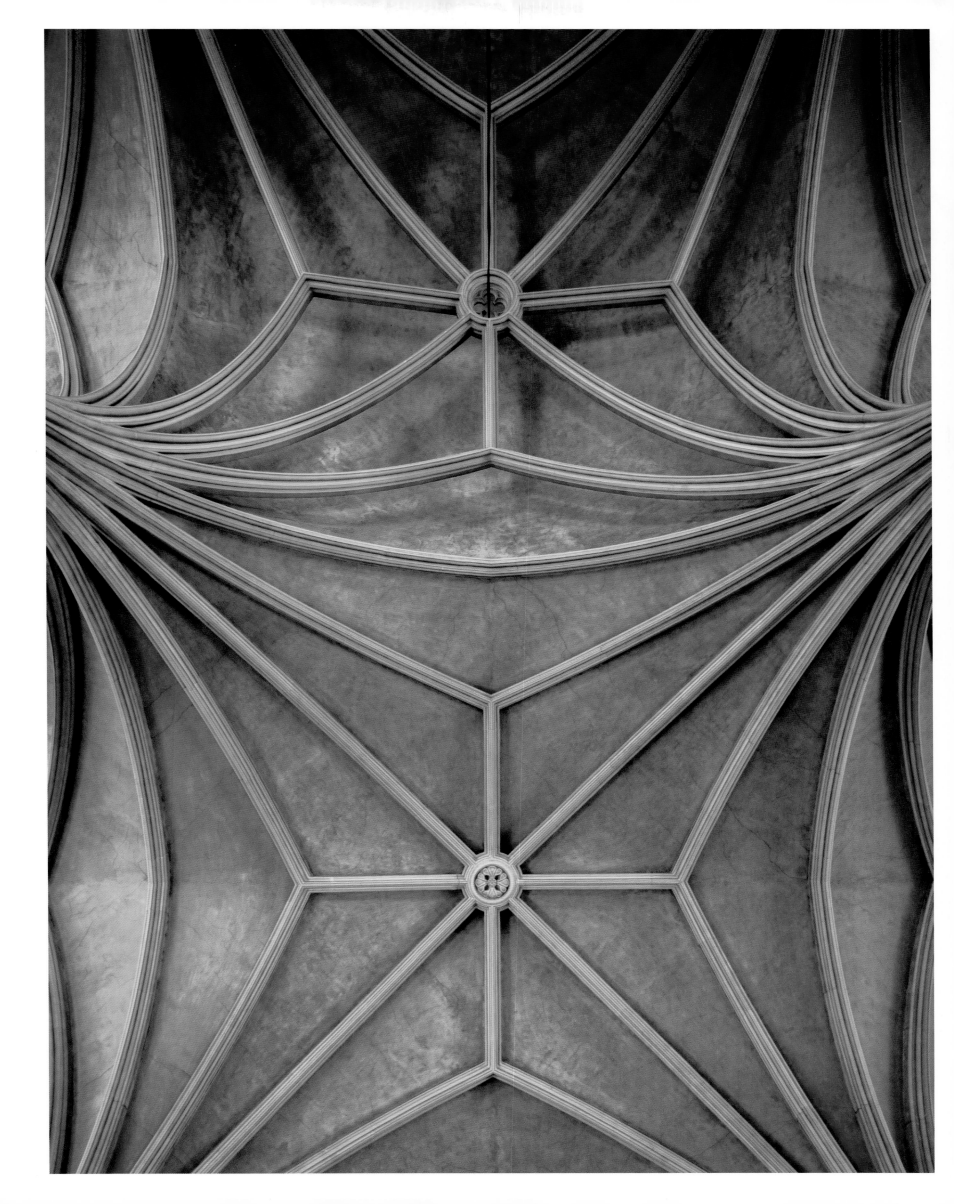

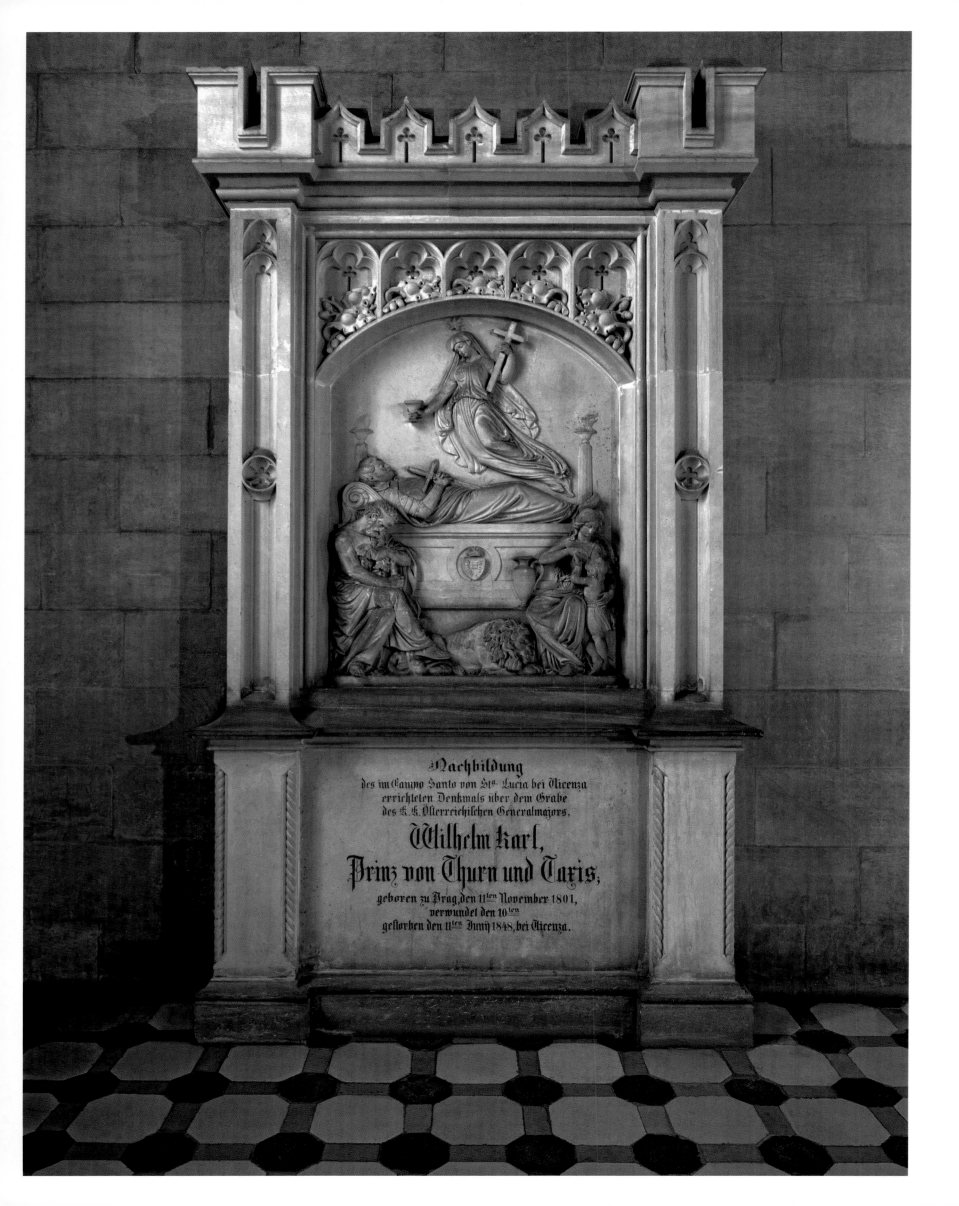

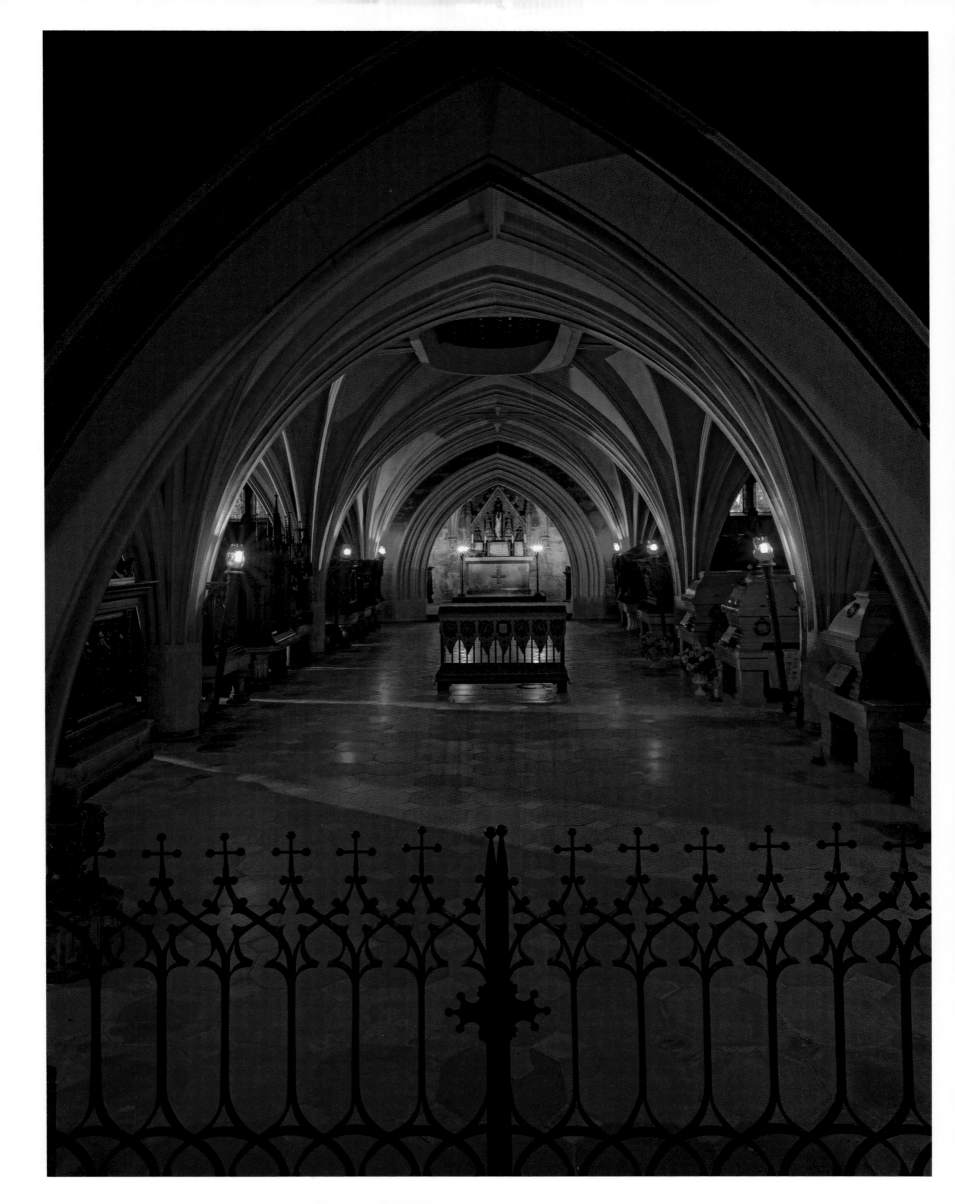

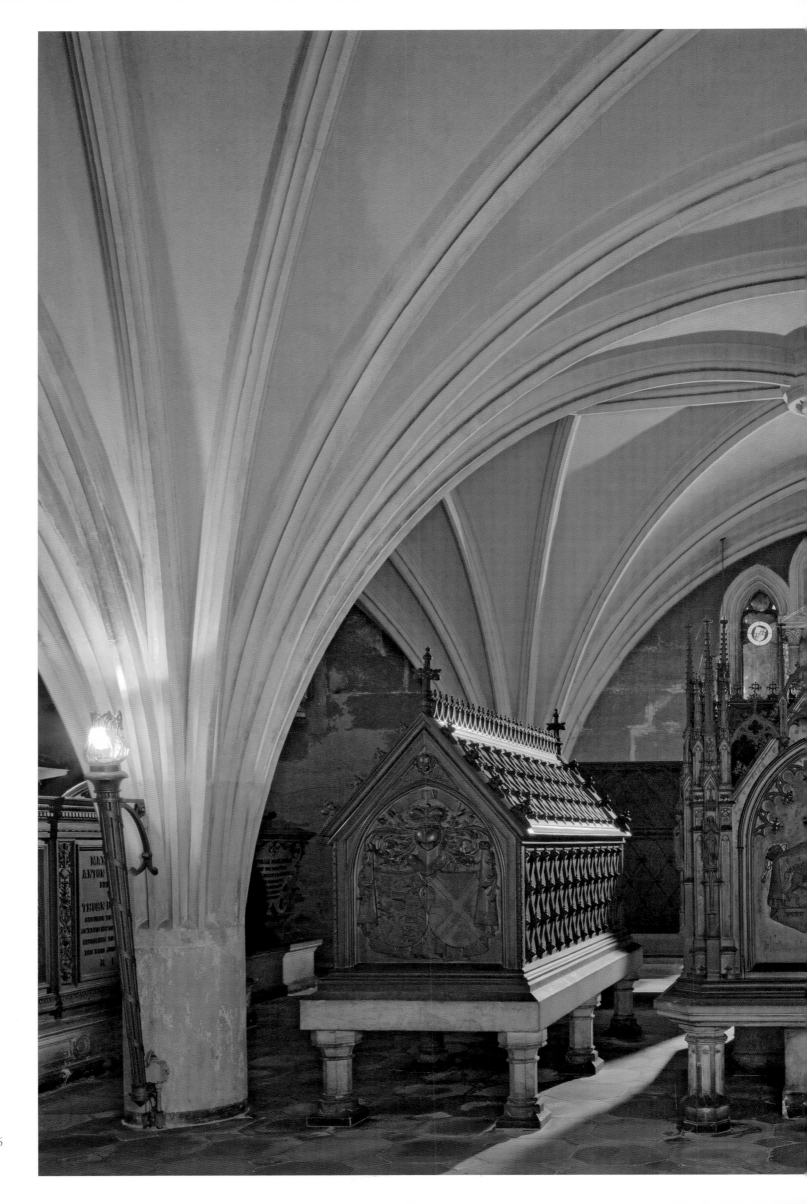

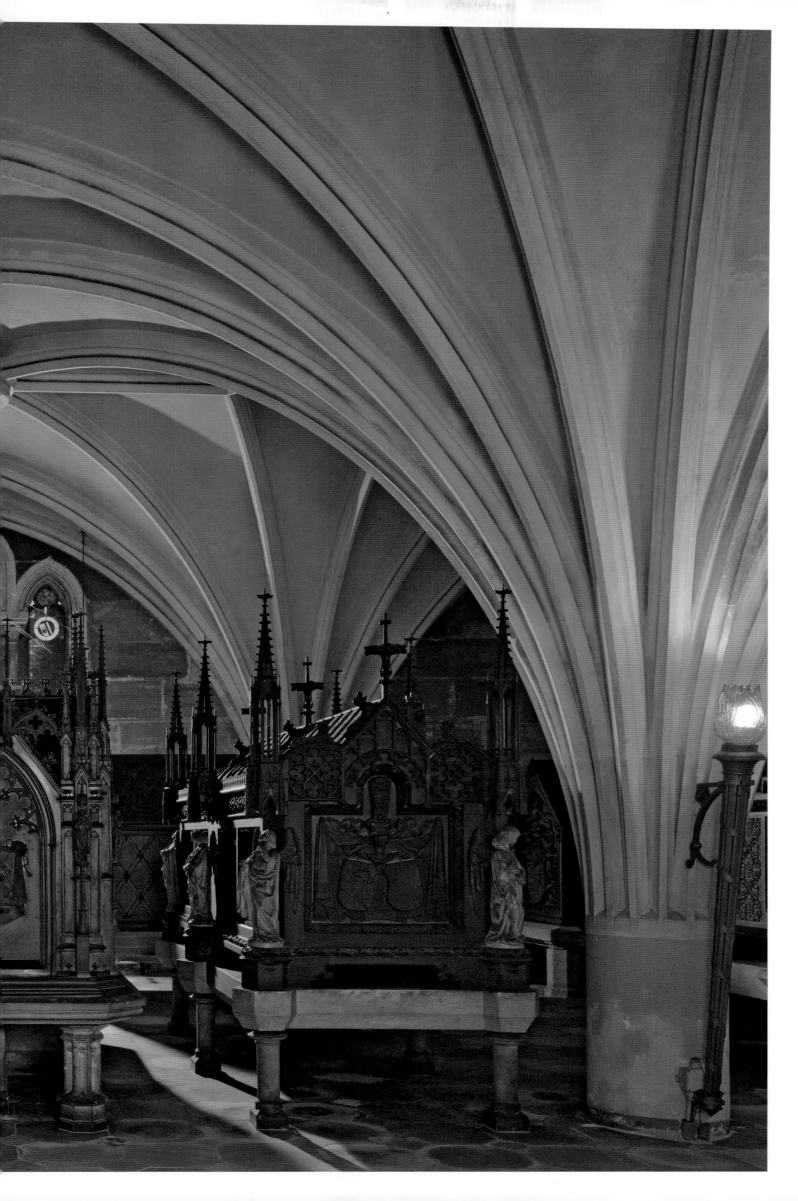

FAMILY TREE
PRINCE JOHANNES THURN UND TAXIS

Princess Maria Theresia, *1980 | Princess Elisabeth, *1982 | Prince Albert, *1983

Hereditary Prince Gabriel, 1922–1942

Prince Johannes, 1926–1990
∞ 1980 Countess and Lady Mariae Gloria von Schoenburg–Glauchau, *1960

Prince Franz Joseph, 1893–1971
∞ 1920 Elisabeth de Bragança, Infanta of Portugal, 1894–1970

Prince Karl August, 1898–1982
∞ 1921 Maria Anna de Bragança, Infanta of Portugal, 1899–1971

Prince Maximilian Maria, 1862–1885

Prince Albert, 1867–1952
∞ 1890 Archduchess Margarete von Austria, 1870–1955

Hereditary Prince Maximilian Anton, 1831–1867
∞ 1858 Duchess Helene von Bavaria, 1835–1890

Prince Maximilian Karl, 1802–1871
∞ 1828 Wilhelmine Caroline Baroness von Doernberg, 1803–1835

Prince Karl Alexander, 1770–1827
∞ 1789 Duchess Therese Mathilde von Mecklenburg–Strelitz, 1773–1839

Prince Carl Anselm, 1733–1805
∞ 1753 Duchess Auguste Marie Elisabeth Luise von Wuerttemberg, 1734–1787

Prince Alexander Ferdinand, 1704–1773
∞ 1703 Sophie Christine Luise Margravine von Brandenburg–Bayreuth, 1710–1739

Prince Anselm Franz, 1681–1739
∞ 1703 Princess Maria Ludovika von Lobkowitz, 1683–1750

Prince Eugen Alexander Thurn und Taxis, 1652–1714
1678 Princess Anna Adelheid von Fuerstenberg–Heiligenberg, 1659–1701

Count Lamoral Claudius Thurn und Taxis, 1621–1676
∞ 1650 Countess Anna Franziska Eugenia von Horn, †1693

Count Leonhard II Taxis, 1594–1628
∞ 1616 Alexandrine de Rye, 1589–1666

Count Lamoral Taxis, c. 1557–1624
∞ c. 1584 Genoveva von Taxis, †1627

Baron Leonhard I. Taxis, 1521–1612
∞ 1556 Louise Boisot de Rouha, †1610

Johann Baptista Taxis, c. 1470–1541
∞ 1514 Christina Wachtendonk von Hemissem, †1561

Roger von Taxis, c. 1445–1514
∞ Alegria Albricci, †1514

Franz von Taxis, 1459–1517

Paxius de Tassis, †1478
∞ Tonola de Magnasco, *1504

Rogerius de Tassis, †1441

Paxius de Tassis, †1414

Plazzus de Tassis, †1399

Rogerius de Tassis, *1353

Omodeus de Tassis, †1333

Omodeo de Tassis, *1251

FAMILY TREE
COUNTESS GLORIA SCHOENBURG–GLAUCHAU

Princess Maria Theresia, *1980	Princess Elisabeth, *1982	Prince Albert, *1983

Countess and Lady Mariae Gloria von Schoenburg–Glauchau, *1960
∞ 1980 Prince Johannes von Thurn und Taxis, 1926–1990

Count and Lord Joachim von Schoenburg, Count and Lord of Glauchau and Waldenburg, County Hartenstein, Lordship of Lichtenstein, Stein, and Remse, Lord of the Lordship Penig, Rochsburg, and Wechselburg, 1929–1998
∞ 1957 Beatrix Graefin Széchenyi de Sárvár et Felsővidé, *1930

Count and Lord Carl von Schoenburg–Glauchau, 1899–1945
∞ 1927 Countess Maria Anna von Baworow–Baworowska, 1902–1988

Count and Lord Joachim von Schoenburg–Glauchau, 1873–1943
∞ 1898 Countess Oktavia Chotek von Chotkowa und Wognin, 1873–1946

Count and Lord Karl von Schoenburg–Forderglauchau, 1832–1898
∞ 1864 Countess Adelheid von Rechteren–Limpurg, 1845–1873

Count and Lord Alban von Schoenburg–Forderglauchau, 1804–1864
∞ 1824 Countess Emilie von Jenison-Walworth, 1806–1880

Count and Lord Wilhelm von Schoenburg–Forderglauchau, 1762–1815
∞ 1799 Countess Anna Leopoldine von Wartensleben, 1775–1826

Count and Lord Karl Heinrich von Schoenburg–Forderglauchau, 1729–1800
∞ 1756 Countess Christiane Wilhelmine von Einsiedel, 1726–1798

Count and Lord Franz Heinrich von Schoenburg–Forderglauchau, 1682–1746
∞ 1723 Countess and Lady Johanna Sophie Elisabeth von Schoenburg–Hartenstein, 1699–1739

Count and Lord Samuel Heinrich von Schoenburg–Forderglauchau, 1642–1706
∞ 1675 Countess and Lady Elisabeth Magdalena Sophie von Schoenburg–Glauchau, 1642–1716

Lord Wolf Heinrich von Schoenburg–Forderglauchau, 1605–1657
∞ 1636 Judith Eva Reussin von Plauen, 1614–1666

Lord Wolf III von Schoenburg–Penig, 1556–1612
∞ 1601 Anna Barbara Reussin von Plauen, 1585–1629

Lord Wolf II von Schoenburg–Penig, 1532–1581
∞ 1552 Anna Schenkin von Landsberg, †1568

Lord Ernst II von Schoenburg, Lord of Glauchau and Waldenburg, 1486–1534
∞ 1526 Countess Amabilia von Leisnig–Penig, 1508–1559

Lord Ernst I von Schoenburg, 1456–1489
∞ 1478 Countess Anna von Rieneck, 1458–1525

Lord Friedrich von Schoenburg, †1480
∞ 1455 Elisabeth von Guttenstein, †1507

Lord Friedrich von Schoenburg, †1426
∞ Countess Sophie von Meissen, †1435

Lord Veit von Schoenburg, †1423
∞ 1372 Lady Agnes von Schoenburg–Crimmitschau

Lord Friedrich von Schoenburg, 1341–1389
∞ Agnes von Wartenberg

Lord Hermann von Schoenburg, 1310–1335

Lord Friedrich von Schoenburg, 1261–1310
∞ 1295 Mechthild von Gera, †1309

Lord Friedrich von Schoenburg, 1247–1291
∞ Countess von Colditz

Lord Hermann von Schoenburg, 1215–1238

Lord Hermann von Schoenburg, 1212–1224

Lord Hermann von Schoenburg, †1174

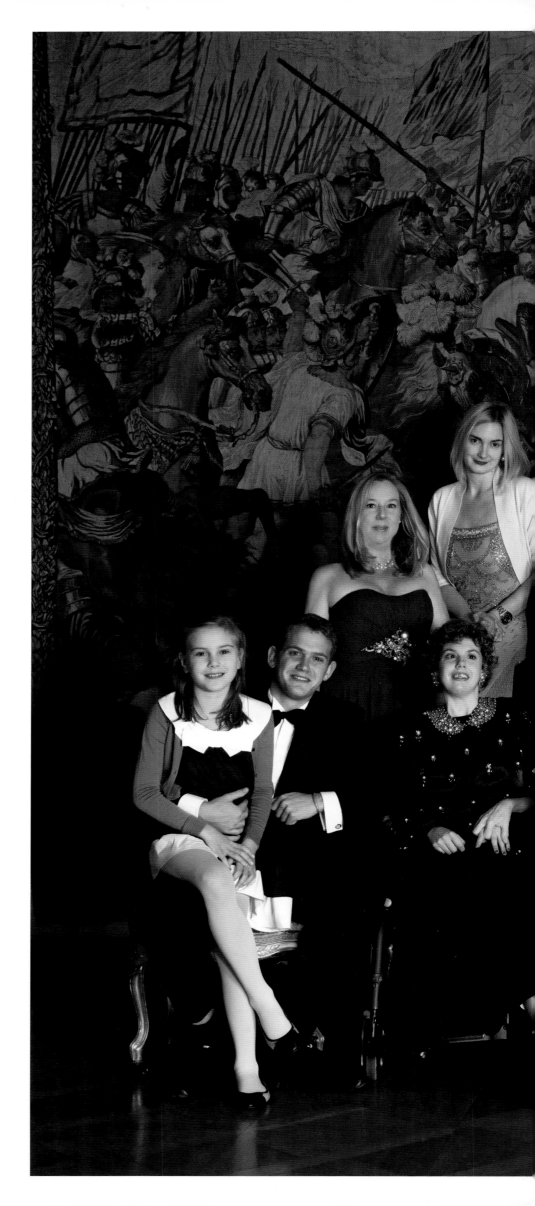

Standing, left to right: Countess Juliet Schoenburg-Glauchau, Princess Maria Theresia Thurn und Taxis, Count Carl-Alban Schoenburg-Glauchau, Count Hubertus Schoenburg-Glauchau, Prince Albert Thurn und Taxis, Alexander Flick, Princess Elisabeth Thurn und Taxis, Count Benedict Schoenburg-Glauchau, Count Alexander Schoenburg-Glauchau, Countess Laetitia Schoenburg-Glauchau, Countess Irina Schoenburg-Glauchau.

Seated, left to right: Carlotta Hipp, Moritz Flick, Pilar Flick, Count Valentin Schoenburg-Glauchau, Countess Maya Schoenburg-Glauchau, Princess Mariae Gloria Thurn und Taxis, Count Maximus Schoenburg-Glauchau, Countess Beatrix Schoenburg-Glauchau, Dr. Friedrich Christian Flick

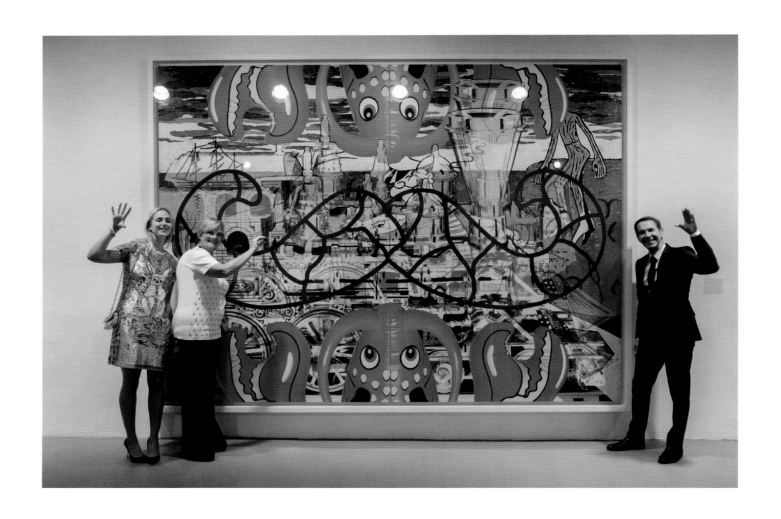

JEFF KOONS

TIME

I've always enjoyed being in the Thurn und Taxis palace in Regensburg. From the first time I entered St. Emmeram in 1989 for Princess Gloria's birthday party to the present day, every time I visit, I feel that I am participating in a personal journey.

Looking back, one of my fondest memories of being in the palace was staying in the private residence with my family. We had a wonderful time experiencing the historical part of St. Emmeram along with the more modern details of the contemporary residence that Princess Gloria and her family enjoy today. My wife, Justine, and I have also stayed in one of the princely bedroom chambers, allowing us to explore and reflect over an extended period of time. We've had the opportunity to let the palace articulate through sense, perception, and intellect, its history, its desires, and its information at different moments in time. There is abundance everywhere and it always brings us back to a sensitivity to life, and the understanding of one's own possibilities and responsibilities. You feel the connection to biology through family which is represented throughout the palace. There are portraits of the princely family from previous centuries to the present hanging everywhere. The history of the family in both their personal and political lives unfolds through these paintings and photographs.

If I have to think of a singular element that is discussed on both the minutest and the grandest scales, it would be time. Time is evoked through the architecture, the decorative arts, the family references, and the preciousness of life's energy in relationship to and in metaphor through objects. When interacting with all of the elements and exploring the Baroque and the Rococo, you end up realizing that the dialogue is about the elasticity we have as individuals in relation to nature and time. Polarities are everywhere: There is the masculine and the feminine, the symmetrical and the asymmetrical, life and death. Generosity and communal responsibility are engaged and interwoven in the daily life of the community—from the festivities in the courtyard and gardens to the interaction with the abbey.

For me, walking from room to room along the long corridors of the palace always leads to discovery— the discovery of the potential to better understand time through all the human disciplines. Every room is a unique experience. Transcendence is everywhere to be felt and contemplated. The journey is a philosophical, sociological, and theological discussion about human life and our potential.

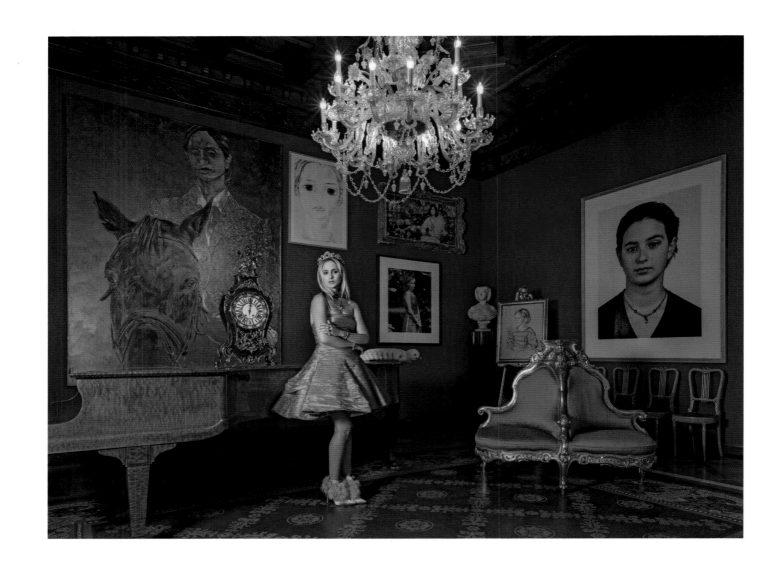

PRINCESS ELISABETH THURN UND TAXIS

HAVE YOU BEEN IN
EVERY ROOM?

As with any child growing up, the other side—that is, my friends' lives—always looked more appealing. In my case this meant I envied my classmates who had houses with white picket fences, whose parents dressed in ordinary clothes, and whose birthday parties involved a big cake, candy, a game of musical chairs, and nothing else.

My siblings and I grew up differently. When we left for school in two bulletproof cars, we passed by groups of tourists standing in our courtyard and accompanied by museum guides. After a birthday party, all anybody in school wanted to talk about was how big "that castle" was. "Does it really have five hundred rooms?" they would ask. "Have you been inside every single room?" I can't tell you how often I've been asked this absurd question. The answer is, of course not. Why would I have been?

Thanks to my parents, my childhood still felt pretty normal to me despite its anomalies. We grew up with a sense of down-to-earthness. There was homework, piano lessons, and sleepovers (although most kids never wanted to come back because of my mum's raunchy contemporary art collection—apparently a photograph by Cindy Sherman of a worm-infested dinner table does not appeal to everyone).

But I loved my childhood. Who wouldn't love playing in a long hallway that, to a child's eyes, felt never ending and was overflowing with toys? Who wouldn't enjoy playing hide-and-seek in the garden (aka a private park) behind the castle? There, little follies, hidden entrances, bits of ruins, and stone sculptures piqued the imagination. My siblings and I had many imaginary worlds, including a sort of Narnia where, instead of a wardrobe, an imposing storage chamber served as our portal.

And, of course, I adored playing in my mother's closet—or should I say, the rooms and rooms filled with impeccable pieces that are perfectly lined up and protected in white cotton capes, which adds to their ghostlike mystique. Though she was generous with some pieces (my sister and I later wore them to a string of eighteenth-birthday balls around the country), most remained off-limits.

As for the jewelry, my mother was even stricter. Most of her treasures have been in the family for centuries and she was very careful to communicate the sense of responsibility that comes with wearing them. Those jewels made my head turn: emerald necklaces, ruby brooches, sapphires, pearls, and diamonds—a dream, of course, to anyone, but especially to a little girl. On her wedding day, my mother wore the stunning pearl tiara that Empress Eugenie wore in the Winterhalter portrait of 1855. One of my earliest memories is of my mother standing in front of an innocent-looking chest painted with figures from ancient China that was her jewelry safe. I loved running my fingers over a strand of pearls, feeling their coolness. To this day, her process of carefully laying out sparkling gems and pearls when getting dressed for a night out hypnotizes me. My lucky mother found in my father a lover and connoisseur of jewelry. He was generous in his gifts and so she was spoiled in this regard.

Then there were the stories of my chic Hungarian grandmother, who fled her home under the growing influence of Communism with nothing more than a few family jewels stuffed into her bra. How important do such heirlooms become when, suddenly, they are all that is left? For my sister and me—save those glimpses and touches we had from the edge of the bed as my mother got ready for a ball—that was all there was.

Opposite: Princess Elisabeth Thurn und Taxis in 2013 with portraits by Ena Swansea (2006), Francesco Clemente (1998), Pierre et Gilles (2004), and Rinecke Dijkstra (2004).

Fast-forward a decade and a half, and it was with both apprehension and excitement that I responded to my mother's request to have us photographed in the castle by Todd Eberle for a book project on the house. Todd envisioned us in a sumptuous castle room, wearing my mother's couture gowns and heirloom pieces. The only connection I felt was to the various portraits of me that my mother had commissioned over the course of my life. Sounds overwhelming? It was.

Meanwhile, I was working as Style Editor at Large for American *Vogue*. I had lived abroad for years and made developing a sense of style my daily bread. Leading a very contemporary life in cosmopolitan cities versus being tucked away in a castle, I felt a little estranged from the prospect of being photographed in pomp and splendor in my childhood home. However, resisting my mother is tough, and Todd's relentless enthusiasm, along with my natural appetite for dressing up, made it a losing battle. I decided the only way out was to be over the top. My references were less stately than exaggerated, less royal than pop. I wasn't trying to mock their idea, but if asked to go back in time, I felt it only made sense to dress in a way that my younger self would have appreciated: in a bright Christian Lacroix gown paired with a pair of recent, baby blue–feathered Manolo Blahnik booties—with rings on every finger, my favorite caterpillar cuddly toy under my arm, and, of course, the ultimate little girl's dream, a tiara.

Flipping through the book's pages, I again feel a sense of disconnect. The interiors look spectacular, but do they evoke my childhood? Not really. Do I recognize myself and my family in certain details: the nursery with its forgotten toys, the photo collages standing in the corner of a room, the door we painted with Keith Haring? Yes, I do. Maybe that's just how memory works, like a pastiche of images from which we make our own reality. And, maybe more aptly, it doesn't matter. After all, do these pictures go far beyond us as a family? Are we, too, perhaps mere objects, simply details in a larger story?

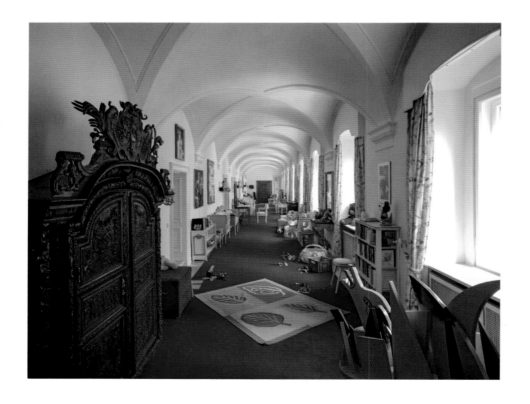

Above: The "Children's Corridor" in the north wing.

MARTIN MOSEBACH

SCHLOSS ST. EMMERAM IN REGENSBURG AND ITS MISTRESS

What is the difference between a *schloss* or castle and a palace? There is no clear dividing line between the two concepts; they have a lot in common. But we could say that a castle is usually to be found in the countryside, very often in a village or small town that forms part of the estate of the castle's occupant. If a castle is in a town, it is usually unattached to anything else, and is the residence of a monarch. By contrast, a palace is almost always located in a town and is often not the only palace to be found there. Its owners belong to an important, influential family who are not necessarily, however, the rulers of the town itself. Many districts in Italy's great cities seem to be made up of palaces. Regensburg, ancient Free Imperial City and home of the Perpetual Diet of the Holy Roman Empire of the German Nation, in many ways resembles one of those

Above: Martin Mosebach visiting the papal palace in the Vatican (2014) .

Italian metropolises with their particular combination of aristocratic and republican features. For example, there is the wonderful confusion of its composition. It is the seat of one of the most important institutions of the empire, and the emperor himself is frequently in residence; it is a city-state with a bourgeois, patrician constitution; and at the same time it is the residence of the Prince Abbot of the Abbey of St. Emmeram, one of the empire's many small sovereigns. After the secularization and dissolution of the empire, his monastery became Schloss St. Emmeram, the home of the Thurn und Taxis family. The Schloss might indeed embody the definition of a city palace, if the princely family had not assumed the inheritance of the sovereign Prince Abbot who had been the spiritual and temporal head of a small state squeezed into the bourgeois Regensburg.

In fact, however, St. Emmeram is more than a castle or a palace. It is a district of the city unto itself, a city within a city, and the two have grown up together over many centuries. Indeed, building work has taken place at St. Emmeram over the course of an entire millennium: the complex comprises a Romanesque cloister and a Baroque hall of mirrors, a huge library and a brewery, the tombs of emperors and saints, a park, a substantial collection of contemporary art, and the offices of the Thurn und Taxis estates.

Germany in its particularism has known many princes, but few with a history that can compare to the origins of the Thurn und Taxis family. Alongside the Fugger family, and perhaps even the Paars, Thurn und Taxis is the only family who acquired their princely rank through significant economic enterprise. During the Italian Renaissance such trajectories were more frequent—consider the Medici and Chigi dynasties, who owed their rise to their position as bankers to princes and popes. By contrast, in Germany entrepreneurship and the aristocracy remained fundamentally separate for a long time.

Of course, it was particular business activities of a substantially political nature that soon made the Thurn und Taxis family indispensable to the emperors. The organization of a courier service that unified the far-flung estates of the Habsburgs became an essential precondition of state-building. The omnipresence of the ruler created by the postal service became an establishing factor in the formation of a centralized bureaucracy. This is the paradox at the heart of the Thurn und Taxis history: their elevation to the feudal ranks of the old empire was achieved because of their modern-spirited postal organization.

Nevertheless, St. Emmeram marks the end of the family's public and political functions. When Bismarck began the Prussian conquest of the German Empire, and the city of Frankfurt (which until then had been a Free Imperial City) fell into Prussian hands, the Thurn und Taxis family soon lost their privilege of running the postal system, as Frankfurt was the center of the Thurn und Taxis postal administration. On Grosse Eschenheimer Gasse in Frankfurt, there stood a pretty Rococo palace which connected communication threads across all Europe. The palace was destroyed during the last war, and its reconstruction was not very successful. But its interiors had long since lost their sparkle: years before, the fittings of the magnificent state rooms with their wood paneling, stuccowork, mirrors, and furniture had been removed to St. Emmeram, where they form a glittering suite of rooms.

What is life like in such an extraordinary house? Many monks used to live here, and the abbot resided here with his advisers and secretaries. How did one live among such a vast agglomeration of rooms and facilities?

The princes of Thurn und Taxis, initially as representatives of the emperor, then as local Bavarian noblemen, held court here in classical style with a huge swarm of officials, minions, cooks, musicians, and librarians. If you stand in the courtyard of St. Emmeram, you will see that it would take hundreds of people to bring life to this Escorial. The modern lifestyle of even very wealthy people would feel slightly panicked by such an amount of space. Even most castle owners today, it has been noted, have created a cozy four-room suite out of their enormous chambers—not so different from an apartment in the city.

But St. Emmeram, whose proportions surpass even the normal-sized schloss, has a mistress who knows how to play this particular organ. Princess and mother-figure Gloria Thurn und Taxis possesses a courageous temperament that she manages to communicate to all around her. For her, "princess" is not simply a title, but also a duty. Under a monarchy, a princess had nothing of the private life our contemporaries hold so dear today. She had to lead her life in full public view, and was exposed to the criticism and scrutiny of friend and foe alike. Gloria Thurn und Taxis is not afraid of such a life that no one is demanding of her today. She seizes the good fortune of her birth as Countess of Schoenburg- Glauchau, a member of the Saxonian aristocracy, and her marriage to the late Prince Johannes Thurn und Taxis as a rare opportunity to live a life out of time with her times: as both feudal princess and democratic contemporary, as pious Catholic and collector of distinctly un-holy art, as patriotic Bavarian and member of the fashionable smart set who wander the world—all at once and at the same time without ever betraying a single one of these roles.

But the word "role" is misleading: Gloria Thurn und Taxis never play-acts; rather, she engages completely with every single moment of her life. Returning from a long period of travel, she bursts into the sleepy residence of St. Emmeram like a hurricane. The castle awakens and is filled with crowds of people. She organizes operas in the courtyard, as the princes of Thurn und Taxis once did in the Baroque period; she opens up the house and park to her guests and the people of the city; and she has revived the old tradition of glorious, multi-colored lights. At Christmas and during the summer, people flock to the castle in hordes, and it reflects the Princess's style that her guests cannot be reduced to one "sociological common denominator." She loves life with a passion, and she loves it wherever she finds it. Her parties are highly colorful, as befits a true court entertainment. And when most of the guests have left, there always remain some hundred and twenty people who are the princess's favorites: the old and the sick who are cooked for every day at the castle, who can eat their meals in a beautiful dining room, or in their own homes. One day in the distant future she will pass Schloss St. Emmeram on to her son, Prince Albert Thurn und Taxis— not as an immeasurably vast hulk made of stone, but as a living organism.

ANDRÉ LEON TALLEY

HOME AWAY FROM HOME

Some of my best moments in life have been spent with my dear friend Princess Gloria Thurn und Taxis in her home, Schloss St. Emmeram. Life with Gloria at the schloss is at once opulent and simple, cozy and correct. It is warm in winter and cool in summer, with huge, open double windows that overlook beautiful gardens, as well as long halls, such as the family quarter's main hall, with its pale-blue-and-white-printed carpet, which was custom-made just for the castle. When I am invited (usually twice a year, for Schlossfestival, the annual cultural festival in summer, and for Christmas), I am given the best guest apartments—the former royal bedroom suite of the late Prince Johannes, Gloria's husband. Outside his princely suite of rooms, Gloria has hung a beautiful full-blown photograph of me in a court coat, on my knees in prayer in front of the oldest cathedral in Novgorod, Russia, taken by the Russian photographer Andrei Rozen. To me, it's a beautiful symbol of our friendship, which has survived decades—since Gloria's early days as the lavish princess who created fireworks in Paris and New York, and throughout her legendary galas at the Schloss.

I first heard of Gloria when she came to Paris as a young bride with her husband, Prince Johannes Thurn und Taxis. She married him in 1980, at the age of twenty, in a beautiful Valentino couture gown. In those days, she would show up for lunch at the Ritz in a cashmere twin set, a gray tweed A-line skirt, and sensible shoes on low, sturdy German heels, until her husband ordered her to let it rip at the couture houses of Chanel and Christian Lacroix. Then she was known as the wife of Johannes, as the woman who was ordering Chanels, at the couture level, like T-shirts.

I will never forget the first visit to Regensburg to photograph Gloria for a piece in *House & Garden*, the Condé Nast magazine (for which I was creative director and, for about nine months, that Anna Wintour edited). I was assigned to capture Gloria playing her guitar as she sat on the edge of the most beautiful bed, a gilded wood bed that was carved by Regensburg craftsmen of the nineteenth century, in the royal bedroom of Princess Therese. The bed, which sits on two gold swans with curved necks, is framed by two pink columns. I spent most of the day without Gloria, until about 3:30 in the afternoon, touring the Schloss with an expert who told me the history of the rooms, including the Crypt Chapel and the ballroom known as the Baroque Room. I remember a wonderful old gentleman with white hair, who told me he had been born at the Schloss. His lifetime's work, which he learned from his father, was to wind all the clocks daily. These days, the clocks are left unwound. Today, the stables are a museum, some of the great gala coaches and vehicles from what is now the Carriage Museum were lent to the famous coach museum of Schoenbrunn in Vienna—and yet Gloria still keeps a state Mercedes-Benz from the seventies on raised bricks, just in case. There are still beautiful gala coaches, upholstered in white damask and faded by age to English cream, as well as everyday small coaches (my favorites are lined in a dark gray plaid wool).

Upon my first visit, I was most haunted by the Crypt Chapel. A former prince had had the crypt installed in the medieval cloister garden; all the ancestral tombs are there, lined up, and they can be viewed through a large opening in the stone floor. One has only to look through this framed opening in the floor to gaze down on neatly lined coffins. The last person to lie in state for seven days was Gloria's husband, Johannes. This crypt or mausoleum is the finest in Germany, and if Gloria decides to, she can, upon her death, take her place in the row of coffins, which still bear the colorful ribbons with gilt lettering from funeral wreaths of the dead.

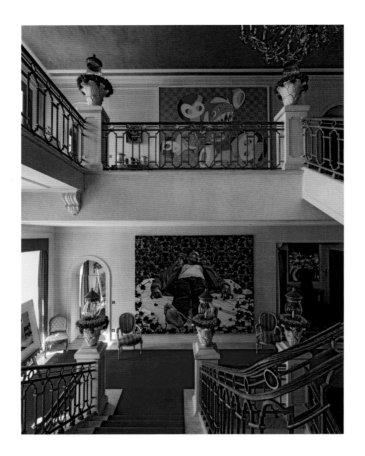

In 1989, Anna Wintour sent me to Regensburg to cover Gloria's thirtieth birthday party, for which American artist Keith Haring designed special plates for more than five hundred guests. I remember vividly feeling quite alone as I stayed in some local hotel and taxied my way to the party, where Gloria was on stage singing punk rock dirges in sunflower Lacroix crystal pleated pants and a brocade jacket.

Gloria once lived life only to get dressed up and shock people with her couture gowns, her spiked punk hair, and a tiara from the family vault, said to have a blue sapphire that had belonged to Marie Antoinette. Now I know a different Gloria, a person who invites you to her homes, treats you to luxury, and follows the appropriate codes of polite, civilized behavior. To be invited to her home of five hundred rooms at Schloss St. Emmeram, or to her Bavarian summer retreat, Schloss Garatshausen (just a mere twenty rooms or so), is to witness Bavarian splendor and share in the history of the princely Thurn und Taxis title. It takes a lot to live up to an invitation to Gloria's, but once you arrive, you are given the full-on treatment of a great hostess. One's only responsibility is to show up for meals on time and properly dressed. Not even her grown children can break these rules. Her son, Prince Albert II, the heir to this pile of gilt and glamour, is a tall, handsome man, who often arrives for dinner wearing one of his father's elegant velvet smoking jackets.

Gloria is like the sister I never had the privilege to love. A force of nature, she is fearless, sometimes quite annoying, hilarious, loud (so am I!)—often barking like a mad dog in the noonday sun—organized, energetic, adventurous, old-fashioned, conservative with very liberal friends, and very religious. Scintillating, adversarial—she's like a drill sergeant at times, bullying you into submission, knowing what is best for you better than you know yourself. At the same time, Gloria is a loyal friend, and she never lets you down, except when there is a better invitation (and quite often there is).

Gloria moves fast throughout her world, her life. At the center is her family, which includes her three children, Maria Theresia, Elisabeth, and Albert. She is a woman who loves to sing, loves to have a good time, and cares about her friends. Gloria is bold, brilliant, bright as a sparkling new Bentley (her car of choice), and fast as a Harley-Davidson (her favorite mode of transportation). She is bombastic, bellicose, bossy, and brassy.

One of my favorite expressions of hers is, "Darling, pull yourself together!" Such an apt string of words, as secure, as flawless as the string of pearls her husband gave her, which she wears almost every day. She is

Above: Stairwell in the Princess's apartment with *Para-Kiti DOB* (2001) by Takashi Murakami (above) and *Lamentation Over the Dead Christ* (2008) by Kehinde Wiley (below).

a great businesswoman and literally salvaged the entire Thurn und Taxis empire from ruin after her husband's death. Gloria pulled herself together, studied tax and economics, and figured out how to get out of debt, saving her life, selling off everything at the Schloss from dinner plates to cars.

Every evening during the annual Christmas market, from the center of the balcony in the formal courtyard at Schloss St. Emmeram, Gloria leads the vendors and shoppers in yuletide songs as bonfires glow in circles. In summer, she might make an entrance on stage, dancing with a Brazilian orchestra and dancers, on the last night of her annual Schlossfestival. The annual music, opera, theater, and concert festival brings people to the center of the Schloss, where grandstand seating is arranged around the centuries-old fountain and the stage is mounted against the formal entrance.

Mass is such a vital part of who Gloria is. She goes to church every day no matter where she is in the world. She drives her entire family into the celebration of Mass during the holy holidays of Easter and Christmas. If she picks you up at the airport in Munich, she will likely say, "Do you mind if I stop for the last Mass of the day?"

The important questions of existence, heaven and hell, and eternity are not only evident in the House Chapel, but also in another part of the Schloss, where she commissioned a work from world-famous video artist Bill Viola, who installed *Fire Woman*, a contemplation of ascension by water and descent into purgatory by fire, in one of the older rooms of the castle. This piece is part of her collection of modern art, which includes works by Jeff Koons, the Chapman Brothers, and Kehinde Wiley—whose monumental portrait of a young African American man asleep in bed with his street clothes on must shock some of the princely visitors, not to mention the Basquiats next to museum-quality furniture in the halls leading to the family's private living quarters.

So much church life brings extraordinary moments in a normal day at the Schloss. The last time I was there, in summer, Gloria discovered a winter chapel, located behind the main altar of the Basilica St. Emmeram, which was used by the former monks in winter when the big church was too cold. She discovered this hidden room in 2012, when she went searching for some books. Gloria, who has lived there since 1980, didn't know it existed. That was a beautiful moment in the living legend of the Schloss, a haven of grace and mercy, where Gloria and her family celebrate and give thanks for the blessings of life.

Above: André Leon Talley

20–21

The west wing of the fourteenth-century cloisters with the Benedict Portal (1240).

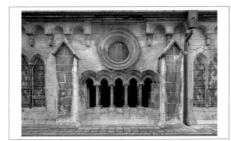

22–23

The cloisters (c. 1230).

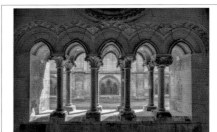

24–25

Romanesque double pillars in the north wing of the cloisters (1230).

26–27

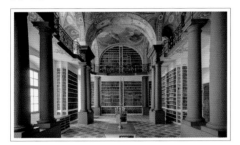

The library (1730) by Johann Michael Prunner, with frescoes created by Cosmas Damian Asam in 1737–39.

28–29

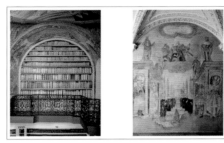

28: The 15,000 eighteenth-century books in the library form part of the Princely Royal Library, which contains a total of 230,000 volumes.
29: The wall painting of 1670 depicts Saints Emmeram, Wolfgang, and Dionysius surrounded by medieval rulers.

30–31

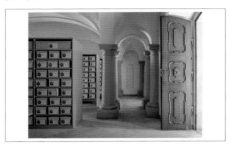

The former chapter house (1170) contains 1,000 documents and 10,000 files spanning the 350-year history of the Thurn und Taxis postal system.

32–33

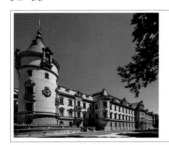

Between 1883 and 1888, Prince Maximilian, followed by his brother Prince Albert I, oversaw the construction of the schloss's magnificent, 165-meter-long south wing by architect Max Schultze.

34–35

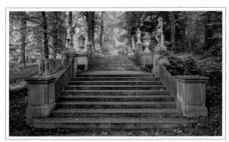

Park steps with statuary and vases brought from the Frankfurt palace (c. 1720).

36–37

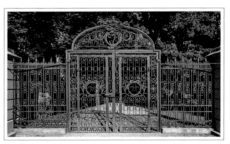

Park gates decorated with the initial *A* for Prince Albert I.

38–39

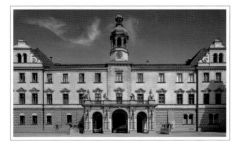

The east wing of the schloss with its large balcony and statues sculpted by Princess Margarete in 1913. They symbolize the historical names and estates of the Thurn und Taxis family.

40–41

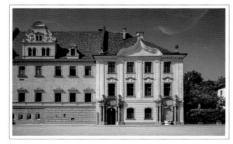

The Baroque library wing, whose facade was built in 1739.

42–43

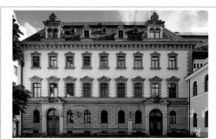

The vestibule in the south wing was built in 1888.

44–45

The vestibule, built in 1888.

46–47

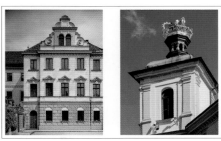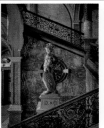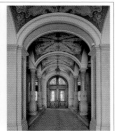

47: Since 1890, gilded princely crowns have adorned the south and north towers of the east wing.

48–49

48: The 1888 marble staircase with the statue of Minerva by Brussels sculptor Jerôme Duquesnoy (1612–1664).
49: View of the south wing (1890).

50–51

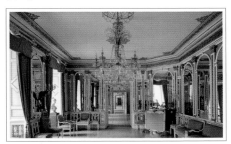

The Hall of Mirrors was created in 1816 for Princess Therese (1773–1839).

52–53

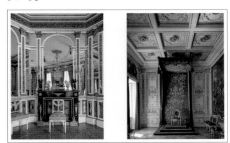

52: The interior of the Mirror Salon was created by master craftsmen from Regensburg.
53: Under the baldachin in the Throne Room, atop three steps, the *sella curulis* (c. 1780) is the throne on which the princes of Thurn und Taxis represented the emperor as principal commissioners at the Perpetual Diet. Three princes of the House of Thurn und Taxis assumed this role in succession between 1748 and 1806.

54–55

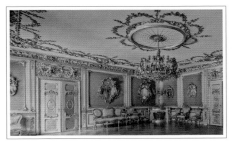

The Silver Room was commissioned by Princess Helene (1834–1890), sister of Empress Elisabeth of Austria (known as Sisi), in 1873. The 1873 chandelier is made of carved wood and plated with a silver and copper alloy. The interior of the room was created by the famous gilder and craftsman to the royal court, Josef Radspieler.

56–57

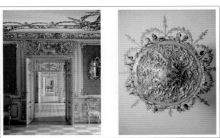

56: View of the east wing's staterooms, which were designed between 1816 and 1873.

58–59

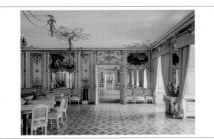

The Yellow Room was used as a music room. The richly paneled Rococo interior (1720) was brought from the Frankfurt palace and installed at Schloss St. Emmeram in 1816.

60–61

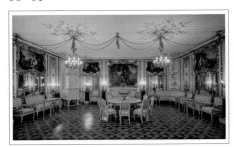

The early eighteenth-century paintings in the Yellow Room are by Innocente Bellavita (1690–1762) and Christian Georg Schütz (1718–1791); the stuccowork is by Paul Egell (1691–1752).

62–63

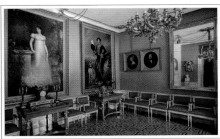

62–63: The Tsar Nicholas Room is named for Tsar Nicholas I (1796–1855), who was married to Princess Charlotte, a niece of Princess Therese. The portrait on the left, which depicts Princess Therese (1773–1839), was painted in 1811 in Paris by the Emperor Napoleon's court painter, François Gérard. On the right is Prince Maximilan Karl (1802–1871) in the uniform of the 2nd Royal Bavarian Chevaulegers Regiment. The two oval portraits (by royal court painter Joseph Stieler, 1830) depict Prince Maximilian Karl and his first wife, Princess Wilhelmine (1803–1835). On the right, reflected in the mirror, is a bust of Queen Luise of Prussia (1776–1810), a sister of Princess Therese.

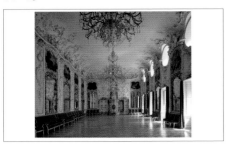

64–65: The Rococo Room was created in 1720 for the Frankfurt palace and then, on the occasion of the marriage of Prince Albert I to Margarete of Austria-Hungary, was reinstalled as a ceremonial hall, preserving original architectural features, in 1890 at Schloss St. Emmeram. The stoves are decorated with Delft tiles (1730), and the early eighteenth-century paintings are by Innocente Bellavita, Justus Juncker, and Christian Georg Schütz.

Chandelier, made in 1730 of Bohemian glass, in the Rococo Room.

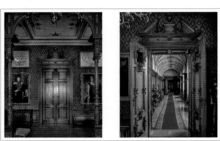

68: Prince Albert I in the parade uniform of the Taxis Regiment (later the 2nd Royal Bavarian Chevaulegers Regiment), founded in 1743 by Prince Christian Adam Thurn und Taxis, whose commander was the incumbent prince of Thurn und Taxis until the regiment was disbanded in 1918. He is wearing the Order of the Golden Fleece around his neck.
69: The Way of the Flags in the south wing (1888).

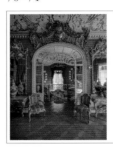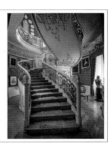

70: View from the Chinese Room of the Golden Staircase of 1887.
71: The neo-Rococo staircase connects the first floor to the second floor and the private rooms of Prince Albert I (1867–1952) and Princess Margarete (1870–1955).

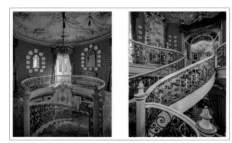

The neo-Rococo staircase.

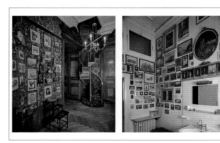

74: The Staircase of Love connects the bedrooms of Prince Albert I and Princess Margarete.
75: Bathroom of Prince Albert I in the south wing with family photos and pictures painted by his children.

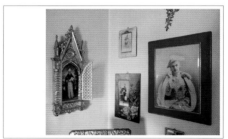

Family portraits in the Painter's Tower. On the right, Prince Albert I is shown in fancy-dress uniform before a costume ball in 1895.

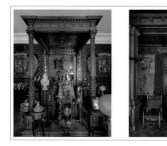

78: Prince Albert I's bedroom, created in 1888.
79: Bust of Prince Albert I (1890).

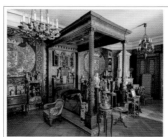

Two Brussels tapestries featuring the princely coat of arms hang to the left and right of Prince Albert I's bed.

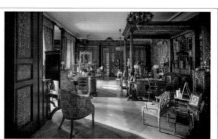

The bedroom of Prince Albert I, created in 1888.

84–85

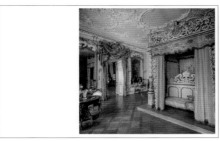

The neo-Baroque bedroom of Princess Margarete, designed in 1888.

86–87

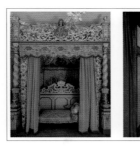

86: The decorative frieze features a golden initial *A* for Prince Albert I.
87: Portrait bust of Princess Margarete, created in 1905.

88–89

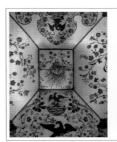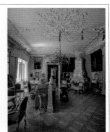

88: The "heavens" above Princess Margarete's bed, designed in 1888.
89: Princess Margarete's study, designed in 1888.

90–91

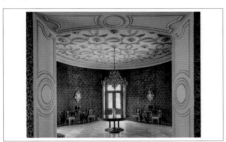

The Tower Room in the south wing (1888).

106–107

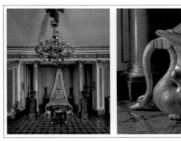

Princess Therese's bedroom, created in the classical style in 1816. The designs for the room date back to the famous architect Leo von Klenze. The swan bed is modeled after a bed belonging to Empress Joséphine, wife of Napoleon I, in the Château de Malmaison, Paris.

108–109

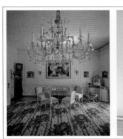

108: A 2002 work by Thomas Ruff in Princess Gloria's guest room.
109: Portrait of M. Graham, an English lady-in-waiting (c. 1790).

110–111

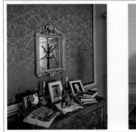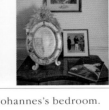

110: Detail of Prince Johannes's bedroom.
111: A photograph of the prince and princess meeting Fidel Castro in 1988 is displayed on a small table.

112–113

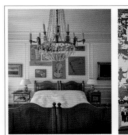

112: Guest bedroom in Princess Gloria's apartment with *Untitled* (2001) by Michael Craig-Martin.
113: Detail of Princess Gloria's mother's drawing room.

114–115

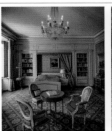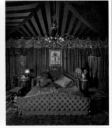

114: Bedroom of Prince Johannes.
115: Princess Gloria's private rooms with *Crucifiction* (1989) by George Condo.

116–117

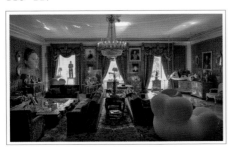

Princess Gloria's drawing room with ball chair (2000) by Gaetano Pesce, *Kopf VII (Fürst Albert von Thurn und Taxis)* (1998) by Stefan Hablützel, and chair (2000) by Gaetano Pesce.

118–119

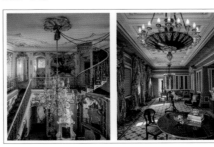

118: The Painter's Tower dates back to the fourteenth century and was converted into a painting studio for Princess Margarete Thurn und Taxis in 1889.
119: Princess Gloria's library, designed in 1988 by Gabhan O'Keeffe.

120–121

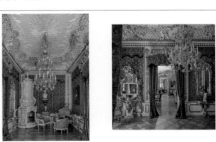

120: Boudoir between the Louis-Seize Room and Princess Margarete's study, designed in 1887, with a Venetian chandelier.

122–123

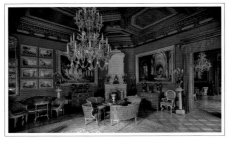

Smoking room in the south wing (1888) with Wilhelm Gail's paintings *The Doge's Palace in Venice* (1839) and *The Church of San Juan de los Reyes* (1837), and a Venetian chandelier (1890).

124–125

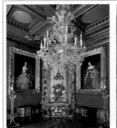

124: Small reception room in the south wing with a Venetian chandelier (1890), a wall panel with chinoiserie-style decoration (1720), and two portraits of Princess Helene Thurn und Taxis.
125: The Louis-Seize Room (1889) with portraits of the Thurn und Taxis family and a neo-Rococo tiled stove.

126–127

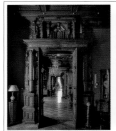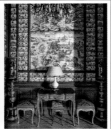

126: View of the enfilade of rooms in the south wing (1887).
127: Boudoir decorated with Delft tiles (1890).

128–129

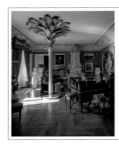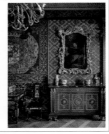

128: The Palm Room, the private study of Prince Albert I, with portraits of Empress Elisabeth of Austria (known as Sisi, center) and Princess Margarete (right).
129: The antechamber leading to Princess Margarete's study with a portrait of the Doctor of the Church, Albertus Magnus, for whom Prince Albert was named.

130–131

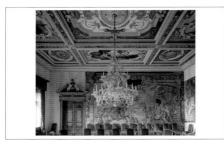

The Large Dining Room of 1888 is still the venue for hunt dinners today. Behind a Venetian chandelier (1890), the 1646 Brussels tapestry depicts Count Leonhard II (1594–1628) and Countess Alexandrine (1589–1666) hunting with falcons.

132–133

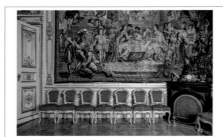

The 1684 tapestry depicts the triumphant entry into Milan of the della Torre counts.

134–135

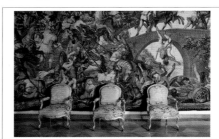

The 1680 tapestry titled *Battle on the Bridge* shows the della Torre counts fighting the Visconti counts for control of Milan in the fourteenth century.

136–137

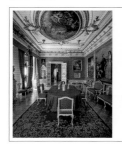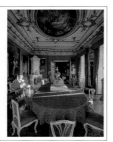

136: The dining room in the east wing, designed in 1888.
137: Tom Friedman's *Untitled* (2013), an arrangement of painted consumer-product boxes, is on the table.

138–139

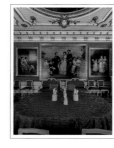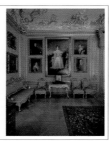

138: The central painting, by Joseph Stieler (1854), was a gift from the Bavarian king Ludwig I.
139: Portraits of members of Austria's archducal house: Josef (1833–1905), Josef (1776–1847), Clothilde (1846–1927), Marie Dorothee (1797–1855), Princess Marie Clementine Caroline d'Orleans (1817–1907), and Ferdinand I, Tsar of Bulgaria (1861–1948).

140–141

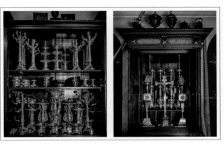

The silver room in the south wing.

142–143

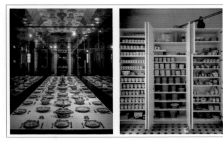

142: An exact replica of the princely dining table, set with the 1735 Du Paquier service.
143: The porcelain room in the south wing (1889).

144–145

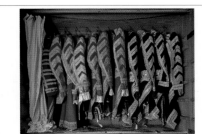

Formal uniforms of the personal servants and huntsmen (1890), which are still used today on special occasions.

146–147

Semiformal uniforms of the personal servants.

148–149

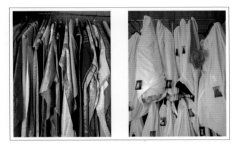

148: Church vestments.
149: Princess Gloria's private closet.

150–151

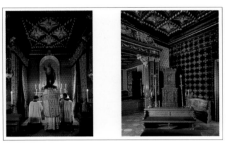

150: Holy Sacrifice of the Mass in the private chapel.
151: The private chapel was built in Princess Helene's former study—also the room where she died—by her son, Prince Albert I, in 1892.

152–153

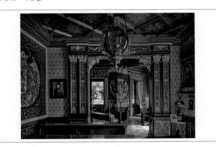

The private chapel.

154–155

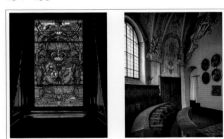

154: The 1892 glass window in the private chapel in the east wing features an alliance coat of arms. It depicts the Thurn und Taxis coat of arms on the left, and that of the House of Wittelsbach on the right.
155: The monks' winter choir of St. Emmeram's Abbey (c. 1730).

156–157

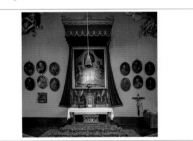

A copy of Raphael's *Sistine Madonna* (c. 1890) hangs in the winter choir, flanked by images of the twelve Apostles (c. 1780).

158–159

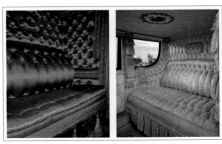

158: The interior of Prince Albert I's personal carriage.
159: The interior of the ceremonial carriage in which Prince Albert I and Princess Margarete drove to their wedding in 1890, as Princess Gloria and Prince Johannes did in 1980.

160–161

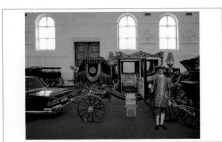

Carriage Museum with Wedding Coach and Mercedes 600.

162–163

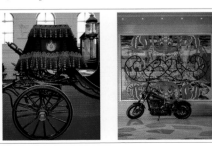

162: Carriage-driving apron for the ceremonial carriage decorated with the princely coat of arms.
163: A Harley-Davidson in front of Jeff Koons's *Lobster* (2003) in the entrance hall of Princess Gloria's apartment.

164–165

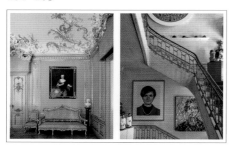

164: Portrait of Empress Elisabeth (1691–1750) in the Silver Breakfast Room of Prince Karl August (1898–1982).
165: Staircase in Princess Gloria's apartment with a photograph by Thomas Ruff (1997), *Untitled (Princess Gloria)* (1988) by Julian Schnabel, *Seven Wigs* by Wiebke Siem, *Greenborn Complexity* by Annette Lemieux (1989), *Altar Boys* by Martin Honert (1991), and *Just Amazing* by Damien Hirst (2005).

166–167

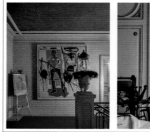

166: Staircase landing in Princess Gloria's apartment with Jean-Michel Basquiat's painting *Larry* (1985) and a 1991 portrait of Princess Elisabeth by John Redvers.
167: A photograph of Prince Johannes by Princess Gloria (1986) in their private apartment.

168–169

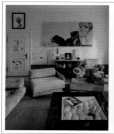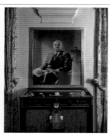

168: George Condo's *Study* (1996) and a portrait by Francesco Clemente (1998) in the children's room in the Princess Gloria's apartment.
169: Portrait of Prince Johannes Thurn und Taxis (1988) by Gottfried Helnwein.

170–171

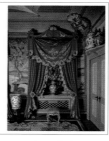

170: Detail from the private chapel showing *The Visit of Zacharias and Elisabeth with the Infant John the Baptist to the Holy Family* (1734) by Karl Bernardini.
171: The Chinese Room in Princess Gloria's apartment, designed by Gabhan O'Keeffe in 1988.

172–173

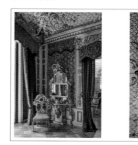

173: Venetian chandelier in the Chinese Room (1889).

174–175

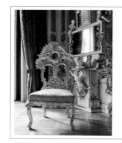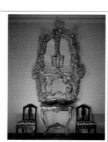

175: Jeff Koons's *Wishing Well* wall mirror (1988) in Princess Gloria's apartment.

176–177

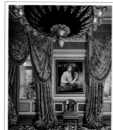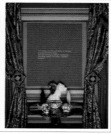

176: Cindy Sherman's *Caravaggioboy with Grapes* (1990) in Princess Gloria's private rooms.
177: *Skulls* by Dinos and Jake Chapman, and Richard Prince, *Jokes* (1988).

178–179

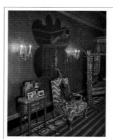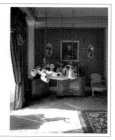

178: Jeff Koons, *Cow (Light Red)* (1999).
179: Jeff Koons, *Dogpool Log* (2003).

180–181

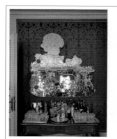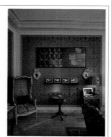

180: Jeff Koons, *Little Girl with Bear* (1988).
181: Andy Warhol's *Black on Black Retrospective* (1979) with Bill Viola's *Four Hands* (2001) below.

182–183

182: Door painting by Keith Haring (1988) in the children's room in Princess Gloria's apartment.
183: Plates by Keith Haring (1989) in Princess Gloria's private apartment.

184–185

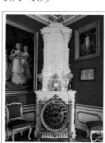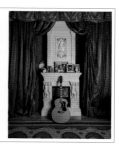

184: Neo-Baroque tiled stove of 1888 in the south wing.
185: Princess Gloria's private apartment.

186–187

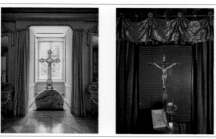

186: Anselm Reyle, *Untitled* (2008).
187: *Crucifix* (1991) by Paul McCarthy in Princess Gloria's private apartment.

188–189

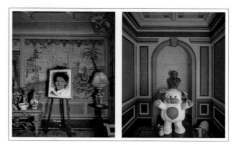

188: Andy Warhol's *Michael Jackson* (1984) in the Chinese Room.
189: Jeff Koons's *Popples* (1988) in Princess Gloria's library.

190–191

Jeff Koons's entry in Princess Gloria's guest book (December 9, 2013).

192–193

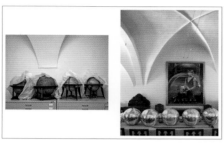

192: Seventeenth- and eighteenth-century globes.
193: *Self-portrait* (2012) by Cindy Sherman.

194–195

194: *Hurry Up Schedule* (2003) by Ed Ruscha in the princess's mother's drawing room.

196–197

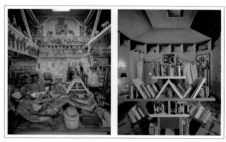

196: Princess Margarete's 1910 studio in the south wing.
197: Bookshelves by Ettore Sottsass (1980) and a ceiling fresco by Andreas Schulze (1988).

198–199

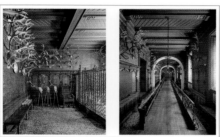

199: The bowling alley in the south wing, built in 1885.

200–201

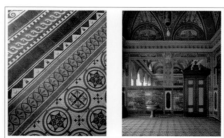

200: Floor tiling in the Winter Garden (1889).
201: The Winter Garden in the south wing, built in 1888.

202–203

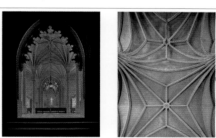

202: The Crypt Chapel, built in 1846, with a statue of Christ, made of white Carrara marble in 1830 by Johann Heinrich von Dannecker, in the altar room.
203: Net vaulting in the neo-Gothic Crypt Chapel.

204–205

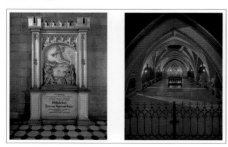

204: Epitaph of Prince Wilhelm Karl Thurn und Taxis.
205: Tomb with twenty-nine sarcophagi.

206–207

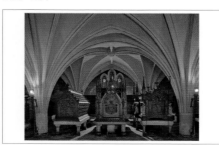

The sarcophagus of Prince Maximilian Karl (1802–1871), with the family coat of arms.

CHRONOLOGY OF THE PRINCELY HOUSE OF THURN UND TAXIS

1251	First official record of the founder of the House of Taxis, Omodeo de Tassis del Cornello.
c. 1470	Members of the Tasso family are employed in the papal and Venetian courier services.
1490	Future emperor Maximilian I commissions Francesco Tasso to establish a permanent postal service between Innsbruck and Brussels (the length of the journey is five and a half days).
	Tasso moves as "Franz von Taxis" from Innsbruck to Brussels.
1512	For their services to the empire, Emperor Maximilian elevates the Taxis family to the imperial aristocracy.
1516	Franz and Johann Baptista von Taxis are named *capitaines et maîtres des nos postes* by the Spanish king.
1520	Emperor Charles V appoints Johann Baptista postmaster general.
1559	The Taxis postal service is designated *Reichspost* (Imperial Postal Service) for the first time, and enjoys an initial period of success.
1608	Emperor Rudolph II makes his postmaster general, Leonhard I von Taxis, an imperial free baron in Prague.
1615	The office of postmaster general becomes an imperial hereditary title in the male line (and, in 1621, in the female line).
1624	Lamoral von Taxis is appointed an imperial count by Emperor Ferdinand II.
after 1648	The Imperial Postal Service is reinstated after the Thirty Years' War and continues to expand.
1650	The name Thurn und Taxis is given imperial authorization.
1681	Count Eugen Alexander Thurn und Taxis becomes prince of the Spanish crown.
1695	Emperor Leopold I elevates the House of Thurn und Taxis to the rank of hereditary imperial prince.
1702	The House of Thurn und Taxis moves from Brussels to Frankfurt am Main as a result of the War of the Spanish Succession.
1704	The house is given a seat and a vote among the princes in the Electoral Rhenish Circle.
1731	The house moves into the newly built Frankfurt palace.
1744	The postal service becomes an imperial fiefdom.
1748	Emperor Franz I names Prince Alexander Ferdinand his principal commissioner, or representative, at the Perpetual Diet in Regensburg.
	The House of Thurn und Taxis moves from Frankfurt to Regensburg.
1754	The House of Thurn und Taxis is given a seat and a vote at the Perpetual Diet.
1775	Under Prince Carl Anselm, the Thurn und Taxis Imperial Postal Service reaches its widest territorial extent.
1780	Prince Carl Anselm pays for the construction of the Prince Anselm Avenue around the Old Town in Regensburg.
1786	Purchase of the estates of Friedberg and Scheer.
1787	The Princely Court Library is opened to the public and managed on a full-time basis. Between 1786 and 1790 the inventory of books increases from 3,000 to 50,000 volumes.
1806	End of the Holy Roman Empire of the German Nation. Thurn und Taxis loses its postal rights in Bavaria and other German territories. With the abdication of the emperor, the office of the principal commissioner comes to an end.
1812	As compensation for the loss of the postal service in Bavaria, Prince Karl Alexander receives extensive landholdings and the former imperial abbey of St. Emmeram, which becomes his new residence.
from 1812	As compensation for the nationalized postal service and by means of purchases, the princely house acquires extensive landholdings in Bavaria, Württemberg, Prussia, Tyrol, Bohemia, and Croatia (a total of approximately 125,000 hectares).
1858	Hereditary Prince Maximilian Anton marries Helene, Duchess of Bavaria and sister of Empress Elisabeth of Austria.
1867	The last Thurn und Taxis postal areas in Central Germany are transferred to Prussian administration, signaling the end of almost four hundred years of the House of Thurn und Taxis's postal service tradition.

1883–88	Construction of the south wing of Schloss St. Emmeram.
1885	Albert Maria Lamoral succeeds as prince.
1890	Marriage of Prince Albert I to Her Imperial and Royal Highness Archduchess Margarete of Austria-Hungary.
1899	The princely house celebrates 150 years of residence in Regensburg (the festivities are delayed for six months due to the assassination of Empress Elisabeth).
1900	With the introduction of the German Civil Code, princely jurisdiction in three judicial bodies comes to an end.
1906–10	Construction of the New Stables in the Schloss.
1919	After World War I the foreign estates owned by the house (100,000 hectares) are relinquished.
1920	Hereditary Prince Franz Joseph marries Princess Elisabeth of Bragança, Infanta of Portugal.
1921	Prince Karl August marries Princess Maria Anna of Braganza, Infanta of Portugal.
1923	Prince Albert I founds the "princely charity kitchen," which provides free meals to those in need.
1926	Prince Albert sets up the Franz-Marie-Christinen-Stiftung to support doctoral students in the humanities.
1935	The princely stables are closed. Prince Albert I founds the Carriage Museum, the first museum in Regensburg.
1942	Hereditary Prince Gabriel is killed at Stalingrad.
1944	Prince Karl August is arrested by the Gestapo for listening to enemy radio broadcasts.
1952	Prince Albert I dies at age eighty-five. He is succeeded by Hereditary Prince Franz Joseph.
1955	Death of Princess Margarete.
1969	Discovery of the Asam frescoes in the library at St. Emmeram.
1971	Death of Prince Franz Joseph. He is succeeded by his brother Karl August (Hereditary Prince Gabriel was killed in World War II).
1980	Marriage of Prince Johannes to Princess Mariae Gloria von Schoenburg-Glauchau. Birth of Princess Maria Theresia.
1982	Death of Prince Karl August. His son, Prince Johannes, becomes head of the house. Birth of Princess Elisabeth.
1983	Birth of Hereditary Prince Albert.
1990	The exhibition *500 Years of the Thurn und Taxis Postal Service* tells the postal history of the house and is viewed by more than forty thousand visitors. Death of Prince Johannes.
1998	The princely house celebrates 250 years of residence in Regensburg. Opening of the Princely Treasure Chamber (a branch of the Bavarian National Museum).
2002	Princess Mariae Gloria opens the first Thurn und Taxis Palace Music Festival and the first Christmas market.
2006	Princess Mariae Gloria is awarded the Officer's Cross of the Order of Merit of the Federal Republic of Germany.
2009	Princess Mariae Gloria, Prince Albert II, Princess Maria Theresia, and Princess Elisabeth are admitted to the Order of Malta.
2010	Princess Mariae Gloria is admitted to the Papal Order of St. Gregory the Great.
2014	Princess Mariae Gloria is awarded the Bavarian Order of Merit. Marriage of Princess Maria Theresia to Hugo Wilson.

SELECTED BIBLIOGRAPHY

PUBLICATIONS ON THE HISTORY
OF THE PRINCELY HOUSE OF
THURN UND TAXIS

Lohner, Anton. *Geschichte und Rechtsverhältnisse des Fürstenhauses Thurn und Taxis*. Regensburg, 1895.

Mehler, J. B. *Das fürstliche Haus Thurn und Taxis in Regensburg. Zum 150jährigen Residenz-Jubiläum*. Regensburg, 1898.

Opacher, Josef. *Das königliche bayerische 2. Chevaulegers-Regiment Taxis, Erinnerungsblätter deutscher Regimenter*. Issue 26, Munich, 1926.

Piendl, Max. *Thurn und Taxis 1517–1867. Zur Geschichte des fürstlichen Hauses und der Thurn und Taxisschen Post*. Regensburg, 1967.

––. *Das Fürstliche Haus Thurn und Taxis*. Regensburg, 1980.

Le Poste dei Tasso, un'Impresa in Europa. Bergamo, 1984.

Dallmeier, Martin (ed.). *500 Jahre Post Thurn und Taxis*. Exhibition catalog. Regensburg, 1990.

Behringer, Wolfgang. *Thurn und Taxis—Die Geschichte ihrer Post und ihrer Unternehmen*. Munich, 1990.

Janssens, Luc, and Marc Meurrens. *De Post van Thurn und Taxis, La Poste des Tour et Tassis 1489–1794*. Brussels, 1992.

Dallmeier, Martin, and Martha Schad. *Das Fürstliche Haus Thurn und Taxis—300 Jahre Geschichte in Bildern*. Regensburg, 1996.

Dallmeier, Martin, Peter Styra, and Manfred Knedlik (eds.). *"Dieser glänzende deutsche Hof—250 Jahre Thurn und Taxis in Regensburg*. Regensburg, 1998.

Baumstark, Reinhold (ed.). *Thurn und Taxis Museum Regensburg*. Höfische Kunst und Kultur, Munich, 1998.

Styra, Peter. "'Er macht eigentlich die Honeurs des Reichstages und der Stadt...' – Das fürstliche Haus Thurn und Taxis in Regensburg." In *Geschichte der Stadt Regensburg*, edited by Peter Schmid, 163–73. Regensburg, 2000.

Kurzel-Runtscheiner, Monica, and Peter Styra (eds). *Mit Glanz und Gloria! Kutschen der Fürsten von Thurn und Taxis*. Exhibition catalog, Kunsthistorisches Museum, Vienna. Vienna, 2007.

Styra, Peter. "Fürst Taxis bleibt doch in Bayern, daran liegt mir viel." In *"Sie haben einen Kunstsinnigen König" – Ludwig I. und Regensburg*, edited by Peter Styra, Bernhard Lübbers, and Hans-Christoph Dittscheid, 25–45. Regensburg: Kataloge und Schriften der Staatlichen Bibliothek Regensburg 2. Regensburg, 2010.

Pchaiek, Christina. "Die Modelle der Heiligen Stätten in der Thurn und Taxis Hofbibliothek. Ein Forschungsbericht." In *Signum in Bonum—Festschrift für Wilhelm Imkamp zum 60. Geburtstag*, edited by Nicolaus U. Buhlmann and Peter Styra, 749–56. Regensburg, 2011.

Renner, Martin. "'Doch ist's nur Vatertausch....' Die Säkularisation der schwäbischen Klöster Marchtal, Buchau und Neresheim durch das Fürstliche Haus Thurn und Taxis— ein zusammenfassender Überblick." In *Signum in Bonum—Festschrift für Wilhelm Imkamp zum 60. Geburtstag*, edited by Nicolaus U. Buhlmann and Peter Styra, 757–93. Regensburg, 2011.

Sauer, Erich. "Die Glasmalereien des Franz Joseph Sauterleute in der Gruftkapelle von Thurn und Taxis." In *Signum in Bonum—Festschrift für Wilhelm Imkamp zum 60. Geburtstag*, edited by Nicolaus U. Buhlmann and Peter Styra, 809–23. Regensburg, 2011.

Styra, Peter. "Wappen und Orden als Zeichen fürstlicher Souveränität." In *Signum in Bonum—Festschrift für Wilhelm Imkamp zum 60. Geburtstag*, edited by Nicolaus U. Buhlmann and Peter Styra, 837–60. Regensburg, 2011.

––. "Zur Geschichte der Post in Bayern." In *I Tasso e le Poste d'Europa*, 167–79. Bergamo, 2012.

––. "Das Haus Thurn und Taxis. Gesamtgeschichte mit Stammfolge." *Deutsche Fürstenhäuser* 37. Werl, 2012.

I Tasso e le Poste d'Europa. Bergamo, 2012.

Styra, Peter. "Zum Wiederaufbau des Frankfurter Palais, Das fürstliche Haus Thurn und Taxis in Frankfurt." In *"Vieles dort ist Jahrhundert alt und doch strahlt alles neu…". Beiträge zu Geschichte und Kunst des Fürstlichen Hauses Thurn und Taxis*, edited by Wilhelm Imkamp and Peter Styra, 189–229. Thurn und Taxis Studies (new series) 3. Regensburg, 2013.

––. "Das Prinzipalkommissariat der Fürsten von Thurn und Taxis." In *Regensburg zur Zeit des Immerwährenden Reichstags. Kulturhistorische Aspekte einer Epoche der Stadtgeschichte*, edited by Klemens Unger, Peter Styra, and Wolfgang Neiser, 145–57. Exhibition catalog, Thurn und Taxis Museum. Regensburg, 2013.

Schlemmer, Hans. "Redende Steine." In *Menschen hinter den Grabdenkmälern in und um St. Emmeram*. Regensburg, 2014.

Foppolo, Bonaventura. *I Tasso, Maestri della Posta Imperiale a Venezia*. Bergamo, 2015.

PUBLICATIONS ON AND BY THE
HOUSE OF SCHOENBURG-GLAUCHAU

Michaelis, Adolph. *Die staatsrechtlichen Verhältnisse der Fürsten und Grafen Herren von Schoenburg*. Giessen, 1861.

Grote, Hermann. "Grafen Herren, und Fürsten von Schoenburg." In *Stammtafeln mit Anhang, Calendarium mediiaevi*, 252. Leipzig, 1877.

Schön, Theodor. *Geschichte des fürstlichen und Gräflichen Gesammthauses Schoenburg*. Waldenburg, 1908.

––. *Stammtafel des vormals reichsunmittelbaren Hauses Schoenburg*. Stuttgart, 1910.

Posse, Otto. *Die Urahnen des Fürstlichen und Gräflichen Hauses Schoenburg*. Dresden, 1914.

Müller, Conrad. *Schoenburg. Geschichte des Hauses bis zur Reformation*. Leipzig, 1931.

Schlesinger, Walter. *Die Schoenburgischen Lande bis zum Ausgang des Mittelalters*. Schriften für Heimatforschung 2. Dresden, 1935.

––. *Die Landesherrschaft der Herren von Schoenburg. Eine Studie zur Geschichte des Staates in Deutschland. Quellen und Studien zur Verfassungsgeschichte des Deutschen Reiches in Mittelalter und Neuzeit IX/1*. Munich/Cologne, 1954.

Schoenburg, Alexander von, Reinhard Haas, and Axel Thorer. *Das Beste vom Besten. Ein Almanach der feinen Lebensart*. Düsseldorf, 1989.

Die Schoenburger. Wirtschaft-Politik-Kultur. Beiträge zur Geschichte des muldenländischen Territoriums und der Grafschaft Hartenstein unter der Bedingungen der Schoenburgischen Landesherrschaft. Glauchau: Museum und Kunstsammlung Schloss Hinterglauchau, 1990.

Frickert, Matthias. *Die Nachkommen des 1. Fürsten von Schoenburg*. Glauchau, 1992.

––. *Die besten Seiten des Lebens von A-Z*. Düsseldorf, 1993.

Schoenburg, Alexander von. "In Bruckners Reich. Erzählung." In *Mesopotamia. Ernste Geschichten am Ende des Jahrtausends*, edited by Christian Kracht. Stuttgart, 1999.

––. *Der fröhliche Nichtraucher. Wie man gut gelaunt mit dem Rauchen aufhört*. Reinbek, 2003.

––. *Die Kunst des stilvollen Verarmens: Wie man ohne Geld reich wird*. Berlin, 2005.

––. *Lexikon der überflüssigen Dinge*. Berlin: Rowohlt, 2006.

––. *Alles was Sie schon immer über Könige wissen wollten*. Berlin, 2008.

––. *In Bester Gesellschaft*. Berlin, 2008. (ISBN 978-3-499-62472-8)

––. *Smalltalk. Die Kunst des stilvollen Mitredens*. Berlin, 2015. (ISBN 978-3-87134-787-0)

PRINCESS GLORIA THURN UND TAXIS
IN BOOKS, WRITINGS, INTERVIEWS

Lacey, Robert. *Aristocrats*. Toronto, 1983.

Colacello, Bob. "Voices of the Couture." *Vanity Fair* (December 1984): 104–07, 132–34.

––, and Karen Radkai. "The Dynamite Socialite. Princess TNT of Bavaria." *Vanity Fair* (September 1985): 80–88, 126–29.

"Glamour und Gloria, Die phantastischen Frisuren der Fürstin von Thurn und Taxis." *Bazar* 2 (1986): 82–97.
Newton, Helmut. "Un prince, une princesse et trois enfants rois." *Vogue* (January 1986): 312–17Dragadze,

Peter. "A Prince Among Princes." *Town & Country* (June 1986): 70–76.

Colacello, Bob. "Let Them Eat Lobster!" *Vanity Fair* (September 1986): 92–99.

Teichgräber, Renate. "A Regensburg, in Germania a cena con Don Giovanni." *Vogue Casa* (November 1986): 194–201.

Olbricht, Klaus-Hartmut, and Peter Knapp. "See mit Glanz und Gloria." *Ambiente* 10 (1988): 28–36

Richardson, John. "Rock'n'Royalty." *House & Garden* (April 1988): 106–13.

Thurn und Taxis, Gloria. "Gloria Fürstin von Thurn und Taxis: Mein Geburtstag." *Bazar* 4 (1989): 226.

Wedekind, Beate. "Gloria Fürstin als Designerin." *Elle* 5 (1990): 20–30.

Magosso, Renzi. "Cosi' vivo nella mia reggia." *Il Piacere* 7, no. 6 (June 1990): 22–33.

Wilhelm, Winfried. "Dem Täter auf der Spur." *Manager Magazin* 21, no. 9 (1991): 33–47.

Halbe, Jochen. "Eine fürstliche Yacht Aiglon." *Meer & Yachten* (July/September 1992): 50–55.

Colacello, Bob. "Diamonds Aren't Forever." *Vanity Fair* (December 1992): 242–47, 273–77.
Doinet, Rupp, and Astrid Sass. "Gloria von Thurn und Taxis 'Ich bin ein armer Schlucker'." *Stern* (September 30, 1993): 26–32.

Uslar, Moritz von. "Jeder weiss doch, dass die Holzpreise im letzten Jahr beschissen waren." *Süddeutsche Zeitung Magazin* (June 26, 1998): 12–17.

Thurn und Taxis, Gloria. "Den Glauben offensiv bekennen." In *Frauen in ihrem Jahrhundert. Predigten aus dem Alltag*, edited by Karl Birkenseer and Werner Schrüfer, 94–104. Regensburg, 1999.
Thurn und Taxis, Gloria, and Alessandra

Borghese. *Unsere Umgangsformen: die Welt der guten Sitten von A–Z*. Niedernhausen, 2000.

––. *Viver em Sociedade. As regras de etiqueta de A a Z*. Lisbon, 2000.

Vadukul, Max. "Fürstin Gloria!" *Vogue Italia* (March 2001): 250–59.

Cunaccia, Cesare, and Max Vadukul. "St. Emmeram in Regensburg, Bayern, Deutschland." *Casa Vogue* (December 2001): 160–69.

Thurn und Taxis, Gloria. "Das innere Gelb der Margeriten." In *Erlebte Religion. Biographische Skizzen*, edited by Michael Langer and Eckhard Nordhofen, 129–33. Freiburg, 2003.

"Maria Theresia von Thurn und Taxis." *Point de Vue* (December 30, 2003): 38.

Borghese, Alessandra, Manuel Frei, and Melanie Acevedo. "African Queen." *Architectural Digest* (2004): 102–11.

Fechter, Isabel. "Das Tüpfchen auf dem 'i'." *Weltkunst* 74, no. 9 (2004): 35–37.

Schröck, Rudolf. *Gloria von Thurn und Taxis: Eine Biographie*. Düsseldorf, 2004.

Weber, Katy, and Martin Scheele. "Familie von Thurn und Taxis. Donner und Gloria." *Manager Magazin* (April 2004).

Thurn und Taxis, Gloria. *Die Fürstin im Gespräch mit Peter Seewald*. Munich, 2005.

Thurn und Taxis, Gloria. "Gloria von Thurn und Taxis." In *Das Leben und die letzten Dinge*, edited by Annet van der Voort and Johannes-Hospiz Münster, 62–72. Breisgau, 2005.

Schoenburg, Alexander von, and Lord Snowdon. "Gloria." *Park Avenue* (November 2005): 52–61.

Colacello, Bob. "The Conversion of Gloria TNT." *Vanity Fair* (June 2006): 108–16.

Gregory, Alexis, and Marc Walter. "Schloss St. Emmeram." In *Private Splendor. Great Families at Home*, 156–83. New York: Vendome Press, 2006.

Eiblm Ralf, Oliver Mark, and Stephan Meyer. "L'art, c'est moi!" *Architectural Digest* (June 2007): 154–61.

Poschardt, Ulf. "Adel Schützen." *Vanity Fair* (June 14, 2007): 54–55.

Haertl, Brigitte, and Oliver Helbig. "Glorias Glanz." *Theo* (fall/winter 2007): 10–14.

Haberl, Tobias, Alexandros Stefanidis, and Dominik Wichmann. "Gloria Fürstin von Thurn und Taxis." In *Sagen Sie jetzt nichts*, 46–47. Vienna, 2008.

Panzer, Marita A. "Mariens Hilfe. Mariae Gloria Gräfin und Herrin von Schoenburg-Glauchau (*1960)." In Marita A. Panzer, *Fürstinnen von Thurn und Taxis*, 151–72. Regensburg, 2008.

Thurn und Taxis, Gloria and Joachim Meisner. *Die Fürstin und der Kardinal: ein Gespräch* über *Glauben und Tradition*. Freiburg, 2008.

Saurma, Charlotte, Gräfin von, and Thomas Schweigert. "Glanz um Gloria." *Merina Regensburg* 62, no. 9 (2009): 28–39.

Colacello, Bob. "Fortune's Children." *Vanity Fair* (June 2009): 128–57.

"So what?" *Vereinigung der Bayerischen Wirtschaft, Magazin* (2012): 14–18.

Moosburger, Uwe, and Angelika Sauerer. "Regensburg glänzt." In *Regensburg, Lebenslinien einer Stadt* by Uwe Moosburger and Angelika Sauerer, 72–87. Regensburg, 2012.

Thurn und Taxis, Gloria. "Bloss nicht besoffen an der Donau laufen!" In

Mein Bayern—Prominente stellen ihre Heimat vor, edited by Tobias Dorfer, 89–91. Munich, 2012.

––. "Katechismus, Katholizismus und Wertekanon." In *Mein Vater und ich—Prominente erzählen*, edited by Josef Seitz, 190–93. Munich, 2012.

––. "Wenn der Glaube fehlt, erlischt auch die Liebe." In *Glauben Sie noch an die Liebe?,* edited by Justus Bender and Jan Philipp Burgard, 23–38. Regensburg, 2012.

Schnell, Christian. "Gloria von Thurn und Taxis. 'Meine Lieblingsaktie ist Apple'." *Handelsblatt* (May 2012).

Eibl, Ralf. "Unsere Fürstin erobert New York." In *Stilikonen unserer Zeit—Wohn- und Lebensgeschichten besonderer Frauen* by Ralf Eibl, 68–79. Munich, 2013.

Thurn und Taxis, Gloria, and Alessandra Borghese. "Buongiorno Monsignore." In *60 Porträts prominenter Mitarbeiter des Heiligen Vaters*, drawn by Gloria Thurn und Taxis with Italian texts (including German translation) by Princess Alessandra Borghese and Countess Valentina Moncada. Rome, 2013.

Wizman, Ariel. "Gloria in Excelsis." *L'Officiel* (September 2013): 272–75.

Apiou, Virginie, and Bertrand Rindoff. "Princesse TNT." *Jalouse* (March 2014): 224–29.

Moehringer, J. R. "Princess Gloria von Thurn und Taxis Would Like to Paint Your Portrait." *Vanity Fair* (June 2014).

ARTWORK CREDITS

12–13
Francesco Clemente, courtesy the artist.
Rinecke Dijkstra, courtesy the artist.
Pierre et Gilles, courtesy Galerie Daniel Templon.
John Redvers, courtesy the artist.
Thomas Ruff. © VG Bild-Kunst, Bonn 2015.

14–15
Francesco Clemente, courtesy the artist.
Rinecke Dijkstra, courtesy the artist.
Pierre et Gilles, courtesy Galerie Daniel Templon.
Ena Swansea, courtesy the artist.

108
Thomas Ruff. © VG Bild-Kunst, Bonn 2015.

112
Michael Craig-Martin. © Michael Craig-Martin.

115
Dinos and Jake Chapman. © VG Bild-Kunst, Bonn 2015.
George Condo. VG Bild-Kunst, Bonn 2015.

116
Bill Viola, courtesy the artist.
Stefan Hablützel, courtesy the artist.

119
Dinos and Jake Chapman. © VG Bild-Kunst, Bonn 2015.

137
Tom Friedman. Courtesy the artist, Luhring Augustine,
New York, and Stephen Friedman Gallery, London.

163
Jeff Koons. © Jeff Koons.

165
Damien Hirst. © Damien Hirst and Science Ltd. All rights
reserved / VG Bild-Kunst, Bonn 2015.
Martin Honert, courtesy the artist.
Jeff Koons. © Jeff Koons.
Annette Lemieux, courtesy the artist and Kent Fien Art, NYC.
Thomas Ruff. © VG Bild-Kunst, Bonn 2015.
Julian Schnabel, courtesy the artist.
Siem Wiebke, courtesy the artist.

166
Jean-Michael Basquiat, courtesy Artestar, New York.
© Estate of Jean-Michel Basquiat.

168
Francesco Clemente, courtesy the artist.
George Condo. VG Bild-Kunst, Bonn 2015.

169
Gottfried Helnwein. © 2015 Gottfried Helnwein.

175
Jeff Koons. © Jeff Koons.

176
Cindy Sherman, courtesy the artist.

177 / Backcover
Richard Prince. © Richard Prince.
Jeff Koons. © Jeff Koons.
Dinos and Jake Chapman. © VG Bild-Kunst, Bonn 2015.

178
Jeff Koons. © Jeff Koons.

179
Jeff Koons. © Jeff Koons.

180
Jeff Koons. © Jeff Koons.

181
Bill Viola, courtesy the artist.
Andy Warhol. © 2015 The Andy Warhol Foundation for the
Visual Arts, Inc./ Artists Rights Society (ARS), New York.

183
Keith Haring, courtesy of Artestar, New York.
© 2015 Haring Estate.

186
Anselm Reyle, courtesy the artist.

187
Paul McCarthy. © Paul McCarthy, courtesy the artist and
Hauser & Wirth.

188
Andy Warhol. © 2015 The Andy Warhol Foundation for the
Visual Arts, Inc./Artists Rights Society (ARS), New York.

189
Jeff Koons. © Jeff Koons.

191
Jeff Koons. © Jeff Koons.

193
Cindy Sherman, courtesy the artist.

194
Ed Ruscha. © Ed Ruscha, courtesy the artist.

197
Andreas Schulze, courtesy the artist.

212
Jeff Koons. © Jeff Koons.

220
Takashi Murakami. © 2001 Takashi Murakami/Kaikai Kiki Co.,
Ltd. All Rights Reserved.

222
Kehinde Wiley. © Kehinde Wiley.

ABOUT THE MUSEUM

PRINCE THURN UND TAXIS MUSEUMS REGENSBURG:

THE CLOISTER OF ST. EMMERAM

The Romano-Gothic cloister of the former imperial ecclesiastical principality St. Emmeram is among the most impressive of its type in Germany. The oldest parts of the building date from the eleventh century and the youngest from the fourteenth. The Romanic capitulary hall, the sumptuous group of windows in the early Gothic north wing, and the magnificent Benedict portal from the first half of the thirteenth century communicate to the visitor, even today, the contemplative stillness of this unique memorial. In the years 1835–43, Prince Maximilian Karl had his building officer, Carl Victor Keim, erect the Crypt Chapel in the cloister garden. It is considered the earliest and most important princely mausoleum in German history. Members of the princely family continue to be buried here.

PRINCELY PALACE

In 1812, the Princes of Thurn und Taxis received the monastery buildings of the secularized imperial ecclesiastical principality St. Emmeram as partial restitution for the loss of the post monopoly in the Kingdom of Bavaria. In 1816 it began to be rebuilt as a residence. Many of the Rococo furnishings of the former family residence in Frankfurt were used. Between 1883 and 1888, the architect Max Schultze built the 150-meter-long south wing of the palace in the neo-Rococo style as new living quarters for Prince Albert I. Representative rooms in the south and east wings are open to visitors: the marble staircase, the ballroom, various salons, the Throne Room, the chapel, and the conservatory. The St. Emmeram Palace is among the most important structures in Germany, comparable to the buildings of the Bavarian "Fairy Tale King," Ludwig II, the difference being that St. Emmeram is still inhabited by a princely family.

THE CARRIAGE MUSEUM

Between 1829 and 1832 the architect Jean-Baptiste Métivier built the stables for the princely palace. They consist of the stable wings for the horses and a six-hundred-square-meter riding hall decorated with sculptures by Ludwig von Schwanthaler. Today, this Carriage Museum contains a comprehensive collection of coaches, sleighs, and sedan chairs from the eighteenth and nineteenth centuries. Ceremonial riding equipment is testament to the elaborate equine husbandry of the Thurn und Taxis.

THE PRINCELY TREASURY

Since 1998, the north wing of the former classicist stables has housed a branch of the Bavarian National Museum. Exceptional artworks from the princely collections, which were transferred to the State of Bavaria in 1993, are exhibited here. Valuable furniture, fine porcelain, snuffboxes, weapons, and exquisite items of gold and silver from the leading manufacturers in Europe allow visitors to experience the glamourous world of one of the most important dynasties of the European aristocracy.

Fürst Thurn und Taxis Museen
Emmeramsplatz 5, 93047 Regensburg
email: museum@thurnundtaxis.de
www.thurnundtaxis.de

PRINCE THURN UND TAXIS COURT LIBRARY

Prince Carl Anselm (1733–1805), the founder of the court library, systematically collected works, and in 1787 the library became available to the public. Today the library is composed of around 220,000 bibliographical works, 1,300 incunabula, 400 manuscripts, 2,900 musical manuscripts, and nearly 400 pieces of early sheet music. Due to the rich variety of its catalog, the library offers a range of material pertaining to history dating from the Middle Ages through the modern era. Art and cultural history, music, Bavarian and Ratisbon history, literature from the nobility, and postal and transportation history are also represented in this very diverse collection. Other noteworthy items are literature dating from the sixteenth to the twentieth centuries and the Häberlin Collection, which comprises 1,900 pamphlets from the time of the Thirty Years' War. Additionally, it is possible to access works from the graphical, philatelic, and numismatic collections. The library also provides interlibrary loan services.

PRINCE THURN UND TAXIS CENTRAL ARCHIVE

The princely central archive houses nearly five thousand archival meters with documents dating from the twelfth century through the present. The oldest catalog entry is from 1689 and pertains to the archive of the princely family and the postal system. Through acquisition of land and principalities in the Netherlands, Württemberg, Upper Swabia, South Tirol, Bohemia, Poland, and Croatia, smaller archives from these locations were brought together to form part of the central archive. The archives from the secularized cloisters of Neresheim, Marchtal, and Buchau were also consolidated with the central archive. The central archive has been housed in Regensburg since 1812. The postal archive consists of roughly eleven thousand documents dating to the period of the Reichspost (1500–1806) and ultimately ends in 1867, when the postal system became state controlled. Approximately fourteen thousand personal records that document the employees in the postal service offer a unique source for historians. Within the abundance of the archive, it is possible for historians and art historians to find documents for numerous areas of research.

Fürst Thurn und Taxis Hofbibliothek
und Zentralarchiv
Emmeramsplatz 5, 93047 Regensburg
email: hofbibliothek@thurnundtaxis.de
www.hofbibliothek.thurnundtaxis.de

Visit us on Facebook:
www.facebook.com/schloss.thurnundtaxis

PLAN OF THE ESTATE

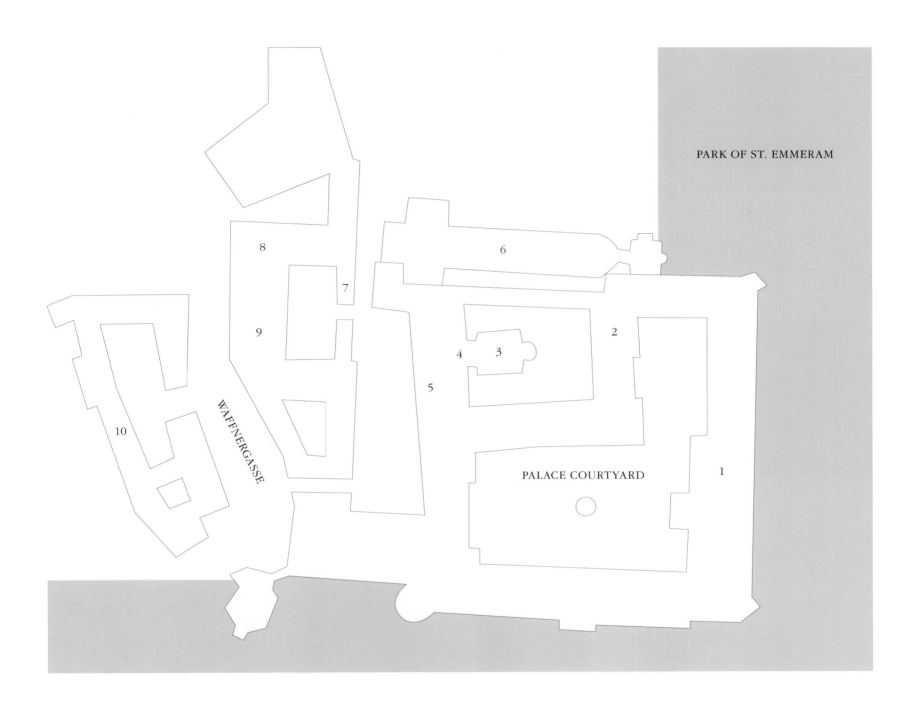

PARK OF ST. EMMERAM

WAFFNERGASSE

PALACE COURTYARD

1. Princely Staterooms
2. Asam Room
3. Crypt Chapel
4. The Cloisters
5. Museum Shop

6. Basilica of St. Emmeram
7. Café
8. Princely Treasury
9. Carriage Museum
10. Princely Brewery (Restaurant)

DEDICATED, IN GRATITUDE, TO MY SON, ALBERT, THE TWELFTH PRINCE OF THE HOUSE OF THURN UND TAXIS.

ACKNOWLEDGMENTS GO TO:

Wolfgang Brandl, Christina Burns, Todd Eberle, Jan Haux, Verena von Holtum, Philippa Hurd, Dr. William Imkamp, Maria Kandsberger, Jeff Koons, Father Julian P. Large, William Loccisano, Father Rupert McHardy, Petra Müller, Vicente Muñoz, Myra Musgrove, Charles Miers, Martin Mosebach, Loren Olson, Richard Pandiscio, Dr. Kurt Rehkopf, Sir John Richardson, my brother Alexander von Schoenburg, Michael Stout, Philipp von Studnitz, Dr. Peter Styra, André Leon Talley, John Charles Thomas, and my children, Albert, Elisabeth, and Maria Theresia.

PAGE 2: View of the south wing of Schloss St. Emmeram, which was built between 1883 and 1888, with the Thurn und Taxis standard flying from the tower.
PAGE 5: Photograph case from 1890 bearing the initial A for Prince Albert I.
PAGE 17: Prince Albert II Maria Lamoral Miguel Johannes Gabriel Thurn und Taxis with the cross of the house order of Thurn und Taxis, "De Parfaite Amitié," which was founded by Prince Alexander Ferdinand in 1773.

FIRST PUBLISHED IN THE UNITED STATES OF AMERICA IN 2015 BY:

Skira Rizzoli Publications, Inc.
300 Park Avenue South
New York, NY 10010
www.rizzoliusa.com

For Skira Rizzoli
CHARLES MIERS, Publisher
MARGARET RENNOLDS CHACE, Associate Publisher
LOREN OLSON, Editor

For Pandiscio Co.
RICHARD PANDISCIO, Creative Director
WILLIAM LOCCISANO, Designer

For Gloria Thurn und Taxis
CHRISTINA BURNS, Editor
DR. PETER STYRA, Princely Librarian

2016 2017 2018 / 10 9 8 7 6 5 4 3 2
ISBN: 978-0-8478-4714-3
Library of Congress Control Number: 2015942710

Printed in China